Brothers in Clay

The Times, Gainesville, Georgia, Tuesday, November 15, 1983

Notes 'n' folks

Area folk potters' art is focus of new book

Two northeast Georgians are among the six folk potters whose work and heritage are featured in a new book, "Brothers in Clay: The Story of Georgia Folk Pottery."

Author John Burrison, director of the Folklore Program at Georgia State University in Atlanta, spotlights **Bobby Ferguson** of Gillsville and **Lanier Meaders** of White County in the story of Georgia folk potters and their descendants, some of whom are fifth- and sixth-generations potters.

The book, which features 157 black-and-white and 12 color photographs, also spotlights J.W. Franklin, Marietta; D.X. Gordy, Jugtown; Chester Hewell, Statham; and Marie Rogers, Meansville.

" 'Jugstowns' lost most of their business when prohibition was declared," according to a release on the book, which is published by the University of Georgia Press. "But the 'Face Jugs' crafted by Lanier Meaders and the pots being turned by folk potters in many areas of north Georgia are now valued and collected."

Also attending the conference held at the Atlanta Dunfey Hotel were **Jean Blackwell, Teena O'Kelley, Teresa Hudgins, Lynn Wiggins, Jill Smith** and **Lori Bolton.**

Beverly Sisk is advisor of the Johnson FBLA Chapter.

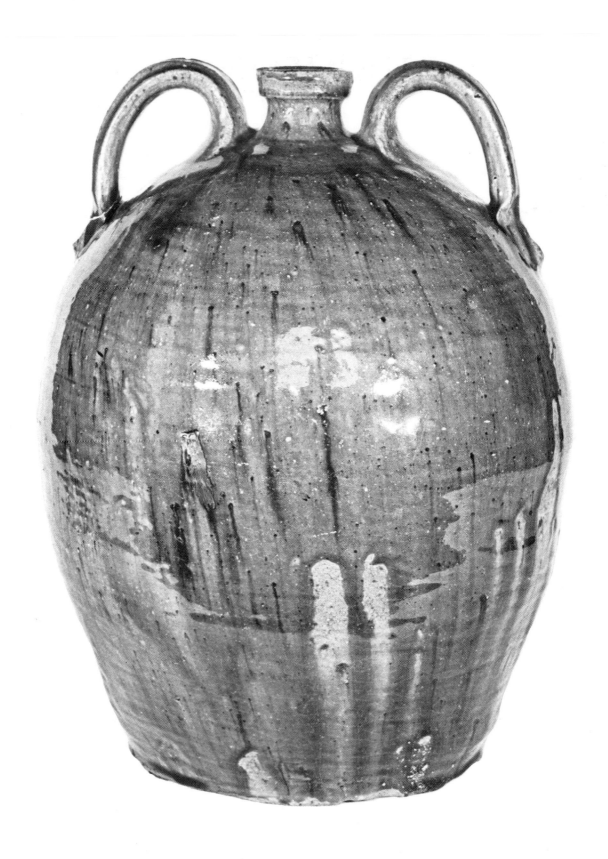

JOHN A. BURRISON

Brothers in Clay

THE STORY OF
GEORGIA FOLK POTTERY

THE UNIVERSITY OF GEORGIA PRESS

ATHENS

Designed by Sandra Strother Hudson
Set in 12 on 13 Linotron 202 Garamond No. 3
Printed in the United States of America

The paper in this book meets the guidelines
for permanence and durability of the Committee on
Production Guidelines for Book Longevity of the
Council on Library Resources.

Library of Congress Cataloging in Publication Data

Burrison, John A., 1942–
 Brothers in clay.

 Bibliography: p.
 Includes indexes.
 1. Pottery, American—Georgia. 2. Folk art—Georgia. I. Title.
NK4025.G4B87 1983 738.3′09758 82-15884
ISBN 0-8203-0657-6

For Lanier Meaders,
without whom all this
would be just history

Contents

CONTENTS

Those old-time potters,
they'd stick together,
help each other out;
it was like a brotherhood of clay.

D. X. GORDY
at Westville, 1970

Acknowledgments

A project of this scope tends to be something of a communal effort. It is my pleasure to acknowledge the contributions of the following:

The many respondents listed at the back—mostly members of pottery families—without whose information this book could not have been written. While space limitations prohibit naming all of them again here, I would like to single out those genealogists who went out of their way to share with me their detailed findings: Bobby Stokes, Anne Ferguson Royal, Margaret Davidson Sizemore, Mildred Craven Galloway, Marie K. Darron, Karen Brownlow Craven, Hazel Meaders Haynes, and Dorothy Brown Wood.

Ralph Rinzler and Robert Sayers, who generously allowed me to use the transcripts of their excellent interviews done for the Smithsonian Institution's Division of Folklife Programs.

The Atlanta Historical Society for a grant to cover color reproduction costs, and Georgia State University's Arts and Sciences Research Committee for funding the Rolader Pottery excavation and certain photographic expenses.

Truly Bracken, Lannis Cranford, Jack Farris, Mary Finneran, Rebecca Plunkett Lasley, Mary Maloy, Judy Meador, Stephen Moorman, Mary Mosteller, Mary Louise Pollock, Jan Rowe, and Nina Walton for interviews conducted for term papers in my folklore classes at Georgia State University.

Linda F. ("Becky") Carnes, James and Emily Tillman, Faye Bell, Carol Dickens, Jean Ellen Jones, Ed Prince, Tom Chandler, William W. and Florence Griffin, Norman Thurston, John Middleton, Becky Lasley, Minette Bickel, W. Lewis and Joan Ballard, Victor and Dewey Kramer, Paula Anderson-Green and Robert H. Green, and Jay and Edie Hardy for companionship and very real assistance on research trips.

Fellow pottery researchers Georgeanna H. Greer of San Antonio, Texas; Charles G. ("Terry") Zug III of the Curriculum in Folklore, University of North Carolina at Chapel Hill; Bradford L. Rauschenberg, research fellow of the Museum of Early Southern Decorative Arts at Winston-Salem, North Carolina; Stephen

T. and Terry M. Ferrell of South Carolina; Daisy Wade Bridges and Stuart C. Schwartz of the Mint Museum of History, Charlotte, North Carolina; Susan H. Myers, curator of the Division of Ceramics and Glass, National Museum of American History, Smithsonian Institution, Washington, D.C.; Peter C. D. Brears, director of museums at Leeds, Yorkshire, England; and Arnold R. Mountford, director of the City Museum and Art Gallery, Hanley, Stoke-on-Trent, Staffordshire, England, for their hospitality and exchange of information and ideas.

Archaeologists Catherine L. Lee, Becky Carnes, William Rowe Bowen, and a number of student volunteers for conducting excavations germane to my research.

John Mark Hodgson for his excellent prints from my photographic negatives, and the staff of Wing's Cameras for their patience and good humor.

Raymond Carter Sutherland, Brad Rauschenberg, Stephen F. Cox, Terry Zug, Georgeanna Greer, D. X. Gordy, Lanier and Mrs. Cheever Meaders, and my editors at the University of Georgia Press, Charles East and Karen Orchard, for reading an earlier version of the manuscript and making valuable suggestions for revision.

The Georgia Geologic Survey for permission to quote from its clay bulletins and use photographs from its files; and the other organizations and individuals who allowed me to use their photos or to photograph their pieces.

Marion R. Hemperley, Georgia surveyor general; Franklin M. Garrett, historian of the Atlanta Historical Society; and Merita Rozier, Gerald H. Davis, Billy F. Allen, Jim Allen, Frederick J. Schneeberger, Franklin and Emelyn Fenenga, John Olson, Frank and Jo Cummings, Bobbelise Brake, Fred Fussell, Mary Creech, George R. Hamell, J. Garrison and Diana Stradling, Paul G. Blount, and Clyde W. Faulkner for various other kinds of help. My apologies to anyone whose assistance I may inadvertently have failed to mention.

Prologue

The crucial event that led to the writing of this book occurred on a blustery March Saturday in 1968. It was my second year as folklorist at Georgia State University, and I was in the midst of gathering information and artifacts for an exhibit on upland Georgia folk crafts. While a graduate student in folklore and folklife at the University of Pennsylvania, my research interests had been largely confined to oral literature, especially ballads and tales. Now settled in Georgia, I was becoming attuned to the total range of traditions in my new environment, and welcomed the opportunity to expand my experience into the realm of material folk culture. I had already interviewed and observed traditional basketmakers, quilters, chairmakers, weavers, and blacksmiths, purchased examples of their work, and obtained older pieces as well. But I was encountering some resistance within myself to pottery; perhaps the cosmic timing was not yet right, or, conversely, I was unconsciously trying to escape my destiny.

I knew of the Meaders Pottery, of course. I had read about the family of White County potters years earlier in Allen Eaton's *Handicrafts of the Southern Highlands*, the book most responsible for whetting my appetite for the Appalachian South. In the summer of 1967 I had seen a rough-cut version of the Smithsonian Institution's film on the Meaders Pottery and had even bought a Lanier Meaders face jug (ironically this happened not in Georgia but in Washington, D.C., at the first Festival of American Folklife). But the event that would trigger my fourteen-year odyssey on the trail of Georgia's jug-makers was still to occur.

Then, on that fateful weekend when the icy hand of winter had not yet released its grip, I was initiated to the Meaders Pottery. I had been further north, visiting a colorful mountaineer friend with a newspaper reporter who was doing a story on Georgia State's folklore program. Our return route would take us through White County, so I suggested stopping by the shop to learn of its status now that the old man, Cheever Meaders, was dead (as I recently had heard). With some difficulty we found the place, unmarked by trade signs. The grounds and tarpaper-covered shop were of such a ramshackle appearance that it hardly seemed

1. Meaders Pottery, autumn 1975.

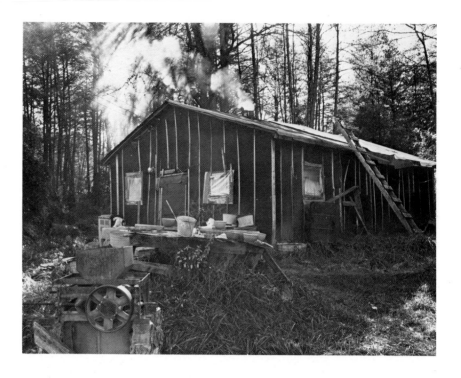

possible anything of substance could be made there. An incessant gray rain heightened the feeling of gloom. But a wisp of wood smoke curling from the roof beckoned us toward the shop. The yard was a sea of red mud, which proved to be ankle deep as we sloshed through it to be greeted by Cheever's son, Lanier (who was then fifty). Working at the potter's wheel, he had heard the car strain up the slippery driveway.

Little explanation of our purpose was necessary; it was almost as if he were expecting us. The reporter and I were given a tour of the establishment: Lanier's new kiln by the shop, built partly of bricks from his father's collapsed one; in the center of the yard the old wooden "mud mill" once used to mix the clay, but replaced by a motor-driven affair inside; the lonely chimney near the road, erected by a black stonemason, which had heated the sagging log shop until Lanier could construct a frame substitute for his father to work in; and the venerable "glazing rocks," a hand-turned mill for refining the ash glaze that Lanier was then still using.

We moved out of the rain into the shop, and it became evident that Lanier was in good spirits. By successfully firing his new kiln he had demonstrated to himself that he was capable of taking over the family business. The fruits of this first harvest sur-

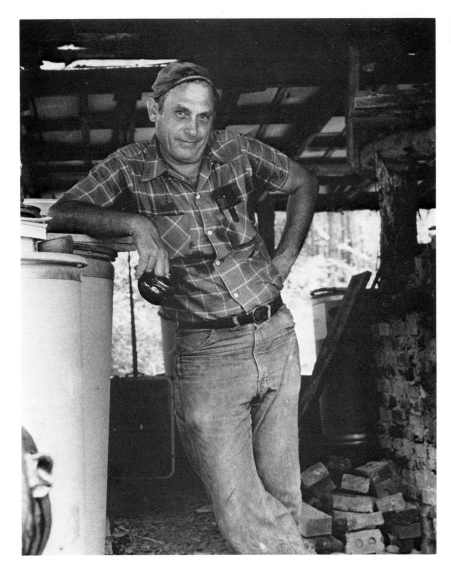

2. Lanier Meaders, summer 1975.
Photo by Kirk Elifson.

rounded us, waiting to be sold. As we talked, Lanier alternated between a deliberate, confidential tone for serious matters and a sardonic tone—accompanied by a crooked half-grin—used frequently to inject comic relief. Suddenly his dark-glazed pottery seemed to come alive, to take on a personality in a way I had never before known for inanimate objects.

Before we left, Lanier bestowed upon me two gifts, the first being a warmly misshapen little brown jug signed C M and cryptically inscribed Don't a had just a sip, said to be the last piece his father had finished before his heart failed while he was bringing in an

armload of wood that winter. The other was a large two-handled jug with graceful Nefertiti neck and drippy olive-green ash glaze, pierced by a number of mysterious holes. This, Lanier explained, was his "laser jug," inspired by an article in a popular science magazine. As he understood it, lasers were produced by concentrating red and blue light, so he had fashioned a pair of units in the old molasses-jug shape, each with holes in the sides to receive light-bulb sockets and a large mouth in the lower wall from which the intensified light would stream. Facing each other, they would create a deadly beam that could cut through steel; but one had been ruined by "that mischievous ha'nt [spirit] working in the kiln," and the surviving laser jug, now useless, was offered to me. "Come back, now," he called as we waded to the car; "don't be a stranger."

I did not become a stranger. Since that first impressionistic visit I have called at the Meaders shop and house on the average of once a month. Lanier is like an uncle to me, and his mother, Arie—who produced some extraordinary pottery in the 1960s—a surrogate grandmother. I now pick up on most of Lanier's very personal, riddlelike allusions, and when I don't he patiently supplies the necessary clues. His standard response to my greeting of "How are you?" is, "Oh, about half crazy!" It was with this enigmatic practitioner, then, rather than with the pots themselves, that my obsession with Georgia folk pottery began.

As I dug into the available resources I came to realize that Lanier was just the visible tip of a substantial historical iceberg. In his community alone he is the last link in a chain of tradition encompassing seventy other potters and spanning a century and a half. And for the state as a whole he represents over four hundred folk potters who contributed to the agrarian life-style that characterized the region until quite recently. As a folklorist I became interested in tracing the continuity of Georgia's pottery tradition from its inception to the present in the belief that, if properly told, the story would reveal a great deal about the role of the folk craftsman in the South.

In her novel of 1910, *A Circuit Rider's Wife*, Georgia writer Corra Harris complained,

> What we call history is a sorry part of literature, confined to a few great wars and movements in national life and to the important events in the lives of a few important people. The common man has never starred his role in it. Therefore, it has never been written according to the scien-

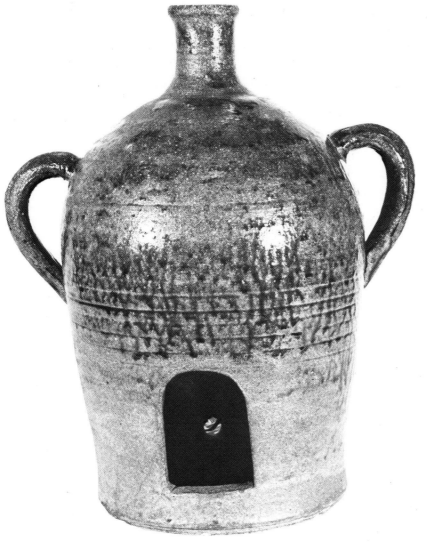

3. "Laser jug" by Lanier Meaders, 1967–68. Olive-green ash glaze, 17½" high.

tific method. It is simply the spray—the big splash—humanity throws up as it goes down in the sea forever. It is what most of us do and what we think [that] perishes with us, leaving not a record behind of the little daily deeds and wingflappings of our spirits that really make us what we are.[1]

The task of reconstructing the lives and work of four hundred humble artisans who, for the most part, escaped the notice of chroniclers is complicated by the fact that these potters seldom

left behind written records of their own.[2] The account books, advertisements, and family records commonplace for the larger northern potteries and so important in their documentation are as scarce as hen's teeth for Georgia. The relaxed attitude of many southern folk potters toward record-keeping was best described by Mark ("Buddy") Baynham, Jr., present owner of the South Carolina Pottery at North Augusta, whose folk-potter father "jotted all his accounts on chips of wood and then burned them for fuel in his kiln."[3] A further obstacle specific to Georgia is the paucity of historical archaeologists, whose excavations have contributed so much to pottery research elsewhere.

Given these limitations, one of my greatest challenges has been to exploit creatively the problem-solving potential of such raw data sources as the United States manufacturing and population censuses,[4] clay bulletins of Georgia's Geological Survey, state gazetteers, city directories, maps, old photographs, deeds and records of land grants and lotteries, marriage and cemetery records, wills and estate inventories, and tax digests. Often it was possible to piece together meaningful sections of the great puzzle—potters' patterns of movement, interaction with one another, family relationships, and standard of living—by thoroughly exploring such documents. Obtaining the assistance of serious genealogists whose families were involved in the craft, and exchanging information with pottery researchers in other states, were critical to this phase of the work.[5] Archival research was heavily supplemented by fieldwork, which involved visiting surviving traditional and semi-traditional operations, documenting pottery examples, and recording oral histories.[6]

In writing and illustrating this book I have kept in mind a varied audience, from fellow folklorists and the more general reader interested in crafts or life in the South to practicing potters and ceramics researchers, collectors, and dealers. In addition, I have tried to repay helpful members of Georgia's "clay clans" by synthesizing the information they provided. With their guidance I have come to appreciate just how important the institution of the family was in perpetuating the pottery tradition, and the literal, as well as figurative, meaning of potter D. X. Gordy's phrase, "brotherhood of clay."

PART ONE

The Potter's World

HUMAN DIMENSIONS OF CRAFTSMANSHIP

Why may not this poor earthen vessel hold
As precious liquor as one made of gold?

What handicraft can with our art compare,
For pots are made of what we potters are.

Inscriptions on English pottery vessels
of the late eighteenth century

An Age of Hands:
The Folk Potter
as Artisan

There was an age in rural Georgia, not so long ago that it cannot be vividly recalled by people still living, when time was not measured by the ticking of a clock but by the rising and setting sun, the phases of the moon, and the changing seasons. This was a time when men and women had a close—and often hard—working relationship with nature. Each farm and settlement was a self-contained, diversified organism, producing for itself out of the natural environment most of the necessities of living which now, in our machine age, require hundreds of specialists and a complex distribution network.

People then relied on the teachings of the past, traditional ways of doing things that had been handed down from generation to generation, changing slightly to remain relevant but always preserving the basic patterns so long as they proved useful. In that day people entertained themselves with treasured songs, instrumental tunes, stories, games, and riddles to enliven a cold winter night around the fireplace or a summer evening on the porch. People worked together then, turning the tedious tasks of corn-shucking, fodder-pulling, log-rolling, house- and barn-raising, and quilting into welcomed occasions through a spirit of cooperation and fun. Such communal "workings" often were followed by a bountiful meal and a "frolic," or dance.

This was an age of hands, when local craftspeople produced the bulk of the material goods needed on the farm, and the crossroads general store, traveling peddler, mail-order catalog or "wish book," and occasional trip to town supplied the rest (coffee beans, salt, and a few "luxury" items). The farm woman converted cotton from the fields and the fleece of her sheep into rugged homespun clothing and beautiful natural-dyed coverlets woven on the

handloom. The woodworker used tools of medieval ancestry to transform timber from the forest into handsome furniture and baskets. And smiths forged "fire-dogs" (andirons), horseshoes, nails, "hog" rifles, wagon parts, and other farm equipment from scrap iron. The log or weatherboarded-frame house and outbuildings sprang up on land cleared of the trees from which they often were constructed. Wild and cultivated foodstuffs were preserved and prepared according to recipes passed from mother to daughter, while medicines were made at home from plants that grew in the woods or an herb garden. All this required an elaborate inherited technology that each family, to live well, had to master.

Nor was this frontier pattern of self-sufficiency restricted to the small-farmer class; it also characterized the large plantations, where slaves assumed the role of specialized artisans. An ex-slave named Mammy Lou recounted the way of life on her plantation near Columbus to writer Harriet Castlen:

> 'Bout fifteen women was kept busy all de time, weavin' de cloth for de gray homespun dresses we all wore. Hester had charge of 'em. She taught me to sew, and Rose taught me to wash and iron and flute. I'd go to de big house, and he'p put up fruit, and brandy peaches and make jelly, and all kinds of wine. . . . Where de mens worked was like a village. Dere was a shop for de blacksmiths and carpenters. Dere was harness makers, tanners, coopers and cobblers. Dere was a shop for makin' brooms and scourin' brushes, and baskets and chairs. Mars Jimmy [the plantation owner] got his millers to grind all de flour and corn, and mens to build chimneys and well curbs. He had a sawmill to saw logs for lumber. A big gin-house to gin and bale cotton, and a mill to grind sugar cane, so de juice would be ready to put in pots and b'iled down into syrup. Dere was menfolks to kill de hogs, and cut 'em up and cure 'em to put in de smokehouses. Dey'd butcher de beef and mutton, too. We got a brick house built over a spring to keep de milk and butter cool.[1]

To some degree, every rural Georgian depended on traditional handskills for survival. "It was a homemade life," declared Cherokee Countian Jess Hudgins,[2] and this life extended from mountains to sea islands. In a published reminiscence, J. L. Herring recalled his late-nineteenth-century childhood in "wiregrass" south Georgia:

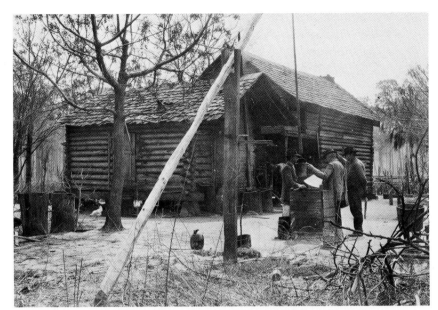

4 and 5. Two views of the Lee farmstead on Billys Island in the Okefenokee Swamp, Charlton County, 1915. In the more remote areas of Georgia a frontier life-style persisted into the twentieth century. The jug, which appears to be a Crawford County product, may have been used to keep milk cool when lowered into the sweep-well or to carry water to the fields. The wedge-shaped pillars supporting the sills of the log buildings, hewn of heart pine impervious to termites, are characteristic of south Georgia; the house had a "stick-and-mud" chimney. This was truly a handmade life. Courtesy of Georgia Geologic Survey.

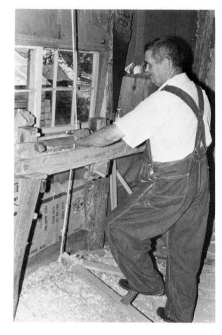

6. *The late Walter Shelnut of White Creek, White County, 1975, one of the last users of the pole lathe, a wood-turning tool of medieval European origin. The chisel, resting on the breastpiece, shaped the chairpost (which revolved freely between the iron points of the two "puppet" heads) with each downstroke of the foot treadle; the spring-power was provided by a pine sapling, the free end of which was tied to a connecting rope wrapped around the wood being worked. Primarily a farmer, Shelnut made, in the tradition of his father and grandfather, "mule-ear settin' cheers" and rockers of oak, ash, and poplar during the wintertime. Having inherited a variety of handskills, he preferred to make things himself— from all the buildings on his farm to much of his equipment—rather than buy them. Photo by Kirk Elifson.*

The Boy was used to home-made things; to the hand mill on the post under the big catalpa tree in the front yard, where the meal for the family bread was ground; the home-made bedsteads, the spotless pine tables. The very chair in which he sat, was turned by some great-grandfather in the remote past and handed down as the heritage of the youngest son; the frame of pine; the seat of rawhide. . . . They were careful workmen in those days, and their work stood.[3]

Georgia countryfolk recognized two varieties of craftsman: the "Jack of all trades" who made things for his own family's use, and the professional specialist who made things to sell. Floyd and Charles Hubert Watkins's *Yesterday in the Hills*, which recreates life in the farming communities around Ball Ground in Cherokee County, points out this distinction: "Even when a man could not make what he needed at home, somebody in the settlement made it for him. The blacksmith, Alf Ridings, could make just about any tool needed on the farm."[4] So too does John Foster Stilwell's unpublished account of his father, Squire Stilwell, in mid-nineteenth-century Henry (now Butts) County: ". . . but few things that had to be made at home that he could not make. Even in the kitchen, at the cowpen, with the cotton cards, the warping bars, the spinning wheel, the loom. Then in the woodshop, the blacksmith shop, the shoemaker's, and in fact almost everything that was made at home he made it. Some of the work was not as finished as by the man who does only one kind of work."[5]

Few country craftsmen were full-time practitioners. Since the rural economy was not entirely cash-based, nearly everyone depended on some amount of farming for subsistence, if not for market; the ledgers of Jugtown potter Rufus Rogers, for example, show him also to have been a struggling cotton farmer. This fact, however, does not make the line that separated the domestic from the professional craftsperson any less discernible.[6] Underscoring the distinction, "respectable" women in the rural South rarely engaged in commerce beyond the sale of butter and eggs for "pin" money; about the only professions open to them were those of teacher, seamstress, and laundress, which were extensions of their domestic roles. Thus, in Georgia, women were confined to the—until recently—economically nonproductive "soft" or textile handicrafts, which also happen to be the most aesthetically oriented. A manufacturing survey of 1810 reported

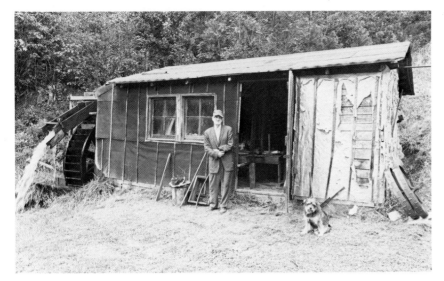

LEFT
7. Mountaineer 'Lijah Payne of Union County before his water-powered woodworking shop, 1980. Mechanical ingenuity has allowed him to supplement a meager farming income by making furniture, tools, and household utensils.

20,058 spinning wheels and 13,290 looms in Georgia, most undoubtedly operated by women for their own families.[7]

Pottery-making, of all the folk crafts practiced in Georgia, was perhaps the most strictly professional, in the respect that no potter set up a shop and kiln just to make wares for his own use. A similarly complex craft such as blacksmithing, by contrast, was practiced by professional and do-it-yourselfer alike (although the latter, with his sparsely equipped small farm shop and limited experience, as John Stilwell noted, could not hope to match the variety and quality of the specialist's work).

During the colonial period, especially, potters were also among the scarcest of Georgia's folk craftsmen. Pastor Johann Martin Bolzius, describing conditions at the Salzburger settlement of Ebenezer twenty-five miles above Savannah, wrote in 1751, "We now have the most necessary craftsmen, such as carpenters, shoemakers, tailors, blacksmiths, locksmiths, weavers, masons, tanners. Several carpenters also do lathe and cabinet work if necessary, and have the necessary tools. One of us can make do as a cooper, but saddle makers and carriage builders, as well as a potter, are lacking. . . . There is still a shortage of . . . potters in Georgia."[8]

Once pottery-making had become entrenched in the state during the next century, it could be such a lucrative sideline that it even attracted shop-owners who were not potters but speculators who, to take advantage of available clay and skilled labor, built shops and then hired others to work in them. Some of these

BELOW
8. John Ed Speed of Warwoman Dell in Rabun County, a domestic blacksmith with a basic outdoor setup for sharpening and repairing his gardening implements and "turning" horseshoes as a service to neighbors, punches a shoe on the anvil as his grandson looks on during the filming of the documentary "Echoes from the Hills" in 1970.

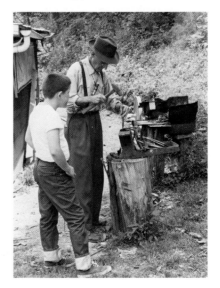

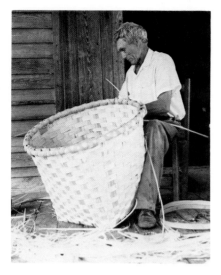

ABOVE
*9. R. L. Richardson of Chattooga
County, 1967, putting the finishing
touches on a white-oak "hamper"
basket of the sort once placed in the
fields to collect cotton but now used
for yard work; he was then selling
most of his baskets to a hardware
store in Summerville.*

RIGHT
*10. Net-maker Frank Hunter of
Saint Simons Island seen through one
of his circular cast-nets, 1979.
These African-style nets have been
used since slavery days for catching
fish and shrimp in coastal Georgia
and South Carolina.*

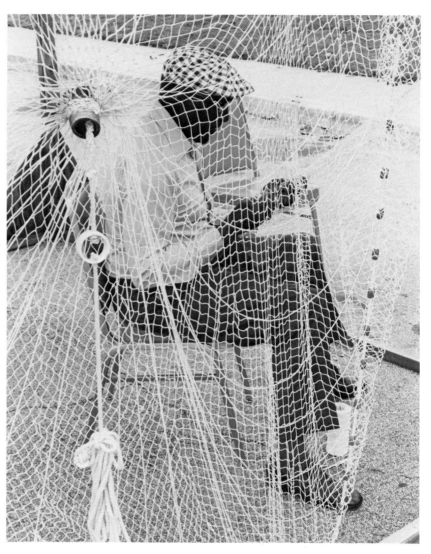

entrepreneurs were members of pottery families who chose to
devote their time to other endeavors while still keeping a hand
in the craft, such as "Daddy Bill" and "Little Bill" Dorsey of
Mossy Creek and Jugtown's "Wile" Rogers; others had no such
background (except perhaps for in-law connections to potters or
peddling experience) but were inspired by successful operations
around them, such as John Meaders and Loy Skelton, both of
Mossy Creek. This situation sometimes complicates the attribu-
tion of marked examples, for a proprietor's name can appear on
wares actually made by his employees.

Shop-owners who were potters, however, were far more nu-

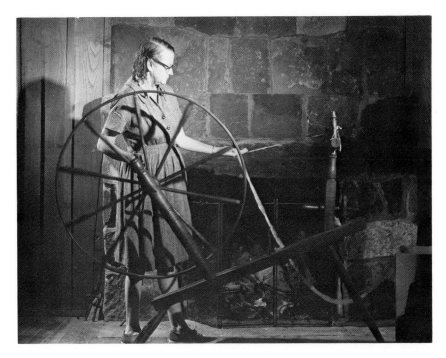

11. Mrs. Dean Beasley spinning woolen thread on a "walking" wheel at the Jay Hambidge Art Foundation in Rabun County, 1970. The Foundation employed local mountain women to produce handwoven cloth which was marketed at a New York City outlet.

merous, working alongside their sons, hired help, a partner, or alone (one-man shops became common only in this century, as young potters abandoned the craft for other occupations). Hired turners freed the owner to devote more attention to his farming, or gave him the capability of expansion to a larger-scale, year-round operation. Some of these were a restless breed, what Bill Gordy jokingly refers to as "tramp potters," a role he himself filled during the Great Depression before settling at Cartersville. Gordy's younger brother, D.X., stayed at home and learned a great deal from the itinerant potters hired by their father, W. T. B. Gordy, at Aberdeen and Alvaton. Based as far away as California, they would be sent for when business was good and orders pressing, and if they sought work the elder Gordy would employ them even in slack times (this was the "brotherhood of clay" to which D.X. referred). Javan Brown recalled that owners sometimes would advertise for potters in newspapers; he answered such an ad placed by Daddy Bill Dorsey in the early 1920s (18B). Needless to say, traveling potters could be important disseminators of ceramic ideas both from outside and within the region.

There is no indication that Georgia's potters were ever assigned by their community a status lower than that of their non-potter neighbors, an issue raised for the craft in a few other

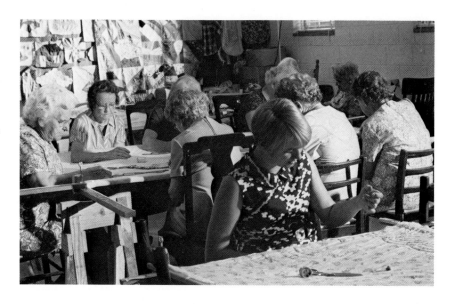

12. The Ben Hill Quilting Club of southwest Atlanta at one of its Thursday meetings in a local church basement, 1970. Teenage novice in foreground practices "shell" stitching pattern on baby quilt of solid (unpieced) material. Of all Georgia's folk crafts, quilting is the most vital today.

societies.[9] In his economic standing the potter, as a professional craftsman, had an edge on those with equivalent property for whom farming was the sole means of support. And as for social acceptance, some Georgia folk potters are known to have taken an active role in both secular and religious affairs, like Rufus Rogers who was an ardent rural-school supporter and church leader, while others held positions of prestige. For example, at Mossy Creek Abram Davidson and Isaac N. Craven were Methodist ministers and Josiah Jarrard was a physician, while James Childs of Jugtown served in the state legislature and William Ewen of Savannah was interim administrator of Georgia in 1775.

Further, the pottery, like the blacksmith shop, sometimes became a social center. The situation described for Charles Decker's Keystone Pottery of Washington County, Tennessee, at the turn of the century is not atypical: "During the winter, while the [enclosed] kiln was fired, a dance was held in the pottery every Wednesday and Saturday night. Decker's son, Dick, was a fiddler—'the greatest in the world,' his nieces declared. He also played the banjo and guitar. The warm pottery then became a gathering place for the neighborhood, and there were square dances with refreshments of apples and cider and homemade grape wine."[10] At the Brown Pottery in Arden, North Carolina, friends of the potter would keep him company during his long firing vigil which usually lasted through the night. Louis Brown, son of Georgia-trained founder Davis Brown, cited storytelling and folk music as common entertainments at such gatherings: "Some of them

would almost stay all night with you. They would tell jokes and have a big time. Once in a while some old guy would come over with a fiddle or a guitar and they'd play. Have some mountain music. And a little bit of everything would go on when they burned one of those kilns of ware. . . . Sometimes maybe somebody'd bring a piece of meat and broil it at the firebox"(20). A detailed description of kiln socializing in White County, Georgia, was written by Hazel Meaders Haynes, daughter of potter Cleater Meaders:

In 1922 there was very little entertainment for young boys and girls in Cleveland, Georgia. They went to Epworth League (now Methodist Youth Fellowship) on Sundays, prayer meeting on Wednesday nights, and Bible School for a week during summer that ended with a picnic.

Cleater J. Meaders had moved to Cleveland and completed building a pottery shop and kiln. The neighbors of town came to view the firing, which lasted until nine or ten P.M., depending upon when the firing had begun in the morning (it took twelve to fourteen hours). The blaze would extend three or four feet above the chimney and would light the whole yard late into the evening.

The Epworth League decided to have a pound supper and play games in the yard once a month on a night the kiln was being fired. They would be notified as to the night of firing. In summer the time to meet was six o'clock and in the fall it was five o'clock. (A pound supper was that all who came brought a pound of food to eat.) A table was placed in the yard ready for food. Adult leaders placed the food on the table, cutting cakes and pies and getting drinks ready.

While the table was being prepared, the game chairman was having games in another area of the yard. Games were chosen so that all ages could play. A few of the games were: Handkerchief, Cat and Mouse, Blind Man's Bluff, Squirrel in the Tree, Marching around the Level, Farmers in the Dell, Rachel and Jacob, Poison, and other old games.

The adult leaders would let the game chairman know when the table was ready. There was no electricity so we had to eat before the kiln fire died down. More games were played after supper if there was enough yard light.

> The kiln could be fired if it was raining. On rainy
> nights the boys, girls, and adults would sit under the
> wood shelter, which was connected to the firing end of the
> kiln, and toast marshmallows. We would also see who
> could tell the greatest ghost story. Some feared to go home
> after hearing such ghost stories. Everyone present seemed
> to enjoy themselves. Older people who came enjoyed fel-
> lowship together. (49B)

Accounts such as this suggest that the potter, when he so chose, could be well integrated into his community, and that, at least within living memory, there was no social stigma attached to the craft.

The question arises, in examining the place of potters in Georgia society, whether their shared occupation in any way set them apart as a class from other craftsmen or from their totally agricultural neighbors. Two behavioral traits do seem to emerge: a fondness for drink and an independent nature. These characteristics were concentrated in the itinerants, whose restlessness may have underlain both their drinking and independence. Truman Bell had this to say about the potters who worked for his father Wesley at Bethlehem in Barrow County: "Most of 'em was a rambly set of people, and big drinkers. Back then they made good money, and didn't care 'bout working but a few days. They wouldn't stay on the job" (12). Louis Brown, who descends from a long line of Georgia potters, elaborated upon this freedom of spirit:

> Most potters were kind of a go-ahead person. You didn't
> find many of the old-time potters that you could kick
> around or anything, because he wouldn't take it. He'd tell
> you off quick if he was in a good job and you said, "I'll fire
> you." He'd just look you in the eye and say, "Fire me." He
> always felt like he could make it on his own, anyhow. . . .
> Why, they're the proudest people in the world. He feels
> like he's a master, and he is! It was a type of trade that was
> a necessity. They've always been independent and they've
> always been determined to do what they want to do.
> When you make a pot, you feel like you can control any-
> thing. (20)

Harold Hewell of the Gillsville pottery family admitted that the old-time potters "usually drank a lot of booze. I don't know

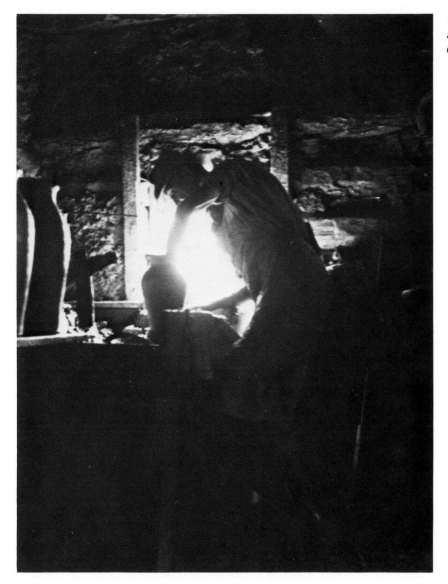

*13. Unidentified Georgia folk potter
in his log shop, 1935. Courtesy of
Georgia Geologic Survey.*

why but that seemed to be one of the basic features" (53A). One
north Georgia potter is especially remembered for his alcoholism,
yet potters who knew him were quick to praise his craftsman-
ship. He would work soberly long enough to buy a few days'
supply of food for his family, then spend the remainder on whis-
key. Sometimes he got drunk just on Saturday night, but he was
better known for his week-long binges. On one such "toot" he
lodged himself in the empty kiln and stubbornly refused to leave,
until his wife smoked him out by kindling a blaze in the firebox.

Sleeping off another drunk on the floor of his rented home, he rolled into the smoldering fireplace and burned his arm badly enough to slow down his turning thereafter. Finally, his employer found him drunk and nearly frozen in an abandoned sawmill; he died the next day.

Not all potters were advocates of strong drink, however. Shopowner Little Bill Dorsey became a revenue officer after his sister was driven to an early grave through marrying a "blockader"; when shot to death while destroying a still in 1921, Dorsey is said to have had seventy-three moonshining cases pending in federal court (6). Members of the same family could have opposing views on alcohol: in 1839 the Reverend John Landrum of Pottersville, South Carolina, who was both a potter and Baptist minister, expelled his potter brother, Amos, from Horne's Creek Church for drunkenness after duly admonishing him.[11] As a final example, James W. McMillan, a Scot who established brick and pottery factories at Milledgeville, Georgia, in the late nineteenth century, was virtually a teetotaler who scorned the use of alcohol by his workers. His granddaughter, Louise Culpepper, supplied this anecdote about the masonry contract McMillan received for the Central State Hospital:

> It is said that when Grandpa was building a sixteen-foot wall around a building at the hospital, one of his brick masons came to work drunk and brought his liquor with him in a jug Grandpa had made. Grandpa hated whiskey, and said if people were going to use his jugs to put whiskey in, that he would just quit making the jugs. He then made the brick mason put his jug of whiskey in the wall and seal it up with bricks. Sixty years later, when they tore the wall down, half the population of Milledgeville was out to see if they could find the jug. All downtown stores were closed for the day. (32)

The search for a common bond uniting Georgia's folk potters, other than the "brotherhood of clay" itself, is disappointed by such exceptions to what otherwise might be seen as a pattern. What remains is the impression that these potters were a diverse group of very human individuals, each with his own story to be told.

CHAPTER TWO

"To Put Stuff In":
The Importance
of Pottery

When Lanier Meaders was asked, "Were the potters pretty important figures back in the old days around here?" he replied, "Well, as far as I could figure out, they was number one. Just about everything else at one time in this part of the country depended upon it. . . . You know, necessity rules everything" (78A). On another occasion Lanier mused, after surveying a row of early jars and jugs in my office, "Those things were as important back in the old days as mobile homes are now; poor folks couldn't live without them." While this analogy never would have occurred to me, Lanier, who worked in mobile-home construction before becoming a full-time potter, did have a point: functional pottery once was as essential to survival as affordable shelter.

Before the general availability of factory-made glass, metal, and plastic containers, vessels of clay were one of the few means of preparing, preserving, and transporting food and drink. Farming communities depended on the potter to provide jugs for holding cane syrup, whiskey, vinegar, and water for thirsty field-hands, churns for making butter and buttermilk, crocks and pitchers for cooling and handling milk, and jars for keeping vegetables, fruit, meat, lard, butter, and homemade soap, as well as for fermenting wine and "home brew." To catalog these wares and their uses is to describe the self-sufficient productivity that characterized the South during its agrarian heyday.

Potters were few and far between on the southern frontier, but the need for their products was great. In the coastal cities, at least, wares from the North and overseas could be had, but only sporadically and at considerable expense did such imports reach

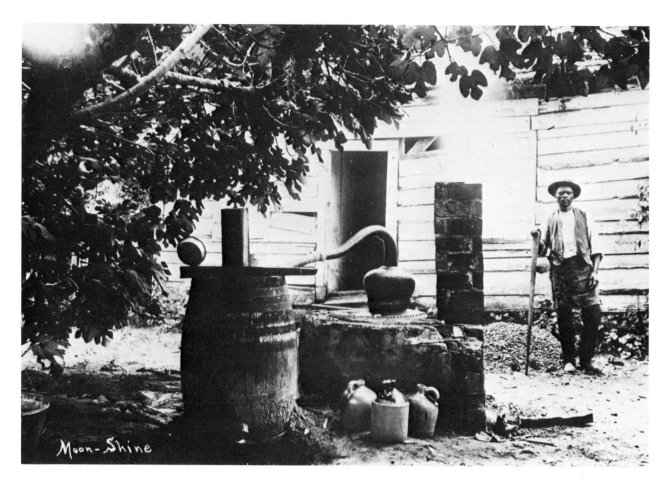

Moon-Shine

14. *A Savannah-area moonshine still, ca. 1890. The whiskey jugs on each side are typical of the salt-glazed products of Atlanta and Jugtown, while the central piece is a factory-made "stacker" jug with two-tone Bristol and Albany-slip glaze. From the William E. Wilson Photographic Archive, University of Georgia Libraries Special Collections, Athens, with thanks to the Atlanta Historical Society.*

the backcountry. Those potters who established themselves in the interior faced the mixed blessing of being overwhelmed by a demand they could not fully satisfy. The Moravian Church diaries from Bethabara and Salem in Piedmont North Carolina describe crowds of disappointed customers, who had come as far as eighty miles, being turned away empty-handed from the potter's shop.[1] Nor was such demand limited to eighteenth-century North Carolina; Georgia folk-potter Cheever Meaders recalled how it was at Mossy Creek in White County during the early years of the twentieth century: "Oh, good grief. . . . What about six and eight wagons a-standing up there, come every day a-wanting pottery to put their stuff in, and us might-near working day and night at it. It was more so in the fall of the year when stuff was getting ripe and ready to put up" (74).

Southern folk potters seldom made plates and cups; the tablewares used by the average nineteenth-century farm family were

of metal or imported white-glazed earthenware, such as those described for Surry County, North Carolina: "We had pewter basins, dishes, plates, spoons, etc. Our cups were tin mostly; some were pewter; but few men had plain delft-ware; china was unknown. Of 'yethen ware' there were crocks, jugs, and jars, which are essential every where."[2] It was these latter items—containers for storing and processing victuals—that were the stock-in-trade of the folk potter.

One of the real challenges of living before the advent of modern refrigeration and canning methods, particularly in the warm southern climate, was the preservation of food. The pottery churn

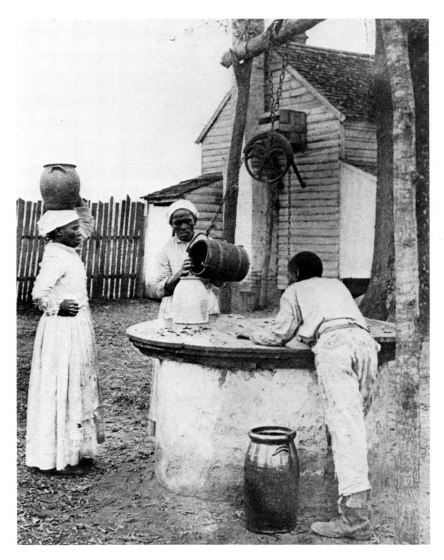

15. *Well scene from* Down South *(New York: R. H. Russell, 1900), a book of photographs by Rudolph Eickemeyer, Jr.*

was an especially useful article, for it could double as a large-capacity storage jar, as explained by the late White County potter Guy Dorsey: "Back in them days, people depended on milk churns for kraut, pickled beans and everything. People depended on that altogether to put up their syrup, and anybody who didn't have a syrup cane patch wasn't doing much good in them days. And there wasn't much else to put things in except that pottery. . . . Back in them days, people that didn't have a cow, why, they wasn't doing much good; so everyone had a churn. And they depended on these shops around to get their ware" (36A).

This is not to suggest that alternatives to locally made pottery did not exist. Georgians living in the mountains or lower Coastal Plain, where there were few potters, managed to get by with wooden containers in addition to the wares wagoned occasionally from the Piedmont pottery centers. Yet stave-built vessels such as churns, buckets, and piggins were relatively scarce in Georgia, the cooper's craft being restricted primarily to barrels for molasses, whiskey-making, and the naval stores (turpentine) industry. Thus, barrels—or their more primitive equivalent, "gums" or hollow log segments—offered the only real competition to pottery until the extensive mass-production of glass and metal containers following the Civil War. Even then, in the impoverished postbellum South, glass canning jars were beyond the reach of many small farmers until after the turn of the century.[3] Steve Lewis, an older resident of White County, remembered "when there wasn't a dozen glass fruit cans in the district, when fruit cans began coming in. Used to, we'd put up our food in them stone[ware] jars, and our syrup in clay jugs" (66).

Although some Georgia potters operated throughout the year, sales were especially heavy during the fall when people were preserving vegetables, butchering meat, and making molasses. The seasonal nature of pottery demand was discussed by Guy Dorsey, whose father, Williams, was an active Mossy Creek potter.

> My daddy made pottery all year 'round, and kept the farm going too. . . . When the weather got so bad that you couldn't burn it off, he'd just keep turning. Our shop had a loft in it, and we'd get up there with them churns and stack them three and four deep, it not burnt. Then, when the weather got right, dried out to where you could go to burning it, why we didn't have to wait 'til he turned a kiln[ful] and dried it; we'd just go to it.
> Sometimes in the wintertime he'd make it and no de-

16. *Molasses-making near Mc-Intyre, Wilkinson County, 1937, with churn for finished syrup beside evaporator. The man in overalls holds a skimmer for removing foam from surface of boiling juice, while the man seated in the background feeds cane into the portable, mule-powered mill. Courtesy of Georgia Geologic Survey.*

mand—after syrup and beans and kraut, all that kind of stuff—just a few milk churns where somebody broke one, or something like that. And I know people would come along and say, what in the world are you gonna do with all them churns and things? My daddy'd tell them that he wasn't uneasy; that he hadn't made any yet that he couldn't get shut of. And, before the fall season was over, people'd be around there hunting broke pieces where they wasn't saleable. Try to pick up something to finish holding their syrup. That's how it'd sell, when the season come on. (36A)

The domain of folk pottery on the southern farm was the smokehouse, the hearth or kitchen, and the springhouse. In her northern Mississippi childhood, according to Theora Hamblett, "every farm smokehouse had several earthen jars, jugs, and bowls of all sizes. They contained molasses, vinegar, sauerkraut, cracklings, preserves, etc. I remember getting candied peach preserves from a large earthen jar. They were put there in the summer, when the peaches had ripened and been preserved."[4]

Myrtie Long Candler reflected on her childhood on a west Georgia plantation near Newnan during the 1850s:

Most all of the food had to be raised at home and as there were so many people to feed great preparation had to

be made for the coming year's supply. In the summer
quantities of fruit was dried; for in the winter ahead there
would be pies, turnovers and tarts to make, and stewed
fruit every day. Sheets of white cloth would be stretched in
the sun. Peaches, apples, pears, and figs would be prepared
and carefully laid out on these sheets. When they were
well dried they were put away in stone jars and sealed.

There were five gallon jars of pickle made;—beet pickle,
peach pickle, ground-artichoke pickle, gherkin and cu-
cumber pickle, green tomato pickle, ax jar hot pickle, and
chow chow, which we called picklelily, all sealed in pottery
jars.[5]

Melted beeswax usually was the sealant. Besides vegetables
and fruits, meat could be preserved in the same manner. A twenty-
five-gallon crock by Dave, the renowned South Carolina slave
potter and poet, is inscribed, A very Large Jar which has 4 handles / Pack it full
of fresh Meats—Then light candles.[6] The candles served more than a poetic
function, for their dripped wax would have sealed a quartered
calf or lamb in brine for plantation use. Mrs. Steve Lewis de-
scribed doing the same thing on a smaller scale in White County:
"They'd get out here and kill a beef and this one would take a
quarter and that one a quarter, and each one would cut it up into
steaks and salt down a jar full of that stuff. And about every three
days they'd pour that water off and re-do it again until they ate
it up. But then there was fifteen of us and it didn't take long to
eat it up. Mother would have to soak out the brine before cook-
ing the meat" (67). Mrs. Herman Snyder of Washington County
inherited a collection of locally made pottery which her parents
used on their farm, including Albany-slip-glazed pieces from the
Brumbeloe Pottery at Chalker. One of these, an eight-gallon jar,
always was reserved for pickling the meat of a shoat (young pig)
in brine, while a gallon-sized crock was used to pack cooked
sausage in its own grease, a technique later adapted to glass Ma-
son jars but Elizabethan in origin.[7]
The stereotype of the jug as a container for whiskey certainly
has its basis in fact,[8] but a variety of other liquids were also kept
in the narrow-necked vessels (stoppered as often with a corncob
as a cork). Mrs. Snyder has three stately five-gallon jugs in which
her parents stored apple cider from their orchard (100), but jugs
of that size normally were used for molasses. The elderly Casta-
low Burton of Habersham County still remembers the licking he
got at the age of five for dumping kerosene into the half-empty

17. Four-handled jar by slave potter Dave of Edgefield District, South Carolina, signed and dated April 12, 1858, ash glaze, 24¼" high. The incised poem indicates that the piece was intended for preserving meat, but when found on an east Georgia farm it was being used as a yard planter. Most likely it had been wagoned into Georgia and sold to a plantation soon after it was made.

syrup jug in the kitchen, where the brown, sluggish liquid was poured into a pitcher for table use (25). Molasses—either the upland sorghum or lowland ribbon cane variety—was once the major sweetening of the southern diet, and was especially enjoyed with biscuits.

A detailed account of the domestic uses of folk pottery in Georgia is found in Gertie Elsberry's unpublished reminiscence of early-twentieth-century farm life near Dallas in Paulding County, ten miles south of a small pottery center. One of her most vivid memories was that of churning:

*18. Set of Albany-slip-glazed wares
attributed to the Brumbeloe Pottery of
Chalker, Washington County,
1920s, from the family farm of
Mrs. Herman Snyder. The large jar
at far left was used to pickle pork,
while the crock second from right was
used for canning sausage.*

Mother would set her churn on one corner of the hearth
so the milk would turn, during the cold winter months.
She would strain the morning's milk into a vessel, and the
cream would rise to the top. She would strain the night's
milk into the churn, and skim part of the cream from the
morning's milk in with it. Then we would drink the
skimmed milk {sometimes called "blue-john"} for supper,
or crumble cornbread in it and eat it. She would save the
milk for two or three days in cold weather, for one churn-
ing. A flour sack was folded three-cornered, and tied over
the churn. She would turn the churn around occasionally
during the day, and move it onto the warm hearth after the
fire was banked for the night. When the sweet milk
changed to a quivery cake of clabber, it was ready to
churn. She would tilt the churn to one side, and the clab-
ber would turn loose from the side of the churn like a huge
mass of gelatin.

The five gallon churn was made of earthenware, as we
called it, and was brown, white, or half brown and half
white in color. The churn stick was made from the handle

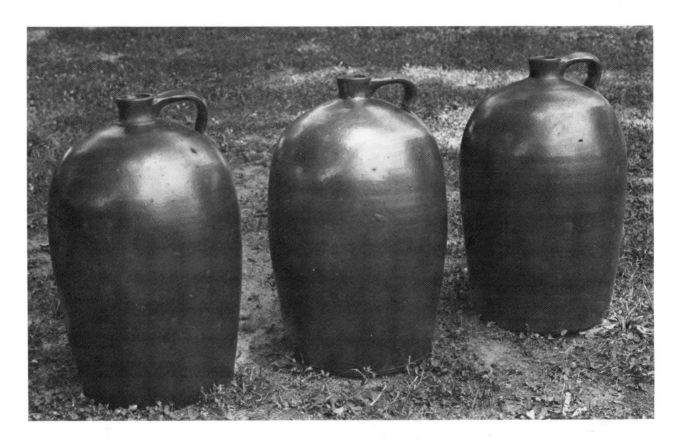

of a worn-out broom, which was sawed to the right length. The dasher was made from two thin pieces of poplar wood, nailed to the end of the churn stick in the shape of a cross, with each end the same length. The churn lid was made from a dressed piece of poplar plank about an inch thick, and was sawed to fit into the top of the churn, which had a niche with a molded flange about an inch below the top on which the lid rested. A hole was bored in the center of the lid with an auger. Poplar wood was used for the lid and dasher because it imparted no bad flavor to the milk.

Churning was a real task in cold weather. The churn was turned often on the warm hearth while being churned, and a little hot water was added to speed up the job. This didn't hurt the buttermilk, as the whey rose to the top after the churning was finished. The whey was used as liquid for making cornbread, or added to the pig's slop.

When the cream had changed to butter and gathered on

19. Set of three Albany-slip-glazed syrup jugs with Jugtown-style handle application attributed to the Brumbeloe Pottery, Chalker, used by Mrs. Snyder's parents to keep cider.

top of the buttermilk, the tiresome job was finished. The butter was lifted out of the churn with the dasher, and placed in a bowl. Then cold water was poured over the butter, and it was worked with the butter-paddle and the water drained off. If the butter was for home use, it was often smoothed over with the butter-paddle and left in the bowl. The paddle was dipped in hot water first, to prevent the butter from sticking to it. After the butter was smoothed over, the paddle was dipped into hot water again, and a fancy design was made on the butter with the tip of the paddle. If the butter was to be molded into half-pound or pound cakes, the mold was first dipped in hot water. The mold was filled with butter and inverted over a dish, and the butter was pushed onto the dish from the warm mold. The inside top of the mold was removable for cleaning, and a flower or other fancy design was carved into the wood. When the butter was packed into the mold, the design was imprinted on the top of the luscious hot-biscuit filler.

We drank buttermilk for supper during the warm months, and caring for the milk wasn't so much trouble. The morning's milk was strained into a jug and placed in cold water. . . . The spring run was a narrow ditch where the water ran from the spring to the branch, which meandered down across the pasture. Mother would set the jugs of milk in the spring run, under the shade of the big mountain oak. Then she laid boards across the run to keep the milk cool. When we were working in the cotton fields we would pass the spring on our way to and from the field. . . . What a blessing a refrigerator would have been. After swinging a hoe all day, toting jugs of milk up a steep hill wasn't fun.

Some people built spring houses over their springs, and these made a fairly good substitute for the modern refrigerator. Butter was cooled in cold water, then wrapped in cold wet cloths and stored in covered crocks in cellar, spring house, or spring run. During warm weather, mother would churn in the kitchen. She would pour a glass of fresh buttermilk from the churn for me, when the job was finished. Sometimes she would sing the familiar chant: "Churn, churn, churn, Come butter come, A little girl is sitting by, A-waiting for some."[9]

The use of churns for pickling vegetables was also described by Mrs. Elsberry:

Making cabbage kraut was a must every year when the cabbage made big hard heads. . . . Sometimes the menfolk would make a kraut cutter by bending the shank of a hoe straight and sharpening the blade with a file. The cabbage were chopped in the large iron washpot. I always chopped mine with a butcher knife. Then the cabbage were packed in an earthenware churn, adding a thick layer of cabbage and a thick sprinkle of salt. Hubby's mother used three level cups of brine salt (the kind we salted our meat with at hog-killing time) to a five gallon churn of cabbage. A small kraut maul was used to "churn" the cabbage and salt as tightly as the churn could be packed until it was nearly full. (The kraut maul was made of poplar wood by some of the menfolk.) When the churn was almost full, a plate was turned down on top of the kraut and weighted down with a clean white flint rock.

The kraut was allowed to "work" nine days. Then it was brought to a boil and canned in fruit jars. A churn always seemed to hold about three times as many cabbage heads as we thought it would, causing us to make an extra trip or two to the garden for more. We had to check every day or two to see that there was sufficient brine to cover the kraut. If not, we would add a little more salt and enough cold water to cover the plate. A thick white cloth and a layer or two of thick brown paper were kept tied over the churn to keep out insects.

We were making kraut under a shade tree in the yard one year, and it seemed that we would never get the churn full. When I finally took a close look to see what was wrong, I discovered that the churn had cracked open all around. The bottom was sitting on the ground, and the rest of the churn was slowly rising up around the packed cabbage and salt. I carefully removed them above the break and placed them in another churn. Nothing was wasted on the farm, and the rest of the cabbage were O.K. to feed to the hogs after the salt was rinsed off. . . .

Green beans were prepared for cooking and cooked a few minutes with a small amount of salt. Then they were placed in churn or crockery containers to ferment or

20. Six-gallon "kraut jar" by Cheever Meaders of White County, ca. 1950s, modified lime glaze, 16½" high. Churns often were used to make sauerkraut, but some north Georgia potters produced a large, cylindrical type of jar specifically for that purpose. The cabbage chopper was recycled from a worn hoe blade by blacksmith Jud Nelson of Sugar Valley, Gordon County.

"work" like kraut. They were canned in fruit jars like kraut, after nine days. . . .

Women would cook a washpot full of beets. They were then peeled and put into churns, and homemade syrup was poured over them. A thick cloth and brown paper was tied tightly over the top of the churn to keep out insects. The syrup would ferment into "vinegar" and pickle the beets. Wild grapes were picked from the stems, washed, and put up in syrup the same way.[10]

Mrs. Elsberry's community used both jugs and tin buckets for sorghum syrup; jugs were also used to store soft lye-soap.[11] The jug was even incorporated into proverbial speech: "When someone expressed an opinion about some current event that they weren't sure others would agree with, they would say that they 'could like it or pour it back in the jug.'"[12] Mrs. Elsberry mentions an interesting secondary use of jugs to scare rabbits away from the sweet-potato patch: "Some would set unstoppered jugs in the patch. When the wind blew it would make a whistling sound in the jugs."[13]

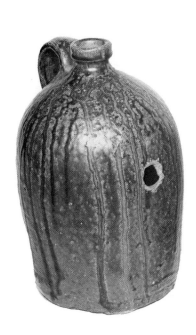

21. *Alkaline-glazed vessels adapted for secondary uses different from their original functions. The jug, 9¾" high—purchased from an antique shop and having no known history— may have been used to "decorate" an Afro-American grave, the wall punctured to break the chain of death and protect the survivors (a custom of possible African origin). The fruit jar, 11" tall—its bottom pierced by three small drainage holes—was hung as a birdhouse for purple martins.*

22. *Mrs. Fred Moore of White County, 1975, using a three-gallon churn made by Lanier Meaders eight years earlier. Photo by Peggy Croft and Rita Southerland.*

Although the descriptions of dependence on folk pottery in this chapter have been cast in the past tense, such wares are still being used traditionally in the South wherever they are available. Churns made at the Marshall Pottery in Texas, by G. M. Stewart of Mississippi, by Norman Smith and at the Miller Pottery in Alabama, by Burlon Craig of North Carolina, and by Georgia's Lanier Meaders are still very much in demand by local country-folk. Mrs. Fred Moore of Mossy Creek churns every day in a three-gallon churn made by Lanier, selling to her neighbors any surplus butter from her two cows. While she may be one of the last churners in the area, she declares that "They's lotsa people buy Lanier's churns to make pickled beans and kraut; use them the old-timey way" (82). Even in a metropolis like Atlanta, I am always pleasantly surprised, while carrying a newly acquired jar or jug on the downtown streets, to be stopped by some older resident who will reminisce about such ware on the farm of his or her youth. And in the modern building that houses my office, there are two cleaning ladies who regularly churn in vessels I supplied, rewarding me occasionally with lumps of sweet butter or plastic jugs of tangy buttermilk.

CHAPTER THREE

Crocks of Gold:
Potting as a Business

"What I like best about making pottery is selling the stuff and getting the money for it." If this statement by Lanier Meaders sounds strangely mercenary for a potter, it is because our modern appreciation of handicrafts as a largely recreational, rather than commercial, pursuit romantically obscures the true motives of the professional country craftsman. "People now think of pottery as an art form," explains Lanier, "but for us it was a way of life, our livelihood. It put food on our table."

Without recourse to technical jargon, this chapter will confront the economic realities of making folk pottery. Any successful business, of course, manages to balance its expenses, or production costs, with income from sales, and in addition yield a healthy margin of profit. If, by today's standards, Georgia's folk potters were not always the most efficient businessmen, these same principles nevertheless obtained for them.

Economic data for the earliest Georgia potters is either nonexistent or very sketchy, but it is possible to draw a more complete picture for craftsmen like Jesse Bradford Long of Crawford County, who worked just over a century ago. Born in 1808, he was the eldest son of potter James Long, who settled in eastern Crawford County in 1826. In 1827 Jesse married Betsy Whittington, and the following year purchased 141 acres on Deep Creek several miles south of his father. In 1830 and 1836 he bought up an additional 135 acres of adjoining property. His great-grandson, Jack, remembered that "Grandpa Jesse had a large house, built of long yellow pine logs, hewn flat and jogged at the ends, so to lie on each other, with hand planed boards to cover the cracks. It was two huge rooms fore and aft, with two rooms on the side at the front, or living room, and one side room

off the dining-kitchen end. Huge fireplaces at each end with rock and brick chimneys, huge mantles at the fireplaces" (69). Mr. J. W. Jones, a native of the area, added that the two-story log home had an outside stairway to the upper floor (64). On the 1850 census Jesse was listed as a planter (as were most cotton-growers of that day), with real estate valued at $2,000; the slave census for that year shows him owning two slaves, and his descendants say that he enjoyed raising race and show horses (as reported by 102A). Clearly, Jesse Long was not a poor man.

In the antebellum period Jesse's pottery would have been a handy way to supplement what must have been a substantial farming income. He was in his fifties when the Civil War broke out, but, according to family tradition, served as a Home Guard captain and produced pottery for Confederate hospitals; fragments of chamberpots excavated from his shop site probably date to this period (plate 78). Three of his sons—two of them known potters—died serving the Confederacy. The war also affected Jesse economically, for while his real estate was valued at $2,250 in 1870, the worth of his personal property had dropped to $500 from $2,900 in 1860.

The tax digests for Crawford County not only flesh out the fluctuations in Jesse's modest fortune, but make it clear that Emancipation was responsible for a goodly portion of his losses. Between 1840 and 1856 his land holdings increased from 277 to 682 acres. In 1856 this acreage was valued at $2,800, Jesse's two slaves were valued at $1,200, and the aggregate worth of his property was $4,830. His slaves, then, constituted one-fourth of his wealth.[1] Shortly after the war, however, the 1868 tax digest shows that although Jesse now possessed 750 acres, their assessment had skidded to $1,500, leaving the value of his entire property (now minus the slaves) at $2,100, less than half of what it was in 1856.

At this point, Jesse and his family were probably beginning to rely more heavily on the pottery business for financial support. The 1880 manufacturing census shows that for that year, "Long's Jug Shop" had invested $250 capital plus $100 worth of materials, and employed seven workers, four of whom were males above sixteen, one of whom was a child, and the rest presumably were females. It is likely that Jesse himself, then seventy-two, had retired from active work, leaving the shop in the hands of younger potters. The population census for 1880 shows Jesse's son Green, Green's son James, Jerome Avera (whose father John had married one of Jesse's daughters), Jesse Harper (who was

married to another of Jesse's daughters), and the latter's thirteen-year-old stepson Sylvester, all as potters living in the same neighborhood; these were probably the four adult males and child working at "Long's Jug Shop."

The 1880 manufacturing census indicates that the skilled workers (i.e., turners) at this establishment earned an average of a dollar a day, while the unskilled laborers (the child and two women) received fifty cents. A total of $600 in wages was paid that year. It was a year-round operation, but during the winter the workers only put in an eight-hour day instead of the usual ten. This steady activity paid off, for the annual production of ware was valued at $1,500, most of which was probably sold to distillers like W. H. Mansfield, who was listed for nearby Macon in the same census. This would have left a net profit of about $500, a tidy sum in those difficult postwar years.

Jesse Long's pottery evidently was among the state's most profitable in 1880; the three other Crawford County establishments listed in the manufacturing census took in somewhat less (Averett's and Dixon's jug shops were, in fact, just about breaking even). To be sure, dozens of other potteries known to have been operating in Georgia are absent from that census; the majority of these were likely smaller-scale concerns, active only part of the year. While Long's shop thus may not present the most typical economic picture, it does give us an idea of the upper end of the scale.

Since we have focused on Jesse Long to help illuminate nineteenth-century pottery economics, it might be of interest to use another member of the family to suggest the standard of living enjoyed by at least the more prosperous early potters. When one of Jesse's brothers, Elijah Long, died in 1841 at the age of twenty-one he left a respectable estate, over which their father, James, was appointed administrator. The list of sales of his "perishable property" (i.e., possessions excluding real estate) gives us a fascinating glimpse into the artifactual life of this Crawford County potter.[2]

[item]	[purchaser]	[price paid]
1 Bed and furniture	Eliza Long [Elijah's wife]	8.00
1 do do	Henry Everett	26.12½
1 B[ed] Quilt	William Dickson	2.00
1 do do	Jesse B. Long	2.75
1 do do	William Long	2.43¾
1 Sp[inning] Wheel	Eliza Long	1.56¼
1 Trunk	William Long	1.12½
1 Sadelle	Jesse B. Long	12.75
1 do	Josiah Dickson	1.50
1 Large Tub	Eliza Long	.87½
2 Setting chairs	do	.50
5 do do	Henry Everett	3.12½
1 Loom	Eliza Long	4.81¼
1 Small Table	do	.25
1 Large Table	William Long	1.06¼
1 Chest	Jasper Whittington	.93¾
3 cups & saucers	Eliza Long	.06¼
1 Coffey pott	do	.12½
1 Set cups & saucers	Jasper Whittington	.50
1 set plates	do	.37½
1 dish & cream pot	do	.62½
1 Small Dish	Jesse B. Long	.43¾
3 Tumblers	do	.62½
2 Small Bowls	William Dickson	.31¼
1 Decanter & Bottle	William Long	.37½
1 Set Knives & forks	Eliza Long	.31¼
1 Looking Glass	do	.43¾
1 Book	D. Wadsworth	.31¼
1 D[inner?] Pott	A. Striplin	1.06¼
1 Oven	B. H. Prichard	.68¾
1 Small pott	J. B. Long	.25
1 Frying pan	A[lford?] Long	.43½
1 Axe	William Dunn	1.62½
2 do	William Dickson	.37½
1 Pot Rack	William Long	1.50
1 pr. Tongs	Jasper Whittington	.43¾
1 fire Shovel	Joseph Long	.31¼
1 Grubbing hoe	do	.50
1 do	A. Bryant	.25
1 Weeding hoe	Joseph Long	.06¼
1 pr. Geer [plow gear?]	do	1.00
1 Plow Stock &c	do	1.12½
1 Shovel plow hoe	do	1.00
1 Iron Wedge	A. Bryant	.75
1 Pair Smoothen Irons	William Dickson	1.12½
1 Coffee Mill	John Garret	.31¼
1 Pad Lock	Giles W. Chapman	.31¼
1 Draw Knife	Joseph Long	.81¼
1 Lot Sundries	do	.25

[item]	[purchaser]	[price paid]
1 Piece of Leather	B. F. Prichard	(not taken)
1 Sythe & cradle	Joseph Long	2.25
1 Pail & Sifter	Eliza Long	.25
1 Bread Tray	William Long	.37½
1 Piggin	Josiah Amison	.25
1 Barrel & Basket	Joseph Long	.50
1 Hamper Basket	William Long	.18¾
3 first choice chairs	James L. Merit	9.18¾
3 second do do	Josiah Amerson	6.75
1 Lot Jugware	Joseph Long	.7½
		pr. Gallon
1 Lot Raw [unfired] Ware	James Long	.1½
		pr. Gallon
1 Red Heifer	A. Bryant	7.75

Included in the inventory of Elijah Long's estate (for which Jesse served as one of the appraisers) are the following items, absent from the sale bill or spelled out in more detail.[3]

[item]	[appraised value]
5 head of cattle	31.00
1 feather bed & 2 quilts & 1 counterpin & 1 sheet	25.00
1 side board	8.00
1 lot Jugware Burnt, 391½ Galls.	25.44½
1 lot of raw ware, 352½ Galls.	5.28¾
6 head hoggs	12.00
1 pair of Temples [used in weaving]	2.50
1 lot of notes to the amount of	77.71½

The total appraised value of these possessions came to $292.32. A decade later, when Joseph Long, another of Jesse's potter brothers, died, the inventory included a "Negro Woman by the name of Margarett" and a "Negro child by the name of Henrietta."[4]

Judging by its material goods, then, this nineteenth-century family of Georgia potters was solidly ensconced in the yeoman farmer/small slaveholder middle class, neither poor nor especially wealthy, but what historian Frank Owsley called the "plain folk of the Old South."[5] By the standards of the day, the Longs enjoyed a moderately comfortable country life, and their involvement in the pottery business must have contributed to this comfort in no small measure.

The great incentive to running a small family pottery was that for a negligible capital outlay one could reap what sometimes must have seemed windfall profits. The real, if intangible, investment was one of training and stamina. With these, the potter could convert common clay into saleable wares. In the process, however, certain operating expenses could not be avoided.

The first of these was the initial construction of the shop and associated equipment. While many of the Georgia pottery shops were built of logs (a relatively inexpensive process), frame and brick examples are also known, and these would have required the purchase of lumber, nails, glass, and bricks. The equipment, while fairly elaborate, was mostly homemade, with some help from the local blacksmith; the kiln would have been the most costly structure to build, especially if the potter did not make his own bricks, and he may have purchased the metal parts of his wheel from a foundry. Periodic maintenance would have been necessary; the wooden clay mill, exposed as it was in the yard, probably was rebuilt every couple of years, and the kiln somewhat less frequently.

Then there was the cost of materials. If the potter had workable clay on his property, his most important raw material was free; otherwise he rented a clay plot or, more commonly, paid the owner a reasonable sum per load. When, for example, Lanier Meaders's father, Cheever, began buying his clay, he paid a dollar per wagonload to the farmer who owned the land; just before his death in 1967 he was paying fifteen dollars a truckload (there is good clay not far from the shop but the neighbor has been unwilling to sell it; currently Lanier buys and mixes together a dark clay from Crawford County and a light clay from Banks County). Fuel, which for the southern folk potters was nearly always wood, was a material they seldom needed to buy, since most farms had a stand of timber; Lanier now obtains sawmill scraps free for the carting off. The last material was the glaze. The great advantage of the alkaline glazes used by many potters in the Deep South was that they were composed of ingredients to which they had free access: wood-ashes, clay, and sand (or powdered glass, usually discarded bottles). They had the option of buying lime for that form of alkaline glaze or making their own by burning limestone in the kiln. Salt and Albany slip—the two other common stoneware glazes—had to be purchased, however, and shipping charges added to the latter.[6] Since few Georgia folk potters decorated their products with cobalt oxide (which produces a deep blue color on salt-glazed stoneware), the cost of that chemical seldom was accrued.

The third category of expenditure was labor. The mules (or, less often, horses or oxen) used to run the clay mill and transport the clay, wood, and finished ware had to be bought and cared for. If the potter had sons to work with him, then the hiring of human labor was unnecessary. Otherwise, he might pay others to turn ware at so many cents per gallon and perhaps an unskilled worker to do the more menial chores: digging, hauling, and mixing clay, chopping and carting wood, making up clay balls for the turner, and helping to burn the kiln.

Of the entries in the ledgers carefully kept from 1910 through the 1930s by Jugtown potter Rufus Rogers and preserved by his daughter (the only such records discovered for Georgia), the most frequent expense related to Rogers's pottery business was payment for labor. During those years a number of local potters worked for him, as well as several who made the Atlanta area their headquarters. For example, the entry for August 12, 1912 reads: "JF Key in acct with SR Rogers for Turning / 1449 gal ware 21.73," and for the same date the following year, in account with the same local potter, "to 829 gal ware turned 12.43," and for August 30, 1913, "to 620 gal. ware turned 9.30." In those early years, then, Rufus Rogers was paying Jefferson Key 1.5 cents per gallon to turn ware. By 1925 Rogers had increased his rate to 3 cents a gallon, as paid to another local potter, McGruder Bishop. And by 1928 he was paying Curtis Bishop 3.5 cents per gallon to turn churns, 3 cents a gallon for flowerpots, and 5 cents each for "art vases," a fee specialization reflecting the shift from food-oriented vessels to those with a more aesthetic purpose.

Of course these figures, in themselves, are of little use without knowing their real value for that particular year, but the increasing cost of labor for the same shop over a fifteen-year span undoubtedly reflects both an inflationary trend and the competitiveness of the factory wage. An account for 1920 also gives a day-by-day breakdown of the number of gallons of "Jug Ware" turned for Rogers by brothers Javan and Otto Brown in August and early September, showing that Javan was producing from 50 to 140 gallons a day while Otto's daily output ranged between 13 and 100 gallons.[7]

Other expenses at the Rogers Pottery, buried in the ledgers amidst loads of cottonseed and guano, are $1.00 to repair a "Jug Wheel" (1915), $5.00 to purchase a jug wheel (1918), and $3.50 in freight charges on a load of Albany slip (Rogers's chief glaze, which he ordered from the E.C.M. Company of Albany, New York) plus 50 cents to local potter John Henry Stewart for haul-

ing the glaze, presumably from the depot to the shop (1925). The following entry of 1915 makes it clear that the repaired wheel—evidently a spare—was being rented to W. C. Rogers, who owned another Jugtown shop: "Feb. 20 to rent on Jug Wheel @ 25¢ Month for 3 Month 75¢ / May 24 Wheel Give out / Aug. 2 Started to use Jug Wheel again from Aug. 2 1915 to Nov. 2 1916 = 15 Months 3.75." Of the $4.50 total debt Wiley Rogers paid $3.00, according to an entry of December 18, 1916.

Until the second decade of this century, the demand for utilitarian pottery was steady enough that Georgia's folk potters seldom needed to resort to salesmanship; it could almost be said that the wares sold themselves. This may be one reason newspaper advertisements by the potters are so rare, although a number had themselves listed in the state business gazetteers of the 1870s and 1880s. Even when a dozen shops were concentrated in the same small community it appears that competition was not a serious problem, and expedients such as "price wars" were almost unheard of.[8] Gluts were avoided by a dual marketing system: the potter sold his wares both at the pottery yard and by wagoning over selected routes where he felt the need was greatest.

While the southern folk potter's market has been described as "purely local,"[9] this is not entirely accurate. The importance of "hauling" expeditions to general and hardware stores in the Georgia potter's marketing scheme is well illustrated by the experiences of the Meaders family of White County. From the 1920s through the 1950s, L. Q. Meaders and his brother Cheever would make such trips, sometimes to North Carolina mountain towns like Andrews, Franklin, Cherokee, and Waynesville, a round trip of nearly two hundred miles which took two weeks. L.Q. recalled:

> I was pretty much the hauler. It was just wonderful to be able to do that in the fall of the year, or summertime. It's just the grandest living there is. We tried to [haul] one load a week, generally always had an order for it by mail. We'd haul from 250 to 400 gallons, a couple of hundred pieces, mostly churns and pitchers, pack them with straw. We had a man at Gainesville [Hall County], Palmer Hardware Company, took our pottery for I don't know how many years, every piece we could make. (77A)

Cheever, too, reminisced about these trips, and the transition from two-mule wagon to truck:

The first trip I ever remember going out with a covered wagon hauling a load of pottery was with my father and one of the girls. Liz, the second girl. I's around twelve years old. He hauled it down to Buford, that's below Gainesville. That'd be thirty-five miles. Drove out down there to some store and sold it off. Then we's on our way back home. Come on this side of Gainesville and camped. Started up a fire on the side of the road, cooked a supper, made coffee, but after awhile we crawled up in the wagon and went to sleep. . . . We was pretty bad to haul it over in North Carolina and South Carolina because we'd get a better price for it up there. Stopped hauling with a wagon around '37 or '38; got a truck then. (74)

23. Maryland Hewell's pottery yard at Gillsville, ca. 1930s. Unglazed planters, flowerpots, and vases and Albany-slip-glazed jugs, churns, and pitchers await sale, while greenware dries on boards. The churns were up-ended to prevent filling with rainwater, which in winter would freeze and crack them. Courtesy of Mrs. Maryland Hewell.

The wares and the proceeds therefrom sometimes posed a temptation to thieves. In wagoning their pottery to Rome (Floyd County) from Paulding County one of the members of the Shepherd family would sleep on the loaded wagon with a gun to discourage pilfering (17), while George Chandler and his brother Oscar of Jackson County discovered that the safest place to camp

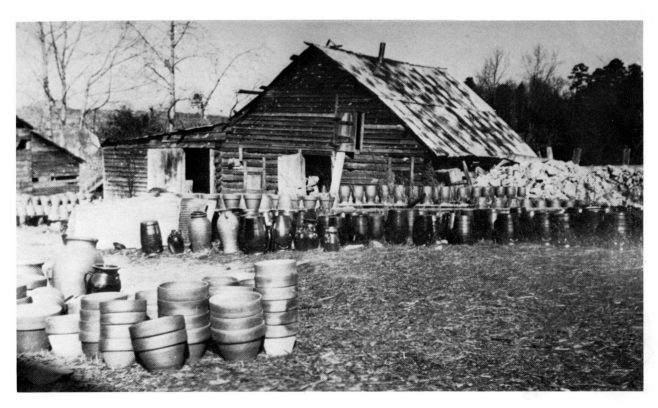

24. Cheever Meaders loading his wares into a straw-cushioned truck preparatory to making a hauling trip, ca. 1950s. At that time the "mud mill" (left foreground) was still in use and the log shop and Cheever's kiln were still standing. Courtesy of Mrs. Janet Boyte.

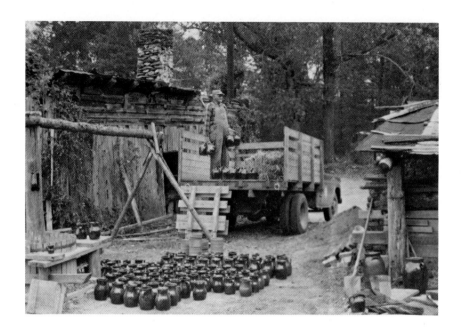

overnight was a cemetery, fear of which kept away unwanted visitors (27).

Although it was the rule for members of the pottery families to do the hauling, sometimes peddler-middlemen or the store owners themselves would visit the shops and buy loads of pottery which they would then mark up for resale. It was not uncommon, for example, for men to come to the Meaders shop for a wagonload of stoneware and wait a week for it to be made, staying with the family while their mules were kept in the twelve-stall barn. A mountaineer named Harkins operated this way, as did Dave Holloway, who ran a crossroads grocery during the depression. On his way back to the mountains from selling a load of chickens and eggs in Gainesville, Holloway would stop by the Meaders place to pick up sixteen dollars worth of churns (200 gallons at 8 cents a gallon—say, 50 four-gallon churns) to sell at his store. More often, however, store owners placed their orders for Meaders pottery in advance by postcard.

Professional wagoners seem to have been especially important customers of the Crawford County potters. Jewel Merritt, whose father, grandfather, and uncle were among those potters, recalled, "Before 1907, my granddaddy told me, there was eighteen in Crawford County, just small potteries, you know. Biggest thing they made was liquor jugs. But some of 'em would make a few churns and bowls and pitchers, what they called back in them

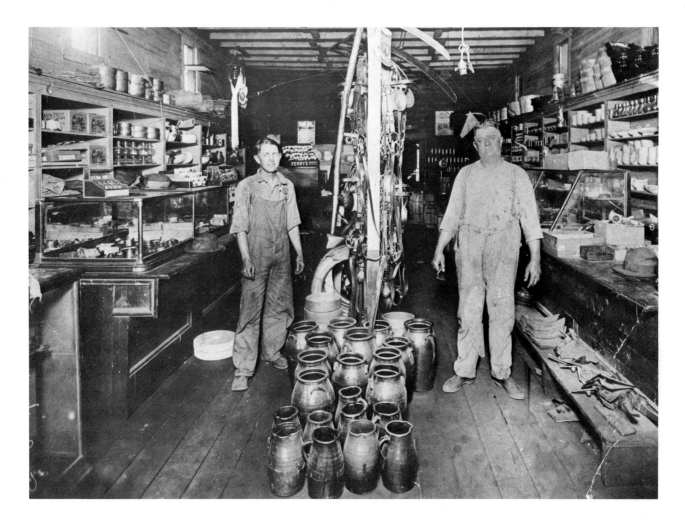

days 'peddlin' ware.' And then there was folks that would buy it and take off in a wagon to south Georgia and peddle it out through the country. Used to be a lot of that done 'way back" (79). The 1860 census for Crawford County lists Wyander Whittington and brothers Julius and Paschal Hoskins as "Jug Peddlers," while Henry Merritt and James Hamlin appear with the same occupation twenty years later. S. N. Bishop is shown as a "Jug Dealer" in the 1860 census for Jugtown in Upson County.

During the Great Depression Jugtown potter Rufus Rogers depended heavily on hauling for his sales. Two to three weeks of work yielded a truckload of ware, which he sold mostly to hardware stores throughout a large portion of west-central Georgia (thirty of which are listed in the front of one of his ledgers). The remainder he disposed of through "yard sales," as he called them.

25. Interior of J. C. Bowers Hardware Store, Canon, Franklin County, 1925, with an assortment of churns and pitchers for sale (J. C. Bowers at right, his son J.M. at left). The glaze (salt over Albany slip) and forms are typical of potters trained in Barrow County. Courtesy of the Vanishing Georgia Collection, Georgia Department of Archives and History.

The longer trips took him about two weeks and grossed an average of seventy dollars, from which he paid for materials (mainly glazing), turners to help produce the ware, and, combined with his farming income, support of his family, which included ten children. In those lean years churns, which could double as pickling jars, were in great demand, for people were forced to return to a more self-sufficient life which included home preservation of foods. Rogers was able to charge fifteen cents a gallon for churns in 1930. The following sample from a page in his ledgers indicates the proportion of hauling to yard sales in his marketing scheme.

		Sales Acct Stoneware 1931	
Feb 30	to date		75.00
	Yard Sale to date		20.00
Mar 18	By truck	Newnan route	60.00
25	" "	LaGrange route	45.00
	" "	Thomaston Ga	8.00
	" "	Jackson Route	10.00
Apr 3	" "	Thomaston	3.40
18	" "	Griffin	10.00
21	" "	Forsyth & Jackson	35.00
23	" "	Covington Route	62.00
25	" "	Manchester	20.00
	"	Yard Sale	5.00

In that one year, at the height of the depression, Rufus Rogers was able to gross $950.30 from his pottery business, which must have gone a long way toward putting groceries on the table.

A ledger notation of the previous year indicates that he did not always pay cash for those groceries, however; in two transactions with a local merchant he traded $6.45 worth of churns. While cash seems always to have been the preferred medium of exchange, barter was not ruled out, as potter Louis Brown of western North Carolina explained:

Lots of times through this region they didn't have the money to buy a jar, but would trade you something for it. And churns, milk pitchers, jugs were always in demand. The potter was happy because he had made his churns and gotten rid of them, and the farmer was happy because he had gotten the churn and maybe traded the potter a pork or something in return. And lots of times he would get the money for the pottery, especially in the towns—in the hardwares and the merchants' big seed stores. I imagine

FAIR DEALING **GOOD QUALITY**

S. R. Rogers Pottery Works
CHURNS, FLOWER POTS, JUGS, ETC.

R. F. D. 1, Meansville, Ga., *2 – 9 –* 193*9*

Mr. R. B. Giles:
Juliette Ga–:
Dear sir –: I will appreciate
your order for anything
you may need in churns
and flower pots.
Yours truly
S. R. Rogers

Fig. 1. Billhead of Jugtown potter S. Rufus Rogers, found in his ledgers. Courtesy of his daughter, Mrs. Leon Gooden.

that if we went back even before then, that there was a lot more trading being done than there was money in circulation. (20)

Rising prices at the Meaders Pottery are an index of both the shrinking value of the dollar and a growing tourist market. At one point during the depression Cheever was forced to sell his wares for a nickel a gallon, and was happy to get even that. Just before World War II he charged eight to ten cents a gallon as a wholesale price to retailers, who marked it up fifty to a hundred percent. During the 1940s—perhaps in response to the publicity given the shop in Allen Eaton's *Handicrafts of the Southern Highlands*—the "yard" price jumped to fifty cents a gallon. And by 1957 prices had both stabilized and become influenced by the non-

traditional system of pricing by the piece rather than by the gallon: thirty cents for small pitchers, fifty cents for jugs, and $1.40 for four-gallon churns.

In 1971, four years after Lanier fell heir to the operation, he was charging a dollar per gallon for plain work; a few years later that price had been doubled for churns, but the rest of his prices were by the piece; now he charges entirely by the piece. It is difficult, however, to quote fixed prices for Lanier's current output, for there are two sliding elements in his system. At first he did not realistically consider the worth of his own labor, but with an increasing emphasis on decorated wares, the amount of work in a piece and its appearance partly determine its price. Further, he has been known to adjust his prices to the individual customer: "If someone comes by in a big Cadillac wanting my stuff just to look at," he told me in 1978, "I try to burn his britches; if it's just some good ol' boy driving a pickup who don't have much money and needs my churns to live, I try to treat him right."

Despite his national reputation, Lanier has kept his prices more modest than those of many college-trained studio potters. What with cultivating a vegetable garden and butchering a hog or two each year, his wares bring in enough income for him and his mother to live comfortably. As he said in 1968, "I can pot on days that I can't farm. If a man's really farming he's got a job every day, rain or shine; but if he don't farm no more than I do, then this pottery makes everything balance out" (78A).

With the accumulated knowledge of his predecessors as his legacy, the Georgia folk potter could achieve such a balance by unlocking the potential in the tons of clay that lay nearby, useless to his non-potter neighbors but for him a buried treasure. Mastery over the clay meant a better life for him and his family, and entitled him to membership in a fraternity of specialized craftsmen whose combined skills, in turn, contributed immeasurably to the quality of life in the region.

"Born with Clay in Our Veins": The Pottery Dynasty

S peaking of the nearly fifty potters who worked at Georgia's Jugtown, potter D. X. Gordy—himself descended from the Bishops, a leading pottery family there—was hardly exaggerating when he said, "They were all kin by blood or marriage" (43). Behind his quiet assertion, which applies also to the state's other centers, lies the phenomenon of the pottery dynasty.

The eight communities to which the majority of Georgia's potters belonged were dominated by certain families, such as the Browns of Jugtown, Atlanta, and the Carolinas (who have maintained an unbroken line of potters for eight generations), the Longs of Crawford County, the Fergusons and Hewells of Statham and Gillsville, and the Dorseys and Meaderses of Mossy Creek. These dynasties were a powerful cohesive and controlling force in Georgia's ceramic tradition; they bound together the brotherhood of clay.

Dynastic regeneration of the craft was preferred to the more urban system of formal apprenticeship, whereby a lad of fourteen was legally bound to a master for seven years to learn the trade, followed by a journeyman phase of working for others before establishing his own shop.[1] With their farming routine, Georgia potters could not have offered full-time training to apprentices even if they had wished to. "Pottery ran in families," explained Lanier Meaders. "It was just a family operation. And the time they wasn't working around the shop, they was working in the field" (78A). Dependence on the family as the chief economic unit was reinforced by the pattern of dispersed, semi-isolated farmsteads that characterized the region from the frontier era into this century.

*Fig. 2. Selective genealogy for Ferguson and allied families, emphasizing the more than fifty potters (indicated by bold type) and those women representing pottery families whose marriages contributed to consolidation. Key to abbreviations: md. = married (number in parentheses indicates which of several marriages); b. = before; a. = after; ca. = circa; * = suspected of, but not established as, being a potter; † = limited involvement in pottery (e.g., Charles David Perdue owned a shop and hired others, but did not actually make pottery). The first three generations worked in the vicinity of Statham in what is now Barrow County, but about 1890 the locus shifted twenty-five miles north to Gillsville in Hall County, where most of the later potters worked. Robert Craven, who became a potter at Gillsville through his non-potter father's marriage to a daughter of Eli Hewell, was a grandson of Mossy Creek potter Isaac Henry Craven, and thus represents another major dynasty with roots in Randolph County, North Carolina. This chart was developed largely from data supplied by Mrs. V. A. (Anne Ferguson) Royal, with further assistance from Zell DeLay, Mrs. B. J. (Karen Brownlow) Craven, Mrs. Maryland (Ada) Hewell, and other members of the Hewell family.*

With the typically large rural family, the likelihood of a succession of sons to serve as a labor pool and chain of continuity was good, and it was usually assumed that a potter's sons would follow in his muddy footsteps. Harold Hewell, who runs a flowerpot plant at Gillsville, spoke of the expectations of his folk-potter father, Maryland: "I think he had it in mind he wanted all of his boys to be potters. . . . I have three brothers, and we've all kept our hand in the business. We must have been born with clay in our veins" (53A, 53B). In earlier times, with fewer alternative occupations to lure away the sons, the chances of their perpetuating the craft were even stronger.

Frequently, Georgia folk potters not born into a pottery family married into one. A young man could be "adopted" into a local clay clan by marrying the patriarch's daughter, then serving an internship in his in-laws' shop, or, alternatively, by first being hired to help a potter with few or no sons but several daughters at home, later marrying one of these after an acquaintance blossomed. He was also eligible to join a pottery family if his sister married a potter's son. Another common pattern was for members of different pottery families to marry each other. The effect of these various kinds of intermarriage, whether intentional or not, was to absorb outside competition and consolidate the dynasties.

A striking example of this ceramic consanguinity is the Ferguson clan and allied families. It all began when Charles H. Ferguson, who apparently had worked in the stoneware "manufactory" of Dr. Abner Landrum at Pottersville in Edgefield District, South Carolina, migrated to Jackson (now Barrow) County, Georgia, near present-day Statham, where he established a shop about 1846. Others were drawn into the craft through marriage to his children, and the web widened as members of these secondary families married one another. Eventually, all the potters among the DeLays, Archers, Dials, Robertsons, and Hewells were connected through the Fergusons. The human dimension of this complex network is suggested by genealogist Anne Ferguson Royal.

> My great-grandfather James S. Ferguson and his brother-in-law George A. DeLay, both born in 1829, were both enumerated in the 1860 census with their occupation as "Potter." I feel quite certain they were then working together (along with William Ferguson, Jonathan Dial, and Nathan Butler) at the place shown on maps of the period as Jug Factory. They both enlisted in Jackson County in

Ferguson and Allied Potters

STATHAM AND GILLSVILLE, GEORGIA

Charles H. Ferguson 1793–1878

the Confederate service on July 17, 1861, and both were in action serving with Georgia Volunteer units in the Battle of the Wilderness, Virginia, on May 6, 1864, a day which certainly must have been the saddest day in the life of my great-grandmother, Mary Temperance (DeLay) Ferguson; for on that day in that battle both her husband, James Ferguson, and her brother, George DeLay, were mortally wounded. (91)

In the next generation, potter Eli Hewell, by virtue of his daughter Catherine's marriage to potter Charles P. ("Charlie") Ferguson (son of William and grandson of Charles H.) and upon his own

26. Charles P. ("Charlie") Ferguson, ca. 1890, about the time he moved from the Statham area to Gillsville. Courtesy of his daughter, Mrs. Annie Lee Ferguson Morris.

(second) marriage to Charlie's sister Frances, became both Charlie's father-in-law and brother-in-law!

Transmission of the craft was limited to the male members of the family, for pottery-making in Euro-American culture was considered a masculine activity (in contrast, say, to American Indians, among whom women were often the potters).[2] This rather rigid sex role seems tied to use of the potter's wheel and commercialization of the craft. When I asked Arie Meaders, Cheever's wife, why there were so few women folk potters, she replied, "As far as the men were concerned, the woman's place was the house, the garden, and the chickens out back." Assistance by the potter's wife or daughter in the menial chores at the shop might be welcomed, but learning to turn ware on the potter's wheel— the act of creation—was virtually taboo. The chances are that most potters, if they wondered about it at all, did not view this as discrimination; instead they might have argued that a woman

27. Eli Hewell and brothers, ca. 1900. Of these five sons of potter Nathaniel Hewell, two established themselves as potters: Henry H. (standing, left) and the bearded Eli (seated, left). The others are (center to right) George, Jim, and Bill. Courtesy of Mrs. Maryland Hewell.

could not be a successful potter because she did not have the strength and stamina to produce the churns and other "bigware" required by customers (no matter that she was perfectly capable of pumping the dasher in such churns until her arm assumed the girth of a ham). Bearing and caring for the children, along with the endless round of household duties, kept a woman tied to the home; is it any wonder, then, that the potter chose to initiate only his sons into the manly mysteries of turning?

The few exceptions prove the rule. If ever a Georgia woman was destined to be a folk potter by virtue of "occupational inbreeding," it was Catherine Hewell Ferguson. Not only was her father, Eli Hewell, a potter, but her mother, Elizabeth, was the daughter of potter Jonathan Dial (whose wife Frances, in turn, was a daughter of potter Charles H. Ferguson). By the time Catherine married her older cousin (and her stepmother's brother), Charlie Ferguson, it is not likely that she was a stranger to clay. The couple is said to have made an efficient husband-and-wife team at Gillsville in the early years of this century; according to the widow of potter Maryland Hewell, Catherine would pull up a pot part-way on the wheel, leaving Charlie to shape and finish it while she began another on a second wheel (56). She was thus deprived of the satisfaction of completing her creations, although she may not have seen it that way. Carrying the feminist potter's banner in modern-day Gillsville is Grace Hewell, wife of Harold and daughter-in-law of Maryland, who specializes in smaller pieces but whose production of unglazed garden pottery sometimes outstrips that of the men in the shop, including her husband and their son Chester (plate 154).

In recent years a couple of other Georgia women with folk-pottery connections have taken up the craft, as much for a hobby as a profession. One is Marie Rogers of Meansville, widow of Jugtown-trained potter Horace Rogers. Since 1974 she has been making some of the older forms on a small scale with her husband's treadle wheel and an electric kiln, such as "Confederate" ring jugs, face jugs, and pitchers (plate 103). These are, however, mostly miniatures, sold as novelty items. Finally, there is Arie Meaders of White County. As the young bride of potter Cheever Meaders she was intrigued by the activities at the shop, which she would observe every chance she could. Once, while her husband was making a chamberpot on special order, she innocently remarked, "What a pretty bowl!" One of Cheever's brothers responded, "Lord, girl, don't you know what that is?" and was "so tickled that he tore down the churn he was working

on, a-laughing" (75B). Humiliated, Arie didn't return to the shop for a long time. It was not until late in life, with Cheever in temporary retirement, that she screwed up her courage and taught herself to turn. Not bound by dynastic training and encouraged by visitors familiar with artistic pottery, she produced wares for a decade that in most respects were alien to the local tradition, remarkably spirited but not what the folk potters would have recognized as "old-timey" (plates 145, 146).

If women folk potters were scarce in Georgia, black potters were even more of a rarity. Only one—Bob Cantrell of White County—has been documented. He worked for about thirty years

at "Daddy Bill" Dorsey's shop, learning to turn while assisting the hired potters. Lanier Meaders remembers him as "a good jar turner; the only black man I ever knew who could" (78A). Afro-American folk potters are better represented in other states, especially South Carolina, where most were slaves trained in their masters' shops.[3] The absence of black potters in Georgia only serves to emphasize the effectiveness of the dynastic system as a barrier which excluded outsiders from the craft; as former White County potter Guy Dorsey explained, "It seems that when it got into one family, nobody else ever got interested" (36A).

In order to contrast them with academically schooled artists, folk artists too often have been characterized as "untutored." Nothing could be more misleading. Folk artists, by all the folkloristic implications of that modifier, are recipients of a tradition in both design and technique.[4] This artistic heritage was not acquired by formal instruction in the classroom, but neither was it strictly self-taught. The process, rather, was one of observation and imitation, or example and practice, with verbal reinforcement when needed. Such training proceeded in an orderly—if informal—fashion, progressing through increasingly complex skills until the entire production sequence and much of the design repertoire had been learned.

The Georgia folk potter unwittingly took his first step on this training "ladder" at an early age by exposure to the shop and a growing awareness that he, as the son of a potter, also would be a potter. Lanier Meaders, who recollects crawling across the dirt floor "on all fours" to watch his father at work, had a playful introduction to the craft: "I used to get up on the headblock, and my older brother would spin me around on it. He'd pedal the wheel and I'd set up on it. Looks kind of foolish now when I get back to things like that" (78A). We may think of the lowest "rung," then, as a subtle indoctrination that began at infancy.

When old enough to help (at about the age of eight), Lanier led the mule around in the pottery yard to mix the clay, made up "balls" for his father to turn, and helped unload and load the kiln (the loading requiring some skill). Later, he contributed to the more strenuous tasks of digging clay and chopping wood. "I've heard a lot of potters say the easiest thing there was about making jugs and jars was cutting wood," declared Lanier's neighbor, Guy Dorsey. "You know that wasn't no play job, was it?" (36A). By the age of thirteen Lanier was learning to turn, and at

29. *Lanier Meaders (right) and his brother John with their grandfather John M. Meaders, founder of the Meaders Pottery, and their uncle L.Q. in background, ca. 1918. As an infant Lanier already was being exposed to the craft. Courtesy of Mrs. Cheever Meaders.*

sixteen he burned the first load of his own ware, one-gallon pitchers and small churns that were so heavy the handles on some broke off as they were being lifted onto the truck.

It would take the young potter from five to seven years to learn the basics well enough to operate on his own, a period equivalent to that of formal apprenticeship. "It takes longer to learn to make a good piece of ware than it does to get a college education," commented Mrs. Maryland Hewell, who made up balls for her husband to turn half a century ago at Gillsville (56). Much of this time was spent at the wheel. "You've got to have the power over the clay," said Javan Brown; "make the clay do what you want it to." Javan was so small when he began turning in Atlanta under the watchful eye of his father, James Osborn Brown, that he had to stand on a "bat" (wooden platform) to reach the wheel. At the age of eighty he told me, "I never wanted to do anything else; I haven't mastered that yet, you know. They say whenever you get old enough to master a trade, you're too old to work" (18B). Yet Javan was precocious enough to go out on his first real

job at the age of thirteen, "borrowed" in the evenings by another potter while at Jugtown to help fill an order for a boxcarload of flowerpots.

Many shops had a second wheel that could serve for training the youngsters, who first worked on a diminutive scale. Truman Bell, whose father Wesley owned a shop at Bethlehem in Barrow County, recalled that the first hired potter—one of the Fergusons—had two or three young boys. "His kids would make little bitty things, and that's the way they learned it. Just come with their daddy and learn it, use the extra wheel" (12). After Javan Brown's brother Davis moved to Arden, North Carolina, he installed a scaled-down kickwheel with a twelve-inch diameter headblock on which his son Louis could practice, the same wheel on which Louis's sons, Charles and Robert (who now operate the Brown Pottery), later learned.

In the early 1930s at Cleveland, above Mossy Creek in White County, the four youngest children of potter Cleater Meaders "tried to follow their daddy" (76) by making miniatures, which they fired in their own little kiln.[5] At about the same time the children of Cleater's brother Cheever, including Lanier, ran a similar mini-kiln, testing the glaze colorants a company had sent by mail. Although imbued with the spirit of play, these minuscule operations were rehearsals for the adult drama of professional craftsmanship. Cleater's sons eventually were enticed away by more lucrative employment, but Cleater junior continued to make pottery, more so now that he is retired. Of Cheever's sons, only Lanier maintains the craft as a vocation, but John and especially Edwin cannot resist the occasional temptation to muddy their hands. Once in the blood, the clay is not easily denied.

Green Glazes and Groundhog Kilns

PROFILE OF A TRADITION

As I went down to a Georgia town,
With the Georgia boys I courted around.
And the Georgia girls who none surpasses,
They all sweet as sorghum molasses.

I been to the North, I been to the South,
Time of a flood and time of a drought.
I've traveled much all over Europe,
But I never saw the likes of sorghum syrup.

And now, kind friends, I bid you adieu,
Sorghum's sweet, and so are you.
And when this cruel war is over,
I'll get a jug o' 'lasses and a pretty goober grabbler.

"Sorghum Molasses," Confederate song
from the Georgia Folklore Archives

Ceramic Regionalism: Stoneware of the Deep South

Students of American culture have for some time recognized the existence of a group of characteristics which, in combination, have set the South apart from the rest of the country. Among these are an agrarian economy stressing a single cash crop (most often cotton), a dispersed settlement leading to isolation, a code of racial behavior institutionalized under slavery and its aftermath, "Jim Crow" segregation, a solid one-party political system, the relatively homogeneous religious outlook of fundamentalist Protestantism, and a shared dialect with plural forms of the pronoun *you*. While it is true that some of the features contributing to this regional identity have been increasingly subject to erosion since the time of change between the World Wars, enough of the pattern remains that the South can still be spoken of as "peculiar."[1]

Within this broad framework are specific folk-cultural traits that have further defined the region's character. Three of America's most expressive musical forms—jazz, blues, and bluegrass—grew from southern folk roots. Emphasis on a "rhetorical aesthetic"—skill with the spoken word—is manifested in political and legal oratory, preaching, and a strong storytelling tradition that has had an ongoing influence on southern literature. Production of molasses and moonshine and an emphasis on greens and "hogmeat" are a few of the more obvious culinary traditions. Other examples may be less familiar. In folk architecture external gable-end chimney placement and raised pillar-and-sill, rather than underpinned, foundations prevail (plates 4, 5), along with such building types as "dogtrot" and "shotgun" houses; there are also regional furniture types like the "huntboard." Most impor-

tant for our purposes, however, is a regional pottery tradition highlighted by rectangular kilns, alkaline-glazed stoneware, and a concentration of ceramic grave markers and face vessels. Some of these southernisms arose in response to the climate or other environmental determinants, some as extensions of Old World traits carried by the region's early settlers, and still others as accidents of history.[2]

Then there are those traditions now identified with the South which once were more widespread. The persistence of maize as a major grain in foods like cornbread and grits,[3] bonnets (an element of female dress that passed out of fashion in less sunny climes), spirituals (once popular among the Pennsylvania "Dutch"),[4] and practicing folk potters are among these vital relics. Outmoded in the change-oriented North, they have survived tenaciously in a region where old ways die hard. A provocative interpretation of this cultural conservatism was offered by geographer Wilbur Zelinsky:

> One of the principal reasons for the distinctness of Deep Southern culture is a retardation in its evolution. While it is true enough that the frontier experience was important in the development of every region in Anglo-America, the exposure of Georgians to frontier living not for a decade or two but throughout the range of their history has been of peculiar significance in the shaping of their culture. Much of what seems peculiar to the Deep South can, then, be attributed to a frontier that came and went elsewhere but has lingered on indefinitely [here], and the otherness of the South is as much a matter of temporal as areal differentiation.[5]

As an index of this regional time-lag, the height of folk pottery production in Georgia occurred during the late nineteenth and early twentieth centuries, whereas in New York State, for example, folk pottery activity reached its zenith in the 1820s, and was on the decline by the 1840s.[6] Just before the turn of the century geologist Heinrich Ries estimated that forty to fifty small country potteries were operating in North Carolina alone.[7] Today there is still a handful of old-fashioned potters active in the South, whereas their counterparts in the industrialized North became extinct long ago.[8] Thus, the very endurance of the southern pottery tradition is a significant regional characteristic.

Antiquarian interest prompted the first serious study of the

defunct northern pottery tradition over half a century ago, but in the Deep South, where the making of folk pottery remained commonplace into this century, intensive research has been underway for less than two decades, and a relatively small amount of information is available in published form. Enough comparative data exists, however, to sketch the general outlines of a distinctly regional ceramic tradition, and it is as a part of this pattern that Georgia folk pottery should be viewed.

What separates folk pottery from the other modes of ceramics is that the forms, production methods, and surface treatment (glaze and decoration) have been handed down from one generation of potters to the next, maintaining a continuity of tradition relatively unresponsive to change. Although there is some leeway for individual variation, it is replication, or conservative fidelity to the inherited tradition, that governs the folk potter rather than innovation or the desire to create a unique product. The pottery designs, then, were slowly refined as they were transmitted through the generations, becoming the shared property of families, communities, even regions of potters. It is as the embodiment of a collective tradition that we can best understand a piece of folk pottery.

Most colonial American potters, rooted in a British or Central European tradition, made earthenware (redware), a soft, porous pottery composed of clay similar to that used for flowerpots but glazed with lead and sometimes decorated with contrasting slip (liquid clay). As early as the 1720s, however, a few Middle Atlantic and Virginia potters were making stoneware, a harder, denser product composed of a purer (usually gray or tan) clay that matures at a higher temperature: 2300 degrees Fahrenheit. The tough, nontoxic stoneware was not generally adopted until after the Revolution, but by the early nineteenth century—when most of the inland Deep South was being settled—it was replacing earthenware over much of the nation. Throughout most of the period explored in this book, stoneware has been the dominant type of folk pottery made in Georgia.

The glaze (a glassy coating that seals the surface of the pot and also contributes to its appearance) is perhaps the most easily recognizable of the features distinguishing the pottery of one area of the United States from another. The variety of glazes used on

stoneware in the Deep South yields a much broader range of colors than seen on northern stoneware (color plate 1).

Salt glaze, found in both regions, is produced by throwing common salt in the kiln at the height of firing, the resulting sodium vapor fusing with molten alumina and silica from the clay of the pot into a transparent coating of glass with the texture of an orange skin. The technique was developed in fifteenth-century Germany, was adopted in England during the late seventeenth century, and in America was the standard stoneware glaze of the North and upper South. Because American potters, in loading the kiln, came to stack their pottery in columns with the mouths covered, prohibiting entry of the sodium vapor, it became customary to wash the insides of the unfired vessels with Albany slip, a natural clay glaze.

From Virginia northward into Canada, such pottery often was decorated with cobalt-oxide blue, which was brushed, trailed, or stenciled onto the unfired surface. In the Deep South, however, where salt-glazed stoneware was made only sporadically, it seldom was blue-decorated. Instead, it typically has an uneven appearance due to drippings from kiln-ceiling bricks, melted "fly-ash" (ashes from the wood fuel blown by the draft onto the shoulders of the ware), concentrated salt deposits (common in North Carolina, where the salt was introduced not into the firebox but through holes along the kiln arch, directly onto the pottery[9]), and spotty heat distribution and atmosphere which caused fire-flashing and mottling. These effects are attributable to the region's rectangular kilns (northern kilns were round and often coal-fired, giving the wares a more uniform appearance) and were unintentional, even though they may add visual interest for the modern observer. "Most potters didn't care what their ware looked like, so long as it didn't leak," commented Javan Brown, whose pottery family in Georgia once specialized in salt-glazed stoneware. To him, though, salt produced the "sorriest" glaze because of those irregularities, and he preferred to work with more uniform glazes (18B).

Salt glazing was important in Georgia at the pottery centers of Jugtown and the Atlanta area from the 1870s into the second decade of this century, and, while there is little evidence of its use before that period, it may be that the Browns, if not others, were familiar with it earlier.

By the 1820s a type of stoneware glaze unknown in the North had emerged in South Carolina, spreading rapidly as potters migrated through the Deep South; the extent of its occurrence is

the western Carolinas, Georgia, upper Florida, Alabama, and eastern Texas, with limited reports in Mississippi and western Tennessee.[10] This distinctly regional glaze depends on an alkaline substance—slaked wood-ashes or lime—to flux, or melt, a silica-bearing material such as sand, feldspathic rock, or glass. Clay, which also contributes silica, serves as a bonding agent and colors the glaze either green or brown (in a wide range of shades) depending on whether its iron content reacts to a reducing (smoky) or oxidizing (free-burning) atmosphere in the kiln. Since these glazes are semi-transparent when well fired, the depth of their

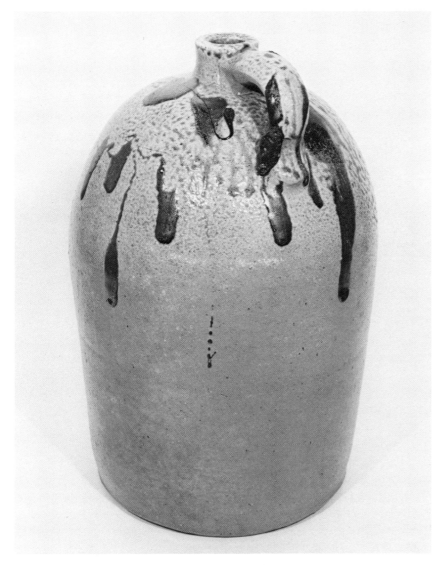

30. Three-gallon jug, 15½" tall, by Edward C. Brown (mark partially obscured), Atlanta area, last quarter of the nineteenth century, showing irregular appearance of salt glaze with green fly-ash puddling on shoulder and numerous dark-brown brick drips which suggest advanced deterioration of kiln when fired.

31. *Set of wide-mouth jugs from White County, late nineteenth century, with olive-green, dendritic-patterned ash glaze known to local potters as "Shanghai" glaze, suggesting an initial awareness of Oriental inspiration. Ranging in capacity from one to three gallons, the jugs— one of which retains its whittled cherrywood stopper—came out of a smokehouse in mountainous Towns County containing a residue of sorghum molasses.*

color partly depends on the darkness of the clay body underneath. Sometimes the alkaline glazes melted and cooled in a drippy flow pattern, giving the pottery a tactile appeal and inspiring such graphic descriptions as "watermelon," "tobacco-spit,"[11] and "snake" ware.

The only other part of the world where high-firing plant-ash and lime-based glazes are found to any extent is the Far East. First developed in China, they were well known there by the time of Christ.[12] While documents have yet to come to light that would explain the origin of alkaline glazes in the South, I believe their resemblance to those of the Orient is no coincidence. Once clay suitable for stoneware was discovered in the Carolina Piedmont, information on these Asian glazes would have been of great interest to potters seeking a cheap, even free, substitute for the salt that otherwise would have been used.[13]

P. Jean-Baptiste Du Halde's *Description . . . de la Chine*, first published in 1735, included two letters written by Jesuit missionary Père D'Entrecolles from the Chinese porcelain center of Ching-tê Chên in which were described alkaline glazes similar in composition to those later used in the South. English translations soon appeared, owing, no doubt, to the fascination with things Chinese in eighteenth-century Britain and America. Because they are no longer readily available, the relevant passages bear quoting:

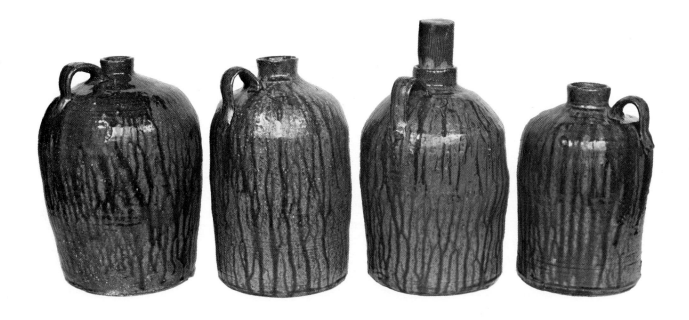

They take big pieces of quicklime, on to which a little water is thrown by hand to reduce them to powder; a bed of dried bracken {a large fern} is spread upon this and then another layer of slaked lime, and so on alternately; then the ferns are set on fire. When all is consumed the ashes are spread upon new beds of dried bracken. This is repeated five or six times running. . . . Formerly . . . they used besides the bracken the wood of the tree *Se-tse* . . . a kind of medlar. . . . The best glazes are made from a mixture of ten parts of the stone glaze [pulverized *Pe-tun-tse*, or feldspar] with one part of the glaze of lime and fern ashes. {1712}

 I have not spoken of a kind of glaze called *Tzu-chin*, that is, burnished-gold glaze. I should be more inclined to call it bronze, coffee-coloured or dead-leaf coloured glaze. . . . To make it they take common yellow [stoneware] clay . . . in a liquid state {after mixing} with powdered *Pe-tun-tse* and some of the ashes of lime and fern. . . . They have shown me this year for the first time a kind of porcelain that is now in vogue, which is olive-green in colour . . . obtained by mixing seven cups of the above-mentioned *Tzu-chin* glaze with four cups of stone glaze, and two cups, or thereabouts, of lime and fern-ash glaze with one cup of powdered flint; all these being mixed in the slip state. The addition of the flint slip produces little veins in the porcelain {i.e., crackled celadon}. {1722}[14]

As an indication of the interest engendered among Occidental ceramists by D'Entrecolles's observations, William Cookworthy of Plymouth, England, had read these letters by 1745 and later reproduced the Chinese lime, fern-ash, and feldspar glaze in his porcelain experiments.[15] As for familiarity with Du Halde's book in the South, an extract from it was published in the *South-Carolina Gazette* of March 5, 1744; the chances are that a reasonably well-educated person in late eighteenth or early nineteenth century North or South Carolina with access to a library could have seen those glaze descriptions.

 Such a person was Dr. Abner Landrum (1784–1859), a physician, scientific farmer, newspaper publisher, and leading figure in the stoneware industry of antebellum Edgefield District, South Carolina. It is not clear how he and two brothers came to be involved in the potter's craft, but their family had been associated with pioneer potters of the Craven family back in North Carolina

before the Revolutionary War.[16] About 1815 Abner established
his shop a mile and a half northeast of Edgefield Court House, in
a community that came to be called Pottersville (map 1).[17] In
1826 architect Robert Mills reported in his *Statistics of South Carolina*, "This village is altogether supported by the manufacture
of stoneware, carried on by this gentleman; and which, by his
own discoveries, is made much stronger, better, and cheaper than
any European or American ware of the same kind."[18] The sophistication of Landrum's ceramic knowledge is suggested by the names
he gave to three of his sons: Wedgwood, Palissy, and Manises.[19]
Whether or not he was responsible for developing the southern
alkaline glazes, he was among the first to use them, and potters
associated with the Landrums diffused this type of glaze into other
southern states, including Georgia.[20]

The earliest documented use of alkaline glaze in Georgia is on
an eight-gallon, double-handled syrup jug inscribed JAMES BUTLE
/ TO HOLD Jug 8 gl 1837 / To HoLD 8 (plates 67, 68). It was found
in northern Washington County, the state's first stoneware center,
and most likely was made by James Bustle, who appears in the
1830 census for adjoining Hancock County and is later known to
have been a potter in Crawford County. Ash- and lime-based
glazes, with several subtypes containing special additives, remained Georgia's dominant glazes through most of the nineteenth century, slowly giving way in the last quarter to the recently
introduced Albany slip. A number of potters refused to abandon
the old homemade glazes, however, and continued to use them
in this century. Lanier Meaders of White County still uses an
alkaline glaze, and he and Burlon Craig of North Carolina are
the last folk potters in the country to do so.

Certain clays contain enough glassy components to be capable
of producing a glaze on their own, once mixed with water into a
creamy slip to permit application. This was discovered of alluvial
clay near Albany, New York, and by the 1840s this Hudson Valley "Albany slip" was being widely marketed to northern potters,
who used it mainly to line the inside of their salt-glazed stoneware. The "patent" or "bought" glaze, as southern potters sometimes called it, did not become available in Georgia until after
the Civil War when trade was resumed with the North, but by
the last quarter of the nineteenth century it was being used to
glaze wares completely, often replacing the more laboriously prepared alkaline glazes. As White County potter Guy Dorsey explained, "You handle one of those old-time glazing mills all day
long and it's pretty bad on you. And then we got to ordering
that Albany slip . . . it didn't need no grinding. And made a

pretty jar, too" (36A). When fired, Albany slip typically is a smooth brown, sometimes with a metallic sheen, but can also appear shiny black or gunmetal gray. Other clay glazes also were used, including Michigan slip, imported from the Great Lakes in this century, and Leon slip, a localized Texas glaze.[21]

Bristol glaze is the fourth major variety encountered. Developed in England, this smooth, opaque white or light gray finish was adopted in parts of the South—especially from the western halves of Tennessee and Alabama westward to Texas—around or after the turn of the century. The basic formula consists of zinc oxide, feldspar, and whiting (calcium carbonate), but other ingredients, such as clay, may be added, thus altering the color.

The four types of stoneware glaze were occasionally combined in various ways, creating an even wider spectrum of colors. For example, it was not uncommon for potters to salt-glaze over Albany slip, producing a patchy green or tan "frogskin" glaze, as it was called in North Carolina.[22] The practice of salt-glazing over a ferruginous (iron-bearing) wash was well known in eighteenth-century England.[23] The most notable Georgia practitioner of this technique was William R. Addington of Gillsville (plate 118). In Alabama, salt glaze was also applied over alkaline glaze and a variety of inside/outside combinations were explored, as much for expedience as appearance.

Jugs of the cylindrical "stacker" type—having a ledge around the shoulder to receive a stacking collar which supported the jug above when fired in the kiln—were sometimes given a two-tone glaze, with Albany slip from the shoulder up and the lighter salt or Bristol glaze on the side. Developed in the late nineteenth century, this form has somehow become the stereotype of the American whiskey jug, and is often used inaccurately in films to depict the colonial or frontier era.

The making of pottery can be viewed as the ultimate civilizing act, for by transforming amorphous clay into formed vessels, chaotic nature is given order in the controlling hands of the potter, who at the same time expresses his society's values and needs. Since the pot is such a highly malleable artifact, it should come as no surprise that its shapes reflect the diversity of the groups producing it. Not all pottery shapes, however, are culturally specific; some represent such perfect solutions to functional problems that they are well-nigh universal. Thus, certain stoneware forms made in the South are distinctly regional, others participate in a larger Anglo- or Euro-American tradition, while within

BELOW, LEFT
32. *Crawford County cream pot stamped 2 on one handle and* BB *on the other, attributed to Benjamin Becham, late nineteenth century; alkaline glaze with "paint rock" coloring, 8¼" high.*

BELOW, RIGHT
33. *White County "cream riser" attributed to Wiley Meaders, ca. 1915; lime glaze, incised 2 alongside handle, 9" high.*

the region each state and pottery community developed its own special shapes.

The cream pots of Georgia and North Carolina offer a good example of intra-regional form variation. Three different styles of vessel, typically of two-gallon capacity, arose in different areas to serve the same purpose: cooling milk and skimming cream. The common type in North Carolina (salt-glazed in the vicinity of Randolph County and alkaline-glazed further west in the Catawba Valley) has a truncated cone shape with an everted and flattened rim and no handles, resembling an inverted beaver hat; it may be derived from similar earthenware cream jars known in Wales and among the early German potters of North Carolina.[24] The Crawford County, Georgia, version is a bowl with pinched pour-spout, related to the standard Anglo-American milk pan but with two loop handles replacing the usual slabs and having a flowerpot-like collared rim.[25] And in White County, Georgia, the "cream riser," as it was called there, often took the form of a large squatty pitcher, apparently a late adaptation of the milk pitcher for a somewhat different purpose.[26]

If the southern alkaline glazes are an indirect Oriental influence, the stoneware forms seem to owe a great debt to Britain. True, the region evolved its own pottery shapes over time, but

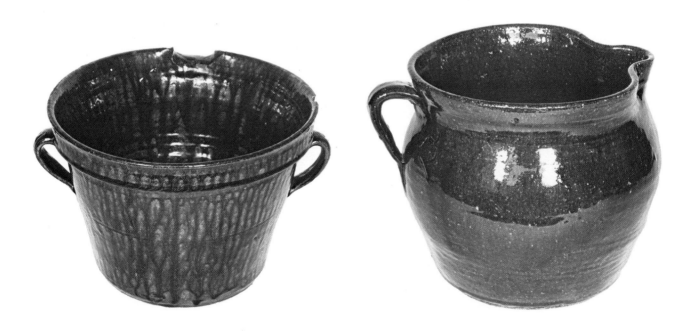

many undoubtedly descend from the earthenwares of the seventeenth- and eighteenth-century English, Scottish, and Welsh country potter. This debt, unfortunately, is obscured by the scarcity of published information on British utilitarian ("coarse") wares of that period.[27] Thus, while statements about sources must necessarily be tentative at this time, a few transatlantic parallels can be pointed out for the sake of illustration.

A form so prevalent in the South that it can be called regional is the syrup jug. As with other pottery forms, its prevalence is a reflection of regional foodways, in this case the importance of molasses in the southern diet. Larger than the whiskey jug (usually three to five gallons in capacity), the bigger examples typically have two loop handles, and those of the antebellum period are bulbous or ovoid. The identical form was produced by eigh-

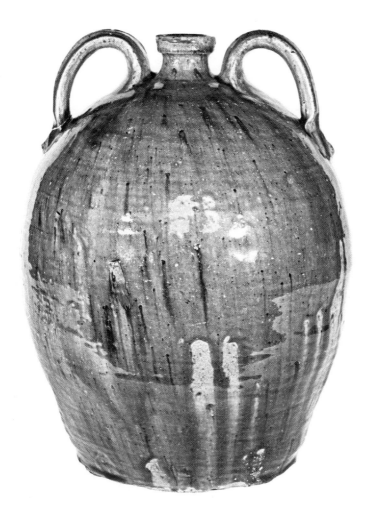

34. *Ovoid, two-handled syrup jug of five gallons capacity, probably eastern or middle Georgia; green alkaline glaze with dark streaks from iron particles which bled from clay body, 17" high. A sharply collared mouth on a southern jug usually indicates antebellum production.*

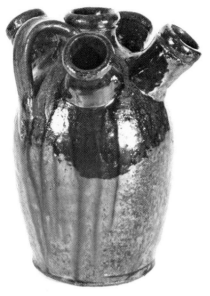

ABOVE
35. Five-necked "flower jug" attributed to Isaac H. Craven of White County, ca. 1870, "iron sand" subtype of ash glaze, 8½" high.

RIGHT
36. Footed ring bottle 9¾" high with light-green lime glaze, marked JL on base and attributed to James Long, Crawford County, second quarter of the nineteenth century. Photo by McKissick Museums, University of South Carolina, Columbia.

teenth- and nineteenth-century English country potters for fermenting wine.[28] Because many southern pioneer potters had an English background, the logical assumption is that the English wine jar was a likely model for the southern syrup jug.

More problematic are the source areas of three other specialized jug forms focused in the Southeast (the latter two known also, but to a lesser degree, in the North). The five-necked "flower jug" localized to north Georgia and western North Carolina surely must derive from the quintal, a type of delft (tin-glazed earthenware) finger-vase made to display cut flowers in Holland, France, and England.[29] The doughnut-shaped ring or harvest jug (called a bottle when made without a handle) is likewise reported both for England and the Continent.[30] And the so-called "monkey" jug, another type of water vessel with a stirrup handle across the closed top and two canted spouts or one spout with an air-hole opposite, is a form unknown until quite late in Britain but common in the Mediterranean, especially Spain and Africa.[31]

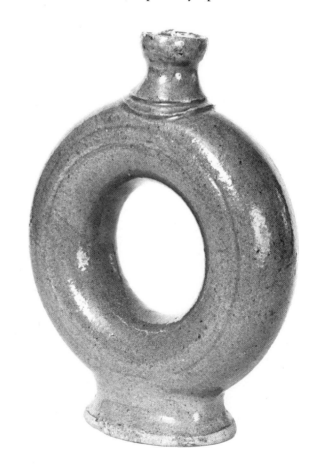

Another form concentrated in the region—from southwestern Pennsylvania to Texas—but for which I have found no clear Old World ancestry is the grave pot, made to be placed on a grave as a marker or flower urn/planter, often in lieu of a tombstone.[32] Actually, this grave pottery varies widely in shape—the marker type limited only by the potter's imagination and ability and not by a specific container function—and may therefore represent the most flexible folk-pottery form in the United States, as well as the most artistically free. In the Shenandoah Valley and northeastern Mississippi, for example, potters molded stoneware slabs

37. "Monkey" jug from Crawford County, the upper portion covered in a smooth, pea-green lime glaze. The unglazed sides promoted evaporation to keep the contents cool; the owner recalls his father using it to carry water to the fields. The stirrup handle and canted spout define the form; sometimes a second spout appeared opposite, but here a simple air-hole facilitated emptying with a streaming action.

38. *Unglazed, wheel-thrown grave marker in a Crawford County cemetery, decorated with combed incising in swag pattern and punctating, relief bands, stepped tiers, and a fluted top with small opening to accommodate a few flowers. Typical for the locale, there is no inscription.*

in the shape of headstones, impressed inscriptions with printing type which were filled with cobalt blue, occasionally incised a decorative motif such as a star, weeping willow, floral spray, or Masonic emblem, and finally salt-glazed them.[33] Elsewhere, grave pots were thrown on the potter's wheel, the planter kind often having a separately turned base. Georgia examples, found in the cemeteries of several pottery centers, are rarely inscribed or glazed but frequently decorated with incised combing, fluted rims, stepped tiers, and relief bands. The tradition of ceramic grave markers seems to have been stimulated by depressed economic conditions following the Civil War, when many families could not afford stone markers. Gerald M. Stewart of Louisville, Mississippi, is the last potter to make this distinctive item.[34]

Just after the midpoint of the nineteenth century there was a shift in the profile of American stoneware jugs and jars from curvaceous to linear, possibly in response to increasing competition from efficiently cylindrical glass and metal containers.[35] This evolution in form can be nicely documented for the larger, semi-industrialized potteries of the North,[36] but the typically smaller-scale, more conservative country potters of the South sometimes continued to make older shapes after they were abandoned elsewhere, often alongside the more recently adopted ones (color plate 8).[37] Further, the generalization about form change applies only to certain kinds of vessels; for others—churns and butter pots, for example—straight sides are early.[38]

Northeastern customers quickly came to expect cobalt decoration on the stoneware they bought, but there was no such decorative norm for southern folk pottery. As a general rule, the stoneware of the Deep South is highly functional, manifesting only a subtle aesthetic in the interplay of form and glaze. Folklorist Peter Brears's description of the typical English country potter is equally applicable to the folk potters of Georgia: "[He] was a maker of utilitarian wares, and only made ornamental pieces specifically to order. Any suggestion that the potter was an artist, a creator of beauty, would have been considered ridiculous. This does not mean that the wares he made were necessarily ill-proportioned or ugly, but it does mean that any aesthetic appeal they might have was based on their function."[39] For every such generalization, however, there are bound to be exceptions. Several decorative techniques are associated with southern stoneware, but it should be understood that they represent a minority tradition.

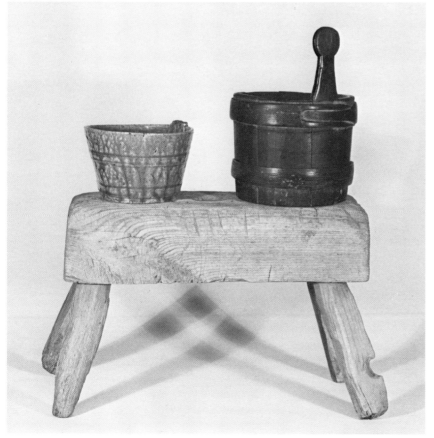

39. *Cylindrical butter pots. The ex-
ample at left, 9¾″ tall, probably
was made in White County and is
ash-glazed; the other, 8¼″ high, is
from either Jugtown or the Atlanta
area, is salt-glazed outside with an
Albany-slip interior, and retains its
original lid. Also shown are wooden
butter-paddle and mold.*

40. *Alkaline-glazed butter pot 3½″
high, made in the form of a small
piggin with two simulated hoops and
extended-stave handle (now broken),
found in the mountains of Lumpkin
County where two potters were oper-
ating in 1850. Similar vessels of
earthenware, called "luggies," were
made in Scotland. A wooden piggin
from Cherokee County, North Caro-
lina, is shown for comparison.*

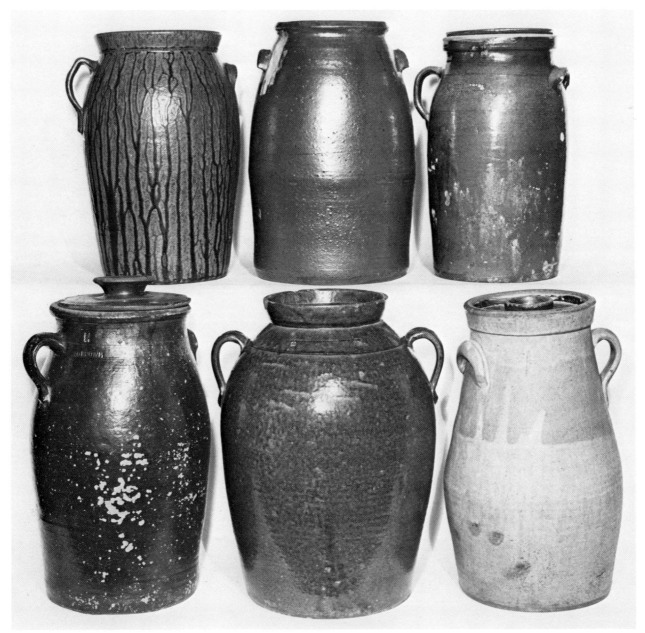

41. *Form variation in Georgia churns. From left to right, top: probably White County, ash glaze; attributed to J. Wesley Jones, Young Cane, Union County, Albany slip; Edward L. Stork (marked), Orange, Cherokee County, Michigan slip. Bottom: James Osborn Brown (marked), Jugtown, Albany slip; Benjamin Becham (marked BB), Crawford County, alkaline glaze; Jugtown, salt-glaze exterior, Albany-slip interior. All have a ledge inside mouth to seat a lid; two of the pottery lids shown (foreground) have raised splash guards.*

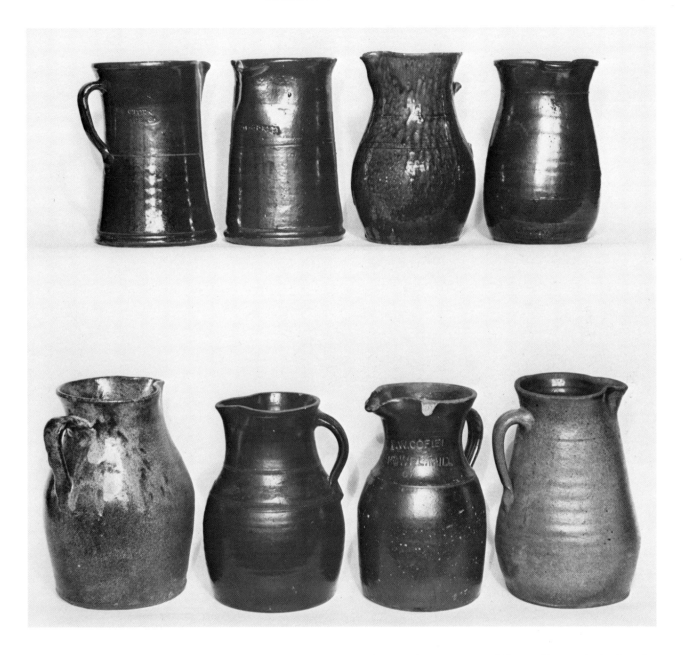

42. *Pitchers, left to right, top: Edward L. Stork (marked), Orange, Cherokee County, slip glaze; W. T. B. Gordy (marked; former partner of Stork), Fayette or Meriwether County, Albany slip; Crawford County, alkaline glaze with "paint rock" coloring; John F. Hewell (marked), Gillsville, Albany slip. Bottom: attributed to Wiley Meaders, White County, "flint" subtype of lime glaze; probably Atlanta area, Albany slip over incised combing; Thomas W. Cofield (marked), Atlanta area, Albany slip; Jugtown, salt-glaze exterior, Albany-slip interior.*

ABOVE

43. Bowls, left to right: straight-sided pancheon type, Crawford County, lime glaze over incised wavy line; curved sides, Crawford County, lime glaze with "paint rock" coloring; fluted rim with alkaline-glazed interior, found in Savannah.

RIGHT

44. Smaller preserve (canning or fruit) jars, left to right, top: probably White County, ash glaze; Atlanta area, salt-glaze exterior, Albany-slip interior (inner mouth turned to seat zinc lid); probably Crawford County, alkaline glaze (mouth turned for zinc lid); probably White County, ash glaze. Bottom: probably White County, ash-glazed interior and handle; Atlanta area, alkaline glaze over incised wavy combing; Washington County, alkaline glaze.

45. *Crocks or multipurpose jars of two to three gallons capacity, left to right, top: Crawford County, alkaline glaze (vertical "chatter" marks were caused by vibration of misaligned wheel as outside was smoothed); attributed to Wiley Meaders, White County, underfired "flint" subtype of lime glaze; Crawford County, lime glaze (with chatter marks). Bottom: Cheever Meaders (signed), White County, modified lime glaze; possibly Atlanta area, salt-glaze exterior (with fireflashings), Albany-slip interior; Washington County, alkaline (probably lime) glaze.*

A spectacular combination of art and craft blossomed in Edge-field District, South Carolina, during the 1840s and 1850s, when several potters trailed or brushed white kaolin and iron-brown slips in geometric or representational designs on their greenware before applying an alkaline glaze. Two acknowledged masters of this technique were Thomas M. Chandler, whose graceful loops complemented his classically proportioned forms and celadon-like glazes (color plate 2), and Collin Rhodes, some of whose bold, even bizarre designs actually may have been executed by female slave decorators.[40]

In North Carolina a few potters, especially those working with alkaline glazes in the Catawba Valley, placed chunks of broken glass on the handles and rims of selected pieces before firing, which then melted down the wall in light green streaks contrast-ing with the glaze (color plate 3).[41]

In Georgia a more subtle approach was taken. An iron-bearing

46 and 47. Pair of face jugs, 7½″ and 6¾″ high, respectively, by an unidentified north Georgia potter, ca. 1900. Albany slip highlights the inset eyes and incised hair.

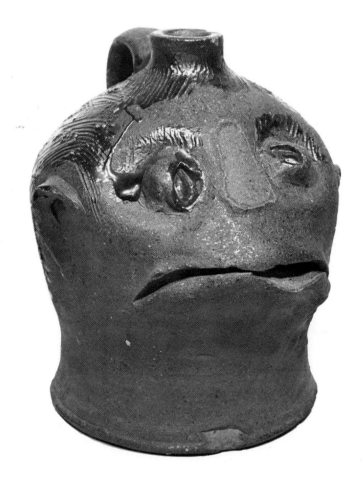

substance (pulverized limonite nodules, or "paint rock," in Craw-
ford County and "iron sand" in White County) sometimes was
added to the alkaline glaze to color it dark brown or black (plates
77, 132, 133). As with the slip decorations on Edgefield District
pottery, this seems to represent a transferral of Old World
earthenware techniques to southern stoneware, for iron oxide was
an important colorant in the lead glazes of English earthenwares
as early as the seventeenth century.[42]

A less localized decorative technique still in use involves the
manipulation of clay by modeling or application. Its best known
manifestation is the face vessel, in which a stylized or grotesque
face is applied to a functional form, most often a jug. Although
the earliest dated examples are from the North, such folk-art
"whimsies" have been made more frequently in the South by both
black and white potters,[43] and are still being made, in much
larger numbers than ever before, as novelty items. For several

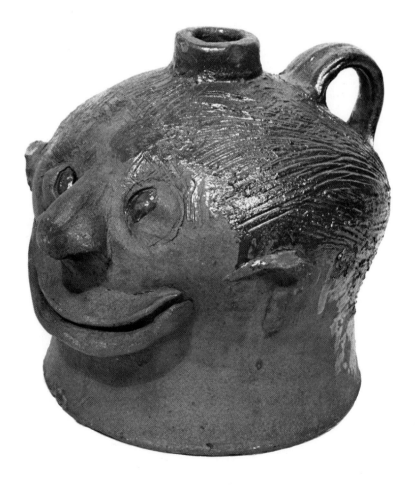

Georgia pottery families—the Browns, Bishops/Gordys, Hewells, Fergusons, and Meaderses—the tradition can be traced for two or three generations, but its origins are obscure. On occasion, horned examples representing the devil have been produced, but most face jugs have no such obvious meaning. With their bared teeth and distorted features they are the antithesis of beauty; as Lanier Meaders, who has made thousands of them, put it, "They're about the ugliest thing a person could make" (78A). Louis Brown of Arden, North Carolina, whose father, Davis, and grandfather, James, had made face jugs in the Atlanta area, commented on their essentially humorous function:

> For years and years, Grandpa made them and Daddy made them. They're just more or less an ornamental jug. . . . The public takes it as a joke. I've seen people get mad. One would accuse the other that he looks like that. But I guess that's what sells them. . . . It's a good seller but really no practical use. . . . The potter would go over there during his odd time and start making a face jug and maybe even . . . make it to look like somebody, or maybe make one to give to somebody. They might go out to a bootlegger somewhere and fill it full and give it to somebody. And then, too, lots of places they would like to attract attention and draw crowds and so they [merchants] would order a bunch of them to be made 'cause everybody'd stop in front of a place to look at them. (20)

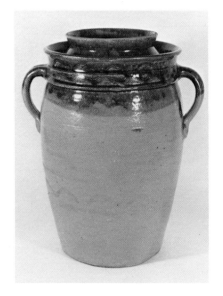

48. Five-gallon Alabama home-brew crock, late nineteenth century, 17¼" high, with seven bands of wavy and straight combing and a single incised wavy line under a two-tone (olive brown and light green) alkaline glaze. A lid fit into the water-filled well surrounding the mouth, providing an airtight seal that still allowed the bubbling gases from the fermenting beer to escape.

The most widespread decoration used in the Deep South was incising, or scratching into the damp clay, usually as horizontal tooling while the pot revolved on the wheel. This could be done in a single accenting line around the shoulder with a sharp implement to "break up" the surface, as Gillsville potter Curtis Hewell expressed it (52), or in a series of parallel lines with a comb or fork; an undulating or jerky movement of the potter's hand created a wavy or sawtooth pattern. A related, if less common, technique was rouletting, in which a patterned band was impressed by rotating the carved rim of a coggle-wheel or a machined gear around the damp wall.

Even such subdued decorative effects as incised combing are seen on only a small percentage of wares made in the Deep South. This rule of utilitarianism is even more applicable to Georgia than to the Carolinas, which were settled earlier and thus were closer to Old World decorative impulses. Other factors which

may have contributed to the state's de-emphasis of ornament in its material folk culture are the persistence of a frontier mentality alluded to by Zelinsky and Bible Belt fundamentalism which, to a degree, dictated community taste. Whatever the explanation, the conditions that encouraged the routine decoration of northern stoneware seldom obtained in the Deep South.

Still, there is much to appreciate in the Georgia pottery tradition. Unfortunately, the emphasis that museums and publications have placed on the "fancier" European, British, and Oriental ceramics (especially porcelain), and the Decorative Arts bias in the study of American folk arts, have conditioned us to equate quality with ornament for its own sake and to regard the exceptional as typical. There is beauty in Georgia folk pottery, but it is an unselfconscious beauty that arises from the harmony of form and glaze and the happy accidents of texture and color achieved by accepting the flow of natural forces. This organic vitality, above all, distinguishes the stoneware of the Deep South. The alkaline and salt glazes, with their unpredictable irregularities, seem to embody the rustic spirit of the frontier, and speak eloquently of the molasses, moonshine, buttermilk, and preserved foods that were staples of southern living.

CHAPTER SIX

"Turning" and "Burning": Making Pots the Folk Way

This chapter derives its deceptively Dantean heading from the two pivotal steps of the production process. For academically trained studio potters and others unfamiliar with the terms, Georgia-born Javan Brown, who vigorously followed the craft in North Carolina until his death at the age of eighty-three, offered this charmingly biased lesson on traditional nomenclature: "These hobbyists who call themselves potters talk about 'throwing' pots. But *real* potters—the old-time potters—'turned ware.' And they 'burned' their ware in the kiln [pronounced *kill*]; didn't know nothing about 'firing'" (18B).

Of the many procedures involved in making folk pottery, the one that most clearly defined the potter as a craftsman was turning. To be sure, the burning was equally critical, for in the kiln two to three weeks' work could be lost; but here there were forces over which the potter had no control ("that ha'nt working in the kiln," to use Lanier Meaders's metaphor). Turning, on the other hand, was more strictly a matter of skill; an ill-thrown pot could be torn down and reshaped, otherwise the maker had to take full responsibility for imperfections. Thus, at the old-time southern shops the word *turner* was virtually synonymous with *potter*.

Along with the pottery designs, the production technology was transmitted from one generation of folk potters to the next. Essentially preindustrial, this technology emphasized handskills over mechanization, and was composed of traits accumulated slowly over at least three centuries. When I asked Lanier Meaders where he believed the origins of his tradition lay, he replied, "It's always been that way, for it can't be any other way." In working with clay certain basic techniques are bound to be universal; yet many other features of the Georgia folk-pottery technology are cultur-

ally specific and are clues by which the lineage of the tradition might be traced. The following description of old-time pottery-making in Georgia—drawn from observation at the Meaders Pottery and D. X. Gordy's Westville shop, interviews with retired folk potters, and artifactual evidence—could contribute to such comparison. While cast in the past tense for the sake of consistency, it documents an intriguing "primitive" technology that still, to some degree, serves a handful of potters in the region.

The first task of the potter was to locate his primary raw material. Not just any clay would do, for the medium in which most Georgia folk potters worked was stoneware, requiring a relatively pure clay that partially vitrifies when fired. Rumors of kaolin, an especially fine clay used in porcelain, may have attracted Philadelphia potter Andrew Duché to the Savannah River area in the 1730s, and in 1767 Staffordshire manufacturer Josiah Wedgwood sent an agent to the mountains of North Carolina for this same white "unaker" or "Cherokee earth."[1] The presence of high-firing clays in the region was well established by the time Georgia's earliest stoneware potters arrived.

Much of the stoneware clay occurs as low-lying alluvial deposits. The first place he'd "hunt" for clay, says Lanier Meaders, "would be on the bottomlands or on the creeks. Where there's water. Find a wet place out in the bottoms somewhere, where the clay won't let the water dry out. And usually that's where you find it. . . . The clay is usually about two feet under the top of the ground, and anywhere from three to five feet thick" (78A). Some potters believed that sycamore trees mark the site of a good clay vein according to Louis Brown, Javan's nephew: "I heard some of the old-timers say that, back when I was a boy. And it kindly beared in the back of my mind that there's sycamore trees around the clay pit. And most of the times when you find clay, you'll also find a sycamore tree" (20).

After the soil overburden was stripped off, a pit was dug and the clay that was thrown up was left to weather for a month or more to increase its plasticity, or hauled to the pottery yard to weather there (the pits could be deep and potentially hazardous; they would fill with water, and both animals and people are known to have blundered in, some of them to drown). The quality of clay could vary significantly within a small area, and it was a fortunate potter who could find a single source that would suit his needs; many had to combine several clays to achieve optimum turning and burning properties. The potters of Crawford County, for example, mixed their dark "swamp mud" with an impure

49. *Potter Maryland Hewell at his clay diggings on Grove Creek two miles southeast of Gillsville, 1935. Courtesy of Georgia Geologic Survey.*

kaolin known as "chalk" in about equal proportions to create a better product. The fine points of clay selection were discussed by Lanier Meaders, who favors "a good, tough blue clay. And the way I determine that, I take a piece of clay and work it up in my hands to about the same softness that I want to turn it on the wheel. And roll it about four inches long and about ¾ of an inch in diameter. And if I can bend the ends of that together without

it breaking in the middle, then I know I've got a good-turning clay. . . . A blue clay that has a good mica base to it is better for making churns. 'Course, sometimes it takes a fine yellow clay with it to make it soften up to where it'll turn better" (78A).

Mixing was done in the "mud mill," which occupied a prominent place in the pottery yard. This mill consisted of an open-top wooden tub in which staggered blades projected from a vertical axle. As a mule or horse, often prompted by one of the potter's children, pulled a sweep joined to the axle, the turning "pins" churned raw clay and water in the tub until the heavier impurities dropped to the bottom and the clay was properly blended, a process that took several hours.[2] Sometimes wires were fastened between the blades to catch stray roots. A Crawford County variation replaced the weary tread of an animal with power harnessed by a waterwheel set in a creek.

The clay, now semi-refined, was blocked up and kept moist in the shop under wet sacking until ready to use. The "jug shop" was usually a rectangular, dirt-floored building often constructed of logs chinked with mud or sealed with boards nailed on the outside. The dimensions of the present Meaders shop—twenty by thirty feet—appear to be typical. The major activity per-

50. *Crawford County clay mill, 1890s. The cross-beam provided support and a pivot for the upper end of the axle, while blades at its lower end churned the clay and water in the tub. Traces attached to the collar of a mule were connected to the singletree dangling from the free end of the pole that turned the axle. From George E. Ladd,* A Preliminary Report on a Part of the Clays of Georgia, *Geological Survey of Georgia Bulletin no. 6A (Atlanta: State Printer, 1898), plate 10 opposite p. 104.*

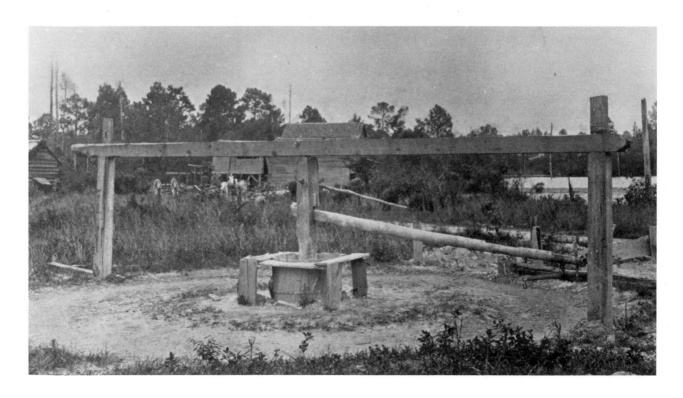

formed in the shop was turning, with the potter's wheel placed in a corner below a window or two for illumination.

Chunks cut from a block of clay were weighed on a set of homemade scales similar to a cotton steelyard to obtain a uniform amount of clay in each piece of ware of a given size. The scale still in use at the Meaders Pottery consists of a tapered, horizontal wooden beam (whittled from a piece of rail fence) hung from a joist. The upper edge of the narrow half of the beam is scored with eight notches ranging from half a gallon closest to the center to seven gallons near the end (the largest piece likely to be made). Suspended from wires at the wide end of the beam is the weighing pan, a square slab of wood on which the clay rests. A loop of wire from which hang plow-points and other metal scraps serves as the adjustable counterweight; it is shifted to the notch representing the number of gallons which the piece to be turned will hold. For example, if Lanier wants to make a gallon pitcher or jar he sets the counterweight on the one-gallon notch, places a lump of clay on the pan, and adds or removes bits of clay until the scales balance; wooden stops nailed to the wall above and below the thin end of the beam keep the affair from collapsing. The resulting lump will weigh about 7½ pounds, to which an additional pound required to close in the shoulder would be added for a jug.

Before shaping, the clay underwent further processing at the wedging table, where it was kneaded to homogenize it and expel air bubbles. After hurling the clay with both hands across a taut wire strung above this "ball board," the potter picked out of the cut faces pebbles and other "trash" not eliminated in the clay mill; some potters screened their clay to minimize this chore. Trapped air and foreign particles caused blisters, blow-out holes, and even explosions in the firing if not removed. In an efficient shop an assistant, or "ball boy," kept up with the turner by preparing standardized "balls" of clay as the potter called for them.

The type of wheel or "lay" (lathe) favored by southern potters is the treadle wheel, on which a low horizontal bar linked to the vertical crankshaft was pedaled with a back-and-forth motion of one leg as the potter stood or leaned against a padded support.[3] At the bottom of the shaft was the heavy flywheel which provided the momentum, while at the top was a smaller wheel, or "headblock," on which the clay was shaped. The latter was sometimes a cross-section sawed from a tree-trunk; preserved at the Meaders Pottery is an old hand-forged crankshaft with an X-shaped platform at the upper end to which such a wooden wheel-

head was screwed, and an iron ball below drilled to receive the flywheel's spokes. The headblock was surrounded by a wooden "crib," the rear wall of which supported two gauges.

The "ball opener," as Lanier calls it—a hinged wooden lever normally reserved for larger pieces—appears to be a regional device but is related to the "jolly" or "jigger" arm used in factories in the North.[4] As the free end or handle was lowered toward the headblock, a thick dowel protruding from the midpoint of the lever's underside entered the clay ball and stopped just short of its bottom as the handle came in contact with the crib's front wall. Swung to the side, the lever widened the cavity in the clay while a bottom of just the right thickness to avoid cracking was

51. Lanier Meaders weighing clay on the homemade scales, 1978.

52. Lanier using the ball-opener lever, 1978. Having made the initial plunge, he pushes it sideways to expand the cavity in the clay.

consistently gauged. The height gauge, widely associated with European potter's wheels,[5] maintained uniformity of size. This consisted simply of an adjustable pointer clamped between two vertical sticks. A potter about to turn, say, a quantity of gallon jugs set the tip of the pointer twelve inches above the headblock face—the standard height for a jug of one-gallon capacity (which would shrink after drying and firing to about 10½ inches)—and used this as a guide for determining the correct height of each jug so that one would be no taller than another.

Under the potter's experienced hands lumps of clay magically

grew into finished vessels. A bibbed apron or "work shirt," usually made from a flour sack, protected against splattering. From time to time the potter would dip his fingers in a container of water to lubricate the turning clay, and excess water was sponged off. Larger items such as churns often were "pieced," or turned in two sections, which were then "welded" together. Presumably this custom arose because some potters lacked the strength or arm-length required to turn tall vessels in one piece; Cheever Meaders is said to have done this because a crippled left arm prevented him from reaching far down inside, but his son Lanier continues the practice more out of habit than necessity.

53. Cheever Meaders "pulling up" a churn, late 1940s. He has "pieced" the churn, or turned it in two separate sections that later would be bonded together; the upper fourth, turned first, is set aside on a moistened board. While standing, he leaned against a padded rest with his left leg operating the treadle, a smoothing chip in his right hand. Note the unhewn, mud-chinked logs of the second shop, unglazed window, and height-gauge stick. Photo by Guy Hayes, courtesy of the Atlanta Journal.

Finger ridges would remain on the inside of the pot, but usu-
ally were smoothed from the outside wall with a "chip," a thin
rectangle of seasoned hardwood with a finger-hole in the center.
Lanier, however, learned that a steel smoother works better with
a metal headblock:

> When they used wooden blocks on that wheel, we used
> to go out in the woods and cut down a dogwood, or
> maple, gum or other fine-grained timber, and split out
> little pieces of it in strips of two-by-three-inch size and
> about a quarter-inch thick, take a knife and whittle it
> down all over and scrape it with glass to get it smooth and
> grind the edges thin on a grindstone. You didn't use a
> metal chip, because it would scrape the wooden headblock
> and get it out of shape. And if you've got a hollow place in
> the headblock you can't keep the bottom of your ware the
> same thickness all over, and nine times out of ten it'll
> crack open. But on a steel block the wooden chip will wear
> out too quick. (78A)

Such scraping would occur when the chip was used to bevel the
bottom of the pot, a finishing touch—called "rubbin' the bot-
tom" by the Hewells of Gillsville—which eliminated a sharp
edge that could cut the customer (plate 57); the Hewells actually
sold pieces with "unrubbed" bases as "seconds." Some chips were
shaped on one side as templates for forming necks or rims when
held against the revolving clay.

Typically, the potter would spend his day turning like pieces
of a given size, such as one-gallon jugs. Javan Brown boasted
that his brother Willy could make four hundred of these in a
single day, "and put handles on every one of 'em before he went
home." At times this repetitive routine must have become mo-
notonous; it is not hard to understand why "whimsies" such as
face jugs occasionally were produced to relieve boredom. Yet some
potters took pride in an almost mechanical regularity, as did Javan
in speaking of his father, Atlanta-based James Osborn Brown:
"I'm gonna throw a plug in for my daddy, he was the best potter
I ever seen in my life (and I've seen 'em all). He could make a
piece a whole lot nicer than you could make in a mold, and make
'em every one just exactly alike, all day long. Couldn't tell one
from the other. I've been 'accused' of that myself but I can't do
it anymore, I'm too durned old" (18B).

Finished pieces were cut from the headblock with a length of

54. *Lanier removing a freshly turned churn from the wheel with a set of iron lifters, 1978.*

wire—sometimes a banjo string or strand from a screen—held taut by a stick grip at each end. To avoid collapsing a pot's damp walls with the hands, it was removed from the wheel with hand-made iron or wooden "lifters" which clamped under the base. The iron version of this specialized tool, forged by the local blacksmith in a graduated set to accommodate wares of all sizes, consisted of two flat crescents hinged together at one end, each with a handle on top. Grasping these handles, the potter opened the blades wide, then closed them so their sharpened inner edges passed beneath the pot (guided by the beveling) until they could support it.

From the lifters, turned pieces were transferred to a plank waiting near the wheel, which when filled would be carried by two workers to the drying area. For potters like Lanier who worked alone, however, it was necessary to set each item as it was finished on an individual wooden platform or "bat." After a row of pots had stiffened a bit it was convenient for the potter to "handle" them assembly-line fashion all at once. The vertical pulled loop of jugs and pitchers works well for pouring, while the horizontal slab or "ear" provides a grip for lifting. Later churns often have one of each, and a jar could have either type: White County jars typically have two slab handles, while loop handles are characteristic for Crawford County.

It was at this stage, too, that any marking was done. The most frequently seen mark is the gallon number, scratched or stamped on pieces holding two or more gallons; while the weighing and gauging contributed to a certain uniformity, the handcrafting process precluded absolute precision ("I ain't made but one eight-gallon churn that I can remember," joked Lanier; "I marked it ten and it probably held twelve gallons"). If a maker's mark was used, it was impressed on the wall or handle with a stamp of wood, baked clay, or lead, and could range from the potter's initials to his full name and post office, depending on local custom (plates 96, 97, 101). The mark had to be carved backwards on the stamp face, and it is not uncommon to find accidentally reversed letters, especially N and S. Normally this carving was done in relief, like printing type, but in Crawford County the initials or number were gouged into the stamp face (intaglio) so that they were raised in the clay of the loop handle (plate 79).

The pottery had to dry for about a week in the shop before it could be fired (this still left chemically combined water in the clay, eliminated during the kiln "tempering"). The process could be hastened by sun-drying, at the risk of the "raw" (green or unfired) ware reverting to mud in an unexpected downpour. Some shops had a wood-burning heater near the drying shelves to prevent moisture in the clay from freezing during the winter.

Except for flowerpots, the raw ware was treated with a liquid glaze, which dried rapidly. Pieces to be salt-glazed in the kiln were first coated inside with Albany slip. Shipped in large barrels in lump form, the natural clay glaze was pulverized and dissolved in water to the consistency of cream, then poured into the greenware, swirled around, and the excess drained. Wares to be glazed entirely with Albany slip were simply immersed in a tub of the solution, and the glaze was usually wiped with the hand or a

damp rag from the bottoms (and mouths of churns or shoulder ledges of "stacker" jugs) to prevent adhesion when fired.

The preparation of alkaline glaze was a more elaborate procedure. Each family using this regional glaze type had its own recipe, the result of traditional knowledge modified by trial-and-error experimentation. As an example, Cheever Meaders's formula for his favorite "Shanghai" (ash) glaze consisted of two measures (the measure being a four- or five-gallon churn) of strained "settlings," a reddish silt dug from a meadow (formerly a mill-pond) a quarter of a mile from the shop; three measures of sifted pine ashes from the kiln firebox (or somewhat less of the preferred hardwood ashes already leached with water in lye hoppers by soap-making neighbors and saved for Cheever); one gallon of powdered glass from soft-drink bottles and broken windowpanes pounded with an iron bar in an old automobile oil pan imbedded in the ground, a substitute for the sand that had been used until glass became more readily available about 1910; and enough water to make thirty to forty gallons of solution. The ingredients were mixed in a tub and run through the "glazin' rocks" two to four times to obtain a smooth consistency, producing enough glaze for a kiln of ware.

Hand-operated glaze mills, identical to the potter's querns used elsewhere for refining lead glaze,[6] graced a number of north Georgia shops. A disc-shaped "runner" revolved in the concavity of the larger base stone. With the Meaders example—which is supported by four upright logs—the glaze mixture was poured into a hole in the center of the flint runner, guided by a bottomless flowerpot. The mill was rotated by turning the handle, a long pole mortised at its bottom end into the runner and boxed in at its top. The glaze, blended between the two smooth faces, flowed through a channel cut into the granite base and out an affixed spout into a waiting churn. The fineness of the grind could be adjusted for each run by shoving wedges under the board which supported an iron pivot-rod running up through the base to a dimple in the center of a hand-forged fitting called the "spider," which locked into a corresponding cross chiseled in the underside of the runner. The runner, balanced on the tip of the rod, thus was raised or lowered. Turning this mill was "man-killing" work, Lanier complained, and he was not unhappy to retire it when the base wore through.

Care had to be taken in handling the alkaline glazes, for the fluxing agent—calcium hydroxide in the lime glaze and, in addition, lye (sodium or potassium hydroxide) in the ash glaze—is

_55. Cheever turning the stone "run-
ner" of his glaze mill to prepare his
favorite "Shanghai" (ash) glaze,
early 1960s. The iron rod used to
adjust the height of the runner (and
thus control the fineness of the grind)
can be seen resting on a horizontal
plank between the mill's legs. Photo
by Edward L. DuPuy._

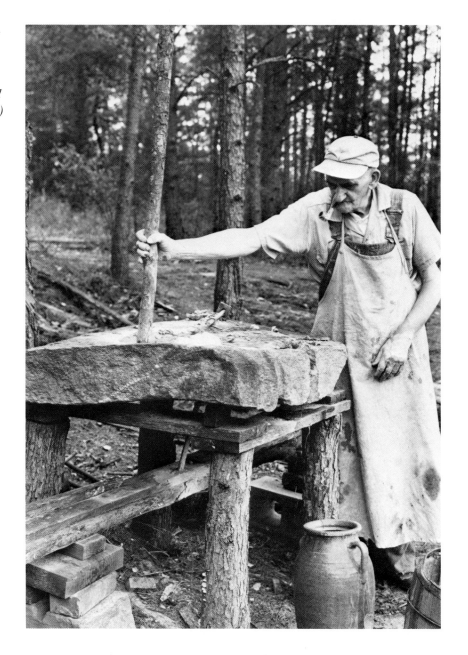

a caustic base. Jewel Merritt of Crawford County, whose uncle
Billy had used both types, recalled, "Either one was rough on
your skin. I seen my uncle glaze with it, it would eat holes in
his hands" (79). The greenware was rolled in these glazes and the
bottoms wiped as with Albany slip so sand from the kiln floor
would not stick.

Along with the alkaline glazes, the rectangular kilns used by southern folk potters are the most significant regional feature of the production technology. These oblong structures are in marked contrast to the round kilns of the North and may derive, via colonial Virginia, from similar German or English kilns.[7] Often called "groundhog" kilns because of their resemblance to an animal burrow (especially the semi-subterranean type), a chimney at one end drew the heat from the firebox at the other end across the ware in between. In Georgia the walls and arched top were brick, with the chimney either of brick or stone. Inside, a low "flash" wall behind the firebox shielded the pottery from direct contact with the burning wood, and at the other end of the ware chamber a wall pierced with arched flues communicated with the chimney. In the firebox end there were one or two "eyes" or stoke-holes through which the fire was fed, draft holes near ground level for air intake, and the loading doorway or kiln mouth (which in White County sometimes was placed in the chimney end to avoid unloading across the firebox). An open-sided shelter protected all but the chimney, its roof often extending beyond the firebox end to form a covered woodshed and work area.

Kiln size varied considerably, but a typical example might hold four to five hundred gallons and measure eighteen feet long by eight feet wide. Those built to fire alkaline-glazed stoneware tended to be so low the potter had to crawl on hands and knees to load and unload, while those intended for salt-glazing generally were taller and more square. Middle Georgia kilns often were surrounded with earth to improve insulation and inhibit expansion. This could be accomplished by building the kiln into a hillside with only the face and chimney-top exposed, as at Jugtown (plate 99), by building it in a trench so the lower wall was below ground level (sometimes done in Crawford County), or by packing mud against the sides and top (e.g., the Rogers kiln at Meansville). Unenclosed kilns—called "tunnel" kilns in White County—were the rule for north Georgia (plate 142); upright posts held tight against the sides by horizontal iron rods with turnbuckles minimized the expansion and contraction that would have shortened their lives.

Loading or "setting" the kiln was itself something of an art. Alkaline-glazed stoneware rarely was stacked, for a runny glaze would cause pieces touching each other to stick together. Thus, "single-shot" or one-layer kilns were designed with the ceiling not much higher than the largest items to be fired. On the sandy floor of the ware chamber, smaller pieces were placed at the ends

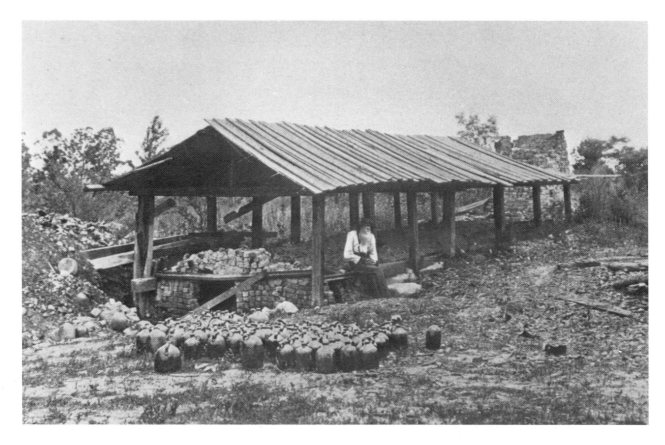

56. "Groundhog" kiln, Crawford County, 1890s. It appears to have been built in a trench with the side-walls below ground level, the arch covered with earth; note waster dump at left. From Ladd, Preliminary Report, plate 9 opposite p. 96.

and along the sides with taller pots in the center, conforming to the curvature of the arch. This arrangement was elaborated by Lanier:

> Next to the fire would be the little stuff, such as one-gallon pitchers, so the glaze wouldn't singe off [they would be below the top of the protective flash wall]. And by the side walls would be the smaller churns, such as a three-gallon churn. And next to that [the second inside row] would be the four. And then through the middle would be the five- and six-gallon churns. That way, the heat would be more even and could get all the way through the kiln. And in the upper end next to the chimney, we put smaller stuff so it won't block the draft. (78A)

Potters could turn the uneven heat distribution of the rectangular plan to their advantage by placing flowerpots and other ware not requiring full stoneware heat at the "cool" chimney end.

Stacking was the usual procedure for firing ware glazed with salt or Albany slip. Churns could be stacked two high while smaller items, such as pitchers and bowls, could be placed on the up-ended base of a churn. Jugs, however, because of their narrow neck, required unglazed production pieces (kiln furniture) to assist in stacking.[8] The cylindrical "stacker" jug (my term) was designed with a ledge at the shoulder to receive a clay collar (ring sagger) or inverted walled dish on which the next jug could rest. Biscuit-shaped wads of clay called "chucks" were inserted under columns of jugs to level them on the uneven kiln floor, while lengths of clay (pugging coils) served as spacers to separate adjacent columns. A few potters, such as Cheever Meaders, made wheel-thrown "setters" or stilts to keep the ware off the kiln floor.

As with most folk pottery there was only one firing, the sepa-

57. *Impression on the base of a gallon jug attributed to the Holcomb Pottery of Gillsville shows that it was fired atop the mouth of a pitcher; the adhesion scar occurred because the Albany slip was imperfectly wiped from the jug-bottom. Note the beveled edge.*

rate bisque and glaze firings for controlling the appearance of more delicate ceramics being unnecessary. The burning took from twelve to twenty hours, depending on the size and efficiency of the kiln and the density of the clay. First a small fire of slow-burning hardwood or green pine was kindled in the firebox and the temperature raised gradually. This gentle "tempering" or "water-smoking" insured that the ware would not "blow" or shatter from too rapid an expansion of the remaining moisture in the clay, and also drove off any dampness in the kiln. When the danger point had passed, fuel—now seasoned pine—was added

58. Jug-stacking furniture. Dishes and separators for firing ledge-shouldered "stacker" jugs in columns, from the waster dump of Jasper Bishop's Jugtown pottery; the salt-glazed jug fragment adhering to the perforated stacking dish is from an unidentified Jugtown site.

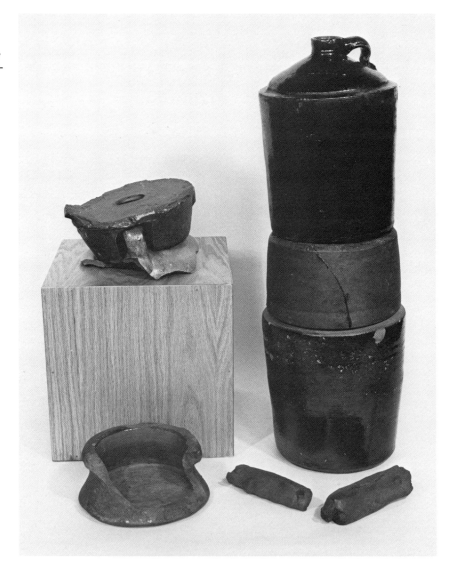

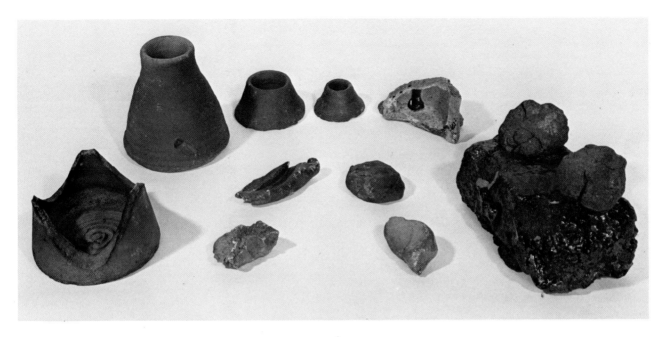

more often, until the pots inside glowed red. During the intense "blasting off" of the final hours, sometimes with especially hot-burning rich or "fat" pine (which Cheever Meaders hauled from the top of nearby Leadpole Mountain to melt his Shanghai glaze properly), the perspiration-soaked potter relentlessly stoked the firebox as a spectacular column of flames and smoke crowned the chimney and the pots inside matured at white heat (color plate 10). Cheever's ex-potter neighbor Guy Dorsey recalled fondly, "Whenever you was gonna go to 'blasting off' the kiln, you could stand about three feet outside that firebox door where you was pitching the wood in and that blaze'd meet you, catching hold of it; that's the kind of wood I loved to burn" (36A).

A number of methods were used to gauge the progress of the firing. One was to insert long splinters through a peephole (created by removing a loose brick) in the chimney end and observe their reflection as they flared up until the sides of the ware shone glossily, indicating that the glaze was melted. Some potters periodically withdrew trial pieces with an iron hook. The fire that shot out the chimney after sweeping through the kiln was also a signal, as Lanier explained: "The flames begin to feather, to springle out like a branch on a tree, more or less free-floating. There's nothing holding it back anywhere, and it begins to turn rather white in place of red. When it does that, it's time for you to think about quitting" (78A).

59. Kiln furniture used to raise ware off floor. Outer semicircle, left to right: wheel-thrown tripod stilt found in woods near Shepherd potteries, Paulding County; wheel-thrown "setters" made by Cheever Meaders mainly for his wife's decorative wares; fragment of similar item from site of Washington Becham, Crawford County, with dripping of "paint rock"-colored lime glaze; wads of sandy clay stuck to brick from floor of Sligh Pottery kiln, Paulding County. Inner semicircle: four pads—two with salt glaze—used to stabilize stacked jugs on uneven kiln floor of Rolader Pottery, Atlanta.

60. Firing testers. Rear: fragments of perforated tiles evidently hooked from the kiln and broken to determine from the color of the paste the progress of the firing, excavated from Rolader kiln area, Atlanta. Front: glaze testers from the Meaders Pottery, the earlier example at right made from a sherd of damaged greenware drilled to receive cones of thickened glaze compound containing cobalt oxide, excavated from waster dump and possibly dating from the time of Mrs. Cheever Meaders's colored glazes; the two clay wads with "slicked over" cones were used by Lanier in the 1970s to indicate melting-point of glaze.

Once the potter was satisfied that the burning could stop, the stoke-holes were closed and a two-day cooling period went into effect. As an extra precaution the chimney-top was sometimes covered with sheet metal to prevent drafts or rain from "cool-cracking" the ware. As the anxious waiting ended, the kiln mouth, which had been sealed up prior to firing, was unbricked, and planks placed across the firebox so the "drawer" (often a youngster) wouldn't have to wade through hot ashes (plate 82).

As the ware was handed out, pieces deemed unfit for sale were thrown off to the side where they would accumulate over the years into a waster dump or "jar pile." The potter's loss is the researcher's gain, for excavation by trained archaeologists can reveal much about the history of the site from sherds showing forms, glazes, markings, and stylistic details. It was not unusual for a substantial portion of the load to be ruined through such accidents as cracking and shearing, warping and slagging due to overfiring (plate 115), glaze adhesion, collapsing of improperly stacked ware, damage from fallen ceiling fragments, and incomplete or "thrown" glazing; underfired ware sometimes could be salvaged in the next burning. In addition to routine visual inspection, the scrupulous potter might have immersed his ware up to the neck in a tub of water to test for inward leaks, thumped the wall and listened for the telltale dull thud or buzz—as opposed to the usual ring—indicating a crack, or blown into jug mouths for the hoped-for air resistance. He might also have had a standard measure with water available in case a customer doubted the accuracy of the gallon marking. Imperfect but still usable pieces were culled as "seconds," to be sold at a discount. In Crawford County, according to one source, "If a piece had only a small crack or hole, it was sometimes mended with a mixture of lime

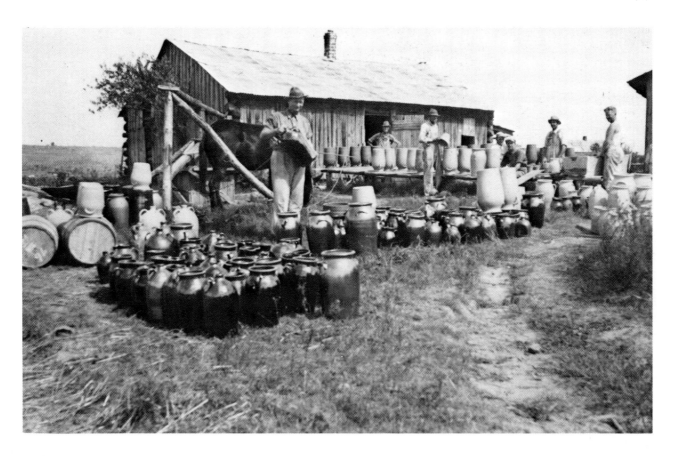

and eggwhite. The repaired area was then smeared with dirt to produce a uniform color."⁹

The kiln smoke had advertised to the community that a load of pottery soon would be available, and those in need would come to select from among the wares scattered unceremoniously in the yard; meanwhile, another production cycle may have begun. The visitor would have heard, from within the shop, the slapping of the clay and humming of the wire at the wedging board which served as a rhythmic counterpoint to the squeaking wheel, parts in the symphony of Georgia life for nearly two and a half centuries.

61. Holcomb Pottery, Gillsville, 1935. The shop is well into another production cycle before the wares from the previous burning are sold. The mule is hitched to the clay mill, a turner stands in the doorway of the weatherboarded log shop with his bibbed apron, while workmen at right appear to be immersing dried greenware in the glaze tub. Fired wares (apparently glazed with Albany slip, a few perhaps with the later "glass" type of ash glaze) include syrup jugs, smaller whiskey jugs, churns, pitchers, and poultry fountains. Courtesy of Georgia Geologic Survey.

Potsherds of the Past

SELECTIVE STATEWIDE SURVEY

Turn, turn, my wheel! All things must change
To something new, to something strange;
. .
Stop, stop, my wheel! Too soon, too soon
The noon will be the afternoon,
 Too soon to-day be yesterday;
Behind us in our path we cast
The broken potsherds of the past,
And all are ground to dust at last,
 And trodden into clay!

Henry Wadsworth Longfellow,
"Kéramos," 1877

CHAPTER SEVEN

Early History: Georgia's First Potters

The story of Georgia folk pottery does not begin abruptly with the white settlers, of course; there was a long tradition of pottery-making among the aboriginal population. The earliest ceramics found in North America, in fact, are from the Savannah River area and date to 2500 B.C.[1]

The southeastern Indians who inhabited the state prehistorically, as well as the historic Creeks, Cherokees, and smaller tribes, made their pottery without benefit of the potter's wheel, kiln, or true glazes. A further departure from the later European ceramics tradition is that the Indian potters appear mainly to have been women. They hand-built their wares—mostly bowls, dishes, and jars for cooking, serving, and storing food—with the coil and paddle-and-anvil methods; decorative techniques, when used, included cord and fabric marking, incising, punctating, or stamping with a carved wooden paddle (sometimes in complicated scrolls or curved parallel lines, as with Cherokee pottery) prior to baking in an open fire.[2]

Unlike the Cherokees and Catawbas of the Carolinas, who were allowed to remain (albeit on small reservations), the Indians of Georgia did not maintain a continuous tradition of pottery-making through the nineteenth and into the twentieth centuries, for by 1838 they had all but vanished from the state, a result of treaty cessions and, finally, wholesale removal to the West on the infamous Trail of Tears.

Georgia's preeminent colonial potter was Philadelphia-born Andrew Duché, the third son of Anthony Duché, an English-born potter of Huguenot stock who had settled in that city by 1705 and in 1730 unsuccessfully petitioned the Pennsylvania House of Representatives for support in "the Art of making Stoneware," to which he had been applying himself "for severall Years past."[3] Salt-glazed stoneware marked with the initials AD and

attributed to Anthony, patterned on both German and English types, has recently been excavated in downtown Philadelphia;[4] while his fourth son, James, was instrumental in producing the first New England stoneware.[5]

Andrew worked with his father and brothers in their Philadelphia "Pot-House" on Chestnut Street until the early 1730s, when he left with his wife Mary for Charleston, South Carolina. The following advertisement appeared there in the *South-Carolina Gazette* of April 5, 1735:

> This is to give notice to all Gentlemen, Planters, and others, that they may be supplied with Butter pots, milk-pans and all other sorts of Earthen ware of this Country make, by whole sale or retail, at much cheaper rate than can be imported into this Province from England or any other Place, by ANDREW DUCHE Potter, next door but one to Mr. *Yeomans*, or at his Pot-house on the Bay.[6]

Shortly thereafter, Duché appears to have moved to the up-country trading settlement of New Windsor, on the Savannah River near present-day North Augusta, South Carolina,[7] where he remained for a year or two, possibly experimenting with the local kaolin (rumors of which may have been circulating then) with the hope of producing the first American porcelain. Several curious wheel-thrown bottles of unglazed white clay with Indian-style punctated decoration have come to light which are claimed to have been found in the swamps of McBean's Creek in Richmond County, Georgia (across the river from the New Windsor site), and there is speculation that they may have been made by Duché for the Indian trade (98). While at New Windsor, the potter was befriended by Roger Lacy, Georgia's agent to the Cherokee Indians, who persuaded him that he might carry on his trade more profitably in the promising new town of Savannah, which had been founded in 1733.

Duché had little difficulty in obtaining initial financial support from the English Trustees of Georgia through their administrator, Gen. James Edward Oglethorpe, for they were anxious to see a potter working in the colony who might produce wares not just for local use but worthy of export; one of the Trustees, the Earl of Egmont, was to take a special interest in Duché's porcelain experiments. With the grant they awarded him, a shop and kiln were built on his Savannah lot. These were described by Col. William Stephens, resident secretary to the Trustees, in a letter dated May 27, 1738.

[T]he Encouragement given to a Potter for carrying on
that manufacture, I humbly conceive was not ill bestowd;
for its very apparent the Bounty was rightly applied: the
building a convenient dwelling house, with a large Kiln in
a room annexed, together with 2 other large rooms, one
for a workhouse, & the other for a Store room; all in one
compact Building, well contrived, handsomly finishd, &
very well accommodated for carrying on the work, suffi-
ciently shew it: the Master of it is a sober, diligent, &
Modest man: he has baked off 2 Kilns of handsome Ware,
of various kinds of Pots, Pans, Bowls, Cups, & Jugs, fit for
many uses: and tho 'twas a large quantity; they are found
so convenient, yt he does not want Customers to take them
off his hands, at a reasonable price: This however he seems
to set no value on, in comparison of what may be expected:
his next aim is to do something very curious, wch. may
turn to good account for transporting; & he is making
some tryal of other kinds of fine clay; a small Teacup of
which he shewd me, when held against the Light, was very
near transparent: indeed from what I have seen in the prog-
ress of that work, I must conclude it cannot fail of proving
a Manufacture that will find good Value abroad; or I am
very much deceiv'd.[8]

Several months later Duché boasted that he was "the first Man
in Europe, Africa or America, that ever found the true material
and manner of making porcelain or China ware,"[9] a not entirely
accurate claim since hard-paste porcelain was being manufac-
tured at Meissen, Germany, as early as 1715; he would, however,
have been the first in the English-speaking world to produce it.
Accompanying that boast was his petition for a fifteen-year pat-
ent on china manufacture, additional money for development, "2
ingenious pot painters," and "a Tun weight of Pig lead, 200 weight
of blew smalt [cobalt-oxide paint] such as potters use, 300 weight
of block Tin, and an Iron mortar & pestle" to be sent from En-
gland.[10] This request was acknowledged by Harman Verelst, ac-
countant to the Trustees, in a letter dated July 14, 1739:

Your Proposal of the 29th of December last having been
read to the Trustees they have been pleased to send you an
Iron Pestle and Mortar in a Cask, 40 pounds wt. of fine
deep Smalt in a Box, 60 pound wt. of fine Tin Ingots in a
Box, and 7½ lb. wt. of Lead in 44 Barrs to encourage you
in the making of Porcelain or China Ware, and by Showing

this letter to William Stephens Esqr. you will be intitled to receive them.

As to the other part of your proposal you are desired to send over Specimens of all you make, and some of the finest Clay baked and unbaked before the Trustees can consider thereof, for without Proofs of your work the Trustees cannot apply to serve You in any manner whatsoever.[11]

By that time Duché had taken into apprenticeship two indentured servants from the German Palatinate, brothers Christopher and William Shantz.[12]

The potter's success in producing true porcelain is uncertain, and the question cannot be resolved without authenticated examples; unfortunately, part of the shop site may have been excavated some time ago for the cellar of a store.[13] William Stephens's excited initial report of a "near transparent" (i.e., translucent) teacup was subsequently qualified by journal entries in the summer of 1741:

> I took Occasion to call on Mr. *Duchee*, to see some of his Rarities . . . all his fine Ware was baking a second Time, as it ought to be, with proper Glazing: But he shewed me a little Piece, in Form of a Tea-Cup, with its Bottom broke out, which he said he had passed through one Baking, and was yet rough; but upon holding it to the Light, as it was, without any Colouring on it, I thought it as transparent as our ordinary strong China [the following entry seems to clarify this as meaning English earthenware] Cups commonly are.[14]

> Mr. *Duchee* . . . thought fit to send to Mr. *Jones* and me, desiring we would come and be present at his forming some of his Clay into useful Cups, &c. We did so, and sat by him, whilst he moulded two or three such, about the Size of large Tea-Cups, which were shaped not amiss . . . and they were white, as he also said, they would be transparent, when baked as they ought to be. . . . But how far it may deserve the Name of Porcelane, when all is done must be left to proper Judges, for its present Appearance differs very little (if any Thing) from some of our finest Earthen-Ware made in *England*.[15]

The materials ordered by Duché—especially the tin and lead—are those English potters would have used to glaze tin-enameled

earthenware or delftware. As for the clay, there is an indication that Duché employed Indians to mine kaolin in what is now Wilkinson County, Georgia;[16] even so, would he have known to mix the pure white clay with the feldspar (petuntse or "china stone") necessary to produce hard-paste porcelain? In February 1739 Duché is said to have discovered "a whole mountain of stone" near the Salzburger community of Ebenezer.[17] He balked, however, at sending samples of his clay to the Trustees, "alledging it was a nostrum of his own, which he would rather hope for a Patent to appropriate to himself, than divulge."[18]

At the same time that Duché was conducting these experiments, he was supporting himself and his wife with a bread-and-butter line of kitchen wares—"Pots, Pans, Bowls, Cups, & Jugs"—evidently drawn from his traditional training.[19] The fact that his Charleston advertisement had specified "Earthen ware," and that his order for supplies included such a large quantity of lead, suggests that he was making lead-glazed earthenware at Savannah, rather than the salt-glazed stoneware on whose manufacture his father had tried to get a monopoly in Pennsylvania.[20] The only statements by Stephens regarding Duché's utilitarian products are that he proposed some improvements in manufacturing "which he had hitherto carried on in a plain Way with good Success,"[21] and "the Ware that he has made, . . . though coarse, he has not fail'd to find a quick Vent for, by sending it to our neighbouring Plantations."[22]

The Savannah chronicler came to dislike the potter; in 1740 Stephens wrote in his journal this rather unflattering description: ". . . active in stirring up Discontents at present, is *Andrew Duchee* the Potter, who, if he would stick to his own Business, we are willing to allow is a Master of that Trade. . . . Tho' very illiterate, he has an artful Knack of talking, and . . . a Heart set to do Mischief."[23] Duché had aligned himself with the Malcontents, a group organized to protest the antislavery and land-grant policies of the Trustees. Thomas Jones, a Savannah magistrate and storekeeper for the Trustees, complained the following year in a letter to General Oglethorpe:

> That Mr. Duchee hath frequently declared, That, tho' the Trustees had advanced some money to him, to carry on his Potterywork, (which by the way exceeds the Sum of Four Hundred Pounds Sterling . . .) Yet he did not reckon himself obliged to the Trust for the same, because it was not their money, but given them to lay out for the Encouragement of Setlers, and Improvements to be made in the

61A. *Lead-glazed earthenware jar marked* AD, *13" tall, discovered by dealer Howard Smith after this chapter was written. All that is known of its history is that it was bought in 1972 at a flea market outside Jacksonville, Fla. It could have been made by Andrew Duché at Savannah; the archaic forked crossbar of the* A *is found also on stonewares associated with Andrew's father, Anthony, in Philadelphia. One would expect detached ("free ear") handles on an eighteenth-century stoneware jar of this sort, but not enough handled earthenware jars from that period are known to determine if this piece, if indeed colonial, is atypical. Courtesy of the Museum of Early Southern Decorative Arts, Winston-Salem, N.C., with thanks to Brad Rauschenberg.*

Colony— That he (Duchee) hath declared that he would not rest, untill he got the Act prohibiting the use of Negro Slaves repeal'd and the people to have a Right to Alienate and Sell their Lands and Improvements and also to elect their Magistrates & Officers—

That he hath endeavour'd to overturn all order and Government among us. . . . I might (had I time) give many other Instances of Mr. Duchees Behaviour & Conversation, tending to disturb, if not subvert the peace & Tranquility of the Colony.[24]

Dissatisfied with the political situation in Georgia, Duché left in 1743. Following a brief visit to England he returned to South Carolina as an Indian trader, became a merchant in Norfolk, Vir-

ginia, and finally settled at his birthplace, Philadelphia. Speculations that he was the one who supplied kaolin to the proprietors of the Bow factory, who took out the first English porcelain patent in 1744, and that he was later associated with Bonnin and Morris of Philadelphia, who established the first American porcelain factory in 1769, seem to be without foundation.[25] What remains, then, is that for a five-year period Andrew Duché made both folk and experimental wares at Savannah, and is the earliest documented potter in Georgia.

About Duché's successor, William Ewen, even less is known. Born in England, he arrived at Savannah in 1734 as an indentured servant, where for two years he served as a basketmaker and clerk for Thomas Causton, keeper of the public store. Having earned his freedom, he struggled as a farmer on Skidaway Island, then returned to Savannah in 1740, when his fortunes began to improve.

In 1748 Ewen was associated with Andrew Duché as a trader among the Cherokees of western South Carolina,[26] which probably explains how he learned the fundamentals of pottery-making. In April 1755 he was granted a public lot in Savannah, and it was recorded that "William Ewen of Savannah Potter . . . had followed the Trade of a Potter Six Years, and that his Kiln, which was in danger of falling, stood on an other Person's Lot, and as he should be obliged to build a new one, and make other Improvements, He was desirous of doing it on his own Land."[27]

How much longer after this he continued to make pottery is not known; although, like Duché, Ewen disagreed with the Trustees'—and, later, the British Crown's—policies in Georgia, he stuck it out, and was rewarded for his revolutionary leanings by being elected president of the Council of Safety in 1775, which made him chief executive of Georgia after the royal governor fled.[28]

Following the Revolutionary War, a third pottery was established in the Savannah area, for which the only existing documentation is the following newspaper advertisement of 1797:

Brick & Tile Manufacture.

Mr. Radiguey, Takes the liberty of informing the Public; that he has established a Manufacture, between the Plantation of Mr. Clay, and the town of Savannah, where may be had, Bricks, Tiles, and Earthenware of all kinds. He has now on hand a quantity of Square-Tiles extremely useful and convenient for paving Ovens and Chimneys.

He, also, would wish to hire some Negroes, either as workmen or apprentices.[29]

It was to Georgia that members of the Moravian Church (Unity of Brethren), a communal Protestant sect based in Saxony, first came as New World colonists. Among the "second company" of Moravians to arrive in Savannah on February 17, 1736, was the German potter John Andrew Dober and his wife, Maria Catherine. On March 8, Dober and two other Moravians accompanied John Wesley, the English founder of Methodism, five miles up the Savannah River to select a site for the schoolhouse and mission that General Oglethorpe had promised to build for them, but Dober had an additional motive: he "was trying to find some clay suitable for pottery."[30]

By September the sixty-foot-long schoolhouse was completed, built atop an ancient Indian mound. A recent excavation of the cellar floor brought to light "a large number of sherds of European [i.e., non-Indian] wheel-turned pottery [which] comprised parts of two vessels, both glazed."[31] Did Dober make those vessels? Did he, in fact, make any pottery while in Georgia? If so, he would have preceded Andrew Duché by a year or so. All we are told, however, is that "Dober's effort to make pottery was a failure, for lack of proper clay, but through General Oglethorpe's kindness a good deal of carpenter's work was given to them."[32]

When the Moravian mission in Georgia was terminated in 1738—two years before the establishment of the first successful New World Moravian settlement at Bethlehem, Pennsylvania—Dober returned to Germany. We find him at Herrnhut, the Moravian mother community, in 1743, when he took as an apprentice Gottfried Aust, who later became the first master potter at Bethabara and Salem, the initial and second Moravian centers in the Piedmont North Carolina tract known as Wachovia.[33]

A later Moravian potter whose work in Georgia is better documented was John Frederick Holland of Salem. He is mentioned in letters written by two Moravian missionaries, John Christian Burckhard and Karsten Petersen, who had come from North Carolina to the Creek Agency on the Flint River (in what later would become western Crawford County, Georgia) as "partners in the Lord's Work." The agency was commanded by Colonel Benjamin Hawkins, a beneficent Indian agent who desired "to lead the Indian from hunting to the pastoral life, to agriculture, household manufactures, a knowledge of weights and measures, money and figures,"[34] so that the red man would be in a better position to compete economically in the expanding white frontier. Hawkins encouraged Burckhard and Petersen, who were skilled craftsmen, to live at his agency, not so much for their spiritual contributions

as for their material ones.[35] As early as 1803, even before Hawkins established the permanent agency, he was recorded as being "anxious to have sent from Salem a potter . . . to teach the Indians the trade. Most of all he would like a potter able to show the Indians how they might improve their work in pottery."[36]

In December 1809 Brothers Burckhard and Petersen, stricken with malaria, sent to Salem for medicine. A Moravian physician named Schumann prepared the medicine and traveled to the Creek Agency to administer it himself. Accompanying him was the potter Holland. Born in Salem in 1781, Holland had been educated in the Boys' School and had apprenticed under Salem's second master potter, Rudolf Christ, from 1796 to 1803. It was in the midst of his journeyman years (1803–1821) that he visited Georgia.[37]

Schumann and Holland arrived at the agency on January 7, 1810. Two weeks later Brother Petersen, although enervated by the fever, wrote, "I built a machine for fabricating pipe bowls according to Br. Holland's specifications, which was quite successful. Since then he has made dozens of them. The Colonel promised to have the [cane] stems made for them. How happy we will be, for the clay pipe bowls of the Indians are very expensive at this time when money is not to be had."[38] Schumann, leaving a supply of medicine, returned to Salem, but Holland stayed on to assist the two ailing missionary-craftsmen until they should recover. In the meantime he established a small pottery operation, probably on the urging of Colonel Hawkins. By June 1810 there must have been a potter's wheel and kiln, for Burckhard and Petersen reported:

> While here Br. Holland busied himself by making and baking pottery, crocks and pots. The clay in this area [on the Fall Line clay belt] is well adapted to making pottery and Holland was quite successful with his.
>
> Br. Holland has been busy making crocks and on several occasions he baked and sold some of them and pipe bowls and plates. The local clay is very good and most of the crocks turned out in good shape. . . . Yesterday we received $88 in payment for dishes.[39]

Brother Holland's stay at the Creek Agency lasted only about eight months, for in early September 1810, himself ill with the fever, he left for Milledgeville, Georgia's capital, from whence

*62. Heart-shaped inkstand attrib-
uted to John Holland, Salem, North
Carolina, ca. 1820s, signed IH.
inside right cavity. Lead-glazed
earthenware with metallic-oxide
decoration over white slip, 2" high
and 5" wide. The floral cutout was
for quill pens, with removable ink-
well on right and sander on left. It
is unlikely that Holland made any-
thing this elaborate during his brief
stay in Georgia. Courtesy of Old
Salem, Inc., Winston-Salem, N.C.*

he returned to Salem. Colonel Hawkins sent after him by wagon
a barrel of his pipes.[40] Holland continued to follow the craft,
becoming Salem's third master potter in 1821. He died on
Christmas day 1843, the last years of his career marred by finan-
cial mismanagement and alcoholic dissipation.[41] Surviving ex-
amples of his work, however, show him to have been a fine potter
in the Central European tradition of lead-glazed, slip-decorated
earthenware.[42] His departure from the Creek Agency effectively
brought to a close the age of earthenware in Georgia, for the next
decade was to see the introduction of stoneware, which quickly
became the dominant type of folk pottery in the state.

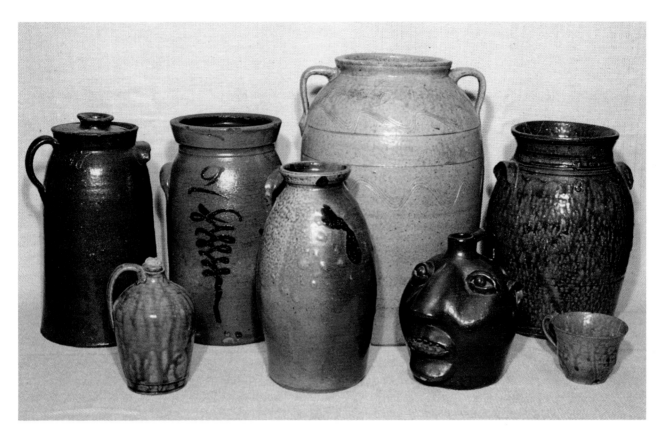

Color Plate 1. Range of glazes on an assortment of Georgia stoneware. Left to right, rear: churn with original lid signed LJ (Lucius Jordan), Washington County, alkaline (probably lime) glaze; churn stamped KLINE (Charles S. Kline), Atlanta area, exterior salt-glazed over cobalt-blue decoration, Albany-slip interior; jar with 6 incised six times around shoulder and wavy combing, Crawford or Washington County, 17" tall, alkaline (probably lime) glaze; jar stamped JL on throat (James Long, Crawford County?), wavy combing, alkaline (probably ash) glaze. Front: jug attributed to Isaac H. Craven, White County, ash glaze; fruit jar in the later Barrow County tradition, salt glaze over Albany slip; face jug attributed to W. T. B. Gordy, Meriwether County, Albany slip; cup, possibly earlier Barrow County, alkaline glaze. From the collection of Mr. and Mrs. William W. Griffin.

Color Plate 2. Jar by Thomas M. Chandler, ca. 1850, stamped CHANDLER / MAKER on shoulder, 18¼" tall, illustrating slip-decorated stoneware tradition of Edgefield District, South Carolina. Swag-and-tassel design executed with trailed kaolin and brushed iron slips under alkaline glaze.

Color Plate 3. Face jug by Burlon B. Craig of Vale, North Carolina, 1980, 15¾" high, illustrating that state's decorative technique of melted-glass streaks. Craig, a contemporary folk potter working in the ash-glaze tradition of the Catawba Valley, revived the local technique with the encouragement of a dealer friend.

Color Plate 4. Jefferson/Jackson jar stamped JL and attributed to James Long, Crawford County, ca. 1830s, 21 1/8" tall. Collection of Billy F. Allen.

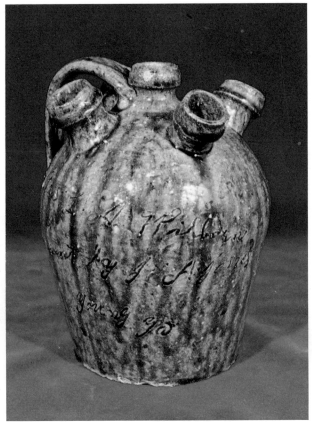

Color Plate 5. Foxhunt jug signed by John C. Avera, Crawford County, 1871, 12¼" high, lime glaze.

Color Plate 6. Ash-glazed "wedding jug" signed by J. A. Jones, Young Cane, Union County, ca. 1870s, 9" high.

Color Plate 7. Unglazed, two-piece grave planter from Jugtown, 18" tall total, inscribed LOUISE BROWN / BORN—JULY 1 / 1914, DIED SEPT. / 12, 1928. Photo by Gary Beck, courtesy of Stephen Moorman.

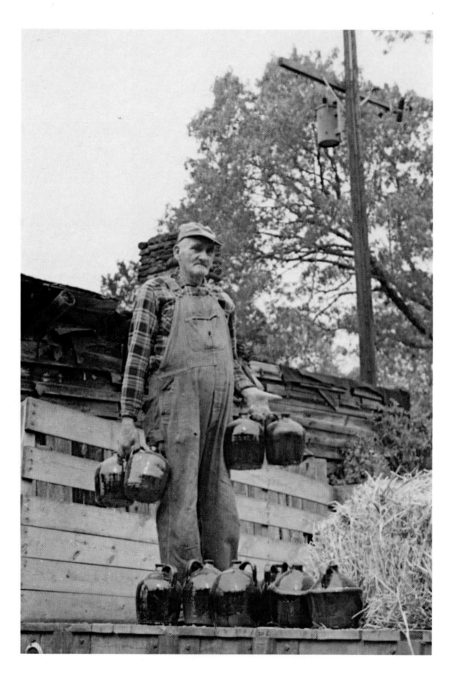

Color Plate 8. The late Cheever Meaders, ca. 1950s, with semi-ovoid and cylindrical "stacker"-type jugs with modified lime glaze. Photo by Janet Boyte.

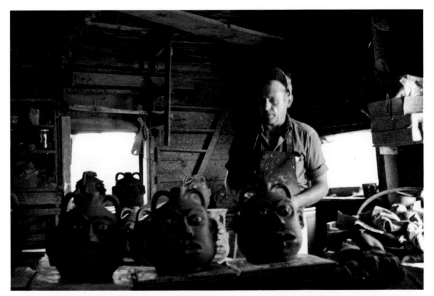

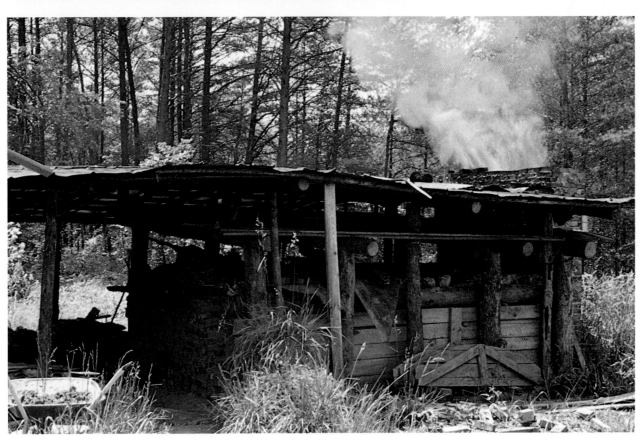

Color Plate 9. Lanier Meaders in shop with unfired two-faced ("politician") jugs, 1975. Photo by Dennis C. Darling, University of Texas at Austin.

Color Plate 10. Lanier's "tunnel" kiln being "blasted off," 1975.

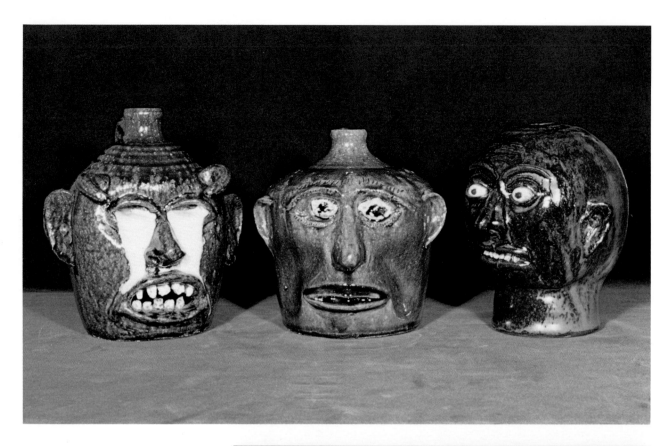

Color Plate 11. Three brothers in clay by Lanier Meaders, left to right: devil jack-o-lantern jug, ash glaze with white ceramic clay, 1971, 9¾" high; experimental "astonished" face jug, modified lime glaze, 1968, 8¾" high; wig stand, modified ash glaze, 1974, 9" high.

Color Plate 12. Detail of Lanier's snake-and-grape vase, 1977, 15¼" tall.

CHAPTER EIGHT

Potters on the Land: Geography of Jug-Making

Duripng the late eighteenth and early nineteenth centuries a human wave swept into Georgia from the Carolinas, people whose forebears had crossed the Atlantic to the Middle Atlantic States and Virginia. As new lands were opened through Indian treaty cessions, these pioneer Georgians or their descendants, spurred by that impulse to seek greener pastures, continued moving westward across the state until, by 1850, the Georgia frontier had closed.[1] James S. Lamar, a noted lawyer and minister of Augusta, opened his *Recollections of Pioneer Days in Georgia* with the following account of his family's migration, typifying the early settlement of the Georgia interior.

> My father, Philip Lamar, and my mother, Margaret Anthony, were born and reared in Edgefield District, South Carolina. . . . My father lived on land that had been settled by his grandfather and other members of the family; when, about 1750, Robert, Thomas and John Lamar . . . came with the tide of Marylanders to the Horse Creek Section. Although it was a new country everyone seemed to think it best to move still farther westward, and there is extant a joint letter, written in 1770 by Robert, Thomas and John to their maternal uncle, Joseph Wilson, who lived in Maryland, [in which they] told him of the Oakee-chee lands in Georgia, with their forests of oak and hickory, and strongly intimated their purpose of moving from South Carolina to that section. . . . It was a time when to move was in the blood of everyone, and [my father] finally decided to carry out the old plan about which he had, no doubt, heard much discussion in the family.[2]

The movement from Edgefield District, in west-central South

Carolina, across the upper Savannah River into eastern Piedmont Georgia, appears to have been an especially significant route. The Lamars were not potters, but some of their fellow travelers must have been, for what we know about the movements of certain early Georgia potters matches this pattern exactly. The pioneer potters, then, were caught up in this larger flood of humanity; their settlement history is best viewed in the context of the general migration.

Except for the initial occupancy of the lands along the lower Savannah River in the second quarter of the eighteenth century, settlement of the state's northern and southern extremities—the Appalachian Mountains and lower Coastal Plain—was (indeed, still is) relatively sparse. The main thrust of migration was into the heartland, the Piedmont Plateau, including the fertile plantation country of the middle Georgia Black Belt. Strategically situated near the head of navigation on the major waterways and thus accessible to markets down river, the state's most important early inland cities—Augusta, Milledgeville, Macon, and Columbus—all lie along the Fall Zone which separates the red clay Piedmont from the sandy Coastal Plain.[3]

The pioneer potters, who were also farmers or small slave-owners, sought out the same optimum conditions as their totally agricultural fellow travelers, but one additional factor influenced their settlement decisions. Evidence suggests that by the 1820s Anglo-American potters in the region were shifting from the fragile and potentially hazardous lead-glazed earthenware to the more durable and nontoxic stoneware. But the purer clays needed for stoneware are not to be found everywhere. The clay bulletins of the Geological Survey of Georgia indicate that such high-firing clays are concentrated in the Piedmont, either as scattered pockets in the upper portion or in more consistent deposits along the so-called "clay belt" which follows the Fall Zone.[4]

Unlike today's studio potters who buy packaged clay through commercial outlets, it was not economically feasible for folk potters of the South to have their clay shipped from any distance. In this respect they were like small-scale country potters everywhere, including those of Britain (from whom some were descended).[5] Thus, Georgia's folk potters were inextricably tied to the land that provided their basic raw material, settling in the Piedmont wherever their suspicions of good clay could be confirmed. This pattern emerges clearly by plotting the distribution of known pottery shops in the state; the vast preponderance were located within the Fall Zone clay belt or in the Piedmont above.

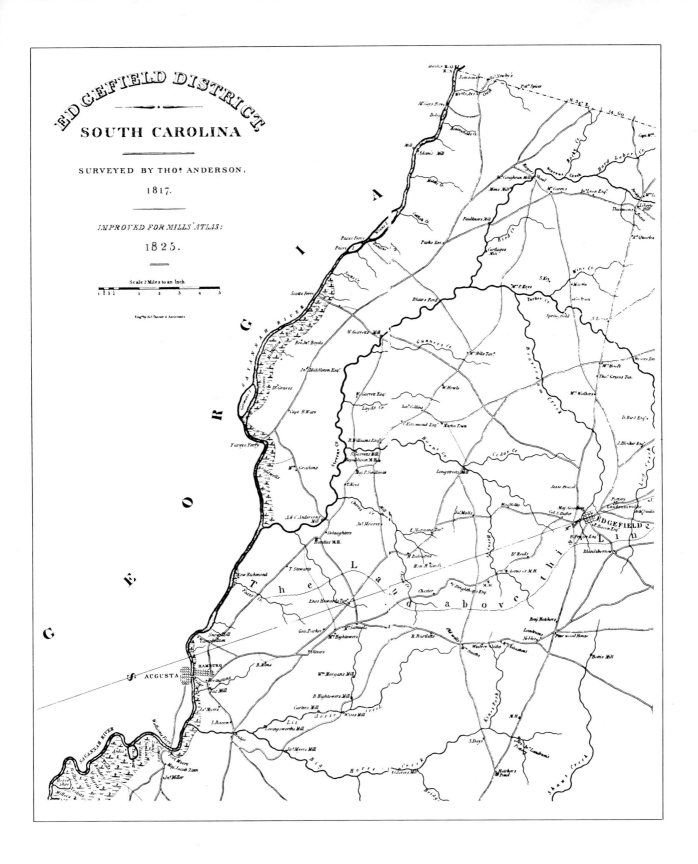

EDGEFIELD DISTRICT,

SOUTH CAROLINA

SURVEYED BY THO? ANDERSON,

1817.

IMPROVED FOR MILLS' ATLAS:

1825.

Scale 2 Miles to an Inch

GEORGIA

Counties

0 10 20 30 40

Miles

The attraction of potters to the Piedmont was not unique to Georgia, however. The major pottery centers of the Carolinas, Georgia's two Atlantic Seaboard neighbors which share this physiographic feature, were also in the Piedmont. These include South Carolina's Edgefield District (where stoneware potters took advantage of the local kaolin for slip decoration and apparently also, at times, as an ingredient in their clay body and alkaline glazes)[6] and North Carolina's Moravian communities of Bethabara and Salem with their lead-glazed earthenware, the salt-glazed stoneware center focused in Randolph County, and the Catawba Valley with its alkaline-glazed stoneware.[7]

The concentration of folk potters in the Georgia Piedmont did not mean, of course, that inhabitants of the mountain and "wiregrass" sections went without vessels of clay; upper Piedmont potters escaped the pressures of a saturated local market by hauling their wares northward into the highlands, while wagoners sold the products of middle Georgia shops far down into south Georgia. Thus were the wares of the Piedmont more evenly distributed, and the extremities of the state served. Further contributing to the availability of folk pottery in these less populous areas was the small number of potters who lived there. While very much the exception to the distributional rule, their work was no less consequential, and this is an appropriate place to discuss two of the better-documented cases. Interestingly, both shops, despite their geographical isolation, could not escape influence from the Piedmont's ceramic traditions.

At Stockton in Clinch (now Lanier) County, less than thirty miles west of the Okefenokee Swamp and twenty miles above the Florida border, the Foreman Pottery was in operation by 1880. Its founder, South Carolina–born Glover G. Foreman, was listed as a potter in the 1881 *Sholes' Gazetteer*,[8] but a good deal of the labor seems to have been done by hired help, mostly drawn from the middle Georgia pottery centers of Jugtown (on the Upson/Pike County line) and eastern Crawford County, according to the 1880 and 1900 censuses. This included Jugtown potter Camelius Brumbeloe and his son Walter, Atlanta's Theodore Brown (son of Jugtown-born potter Thomas O. Brown), Crawford County's John Becham and his sons Will and Glover, Foreman's sons McLin and Joe, and Dewy Allen. Only Theodore Brown and John Becham are specifically referred to as "Turners" in the censuses.

The number of hired workers suggests a large operation, a fact confirmed by Floyd Allen, who lives near the site and remembers the pottery from his boyhood when it was run by Joe Foreman,

FACING PAGE
Map 2. County map of Georgia showing distribution of four hundred known folk potters since 1738. Each dot represents a shop site; there were more potters than shops, for several potters commonly worked at the same site (although some potters, especially itinerants, worked at more than one shop). The area between the two unbroken lines is the Piedmont Plateau, where most of the potters settled. The scarcity of potters in Georgia's Appalachian Mountains (above the upper line) and Coastal Plain (below the Fall Line) is related both to inadequate supply of stoneware clay and limited population. Clusters of dots represent Georgia's eight pottery centers; in addition, the centers of Edgefield District, South Carolina, and Randolph County, Alabama, are shown to extend the pattern.

who sold it around 1915 and left the area. The shop "was large enough to hold 200 head of cattle" (1). The clay was obtained from the banks of the nearby Alapaha River, and the wares were carried by mule and wagon "as far north as Fulton County, east to Brunswick, and west to Valdosta." Alkaline glaze, containing sand from nearby sand-pits, was the type used. Two syrup jugs owned by Mr. Allen and used by his parents, which he attributes to Joe Foreman, have a streaky brown glaze reminiscent of the ash glaze sometimes seen on White County wares, but have mouth and handle detailing not seen elsewhere. A churn with a lighter olive glaze and two loop handles at the shoulder, also used by Mr. Allen's parents, has a Crawford County feel and was probably made by one of the Bechams. The pottery produced at this south Georgia shop, then, appears to represent an amalgam of several other locales.[9]

The only true mountain shop for which I have more than sketchy information is the Jones Pottery at Young Cane, eight miles west of Blairsville in Union County. North Carolina–born Wilson Jones had settled in that part of the Blue Ridge by the 1840s, and his sons, James A. and John Wesley, who were born in Georgia, are the first known potters.

Recently I acquired an ash-glazed, five-necked jug inscribed Miss L. A. Wilborn / apresent [sic] by J. A. Jones / Young Ga which undoubtedly was made at the Young Cane shop. At Mossy Creek, in the foothills of White County, potters of North Carolina background made this form to display cut flowers, but the story behind Jones's piece is that it was a "wedding jug" (58), the central neck intended for the preacher, the rear spouts for the bride and groom, and the front ones for "the people who stood up for them" (i.e., the best man and the maid of honor); the tradition does not specify what beverage would have been consumed at the ceremony. Unfortunately a search of the Union County marriage records failed to yield up Miss Wilborn so that the jug could be dated (assuming it was indeed made as a wedding gift), but a Lavina Welborn, age eighteen, is shown living with her mother in the 1870 census for Union County. The fact that the quintal form is only reported in one other area of the South—the Catawba Valley of North Carolina[10]—suggests that James Jones's father, Wilson, was trained there as a potter.

Sholes' Gazetteer of 1879 advertised that J. H. Thomas and J. A. Jones were then jug manufacturers at Young Cane,[11] and this is the earliest date that can be established for the shop. The 1880 census lists both James and John Wesley Jones as farmers, but

63. Five-necked "wedding jug" signed by J. A. Jones, Young Cane, Union County, ca. 1870s, olive-brown ash glaze, 9" high, a product of one of Georgia's few mountain potteries.

John H. Thomas is shown as a potter. This seems to be the same John H. Thomas who had married Frances Ferguson, daughter of potter William F. Ferguson, at Jug Factory in Jackson (now Barrow) County in 1876 (and whose sister, Adeline, married potter Charles P. Ferguson). If so, there is no record of what attracted Thomas to that spot in the mountains sixty miles above his home or how his partnership with James Jones came about, but he would have brought with him the Jug Factory tradition of the upper Piedmont.

The oral history of the Jones family makes no mention of either potter. As far as Maude MacDougal Jones could remember, the shop was run by her father-in-law, John Wesley Jones (63). In

addition to potting, Wesley raised a crop in the summers and prospected for gold and silver in the winters. When he retired in 1903 his son, Dock, Maude's husband, continued to operate the shop for several years, closing it about 1912 (another son, Henry, is shown as a "Turner [Jugs & Jars]" in the 1900 census). Wesley's younger children, who helped at the shop, would shyly scurry away and hide at the clay pit when visitors came, Mrs. Jones recalled.

The Jones Pottery produced mainly jugs for "white lightnin' and surp" (moonshine and sorghum molasses) and churns. Wesley would haul his ware by horse- or mule-drawn wagon (he refused to use oxen because they were too slow) to Blue Ridge in Fannin County and Copperhill, Tennessee, often trading it for groceries. At first, only ash glaze was used: fireplace ashes were saved, sifted, and run through a mill with the other ingredients. The tunnel kiln and waster pile have since been leveled, but ash-glazed sherds were recovered from a drainage ditch near the site. The later ware was mostly glazed with Albany slip. Two distinctively shaped churns used by Mrs. Jones to pickle beans and sauerkraut and attributed to Wesley about the turn of the century exhibit the Albany-slip glaze (plate 41).[12]

A phenomenon associated with the geography of jug-making is the formation of pottery communities or "jugtowns." These were basically agricultural settlements containing concentrations of potters. Georgia has had eight such centers, its only true craft communities (as distinct from occupational communities such as milltowns, logging and mining camps, or fishing and turpentine villages), where the majority of the state's folk potters worked. The explanation for such clustering is not as simple as an inexhaustible supply of stoneware clay, for while such clay exists there it is not always limitless or easy to obtain, and there are other places with good clay but no history of potters. At least two other factors seem to have determined which locations were to become pottery centers: the magnetic force of key pioneer potters who attracted other potters into their orbits, and accessibility to markets.

While part of a rural environment, Georgia's jugtowns, by design or coincidence, were all within fifteen miles of a major town or city, the inhabitants of which, until after the turn of the century, also had need of functional pottery, and were more likely to be a dependable source of cash than farmers. Indeed, two of

these centers catered to the cities they were near: the potters of eastern Crawford County specialized in whiskey jugs for the Macon distilleries, while those working at Howell's Mills in Fulton County made jugs for Atlanta distillers like R. M. Rose.

Another peculiarity in the location of Georgia's jugtowns is that they were well into the interior of the state, rather than at the eastern border which funneled masses of pioneers westward from South Carolina. While Georgia's pioneer potters certainly passed through that critical springboard to interior settlement, few stopped permanently. One exception was South Carolina–born Allen Gunter, who was almost certainly trained in the alkaline-glazed stoneware tradition of Edgefield District and had settled in Elbert (now southeastern Hart) County by 1830, where he was recorded as a potter in the 1850 census.[13] Although his neighbors, the Brocks, became caught up in the craft, they later moved west to Paulding County, and somehow Gunter's community never materialized as a pottery center.[14] Another place with this unrealized potential was Augusta, which began as a fort in 1735.[15] The following advertisements, which appeared in 1814 in the *Augusta Chronicle*, seemed to bode well for the future of pottery-making there:

FOR SALE.

EARTHEN WARE at the POTTERY near the INDIAN SPRINGS [a trading post six miles northwest of the town center]—A considerable deduction will be made to Whole Sale Purchasers.

June 3.

FOR SALE.

A FRESH ASSORTMENT OF EARTHEN-WARE, at the Pottery near the Indian Spring. CRATES will be furnished to wholesale purchasers.

Hightower Davis,
Manager for the Proprietor
Sep. 16 of the Pottery.[16]

Although Augusta developed a brick-making industry, few other potters ever worked in the area.[17]

A tentative order can be assigned to the establishment of Georgia's eight pottery centers. The earliest—and most easterly—is northern Washington County, where two potters from Edgefield District were making stoneware by 1820. Two other potters who appear to have worked there carried the alkaline-glaze tradition to eastern Crawford County, where a shop was operating by 1829.

The same thing may have happened with Jugtown, although there is no such early documentation of pottery activity. In north Georgia, it is likely that potters of North Carolina origin were potting at Mossy Creek by the late 1820s, and about 1846 another Edgefield potter opened the shop at Jug Factory. The remaining centers—northern Paulding County, the Atlanta area, and Gillsville—emerged after the Civil War; at the latter two there had been limited activity before that, but it required pollination from earlier centers for them to blossom.

With one or two key pottery families as the nucleus, and fed by the patterns of dynastic consolidation described in Chapter 4, these jugtowns grew, creating as they did so individual stylistic "schools" of pottery tradition, the development of which can be partly explained by the diversity of influential potters' backgrounds, local differences in ceramic needs and tastes, crossfertilization among the centers, and even creative tendencies in some of the potters. For each community specific glazes, vessel types and form variations, marking and decoration, and details such as handle shape and placement combined in such a way as to distinguish its wares from those of every other center. Familiarization with each center's "personality" traits can thus be useful in establishing the provenance of unidentified wares, so long as the examples are not atypical.

Consciousness of the pottery community's special identity was ever present even for those inhabitants not involved in the craft, for visual reminders of the occupation were in the air as well as on the land. Jewel Merritt, a Crawford County potter, recalled the appearance of his community in the early years of this century: "On a given day, you could look around the countryside and tell who was burning his kiln by the smoke risings" (79).

An index of the frequency with which pottery centers once dotted the southern landscape is the number of placenames associated with the craft.[18] While some were not officially registered or shown on maps, they are often still known by residents of the area. Chief among these is the name Jugtown, which occurs no less than seven times in the region. The famous Jugtown Pottery, established in 1922 by Jacques and Juliana Busbee near Seagrove, North Carolina, and still in operation, took its name and its first potters from the community that straddled Randolph and Moore (and also included the neighboring parts of Chatham and Montgomery) counties. North Carolina had two other Jugtowns, however, one located at the juncture of Catawba and Lincoln counties and designated as a post office from 1874 to 1906, and the other

in Buncombe County just west of Asheville.[19] Middle Tennessee's Jugtown, in western White County, was a pottery center from 1850 to 1918.[20] South Carolina's Jugtown was near Gowensville in Greenville County, the northwestern corner of the state; few local people today remember it.[21] Alabama's Jugtown was located in Shelby County east of Birmingham, near Sterrett.[22] And Georgia's Jugtown, on the Upson and Pike County line, produced Bowling Brown, whose descendants are still potting in the Carolinas, and W. T. B. Gordy, whose two sons are active Georgia potters. The prevalence of this name testifies to the place of potters on the southern cultural landscape.

The strong inclination of Georgia's folk potters to cluster in communities within the Piedmont Plateau has determined my approach to presenting their story. The following chapters detail the histories of these eight centers, and are ordered so as to best show the sequence of influence that one had upon another, the movement of ceramic ideas that occurred with the migrations of potters within the state. The first three centers are in middle Georgia, the remaining five in north Georgia. For handy reference, each chapter begins with an abstract summarizing the chief characteristics that distinguish that center's pottery tradition, and concludes with a simple list of all folk potters known to have worked there. As the heading of Part Three indicates, this survey is selective, concentrating on those potters who appear to have had the greatest impact on the tradition and for whom the fullest information exists. Any known folk potter omitted from this discussion is, of course, included in the detailed Checklist and Index of Georgia Folk Potters at the back of the book.

CHAPTER NINE

Northern Washington County

Began about 1818. NUMBER OF POTTERS: *around twenty.* KEY NAMES: *Massey, Cogburn, Redfern, Jordan, and later, Brumbeloe.* GLAZES: *alkaline (smooth when well fired, rough when not), with Albany slip after 1910.* MAKER'S MARK: *marked examples rare.* MAIN FORMS: *food-storage jars with loop handles attached just below everted rim (and sometimes an undulating line or series of straight lines incised around shoulder) and double-handled syrup jugs.* SPECIALIZED FORMS: *closed-top (dome or cone) cylindrical grave pots.* HIGHLIGHTS: *earliest stoneware center, with Edgefield connections.*

The northern triangle of Washington County, above the village of Warthen and including Hamburg State Park, lies in the Fall Zone about halfway between Augusta and Macon and fifteen miles from any major town. Despite the paucity of detailed information on the local ceramic tradition, the fact that the first recorded Georgia stoneware was made there, and the role this small pottery center appears to have played in the early development of the two other (more extensive) middle Georgia centers—eastern Crawford County and Jugtown—make northern Washington County the logical place to begin this survey.

Assistant State Geologist George Ladd briefly described the community in 1898, which must have been just before the local tradition played out: "Washington county . . . has a number of small potteries, operated in a manner, similar to those in Crawford county. The wares are made, at intervals during the year, and are disposed of, by peddling through the country. The leading potteries are those of J. M. Bussell, John Redfern and Andrew Redfern. The business has been carried on, for the past 75 years, or more."[1] Ladd's estimate of the antiquity of that tradition was accurate, for by 1820 there were at least two potters operating north of Warthen. The manufacturing census of that year lists them both as "Stone ware manufacturers" as follows: "Abraham

Massey. Jugs, Jars, Coffee boilers, etc. $2000 [annual market value of products]. Cyrus Cogburn. Jugs, Jars, & etc. $3000."[2] In closing his enumeration of Washington County, Tilman Dixon, the marshall's assistant, added this note: "There is on the Little Ogechee river the firm of a Stone-ware Manufactory, the men who are engaged in the business informed me that their ware was equal to any in the Southern States, tho' as yet they were only able to carry it on in a small way. They make a waggon load which one of them takes and carrys through the Country untill it is sold and when that is disposed of they return and make another and so on."[3]

In 1815 Abraham Massey had witnessed a deed in Edgefield District, South Carolina, in which a parcel of land was acquired by Abner Landrum as part of a venture that would culminate in the selling of lots for the village of Pottersville.[4] It was about that time that the Landrums became involved in stoneware manufacture there, if not as the originators of southern alkaline glazes at least among the earliest users. In this context it is not unlikely that Massey worked in Landrum's shop and brought the recently developed glaze with him when he moved to Washington County. The fact that he was making "coffee boilers" in 1820 supports this hypothesis, for coffeepots with tubular spouts have been excavated from early Edgefield District waster dumps.[5] The 1825 tax digest shows him owning 196 acres on the (Little) Ogeechee in the Ninety-Sixth District;[6] the 1830 census has him still living in Washington County with his wife and six children, but what became of him later is not known.

The 1850 census for Rusk County, Texas, where Cyrus Cogburn spent his last years, indicates that he was born in North Carolina. It is likely, however, that he belonged to a family that had migrated from North Carolina to Edgefield District, where, like Massey, he may have been involved in the early stoneware industry.[7] In 1818 Cogburn was paying taxes in Washington County, and in the 1825 tax digest he is recorded as owning 300 acres of pineland on the (Little) Ogeechee, not far from Abraham Massey: the tracts of both potters adjoined that of a third party.[8] That same year he sold 300 acres in Edgefield County, South Carolina.[9] In 1827–28 Cogburn paid taxes for land on Tobler's Creek in southern Upson County, and the 1830 census shows him in Talbot County. He continued his westward migration to Macon County, Alabama (where he is found in the 1840 census), and by 1850 he and several potter sons had settled in Texas. Excavations at two of the sites associated with him in Rusk County

63A. *Broad-bellied syrup jug attributed to antebellum Washington County, 15" high, stamped V on shoulder. The light tan alkaline glaze, shape, and neck-collaring point to the Edgefield District, South Carolina, background of middle Georgia's stoneware tradition.*

64. *Alkaline-glazed wares signed J or LJ and attributed to Lucius Jordan, third quarter of the nineteenth century. The collaring on the neck of the syrup jug at left is reminiscent of that on jugs from Edgefield District, South Carolina.*

turned up salt-glazed stoneware, and a third revealed a peculiar alkaline glaze.[10]

Unfortunately, deeds that would help to locate the Washington County properties of Abraham Massey and Cyrus Cogburn were destroyed in a courthouse fire, and, of course, these potters worked too early for their sites to be remembered and identified by living residents. The exact nature of the stoneware they made in Georgia, then, cannot be determined until marked examples are found. It is probable, though, that some of the potters who later worked in northern Washington County began their careers in the shops of Massey or Cogburn. For example, William B. Lewis, who was born in 1804 and is shown as a potter in the 1850 census, would have been old enough to work in the Massey or Cogburn shops when they were active in the 1820s, and he is linked with Cogburn to the extent that he, too, was paying taxes for land on Tobler's Creek in Upson County in 1827.

Another such possibility is Lucius Jordan. Although born later than Lewis, he could have worked in Massey's shop if it continued to operate into the 1830s. In any case, Jordan was the only Washington County potter who occasionally marked his wares

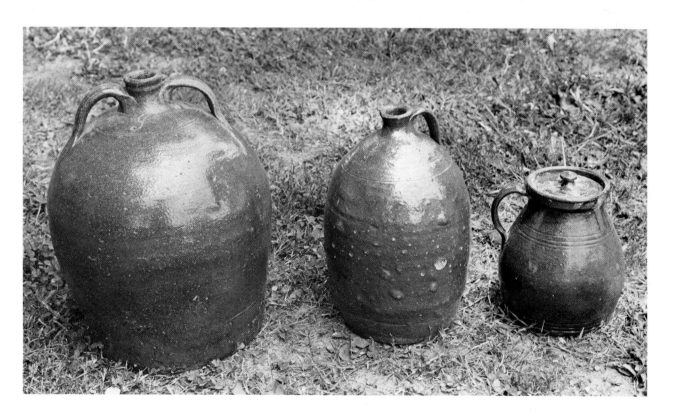

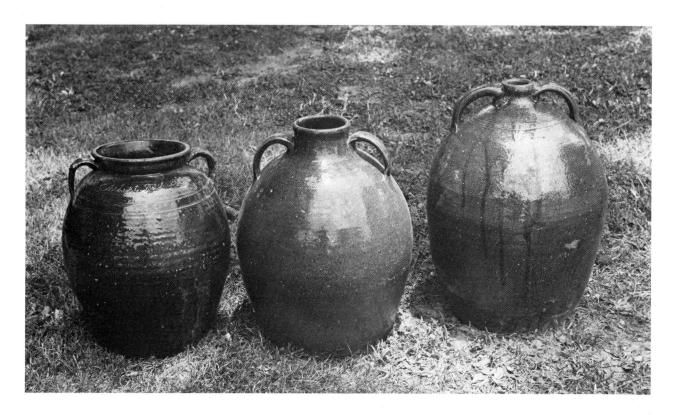

(by incising in script the initials L J or J), the majority of which were pleasantly ovoid food-storage jars with graceful strap handles affixed just below the everted rim and highlighted with one or more lines incised around the shoulder, sometimes undulating in the "sine curve" pattern most often seen on North Carolina wares. His small churns have a more severe, elongated bell shape reminiscent of an empire gown (color plate 1). All the wares attributed to Jordan are coated with some type of alkaline glaze, usually smooth when well fired and often seeming to contain a substantial proportion of clay. The 1820 manufacturing census included a "lime-burner" near Sandersville (the Washington County seat), so there was lime to be had in the area.

By 1838 the Redfern family, with Branson Redfern at its head, had settled in Washington County, having migrated by way of Hall County from Anson County, North Carolina.[11] Of Branson's five sons, two are definitely known to have been potters on Cowpen Creek: John and William Andrew. Cylindrical, uninscribed grave markers in a local cemetery, with closed dome- or cone-shaped tops and only the bottoms dipped in a smooth green glaze, are attributed to them.[12]

65. Alkaline-glazed wares attributed to Lucius Jordan. The jar at left bears the name Albert Rachels in script, a neighbor for whom it was most likely made.

ABOVE
66. Wheel-thrown, uninscribed grave markers, their bases dipped in alkaline glaze, 10½" and 16¼" tall.

FACING PAGE
67. Earliest documented piece of Georgia stoneware, an eight-gallon, two-handled syrup jug inscribed JAMES BUTLE / TO HOLD Jug 8 gl 1837 / To HoLD 8, *tan alkaline glaze.*

While a great deal remains to be learned about the Washington County stoneware tradition, from what has so far been observed there appear to be significant correspondences between the wares of that center and those of eastern Crawford County. For example, the smooth green or tan lime glaze characteristic of the latter community is similar to that seen on Washington County wares; and the jar forms, with their two loop handles (including the small "beanpot" type), look much the same in both areas.

The most obvious explanation for these resemblances is that James Long and John Becham, key pioneer potters in Crawford County, transplanted the Washington County tradition when they migrated from that center; this likelihood will be explored further in the following chapter. However, there is at least one instance of the influence moving (later) in the reverse direction. James M. Bussell, noted by Ladd in 1898 as potting in northern Washington County, had moved there sometime in the 1870s from eastern Crawford County, where he appears to have been the son of James Bustle (listed as a "Jug Maker" in the 1860 census, and who, in turn, may have been trained in one of the original Washington County shops; he appears in adjoining Hancock County in the 1830 census, turning up in Crawford by 1850). Bussell is remembered by a few older Washington Countians:

> Now, I heard that this Bussell carried a load of pottery to Milledgeville with his wagon and team. And on his way back, he picked out a nice house to spend the night. The old man who lived there just welcomed him, called his boys (he had a houseful of boys) to take this potter's stock out there and feed and water them; asked him if he'd had anything to eat, said he hadn't, so he told his wife to put stuff on the table. So she cooked plenty and he ate supper, and was settin' up by the fireplace and the old man told him, said, "I don't believe I got your name," and so he said, "My name's Bussell; I don't think I got your name," and the old man said, "My name's Ennis." Now, this Bussell had always heard the Ennises were bad folks. After that old man—that 'bad' man he'd heard about all his life—had done all those nice things for him, Bussell went to bed and didn't sleep a wink, thinking he might have his throat slit and his money from selling that pottery robbed. But, of course, nothing happened to him. (33)

The Brumbeloe Pottery was the last in northern Washington County. Established at Chalker about 1910 (by which time the

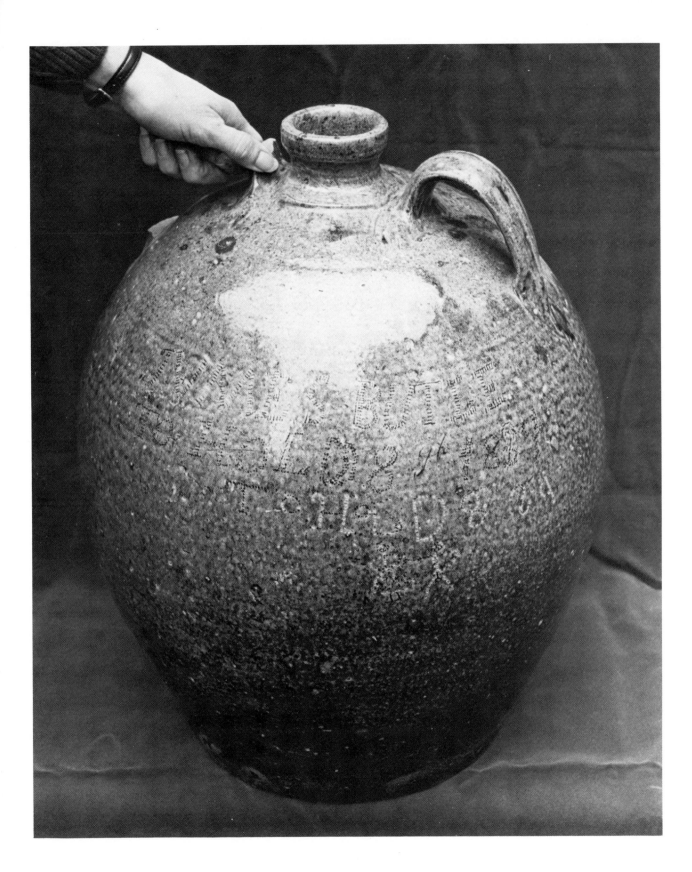

RIGHT
68. Detail of punctated stick-figure woman and man below inscription on the 1837 jug. Found in Washington County, its maker—probably James Bustle—most likely trained in either Massey's or Cogburn's shop.

BELOW & TOP OF FACING PAGE
69 and 70. Kiln and yard at Brumbeloe Pottery, Chalker, 1926. Courtesy of Georgia Geologic Survey.

local alkaline-glaze tradition must have died out) by brothers Walter, Oscar, and Newt Brumbeloe of Jugtown, it was operated until the late 1920s. At Chalker they continued to produce Albany-slip-glazed wares in the Jugtown tradition, hiring potters Edward L. Stork, originally of Columbia, South Carolina, and Claude Bennett, whose father George and uncle John also helped at the shop. Of the three brothers, Newt and Walter did most of the turning, while Oscar was manager and spent his time burning and hauling (48). Oscar apparently had a short temper, for one resident recalled him borrowing a mule from her father after he shot his own unruly animal while trying to mix clay (41). Another story is told of a Prohibition-era city-slicker driving through the area who accosted an old man hauling a truckload of whiskey jugs, thinking to buy a gallon or two of good local moonshine. When asked what he was getting for his stuff, the old-timer replied that it was ten cents a gallon. "Why, man," exclaimed the stranger, "you can't even buy corn in the ear for that!" Imagine his disappointment when the hauler explained, "I'm not selling corn either liquid or solid, just the jugs" (15).

The village of Chalker, five and a half miles northeast of Warthen, grew up around a brickyard and, later, a sawmill owned by the Oconee Lumber Company. When the timber boom ended

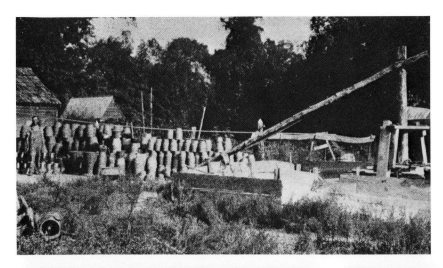

BELOW
71 and 72. Sequence of turning a "stacker" jug at Brumbeloe Pottery, 1926; note the height-gauge stick. Courtesy of Georgia Geologic Survey.

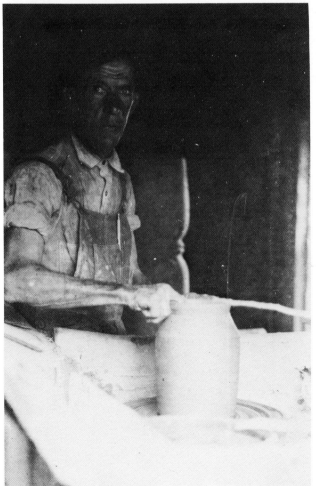

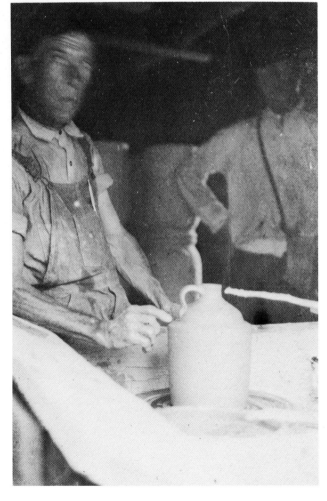

and rail service was discontinued, Chalker was abandoned and the buildings eventually disappeared. All that remains of the community and the local pottery tradition is in the memories of a few older people or lies buried in the earth, awaiting the spades of archaeologists.

WASHINGTON COUNTY POTTERS

Becham, John*	Giles, ————*
Bennett, Claude	Griffin, Henry*
Bennett, George†	Holloman, Daniel*
Bennett, John†	Jordan, Elbert
Bridges, William E.	Jordan, Lucius
Brown, William*	Lewis, William B.
Brumbeloe, Newton J.	Long, James*
Brumbeloe, Oscar E.	Massey, Abraham
Brumbeloe, W. Walter D. S.	Redfern, Branson*
Bussell, James M.	Redfern, James*
Bustle, James*	Redfern, John
Cogburn, Cyrus	Redfern, W. Andrew
Cogburn, Jackson*	Redfern, Wilson*
Cogburn, Levi S.*	Stork, Edward L.
Cogburn, Tomlinson F.*	

* Suspected but not established as a potter, perhaps known as a potter elsewhere.
† Limited involvement in craft as shop-owner or assistant but not turner.

CHAPTER TEN

Eastern Crawford County

Began in late 1820s. NUMBER OF POTTERS: *about sixty-five.* KEY NAMES: *Long, Becham, Merritt, and Averett.* GLAZES: *lime predominant, with "paint rock" subtype; some ash and, later, Albany slip.* MAKER'S MARK: *initials stamped in relief on top of loop handle.* MAIN FORMS: *whiskey jugs (including beehive shape) for Macon and local distillers; jars and churns typically with two vertical loop handles on shoulder; also pitchers (those with alkaline glaze often have an ornamental mid-section roll), bowls, and some syrup jugs, spittoons, and chamberpots.* SPECIALIZED FORMS: *flowerpot-shaped pitchers; squatty, beanpot-shaped jars; coffeepots (with either tubular or V-shaped spouts); monkey (water) jugs; "flambeaux" (lamps); unglazed grave pots with narrow opening at top, decorated with relief bands, stepped tiers, and tooled wavy combing; late face jugs by Eddie Averett.* HIGHLIGHTS: *Washington County connections; some incised decoration; a few water-powered clay mills used; peddler distribution important.*

Lying near the center of the state, eastern Crawford County is just ten miles west of the city of Macon in Bibb County, yet it is almost as rural and isolated today as it was a century and a half ago.[1] Stretches of pineland are broken by small peach and pecan orchards, cattle farms, and swampy creek-bottoms, while the alternately red clay and sandy soil signal the presence of the Fall Line, which slashes diagonally across the county. The only population centers are centrally located Knoxville, the county seat, and adjoining Roberta, whose citizens number little more than 100 and 850, respectively.

Once open to settlement, Crawford County quickly became part of the Cotton Kingdom, with some corn and sweet potatoes also grown as cash crops; but the sandy pineland of the eastern part could not support large plantations, so that there the wealthiest inhabitants were small slaveholders (owning fewer than twenty slaves).[2] One of these was James Long, the founder of Georgia's second largest pottery community.

His great-great-grandson Jack, the last of fifteen Longs to make pottery in the area, wrote near the end of his life, "Once there were 18 potteries in Crawford County. All of them specialized in making whiskey jugs" (69). Some sixty-five "Jug Makers" (as the

United States census enumerators often listed them) operated at those shops, most before 1907, when the state prohibition went into effect. Many of their jugs were sold to licensed distilleries in Macon, where bottle hunters in recent years have dug up hundreds of them in old trash dumps: "It required two mules to pull a wagon loaded with jugs to Macon, as they could carry about 400 jugs on a wagon."[3] The rest were used by local distillers. According to a native, who was born into one pottery family and married into another, "Half the people in our part of Crawford County were making jugs and the other half were making liquor to put in 'em" (as told by 102A). The potters were concentrated in Sowell's Militia District, in later years associating themselves with the post offices of Dent, Pine Level, Gaillard (or Galliards), and Lizella across the Bibb County line.

The most extensive published descriptions of this community are found in the clay bulletins of the Geological Survey of Georgia, beginning with that by George Ladd in 1898:

> At many points in Crawford county, the clay, which is doubtless Potomac, is used for the manufacture of common pottery, an industry carried on in this country in a primitive way, and under conditions, which make its continuation remarkable. There are certain families, which are brought up, generation after generation, as potters, the business being carried on chiefly at odd times in the winter, and, at intervals, in the summer during the making of crops. . . . The products of this pottery are sold mostly by peddling, the articles being carried in wagons, so the writer was informed, sometimes to a distance of 75 miles, and disposed of, partly for cash and parly in trade. . . . Among the proprietors of different establishments, are Messrs. J. Becham, W. Becham, S. Becham, J. S. Newberry, J. N. Merritt, Thos. Dickson, H. N. Long and H. D. Marshall.
>
> The kilns . . . hold from 300 to 500 "gallons" per burning. They are rectangular, and have an intermediate draft. The clay used is a mixture of "chalk" (white Potomac clay), with mud obtained from the swamps. The clay is hauled to the potteries in wagons, over several miles of sandy roads. For glazing, these potters use a mixture of wood ashes, lime and sand. This is colored by the addition of powdered limonite. It makes a fairly good glaze; but it is rough, owing to the coarse sand contained.[4]

Further details were supplied by Otto Veatch in 1909: "The glaze is a mixture of lime and swamp mud, or lime, swamp mud and stream sand, and may be colored by a ground, siliceous limonite which occurs abundantly in this part of the country. In some instances, the potter burns his own lime, using the soft limestone at Rich Hill for this purpose. . . . The jugs are mostly hauled to Macon in wagons . . . and are used in the whiskey trade."[5] And in 1929 Richard Smith reported,

> In the eastern part of [Crawford] county, far from railroad transportation, there are a number of outcrops of kaolin, usually small and very impure and sandy. This section of the county was long the home of a unique pottery industry, now gradually dying out. These potteries or "jug factories" were operated by farmers, using primitive methods handed down from father to son. The ware, consisting chiefly of jugs, churns, and flower pots, was made from a mixture of impure kaolin and swamp clay or mud. . . . Veatch reports that in 1906 there were 12 of these potteries in the county, having a total output of about 160,000 gallons. . . . In 1927 just two of these potteries . . . were left.[6]

The history of the eastern Crawford County pottery community appears to have begun in 1826, when James Long purchased 172½ acres near Echeconnee Creek, which forms the county's eastern boundary.[7] He wasted little time in setting up a shop, for in 1829 the Reverend Adiel Sherwood's *Gazetteer of the State of Georgia* reported: "There is a pottery in the eastern part [of Crawford County], near the Icheconnugh, where large quantities of earthenware are manufactured."[8]

The details of Long's background are far from clear, but there are some suggestive clues.[9] Much of Jack Long's knowledge of his ancestors had come orally in 1933 from an old man named Matthew Wiggins, who, in turn, had learned of the family's travels from his guardian Jesse Bradford Long, son of James. To quote from one of Jack Long's letters: "This old man Wiggins . . . told me that our people were Scots. That they worked in the potteries around Glasgow, then came to Newcastle-on-Tyne, England, where everything was pottery. The family was large and they were told there were opportunities galore in America" (69). Newcastle-upon-Tyne, coal-rich capital of Northumberland in northeastern England, was not one of Britain's largest pottery centers, but a

thriving industry in both plain and fancy earthenwares did exist there, beginning about 1730.[10]

Census data consistently show James Long to have been born in Maryland in 1785. This, combined with the approximate starting date for the Newcastle potteries, suggests that his grandfather, perhaps, emigrated from England to Maryland around the middle of the eighteenth century.[11] Long's precise route into Georgia is not known, but it almost certainly took him through Virginia, North Carolina, and South Carolina, probably in the company of his parents.[12] By 1805, a James Long was living in Washington County, Georgia, where he participated in the land lottery of that and subsequent years.[13] A tax digest hints that he may have been there as early as 1794, when a Warren County resident was paying taxes on property in Washington "on the [Little] Ogeechee River adjoining lands of Beckham and Long."[14] The proximity of these two families may be significant, for the Bechams were later to become another Crawford County pottery dynasty.

The census of 1820 seems to confirm that the James Long living in Washington County was the same who later established a shop in Crawford, for the information given on the family members (one of whom—probably James—is listed as "engaged in commerce") and their ages generally conforms to the known facts about the potter's family. Near him at that time were others known to have been living in the northern part of Washington County, including stoneware potters Cyrus Cogburn and Abraham Massey, with one of whom Long may have worked (the three were contemporaries in age). The 1825 tax digest for Washington County shows that James Long had 100 acres on Williamson Swamp Creek, which runs just north of Warthen, but he is listed as a defaulter, owing $1.15 in taxes.[15] It may be that by then he already had moved, or was anticipating the move, to Crawford County.

Once established in Crawford, James Long was to become a prosperous small planter. The tax digests tell the story: by 1840, he had acquired 680 acres of pineland and five slaves; in 1856, he owned eleven slaves valued at $7,000, and the aggregate value of his property was $10,855; and in 1868, three years after the Civil War and a year before his death, he owned portions of five lots totaling 775 acres. Most of his wealth having been in his slaves, the total value of his property that last year was $3,199, still substantial enough to make him the seventh wealthiest (of ninety-five heads of households listed) in Sowell's District.

As with Georgia's other pioneer potters, little is known about the wares of James Long. At his house site (the rather modest, one-story dwelling was destroyed by a tornado in 1959), handle fragments were found stamped JBL, the mark of his son Jesse, but nothing was found that could be attributed to James; and his supposed pottery site, about two miles away (where another potter is said to have later operated), was leveled and developed for new housing.

However, a piece has come to light that very well could have been made by James Long, and since it is also one of the most extraordinary examples of Georgia folk pottery ever discovered, it bears description here. A stoneware storage jar of about twelve gallons in capacity, it was found by dealer and collector Billy F. Allen in an Atlanta antique shop, where it was being used as a trash receptacle; unfortunately, no background information could be supplied. Of graceful ovoid form, it has the double loop handles characteristic of Crawford County jars, and its smooth, medium/dark tan glaze resembles the lime glaze common to that area (color plate 4). The initials JL (with the serifs at the tops connected to form a distinctive mark) are impressed on the shoulder within each loop handle, and are not raised in the typical Crawford County manner.[16] The jar is elaborately decorated by the process of sprig-molding, a technique almost unheard of in the Deep South but one often associated with British stoneware.[17] Small molds of baked clay containing an intaglio design were filled with moist clay to produce the design in relief which adhered to the wall of the formed pot. The dominant motif used on the piece in question is a handsome grapevine, complete with leaves and grape clusters, applied around the neck, on the handle tops and terminals, and as a wreath flanking the head of Andrew Jackson, which stands out in bold, detailed relief on one side. On the other side, crossed floral sprays frame the face of Thomas Jefferson. The name of each figure is lettered in a semicircle below the head, while suspended above, an eagle with outstretched wings holds in its beak a banner proclaiming HURAH FOR JACKSON or . . . JEFFERSON. Finally, the upper half of each head is surrounded by a series of radiating lines suggesting a halo.

Folk pottery bearing a political message is rare in the South, but there is no mistaking the meaning of this jar. It reflects support for the Democratic Party (established in 1828) and its early leader, Andrew Jackson, who was president of the United States from 1829 to 1837. Partisan politics developed in Crawford County during the 1830s and reached its highest enthusiasm during the

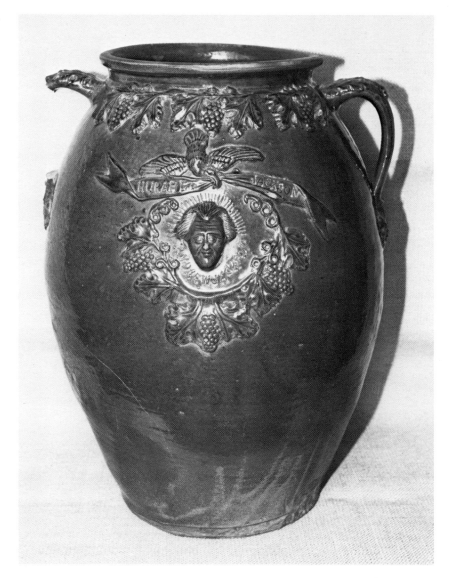

73. Political jar attributed to James Long, ca. 1830s, tan alkaline (probably lime) glaze, 21⅛″ tall. Collection of Billy F. Allen.

1840 election; the sympathies of the small slaveholders were Democratic.[18] Assuming the Jefferson/Jackson jar was made in Crawford County, it seems most likely, then, to have been produced in the 1830s or 1840s; and it is unlikely that molds for the sprigging, especially the heads, would have been painstakingly created for a single work. It is not difficult to imagine a potter like James Long capitalizing on the political climate (while expressing his own views and those of his class) by creating a line of jars that were at once functional, decorative, and supportive of his customers' political allegiances.

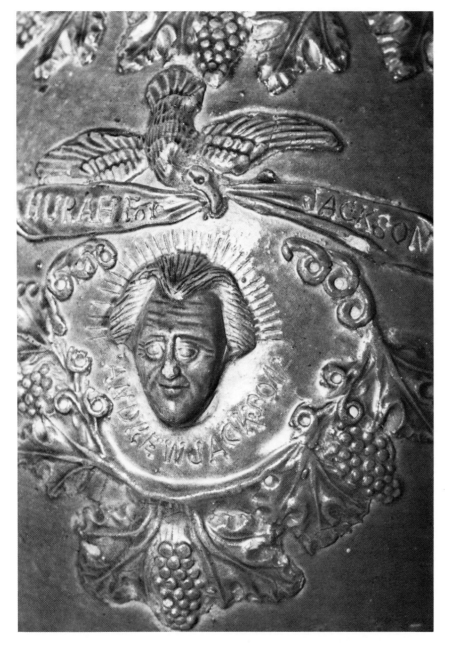

74. *Closeup of Andrew Jackson's head and surrounding sprig-molded motifs.*

The glaze preferred by the Long family seems to have been the lime variety of alkaline glaze, with some use also of ash glaze. When one of James Long's potter sons, Joseph, died in 1851, a half-hogshead of lime rock was included in the inventory of his estate.[19] The listing of this item just below "622½ Gallons of Jug Ware," "40 Gallons of Damaged Ware," and "209 Gallons of

*75. View of other side featuring
Thomas Jefferson.*

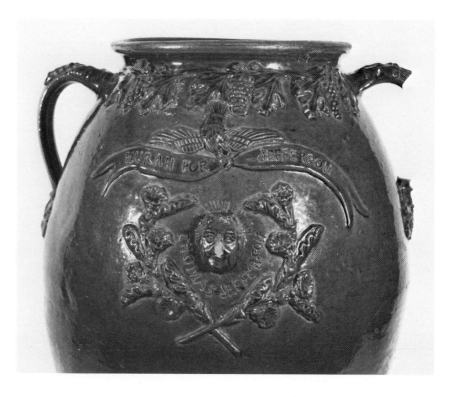

*76. Detail of stamped initials
within handle on shoulder.*

Raw [green or unfired] Ware" leaves little doubt that the lime-
stone was associated with Joseph Long's pottery business; had he
lived, he would have reduced it to lime in his kiln and used it in
his glaze. Instead, his older brother, potter Jesse Bradford Long,
bought the lot of rock for thirty-seven cents.[20]

It is not known whether it was the Longs, or another of the
older Crawford County pottery families, who discovered that they
could color their lime glaze by adding pulverized nodules of li-
monite/hematite, iron concretions that occur naturally along the
Fall Line and are still being plowed up in fields.[21] Jack Long's
brother Ben, while never a potter, remembered this "Indian paint
rock" as it was used at the shop of their father John in the 1890s:

> Have you ever seen a red rock and you bust it open and it
> has a recess in it? Well, there was just numbers of these.
> Some people called it Indian rock or Indian paint rock. I
> understand that the Indians used it for to make marks on
> their face. Usually they were the size of a fist, and you'd
> bust it open. It's hollow inside, and it's pounded up to
> where it's just a perfect powder. Pounded up in what they
> called a mortar—an iron bowl—with an iron pestle, until

it became just as fine as face powder. And they used that in the glaze. Called it "rock glaze." When you burned it, it turned a dark color. (68)

Normally, the "paint rock" changed the usually green or tan lime glaze to dark brown (nearly black), but variations in the glaze formula and firing conditions could produce other hues, including gray-brown with a metallic sheen resembling Albany slip. Sometimes, in the firing, the iron particles drifted toward the bottom of the pot, creating interesting patterns of shading in the glaze; while at other times, poorly blended glaze ingredients caused a tortoiseshell effect.

Several of James Long's sons were potters, but the most prolific seems to have been his eldest, Jesse (introduced in Chapter 3). Jesse's home was about four miles south of his father's, on Deep Creek. Pottery was produced at the nearby shop for at least half a century. As Jack Long wrote, "[Great-] Grandpa Jesse had quite a sizeable pottery, that was operated for many years after his death, and broken pottery there once looked like a small mountain. But

77. Variations in "paint rock" subtype of lime glaze. On pitcher at left (stamped HD on handle and attributed to Henry D. Marshall) the colorant is uniformly diffused, producing a dark brown glaze easily confused with Albany slip; jar at right with "beanpot" form shows the coloring evenly distributed but in "hare's fur" pattern; while on two central jars (the one at left having slab handles atypical for Crawford County) the iron particles drifted toward the bottom, creating interesting gradations of shading. In the foreground is an assortment of "paint rocks" (limonite/hematite nodules) plowed up in Crawford County and of the sort pulverized and used by the potters as a glaze colorant.

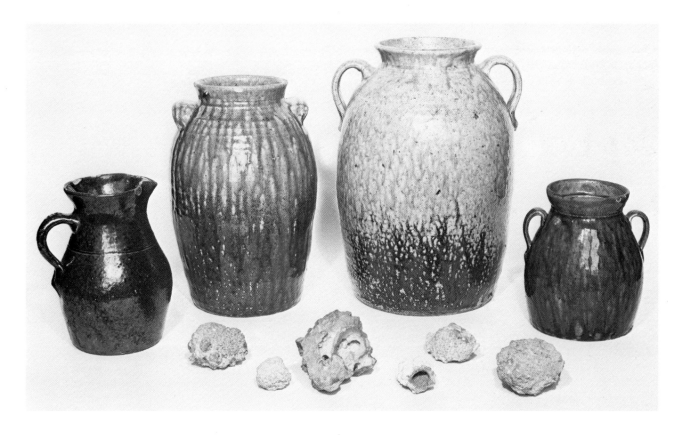

today you have to be careful to find even a bump on the ground" (69).

In February 1973 the site was located and explored by Georgia State University archaeology students under the supervision of Catherine Lee. Indeed, the piles of ruined ware had been considerably disturbed; residents familiar with the site stated that many of the sherds had been used as filler for building local roads (the use of waster sherds as road-fill is also reported for the Franklin Pottery of Marietta in Cobb County).

The most disturbed, but apparently the earliest, waster dump was excavated, while a surface collection was made at the largest, which literally forms a sixty-foot-long, eight-foot-high bluff overlooking a former road bed. The overwhelming majority of forms recovered are those of whiskey jugs, with some large two-handled syrup jugs, churns, pitchers, chamberpots, bowls, flowerpots, and the tubular spout of a "monkey" (water) jug or coffeepot. Many of the sherds display what appears to be a lime glaze, but Albany slip, and an olive-green, drippy glaze resembling ash glaze, are also represented. This variety of glazes is reinforced by the testimony of Ben Long:

78. Partially reconstructed chamberpot, ca. 1860s, excavated from Jesse Long shop site, 5" high, with drippy, olive-green alkaline glaze.

Well, there is "rock," and lime and sand glaze, and Albany slip, which used to be pretty costly. . . . I believe I told you earlier that they used ashes to make a part of that glaze. You see, they burned the kilns with wood and they'd have an ash pit there. They'd have to take out the ashes every so often, and have a certain place to go and dump 'em. Threw it away, except what they needed in the glaze. There was a large wooden vat that would hold about sixty or seventy gallons, filled with this glaze, and they put the jug in there, give her a twist, and pour it out. They'd take their hand and wipe the bottom so that it wouldn't glaze, otherwise it would stick to the sand on the floor of that furnace. (68)

79. Stamped mark of Jesse Bradford Long on eight-gallon jar with "paint-rock"-colored lime glaze; initials in relief and placement atop loop handle are Crawford County characteristics. Photo by Jay Brooks, courtesy of the Atlanta Historical Society.

A number of small whiskey jugs by the same hand, the handle-top of one stamped with the initials AJ (accidentally reversed for John Averett or Jerome Avera?), display an amazing rainbow-like striated coloration—mainly blue-green, cream, and brown— possibly another variation of the "paint rock" subtype of lime glaze.

Other initials, which marked about a third of the jug handles noted at the site, include JBL, HNL, HN, L, WM, CM, LA, and GR. This represents only a small percentage of the marks seen on Crawford County wares. In most cases, the initials clearly are those of the potters; but a few are less likely to stand for names (SX, SMX, JX, and XG). The initials also can be misleading, for they are sometimes reversed or represent only the first and middle names of the potter (as with HN, probably for Henry Newton Long). One cannot help but wonder about the purpose of these stamps, especially when contrasted with the absence of marking on most White County wares or the full names and post offices that characterize the marks of Jugtown and Atlanta-area potters and are more obviously an advertising device. The most likely possibility for the Crawford County marks is that they were a way of distinguishing the work of the hired turners employed at several of the local shops (including Jesse Long's) in order to keep track of each man's output so that he could be fairly paid.

A specialized form not represented in the sherd samples from the Jesse Long site but reputed to have been made there is the flambeau, a type of lamp or torch. As described by Ben Long, it was similar to a candle sconce; his father used two of them to illuminate the shop when working at night. Made of three joined sections, the base was a dish of about ten inches diameter, with

a cup about six inches high and three in diameter in the center for holding oil and a cloth "week" (wick). A curved reflector, about an inch thick, ten inches wide and ten high, was attached to the back edge of the plate; it was highly glazed, and would have to be cleaned of the smudging periodically. "You could put 'fat lightwood' splinters in it if you didn't have oil; they didn't make it on a big scale" (68). A second type of flambeau, resembling the "monkey" jug with two necks, was filled with kerosene and used for night work at Crawford County sawmills (64).

When Jesse left Crawford County about 1882 to join some of his children in Texas, two grandsons (whose father, potter Jasper Newton Long, had been killed in the Civil War) carried on the operation: John Sebastian and Henry Newton Long. John's pottery career ended tragically one June morning in 1895 in a freak accident. As local historian Bobby Stokes heard the story, John walked from his home down to Deep Creek, which was swollen by three days of rain and flowing swiftly, to see about his water-powered clay mill, mounted on a platform in the creek with a paddle wheel geared to a shaft with projecting iron blades that churned the clay inside a wooden tub. Wading to the platform, he tried to stop the mill, which was running too fast, but his coattail got caught by the whirling blades and he was dragged in. When he didn't return for breakfast, his wife sent their two boys to fetch him. Finding only his hat floating on the water, they ran for their uncle Henry, who, on examining the mill, found his brother John ground up (102A). This is the way Ben Long, the youngest of those boys, later remembered it:

> My father built a machine to grind up this mud. It ran by water and was used to mix together the different types of clay that would stand without what they call "cool-cracking" (a crack would come across the bottom after it was burned, and of course it would leak; the mixing of these two kinds of clay eliminated that). There was a paddle wheel, you know, and it sit down in the water. Of course the water run down under it and turned it. And that shaft, in turn, had staggered iron pins; I think there was eleven. And as it turned, it mixed that mud together.
>
> They had a freshet there and the water became unruly and my father couldn't stop the thing. He was all by himself early in the morning, and the supposition is that he was attempting to do something inside that tub, and one of the pins struck him right through the wrist and there

was no way for him to keep out of it. That was before I was six. My brother Jack was six years older than myself, and he and I found our father. And that wheel was still turning and we was unable to stop it. So we had to go back to the house to get his brother, my uncle, to come and stop the machine.

My mother had seven children—all too small to do any work—so she came to Macon and we were reared in Macon. Of course, our interests were still out here. My uncle was administrator and he carried on the business for a time, and then it was sold. You can scarcely tell now where the place was. (68)

A third variant of what has become a local legend was supplied by Jewel Merritt, of another prominent Crawford County pottery family:

Now, Ben Long's father got ground up in a clay mill. Then, they was on Deep Creek; the creek was kinda swift, you know, and they had a water wheel out in the water that ground the clay, and when they'd get ready to stop it—didn't have no pond or no dam or anything—they'd just stick a pole through the spokes in the wheel, see. Ben Long said he [John] got up one morning and told his wife he was going down to the shop and grind a mill of mud while she's cooking breakfast. And said they just kept waiting and he didn't return, so his mother sent him down there and he found his daddy in the clay mill. They thought he had reached up there with his hand to get a piece of mud to see how it was, and one of them pins caught his hand and drug him in there. I don't know whether that shop was operated much after that or not; that was before my time. (79)

The Longs seem to have been prone to such occupational mishaps. A Long family genealogist, Mrs. Martha Jane Hampton, writes:

In 1841 Elijah Long [son of James] worked at the pottery and died while working there, leaving a widow, a small daughter and an unborn child. This unborn child was named William Elijah Long. He also worked at the pottery and in the spring of 1866, he died from heat pros-

tration at the kiln—six months prior to the birth of his child. This child was named Sarah Willie Long and was my grandmother. (47)

After John Long's death his younger brother, Henry, carried on the business through the end of the nineteenth century. Resident J. W. Jones recalls that at that time the operation was extensive, with two kilns alternating full time: while one was being fired, the other was unloaded. But Henry Long encountered financial difficulties and lost the property about 1902. Still, the shop did not close; for at least another five years it was run by Rodolphus Yaughn, according to his daughter, Mrs. J. W. Jones (64).

The Long family's involvement with pottery ended with John Long's son, Jasper Newton ("Jack"). Although he worked mainly as a millwright and machinist, the trauma of his father's accident did not completely dampen his enthusiasm for clay. Before the Great Depression he opened a pottery at Echeconnee Station on the Central of Georgia Railroad in neighboring Peach County, using Byron as his post office. There he produced Albany-slip-glazed wares, both wheel-turned and slip-cast (including rather basic hound-handled pitchers of the sort that became popular in the early nineteenth century); but he panicked when the going got rough financially and sold the shop for next to nothing in 1938, bringing Crawford County's most powerful pottery dynasty to a close.

The Longs were not the only clay clan in the community, however. Members of the Becham family were potting there by 1850, their ancestors having come from England (probably Norfolk) to Virginia, then proceeding to Granville County, North Carolina, Edgefield District, South Carolina, and Washington County, Georgia.[22] Bechams received land grants in Washington County as early as 1784, and are established as living there by 1793, when they appeared on the militia muster rolls.[23] By 1830 many of the Washington County Bechams had migrated to Pike County, but that year's census shows a John "Beckun" in Crawford County, with sons in the right age brackets to be the earliest known Becham potters.

It is not known whether the craft practiced by William, John, Allen, Washington, and Benjamin Becham was learned in Crawford County through contact with the Longs, or by a previous generation back in England, Edgefield District, or Washington County, but in this case family inheritance seems likely. The 1850

census shows these five brothers—the oldest three recorded as "Jug Makers"—living together, evidently clinging to one another for mutual support after the death of their father. Although the eldest, William, is listed as a jug-maker in three successive censuses (1850–70), the best-remembered potter of that generation is "Wash" Becham, who, at the "jug shop" adjoining his two-story log home about five miles west-southwest of James Long, specialized in handsome beehive-shaped whiskey jugs with flared and everted mouths and strong handles, the upper end of which embraces the neck and is often stamped WB.

Based on marked examples, the youngest brother, Ben (BB), seems to have been more versatile, producing churns, flowerpot-shaped pitchers, and deep bowls or milk pans in addition to jugs

80. Becham jugs. The three whiskey jugs are stamped WB for Washington Becham, and display the characteristic beehive shape with flared mouth and wide upper handle embracing neck; the pear-shaped syrup jug is stamped CJB and was made by Wash's son Jack. All are lime-glazed, and except for the smallest are "paint-rock"-colored.

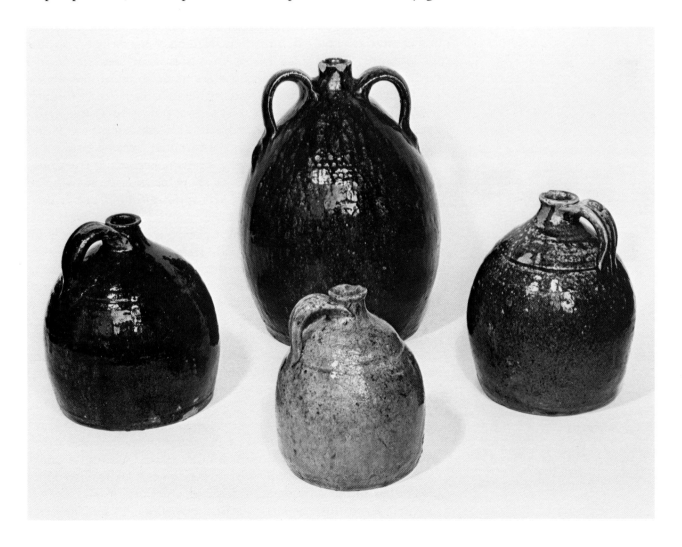

(plates 32, 41). Both potters preferred the "paint rock" type of lime glaze. John's sons, Seaborn and John III, maintained the craft into this century, as did Wash's sons, Jackson Columbus ("Jack") and Franklin Lafayette ("Fate"). The beehive-shaped jugs made by both clearly derive from their father's but lack the flared mouth. In addition, Jack (CJB) produced distinctive pear-shaped syrup jugs.

According to Henry Becham—one of Fate's sons—Jack stayed with Wash at the old shop while Fate struck out on his own, setting up a shop nearby which he operated for three years using a water-powered clay mill. Upon marrying, he moved to Knoxville District (his wife's family's territory), continuing to make pottery until about 1918. When Fate wasn't potting, he kept a small, one-mule "booger" farm with a large garden mostly for home consumption, including a cotton patch "to keep us kids out of trouble" (10). Besides jugs for whiskey and cane syrup he made churns, bowls, pitchers, flowerpots, unglazed cylindrical "stools" for large planters, and unglazed drainpipes used in the local "plantation bottoms." Fate also made a set of cuspidors, modeled on the brass variety, for the Knoxville courthouse.

His clay was the usual combination of "swamp mud" and "chalk," at the second shop mixed in a mule-drawn "mud mill" (one of Henry's chores as a boy). The glaze consisted of lime, "blue creek mud," and common salt—no ashes or sand—mixed with water to the consistency of buttermilk. On examples of their father's work owned by Henry Becham and his brother Frank this glaze ranges from pale to medium green, with a runny pattern more often associated with ash glaze than with the lime glazes of other Crawford County potters, perhaps a function of the salt.

Fate's kiln, which took around fifteen hours to burn, is said to have been about ten feet wide and over thirty feet long, capable of holding nearly a thousand gallons of ware, or three two-horse wagonloads. The potter rarely made hauling trips himself; instead, his family helped to load the wagons of middlemen peddlers. Henry attributes the demise of his father's operation to prohibition: "When Georgia went dry, that put a stop to the making of stone jugs."

The Averett family also contributed to Crawford County's pottery history. There were Averetts in Washington County by 1793,[24] and a James A. Everett occurs in the 1830 Crawford County census. The earliest known potter was Henry Averett, listed as a jug-maker in the 1850 census. There, he appears just below the five Becham brothers, with "E. Beckum, Planter"—evidently a

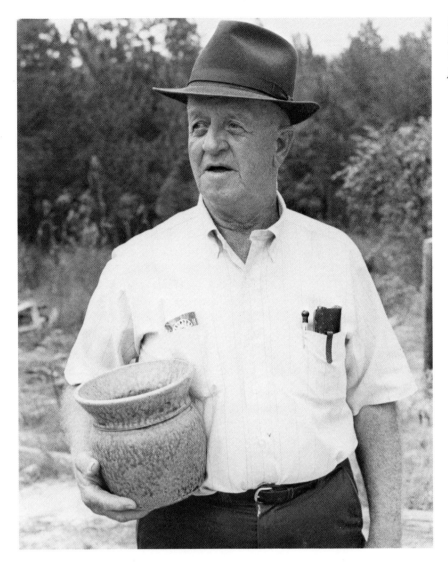

81. *Lime-glazed cuspidor made by Fate Becham for the Crawford County courthouse at Knoxville, displayed by his son Henry.*

sixth, non-potting brother—staying with him. This association suggests that Henry Averett may have begun his pottery career by working in the Becham shop, although it could have been the other way around. Two of his sons, John B. and William, were also potters; the latter is said to have worked with his son Thomas for John and Henry Long in the late nineteenth century.

Eddie Averett, the best-remembered potter of the family, was the son of Andrew Averett, who may also have been a potter and the brother of Henry. Richard Smith visited Eddie's operation shortly before its closing about 1928:

The pottery of E. C. Averett (Lizella) is 5 miles south-west of Lizella on the old Macon to Fort Valley Road. It is a typical old-time, one-man pottery, making jugs, churns, flower-pots, and small vases. The body used is a mixture of three parts of impure kaolin to two parts of swamp clay, both obtained nearby. It is tempered in a small crude pug-mill driven by a gasoline engine, and the ware is turned on a primitive potters wheel. Albany slip glaze (a fine brown-firing silt from the bed of the Hudson River near Albany, N.Y.) is mostly used, although some of the ware is given a lime glaze made from two parts of sand to one of slaked lime. . . . The production averages one kiln a month or about 6,000 gallons a year, most of which is sold on the yard to passers by.[25]

"Crude" though this equipment may have been, Averett by this time had made several concessions to modernity: the gasoline-powered clay mill, the adoption of Albany slip, and the production of "arty" vases to supplement his more utilitarian line, as shown in a photograph taken in 1927. According to his daughter Emmaus, wife of potter J. Otto Brown (who had come from Jugtown to Crawford County to work for Averett's neighbor Emmett Merritt), Eddie alternated his potting with blacksmithing and repairing watches; the glaze she most remembers him using was "sand and ash," for she helped to pulverize, with a brick, the glass that later was used in lieu of sand. She recalled that he made face jugs, and is the only local potter known to have done so (19).

Of the older Crawford County pottery families, only the Merritts are still making clay products, but of a sort markedly different from those of their forebears. In Crawford by 1830, their involvement in the local ceramic tradition may have begun through association with the Bechams. The first recorded potter of the family is Elbert Merritt, shown in the 1850 census as a planter but in 1860 as a jug-maker, living next to potter William Becham. In 1848 he had married Elizabeth Becham, presumably William's sister. Adjacent to Elbert in 1850 was what must have been his brother, Riley Merritt, and his wife Nancy, age thirty, along with Penelope Becham, age twenty-five; this suggests that Riley's wife also was a Becham, and that when their father died Penelope moved in with her older sister and brother-in-law. Riley is not recorded or remembered as a potter, but John and Jack Merritt, who were evidently his sons (in 1870 they were living with their widowed mother, Nancy), are. The Merritts were also

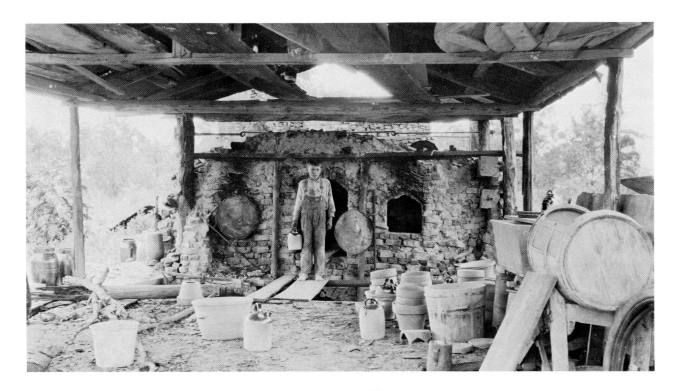

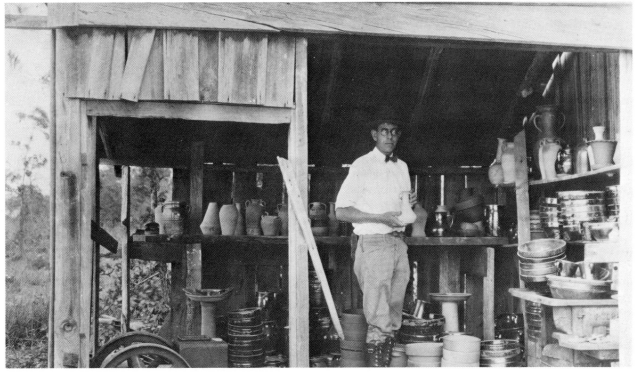

84. Outing at Billy Merritt Pottery, ca. 1900. Mule in background is hitched to clay mill; billowing cloth at right could be canvas cover for one of the wagons.

connected with the Averetts: Henry Averett married Catherine Merritt, and Henry's son, John B., married Sarah Merritt, sister of John and Jack (who are said to have worked for Eddie Averett).

One of the most prolific of the old-time Merritt potters was Elbert's son, William Dennis ("Billy") Merritt. When he abandoned his shop near Sandhill Creek in the late 1920s, he left an extensive waster dump which illustrates his solution to survival as a potter in the face of prohibition. The majority of sherds near the surface were of bowls, with only a small number of jug fragments. There were more bowls, with a greater variety of sizes and profiles, than I have seen at any other site in Georgia; such "peddling ware" must have become Merritt's specialty after the decline of whiskey jugs in 1907. All the sherds noted at this site seem to be lime-glazed, indicating that he shunned Albany slip after it had come to be used by other Crawford County potters; but a simple spittoon once used at a local church, owned and

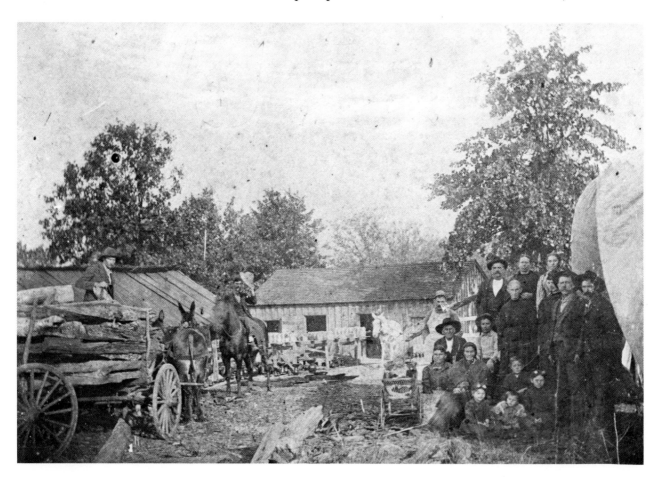

attributed to Billy by an older Crawford Countian, is coated with the "bought" glaze.

The most unusual items seen at his site were flowerpot-shaped pitchers, ranging in size from approximately one through three quarts. These are essentially hand-turned, alkaline-glazed flowerpots with a handle and pinched pourspout; the larger examples may have doubled as bowls or milk pans. Some have a mottled cream, green and brown coloration reminiscent of Rockingham-type ware. The form, known also to other Crawford County potters, is not far removed in concept from the loop-handled, truncated cone-shaped "clabber bowls" or "mortars" of Edgefield District.[26] The more standard pitchers produced at Billy Merritt's shop have a characteristic roll or small folded bulge running around the outside about one-third below the mouth, a detail also seen on some Edgefield pitchers.

A substantial number of churns, with two loop handles, were found at the site. The two-gallon size resembles a cream pot in form, but is known to have been used as a churn; an unglazed lid with splash guard, made to fit one of these small churns, was recovered. On one handle-top of the churn a gallon number frequently was stamped, ranging from two to five on the examples seen. The raised initials WD appear on some handles.

Also found were the upper portions of two clay coffeepots—with applied V-shaped spout and inner flange intended to seat a lid—and sections of three delicate, loop-handled jars that could have been made for honey or sugar. Part of a "monkey" jug was unearthed, with a separately turned off-center filling mouth and part of the stirrup handle that arched over the closed top; there would have been a longer, thinner drinking spout on the side that is missing. Such a spout was found, but the wall section

85. Flowerpot-shaped pitchers, a distinctive Crawford County form. The central example was partially reconstructed from sherds found at Billy Merritt shop site, while that at right, 6" tall, is attributed to Benjamin Becham.

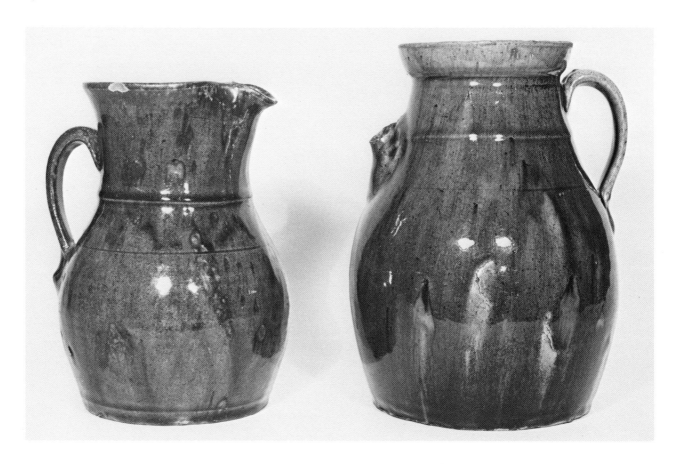

86. Pitcher and coffeepot (tubular spout broken), 8¼" and 9¼" high, respectively, showing typical roll or decorative bulge at shoulder in addition to incised line around midsection. The lime glaze on pitcher may have a trace of "paint rock" coloring, but most of the variation is due to melted iron particles that have bled from clay body into glaze; the coffeepot, however, shows definite coloring in "hare's fur" pattern, as well as characteristic tendency toward spalling (shear-cracking), possibly due to imperfect fluxing of the kaolin that composed about fifty percent of body.

attached to it is more like that of a coffeepot than a jug. Several flat-rimmed chamberpot fragments were also recovered. One bowl sherd is decorated with wavy combing similar to that seen on the unglazed grave pots at local cemeteries attributed to the Merritts.

A more enduring response to the drop in demand for whiskey jugs was that of Jack Merritt's son Emmett, who made the transition from folk pottery to mass-produced flowerpots after establishing the Middle Georgia Pottery, described in 1929:

> The Middle Georgia Pottery, operated by Emmett Merritt (Lizella), is 5 miles southwest of Lizella near the old Macon to Fort Valley Road, half a mile north of the Averett Pottery. . . .
>
> Although the direct descendent of a primitive "jug factory" established by Mr. Merritt's grandfather, this pottery has been considerably modernized. The principal product

is flower-pots, although jugs, churns, and small vases are also made.

The flower-pots are made from a mixture of equal parts of swamp clay and reddish, iron-stained kaolin, tempered in a 9 foot wet-pan and a small combination pug-mill and stiff-mud brick machine having two round dies. The pots are shaped on a Bard pot machine having a revolving inside mold and a stationary outside mold, both of steel. After air-drying for two weeks, they are fired to cone 07 or 08 in one of two round down-draft kilns, one 12 and the other 16 feet in diameter. The end point is controlled by

87. *Side-handled coffeepot with "paint-rock"-colored lime glaze. The form is related to that of eighteenth-century European ceramic and metal coffee and chocolate pots.*

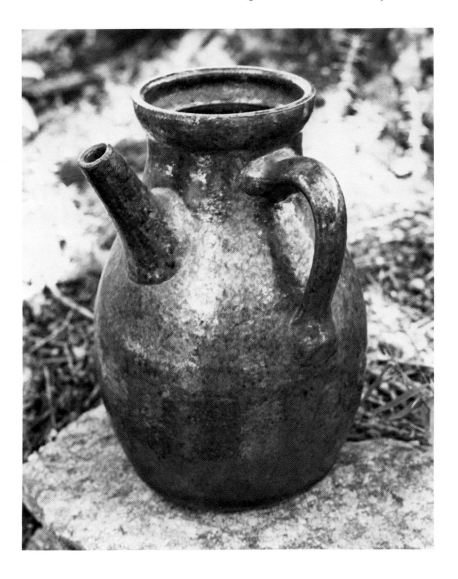

88. Wheel-thrown, uninscribed grave marker with combed decoration (top broken), attributed to the Merritt family.

American standard pyrometric cones, and the firing takes 45 to 60 hours.

The jugs and churns are made from equal parts of swamp clay and white somewhat sandy kaolin. They are turned by hand on the potters wheel, and are given an Albany-slip glaze or are salt glazed at the end of the firing period [this is the only reference to salt-glazing in Crawford County, and possibly represents the influence of J. Otto Brown, who had worked for Emmett Merritt several years earlier]. . . .

The plant produces 6,000 to 7,000 gallons of jugs and churns and about 700,000 flower-pots per year.[27]

Jewel Merritt, Emmett's oldest son, was able to remember the more traditional aspects of the plant during its transitional period, as well as the later days of his grandfather Jack and great-uncle Billy. The last Crawford County practitioner acquainted with the older approach to pottery-making, his recollections are worth quoting in some detail:

After prohibition they all quit, except Mr. Billy Merritt, he kept operating, he was right past Sandhill Creek; and there used to be one right down here on Knoxville Road, Mr. Eddie Averett, but he's been dead for more than thirty years, and his place just went to nothing, didn't anybody keep it up. Then my granddaddy Jack, he had one about a hundred yards [beyond the Middle Georgia Pottery]; he went to farming mostly, but in the winter they'd go back to making some pottery. And then he finally just quit farming about it, and went to making, he didn't make nothing but churns. Well, a few pots. And he done that up 'til he died.

We operated down here at the old pottery that my daddy left [the Middle Georgia Pottery]; he left it to a half-brother and myself. Well, Bill's still down there. I built a flowerpot plant [Merritt and Son Pottery] here on the corner of South Lizella and Knoxville roads [across the Bibb County line] in 1950; that belongs to my son Charles now.

All the clay that's ever been used in this country come off of Echeconnee Swamp. It's a light red. Well, they used to get some on this creek up here called Sweetwater; it was a white-burning clay. We used to grind clay with a mule, just like an old-timey cane mill, you know.

They used to use lime and sand glaze. They called it sand; they'd use part of the clay, a certain amount, I never did know [the exact formula], they quit that before I got large enough to know anything about it much. But they'd take so much of the clay they used to make the pottery with, and they'd mix a certain portion of lime with it, quicklime; they'd use a lump lime, I'd call it, because they'd have to put it in a vat and slack [slake] it, you know. They'd mix that up into a slurry and they'd dip their ware. And then, you can use wood ashes and clay, that will make a glaze. [In response to a question:] Salt glaze? No, that's something right in this part of the country they never did use. My daddy stopped using lime and ash glaze and started using Albany slip 'way back there. My granddaddy never did use Albany slip, he always just used lime or ashes and clay. They bought the lime in Ma-

89. Set of grave markers from another cemetery, evidently all by the same potter, lined up to show variations.

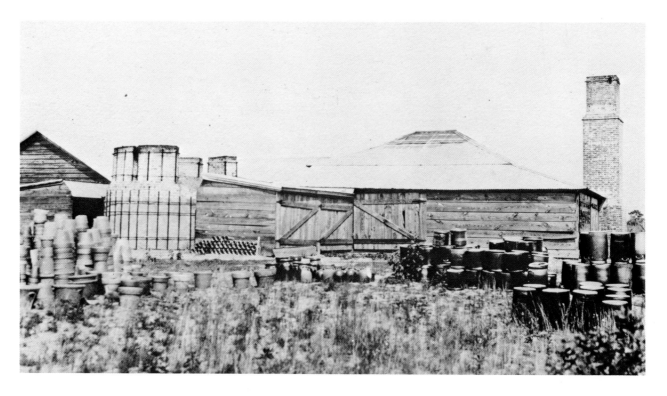

90. Emmett Merritt's Middle Georgia Pottery, 1927, when it was still producing glazed wares. Shown are slab-handled churns and crocks, jugs or poultry fountains, tub planters and flowerpots, and drainpipies. Courtesy of Georgia Geologic Survey.

con at building supply places. I remember my daddy using a little lime glaze, but mostly he switched to Albany slip, and I never did fool with nothing but Albany slip. We used to turn a few churns and things like that, but that's been more than forty years ago. We quit making glazed ware, just went to flowerpots. . . . Now, we always put trial pieces while burning Albany slip. We'd make some little small pieces and put a hole in 'em and glaze 'em and put 'em in there, and then you could take an iron rod and reach in and pull out one, tell when it was finished.

They used to fire those old groundhog kilns in one day. They would fire up early in the morning and finish that night sometime. Might be ten, eleven o'clock finishing. Some of them'd unload it early next morning, had to see how it done. Of course, they might have to use gloves or sacks or something, it'd be hot. But it had to come out next morning! It would have been a lot better if they'd have thrown something over the top of that stack to cut the draft down after it quit firing; they wouldn't have lost so much ware. They used to have lots of it cool-crack, it'd cool too quick 'cause the kilns was left wide open. (79)

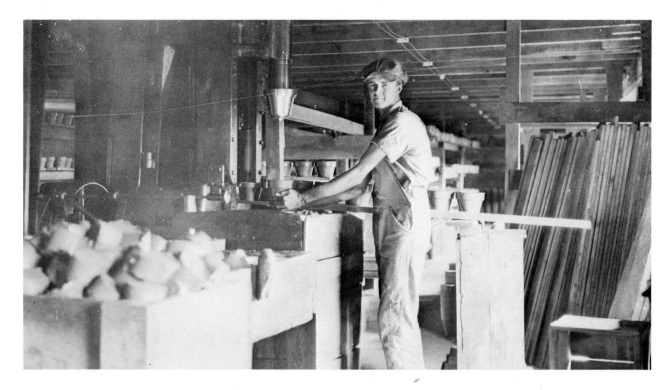

The Middle Georgia Pottery is now run by William E. ("Bill") Merritt, Emmett's younger son. Bill recalls that several decades ago, when the plant was operating at full force, it had its own commissary where workers could buy such items as lard and tobacco, blacksmiths were employed to keep the machinery in repair, over three hundred wagonloads of clay a year were hauled from Echeconnee Creek, and there were as many as twelve wheels for turning ware by hand. Only two wheels are still in working order and have been converted to electric power; they are occasionally used by Bill's sons, Mike and Craig, to make studio-type pottery. Initially, the two round kilns and the original smaller rectangular one were fired with wood, then coal in the early 1940s (by this time the groundhog kiln, which had been reserved for glazed stoneware, was gone), then diesel fuel, and finally were converted for gas firing (80). Not too many years ago two kilns of flowerpots and saucers were fired every few days; now they are burned much less frequently, and the bulk of Bill's business comes from distributing the products of others, including a line of Indian pottery imported from Central America.

The two flowerpot factories run by Bill Merritt and his nephew Charles represent the last tenuous link with the Crawford County

91. Molding the flowerpots that became the specialty of the Middle Georgia Pottery, 1927. Courtesy of Georgia Geologic Survey.

pottery tradition. The same "swamp mud" that once produced some of Georgia's handsomest folk pottery is now being processed by Charles's younger brother, Ray, and sold as "Lizella Clay" to ceramics firms, schools, and studio potters all over the country, but few who use it are aware of the history it embodies.

AFTER THE FOX: IN PURSUIT OF A SPECIAL JUG

Five years had elapsed since I last had visited eastern Crawford County; I was returning to locate new sites and important examples of local wares. But I had forgotten the county roadmap, and my traveling companion and I were—I confess—lost. Suddenly I recognized a familiar landmark, the general store that was, I recalled, across the road from the old homesite of pioneer potter James Long. Five years earlier, however, the site had been overgrown and partly surrounded by swamp. Now, there was a mobile home there and the swamp had virtually disappeared.

Disoriented, we entered the store to clear up the mystery. "Is that the old homeplace of the potter, James Long, across the road?" I inquired. The store ownership had changed, and the new proprietor wasn't sure. An affable man who had just come in and heard my question offered, "If you're interested in old pottery, I have a jug at home with writing all over it and a fox-hunting scene."

Quickly shifting my attention, I persuaded this new-found friend to take us home. My excitement at the prospect of an inscribed and decorated pot was tempered by the experience of countless wild-goose chases, yet hope springs eternal. This time, I was not to be disappointed. On a shelf in his kitchen sat the piece, a two-gallon jug with one of its two handles missing. The beehive shape and lime glaze fit it into the local tradition, yet the underglaze incising that covered it was outside my experience. Carefully inscribed on the front wall was the legend,

J. MARSHALL'S JUG
MADE AND WARRANTED BY J. C. AVERA
AUG the 31st 1871.

Below that was a cartoonish figure of a hunter grasping a rifle, the criss-cross pattern of his suit suggesting tweed. To the right were two economically sketched dogs in flight, and continuing in the same direction, around the other side, was a bushy and harried-looking fox. The tiers of cross-hatchings dominating the

jug's back suggested stylized woods into which the fox was fleeing. In addition, a decorative stamp or die had been impressed in several rows into the clay.

Should I content myself with photographing and measuring this remarkable piece, or could I persuade the family to sell it, using the argument that it deserved to be protected from further damage and preserved where many could appreciate it? Two hours later I was hoarse, in debt, and emotionally wrung out, but I had acquired the jug for posterity.

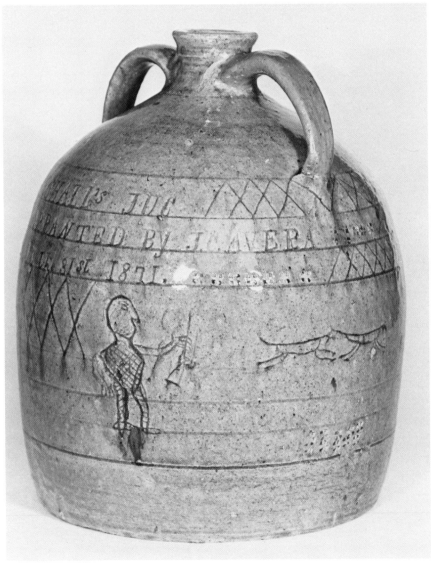

92. Two-gallon whiskey jug in bee-hive shape by John C. Avera, 1871, 12¼" high. Armed hunter (probably representing the recipient, John Marshall) and two dogs in pursuit of fox were incised under a light-tan lime glaze. Note decorative stamping; handle on right has been restored.

93. Other side of foxhunt jug show-ing fox fleeing into area of cross-hatchings which may represent woods.

Subsequent research fleshed out the documentation already present. In the 1860 census John C. Avera is shown as a carpenter, but in 1870 he is listed as a "Jug Turner." About 1854 he had married Mary Ann Elizabeth Long, daughter of potter Jesse Long (102B), and the 1880 census shows their son, Jerome, working at Jesse's "jug factory." It seems likely, then, that John Avera entered the craft through his association with the Longs.

The tax digest for 1871, the year Avera made the foxhunt jug,

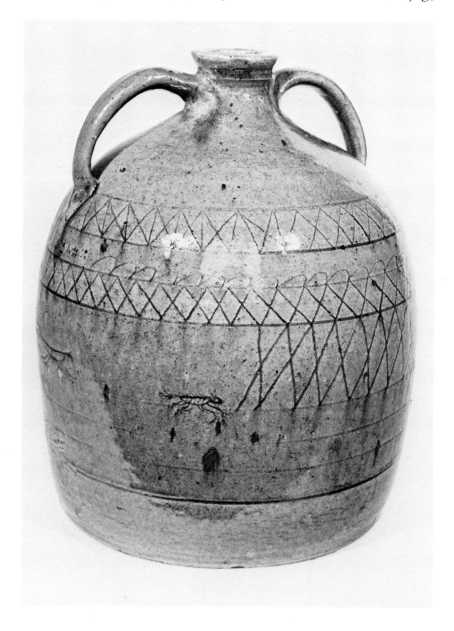

shows that he owned no land, had $150 in cash with the remainder of his property valued at $50, and was supporting five children. The same document shows John Marshall, the man for whom the jug was made, to have been a prosperous landowner, with portions of four lots totaling 275 acres valued at $2,000; the aggregate worth of his property was $3,060, a considerable sum in those Reconstruction days. The scene on the jug is reinforced by the recollection of Bobby Stokes that his great-great-uncle, John Loudy Marshall (1837–1917), loved fox hunting (102A). In the 1860 census he appears as overseer of James Long's plantation; his brother, Henry Doss Marshall, is known to have been involved in the pottery business.

By 1880 John Avera, a potter too poor to have his own shop, had abandoned Crawford County, for the census shows him as a farmer in south Georgia's Lee County, and in the 1900 census he appears as a widowed dispensary manager at Bronwood in adjoining Terrell County. While his pottery career thus seems to have been relatively short-lived, it is distinguished by this extraordinary surviving example of his work.

CRAWFORD COUNTY POTTERS

Avera, Jerome
Avera, John C.
Averett, Andrew*
Averett, Eddie C.
Averett, Henry
Averett, John B.
Averett, Thomas J.
Averett, William
Becham, Allen
Becham, Benjamin J.
Becham, Franklin Lafayette
Becham, Jackson Columbus
Becham, John, Sr.*
Becham, John, Jr.
Becham, John, III
Becham, John
Becham, Seaborn
Becham, Washington
Becham, William
Brown, J. Otto
Bryant, James E., Sr.*
Bryant, James E., Jr.
Bryant, John Lafayette*
Bryant, Laban L.
Bussell, James M.*
Bustle, James
Croom, Giles W.
Dickson, Leonidas S.
Dickson, Thomas
Harper, Jesse
Harper, Sylvester
Hart,————*
Hartley, J. Monroe
Hicks, Elijah H.*
Jones, William B.
Long, Alford*

Long, Elijah
Long, Francis M.
Long, Green W.
Long, Henry Newton
Long, James
Long, James B.
Long, James M.*
Long, Jasper Newton
Long, Jasper Newton ("Jack")
Long, Jesse B.
Long, John H.*
Long, John S.
Long, Joseph H.
Long, Virgil O.
Long, William E.
Long, William F.*
Marshall, Henry D.
Marshall, William J.
Merritt, Charles W.
Merritt, Elbert
Merritt, Emmett
Merritt, Jackson N.
Merritt, Jewel E.
Merritt, John
Merritt, Monroe
Merritt, Riley*
Merritt, William D.
Merritt, William E.
Newberry, J. S. (or H.)
Newberry, Wiley J.*
Stork, Edward L.*
Whittington, Jasper N.*
Yaughn, Coot
Yaughn, James
Yaughn, Rodolphus

* Suspected but not established as a potter, perhaps known as a potter else-
where.

CHAPTER ELEVEN

Jugtown
(Upson/Pike Counties)

Began around 1830s. NUMBER OF POTTERS: *about fifty.* KEY NAMES: *Brown, Bishop, Brumbeloe, and Rogers.* GLAZES: *Albany slip, salt, and early alkaline.* MAKER'S MARK: *ware often stamped on shoulder or lower wall with potter's first and middle initials and surname, sometimes post office (Delray, Kenzie, or Meansville).* MAIN FORMS: *jugs (later type cylindrical, with handle-top applied at or near mouth and often a stacking ledge around shoulder) and churns.* SPECIALIZED FORMS: *marbles, grave pots, ring jugs, and face jugs.* HIGHLIGHTS: *earth-enclosed "groundhog" kilns were concentrated here; Marie Rogers currently making miniatures.*

In contrast to North Carolina's well-publicized Jugtown Pottery, Georgia's Jugtown (an unofficial name not appearing on maps), ten miles north of Thomaston on the Upson/Pike County line, is virtually unknown to American ceramics historians.[1] Lying a short distance above the Fall Line, with stoneware clay available in the swampy bottomlands of Potato Creek, the community has been home to approximately fifty folk potters. It also has been a stronghold of King Cotton, supplying the local textile mills that began to spring up in the 1830s. These two interests did not always coexist peacefully; according to D. X. Gordy, farmers in the area used to complain that their cotton was being blackened by soot from the kilns (43).

The most extensive published description of Jugtown—a single page in a hefty 1930 history of Upson County, evidently based on conversations with older residents now dead—bears quoting.

In a remote section of Upson County, approaching the Pike County boundary, is found a variety of clay peculiarly adapted for use in making pottery, and here that industry has been practiced for nearly one hundred years in the village called Jugtown.

The first known pottery was operated by Bolling Brown,

on what is now known as the Franklin place, but the in-
dustry was later transferred across the creek. . . . The
Brumbeloe family were perhaps the next operators and it is
said one of them turned utensils for the Confederate sol-
diers during the War Between the States. S. R. Rogers
who operates the pottery at the present time learned the
trade while he was a child, as most potters do. He is a
grandson of Frederick Rogers and his wife Jennie Brown
(who was a half-sister of Bolling Brown). . . .

Others who have operated plants in this section are:
J. O. Brown, J. J. Childs [served as State Representative
1923–26, State Senator 1926–28], W. C. Rogers, J. H.
Stewart, B. S. Salter, J. W. Salter, J. F. Key, John
Creamer and S. L. [*sic*] Rogers.

S. R. Rogers married Ida L. Salter and they have ten
children. Products of Jugtown factory have been shipped to
fifteen states by Mr. Rogers.[2]

This, combined with the following oral history narrated by
William L. Traylor, kin to the Brumbeloes and one of the few
residents who now remembers the potters in some detail, sets the
stage for an exploration of Jugtown's ceramic history:

As best we can get together, they were twelve or maybe
fo'teen of those shops in a circle right around in here.
That's why it's named Jugtown.

They would go down here on Potato Creek and they was
a certain type mud down there and it was dug down here
on the creek. And it was brought back in, and put in a big
ol' round concern and ground. Mule pulled that. The clay
was just cut all up and all the trash was taken out. And
they got that mud all worked up.

They had days that they'd grind the mud (as they called
it), and then they'd have days that they'd turn it into
either jugs, churns, or flowerpots. That mud was weighed.
Say, for instance, they'd make jugs for so many days, and
you'd have a big room, maybe twenty by thirty foot, and
they'd have boards, and as they'd make 'em they would set
those jugs on those planks, and when they got so many
made then they'd glaze 'em with Albany slip and carry 'em
out and put in the kiln.

Let's see, there was uncle Newt Brumbeloe, but now his
original business was in Chalker; he came over here later

years and worked for uncle Ben Salter up here on the ol'
Indian Trail Road for a number o' years. And, let's see,
they was three or four of the Brown boys. And, uh, one,
two, three of the Rogers: uncle Wile Rogers, uncle Rufus
Rogers, and then Horace Rogers. And then you had a fam-
ily too, the Bishops. I believe it was three of those con-
nected with it. And the first pottery in these parts was
probably opened in the 1860s by Jasper Bishop. And then
in later years—not too many later—ol' uncle John
Creamer bought a po'tion of land just over in Pike County.
Now, a po'tion o' that ol' buildin' is still there, but none of
the parts that you work with, they're all gone.

There was Frank Long [said to be from a local family,
not directly related to the Crawford County Longs]. Now
at that time he was [working] on the Salter place. Great
big house, 'bout a six room house. They had a huge barn
out there, and then they had the kiln and other stuff over
here on this side. And he [Long] lived right across over
there, half a mile, I reckon, from the place. And he
walked back and forth over there to his work. He was a
little man. Let's see, now, that would go back in the latter
part o' the twenties, first o' the thirties. The Stewarts' fur-
nace was, I believe, the last one done away with right in
this area. Uncle John Henry Stewart was runnin' that when
it closed down, sometime in the thirties. It was done away
with, just folded up.

Well, as the different members of the family grew up,
they decided to do somethin' else, and they just folded up.
And when the pa got to where he couldn't fool with
it. . . . It was kinda muddy, you know what I mean. It's
not what you'd call real dirty work, but it's just not the
cleanest work. And that dampness at the wheel is one o'
the greatest contributors to TB that I know of. I know o'
several [potters] that died of TB. Now, my uncle, Newt
Brumbeloe, he did. And he fooled with pottery for years
an' years.

They'd carry that pottery to different towns. Mule and
wagon. Be gone a week, two weeks, somethin' like that.
They'd camp along the road, have their canvas tops, you
know, carry their food. Sell the pottery out o' the wagon or
maybe once in a while you'd have a man to tell you,
"Well, I'll take so many o' this, that or the other." And
he'd get a whole load. Well now, they'd get back on a

whole load lots quicker like that. They'd go over here to Jackson [Butts County], and Senoia [Coweta County], oh, just several o' these places scattered 'round here. Far as LaGrange [Troup County on the Alabama border]. I believe I've heard one or two say they went over 'way into Alabama with a po'tion of 'em. A good bit o' that was sold in Georgia, most of it. They'd charge fifteen, twenty cents for a gallon jug.

Nearly every home that you could think of back years, they all kep' cows. They had your fresh buttermilk and 'course naturally had your sweet milk twice a day, mornin' and night. But it was put up in that glazed earthen churn. Most of 'em was three, four, five gallons; once in a while they made sixes, but wasn't often.

And, too, some of 'em made these ol'-time marbles. I don't know whether you've ever seen what we called "Five Marbles in the Ring." You'd have your board set up 'way off out yonder and you'd have a line so far, and your big ring 'round here and your marbles 'bout that big. They were 'bout, I would say, an inch in diameter. And then the taws [large marbles for shooting] were just 'bout as big as your microphone head there, maybe a little smaller. Back then, they didn't have too much for recreation. Maybe people'd get caught up with they work, why they'd go to a neighbor's house and shoot marbles all evenin'. Now, they glazed and burnt 'em just like they did your other [pottery]. And they were hard, you might coulda thrown it real hard and cracked 'em up some, but as far as just playin' and shootin' 'gainst one another, you didn't break 'em like that. Quite a few of the families kep' those marbles.

The particular ones that I called, they were just potters altogether, but now they were some in that family that was runnin' the farm. Each home that I've called, they were farmers. Pottery was the way they made lot o' their cash money. And they didn't have too much back then. (104)

The earliest known Jugtown potter was Bowling (Bolling) Brown, one of no less than twenty-five Brown potters spanning at least eight generations. There are few southern states whose clay has not been touched by this amazing dynasty of peripatetic potters, apparently beginning in eighteenth-century Virginia. In their perambulations over the next two centuries they have worked

in North and South Carolina, middle, north, and south Georgia, Alabama, Mississippi, and Texas.

According to family tradition, the patriarch of the line was an English immigrant potter named John Henry Brown (18, 108). Needless to say, the commonness of the name has been a major obstacle to tracing the earliest members of the family. Working from the knowledge that Bowling was an early Jugtown potter, it was at least possible to pick up the thread in Georgia. In a will dated January 13, 1851, a William Brown of Pike County refers to his son Bowling.[3] Exactly two months later, the estate of "William Brown deceased" was appraised, and the last item on the brief inventory was "Turning implements" valued at ten dollars, a likely reference to potter's wheels and accessories.[4] In the 1850 census of Pike County, a year before his death, the same William Brown, age sixty-six and born in Virginia, is shown as a farmer, with real estate valued at $3,650. His wife and several children are listed, but Bowling is not among them or anywhere else in the 1850 Georgia census index. Bowling later moved to Howell's Mills, northwest of Atlanta, and in the 1880 census for the Buckhead District of Fulton County he is shown as a seventy-three-year-old potter, born in Georgia, father born in Virginia. There is little doubt, then, that Bowling's father was Virginia-born William Brown, with a documented suggestion that he, too, was a potter.

Also in the 1850 Pike County census are Benjamin and Hiram Brown, ages seventy and sixty, both born in Virginia (Hiram is shown as a cooper in the 1860 Upson County census). It is probable that they were brothers of William. A Benjamin G. Brown was paying taxes in Pike County in 1825, and the 1827 Upson County tax digest shows two William Browns owning land on Potato Creek; the 1830 census has William, Benjamin, and Hiram all in Pike. The earliest deed recorded for William is 1827, in which he was selling land in Upson; by 1831 he was purchasing land in Pike.[5]

In their journey from Virginia to Georgia the brothers would have stopped in a more easterly county before the Jugtown-area lands were opened. We know that William was in Georgia by 1806, when Bowling was born. A Hiram and William Brown were in Hancock County in 1812,[6] and by 1820 there were two William Browns in adjoining northern Washington County, near known potters. If William migrated to Upson/Pike from Washington County, it would have been about the time a group of Bechams (who are not recorded as potters at Jugtown) made the

same move. Supporting the possibility of this route is the ap-
pearance in the 1827 Upson County tax digest of Washington
County stoneware potter Cyrus Cogburn; his property was on
Tobler's Creek, somewhat south of the Jugtown area.

Little is really known about the early pottery activity of the
Browns at Jugtown; when interviewed in 1977 Javan Brown, the
oldest living potter of the family, was not aware that the Browns
had been at Jugtown before the turn of the century. In the 1860
census for Pike and Upson counties, Bowling Brown, his sons
John S. and Bowling P., his younger brother William S. (who
had married potter Jasper Bishop's sister, Nancy, and was then
living with him), and his son-in-law Thomas B. Cofield, all ap-
pear as "Jug Manufacturers" or "Jug Makers." Eventually these
potters gravitated to the Atlanta area, but members of later gen-
erations, such as Javan's father, James Osborn Brown (grandson
of Bowling), made periodic pilgrimages back to Jugtown. A gossip-
column clipping, "Kenzie Kindlings" (Kenzie is short for
McKenzie, the name of a local store owner), found in one of the
ledgers of potter Rufus Rogers and probably taken from the
Thomaston newspaper sometime in the first two decades of this
century, documents the Browns' continued association with Jug-
town: "Mr. J. O. Brown has completed another pottery factory
and burned the first kiln of ware Saturday. This makes a total of
five factories, four running and one idle which are located within
a radius of one mile of here and yet there are people in Upson
and Pike counties who have never seen a jug made."

If the Browns were Jugtown's first potters, the Bishops were
not far behind. Family tradition has it that the Bishops practiced
the craft back in their homeland, Holland (13, 43, 71). South
Carolina–born Thomas Bishop, at Jugtown by 1840, is the first
who can be connected with the local pottery business, although
he was recorded as a farmer in the 1850 census. His sons Jasper
and Henry are the earliest documented potters of the family.
Spencer N. Bishop, probably Thomas's oldest son, appears as a
"Jug Dealer" in the 1860 census; in 1847 he had married Nancy
Brown, possibly a daughter of William. Another Brown connec-
tion, mentioned earlier, is that William Brown's son, William
S., married Thomas Bishop's daughter Nancy in 1854.

On the whole, Jugtown's potters seem to have been less tied
to home than those of Georgia's other centers, and the Bishops
are no exception. Henry Bishop once ran a pottery near Digbey in
Spalding County, about twenty miles northwest of Jugtown at
the juncture of Line Creek and the Flint River. There, with Charlie

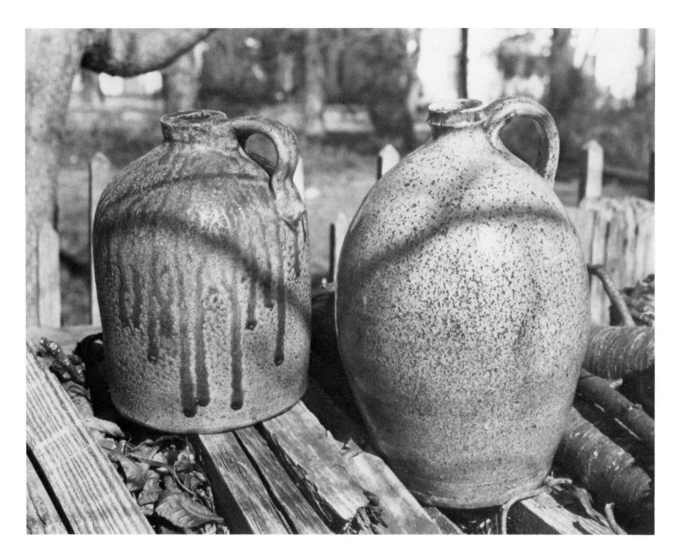

Kline and, later, Jefferson Key, he specialized in salt-glazed whiskey jugs for the licensed distilleries at Griffin and Drewryville (43).

The groundhog kiln used by Jasper Bishop, located in Pike County six miles below Zebulon, is the only reasonably intact example standing in Jugtown; when it ceased to function as a kiln, it was used as a storm and food cellar. Resembling an animal burrow lined with sandy-mortared bricks, it is sunk into an embankment and thus surrounded by earth, so all that is exposed are the kiln face and fieldstone chimney-top. The floor is about seven and a half feet square, and, while deterioration of the bricks did not permit an accurate height measurement, the arched ceiling would have allowed for the double stacking of churns. Sherds

94. Jugs thought to be of Jugtown provenance. The example on the right, having cream-colored alkaline glaze with tan flecks, is probably antebellum, while that on the left, salt-glazed with heavy deposit of fly-ash or salt and handle-top applied at lip, is typical of the later nineteenth century.

collected from the surface of the overgrown waster dump were glazed with Albany slip, but the inside ends of the kiln bricks have a thick, clear to bluish deposit of salt glaze, and many had crumbled off, probably from corrosion by the hydrochloric acid that was a by-product of the salting. Pottery forms recovered from the dump include "stacker" whiskey jugs, churns, churn lids with splash guards, milk pitchers, mixing bowls, flowerpots, jug-stacking dishes (some glazed), and elongated spacers used to separate columns of stacked ware (plate 58). As decoration, several bowls and flowerpots displayed incised wavy combing or two parallel lines with a continuous sawtooth pattern scratched between them. A number of fragments were stamped J.A. BISHOP / DEL RAY GA on the shoulder, and the mark JD BISHOP was also found. Jasper's sons, James, William Davis, John, and Andrew, were all involved in the craft.

Information on the later history of the family was provided by Fred Bishop, the only resident of Jugtown once involved in pottery-making. Fred recalls that his grandfather, William Davis Bishop, was as much a trader as a maker of pottery, going off for a week at a time on hauling expeditions by covered wagon to hardware stores in towns like Manchester (Meriwether County) and Griffin (Spalding County). Fred says that his father, Curtis, "one of the best" of the Jugtown potters, worked for others after closing his own shop, including Rufus Rogers and W. T. B. Gordy. Fred himself entered the craft early, quitting school at the age of eleven to go "on the road" with his father. He especially remembers his stints in South Carolina with J. W. Johnson at Lanford and the Baynhams at North Augusta. The decline in business during the Great Depression caused Fred to enter the Thomaston textile industry, but he still lives in Jugtown; on what is now his lawn the kiln of William Brumbeloe once stood.

Fred confirmed that most of the Jugtown kilns were enclosed in earth, with ditches dug around them to draw off water from rainfall. He remembers John Creamer as the only local potter with a kiln that was not embedded in the ground. Creamer is said to have hired members of other Jugtown pottery families— Rogers, Salter, and Brown—to work in his shop. During the period recalled by Fred, Albany slip was the basic glaze, with salt glaze used only occasionally. The walled dishes used to stack jugs (if not perforated to accommodate handles and mouths) were often glazed so that they could be sold as dog feeders or chicken-watering pans. The potters sometimes made playing marbles for their own children, seldom if ever selling them. Molded tobacco-

95. Three generations of Bishop potters, 1917: Jasper (bearded), his son W. Davis (with mustache), and his grandson Curtis. Also shown is Hugh Bishop, eldest child of Curtis. Courtesy of Mrs. June Bishop Maddox.

pipes were made of the same clay as jugs, and flowerpots, "nesting" one inside the other in columns, were burned at the chimney end of the kiln where the temperature was lower. The jugs, Fred claims, were used mainly to hold syrup, as the quality of the local clay was not always high enough to be impervious to alcohol, even when glazed. He believes that prohibition was thus less a cause of Jugtown's demise than the emergence of modern canning methods (13).

It seems that the Brumbeloes were drawn into the Jugtown pottery business through their connection with the Bishops.

William R. Brumbeloe is shown as a "Jugmaker" in the 1880 census; Emanuel J. Brumbeloe, evidently William's father, appears in the 1850 census as a hatter, living two houses from Thomas Bishop. Bishop's sons, Jasper and Henry, in addition to being potters, are also known to have been involved in hat-making; that was the occupation shown for Jasper in the 1870 census, and Henry, according to his great-nephew D. X. Gordy, made stoneware in the summers and hats in the winters, which he peddled by wagon. One can almost imagine the two neighboring families exchanging skills, the Bishop boys learning to make felt hats from E. J. Brumbeloe while the latter's sons learned potting in Thomas Bishop's shop. Walter, Oscar, and Newt Brumbeloe (who moved to Chalker in Washington County about 1910), sons of potter Camelius (another son of Emanuel), and William's son James Andrew, were the last generation of Brumbeloe potters at Jugtown.

Another set of potters tied to the Bishops is the Gordys, two of whom are still active on the Georgia ceramics scene. The family had settled early at Jugtown but did not become involved in making pottery until William Thomas Belah Gordy (whose father had peddled the local wares) received training from his uncles, Henry and Jasper Bishop. Once he had learned the basics, the young Gordy left Jugtown and went into partnership with a roving potter named Edward Leslie Stork.

Stork was a late, and somewhat indirect, link with the stoneware tradition of Edgefield District, South Carolina. His father, John J. Stork, began his career as a cabinetmaker in that state's capital, Columbia; but by 1870 Lemeus Landrum was running the pottery his father Abner had established on the outskirts of town after leaving Pottersville, and John Stork and his brother William were working there. During the 1880s Edward must have learned the craft in the Columbia shop, after which he took to the road.[7] The exact order of his movements is unclear, but according to his daughter he potted in Alabama and Mississippi after leaving South Carolina (14). In Georgia he is said to have zig-zagged from Elberton, near the South Carolina border, west to Orange in Cherokee County, then south to Senoia in Coweta County, east to Chalker in Washington County, then southwest to Crawford County, moving up in a covered wagon to Alvaton, in Meriwether County about twenty miles northwest of Jugtown, where in 1907 he joined W. T. B. Gordy.

Their first shop was obtained from potter Frank Gibson, who was leaving for North Carolina. A year later they moved north

to Shakerag, a settlement in Fayette County not far below Atlanta, converting an old log double-pen house into a shop. It was Stork who introduced the above-ground tunnel kiln to Gordy, who previously had known only the earth-enclosed groundhog kilns of Jugtown; Gordy would adopt the former because it attracted less moisture, making it easier to fire. After half a year they moved again to Aberdeen, near present-day Peachtree City, in the same county.[8] The partnership dissolved in 1909 when Stork left to settle at Orange seven miles east of Canton, where, until his death in 1925, he produced a wide range of wares usually glazed with Michigan slip, which sometimes fired to a burnt-orange color.[9]

Gordy remained at Aberdeen for ten years, then returned to Alvaton for an additional seventeen years. Most of the surviving folk pottery with his mark dates from this second Alvaton period, 1918–35. He used mainly Albany slip as his glaze, occasionally salt-glazing over it.

One of his specialties was the home-brew crock, a popular item during Prohibition when do-it-yourself zymurgy was the rage. Home brew (beer made of malt, yeast, and sugar), hard cider, and wine could be fermented in any vessel, but the home-brew crock was designed specifically for the purpose and was more reliable. It was basically a large churn with a wide groove, or well, turned into the mouth to receive a corresponding flange on the underside of the lid (plate 48). Filled with water and the lid placed over it, the well created an airtight seal that prevented the fermenting liquid from turning to vinegar, while at the same time permitting the escape of gases which, if not liberated, could lead to a very messy explosion. W. T. B. Gordy's son, D. X., remembers falling asleep as a child to the rattling of his father's home-brew lids in the kitchen as the beer "worked" and the gases bubbled out. The sugar shortage of World War I had made five-gallon jugs for home-grown molasses another good seller at the Gordy shop, and when demand for that purpose declined, "blockaders" took up the slack. But by the mid-1920s most moonshiners were packaging their product in square metal cans lined with paraffin, which were better able to withstand the bumpy trips to market in touring cars and roadsters.

In addition to producing such functional wares, W. T. B. Gordy occasionally displayed artistic tendencies that he later would have cause to exploit more fully. His wife Annie contributed to this branch of his work, adding decorative detail to the jugs and banks he fashioned in the form of human figures and modeling the

grape clusters, oak leaves, ears of corn, lizards, and butterflies from which he created molds to ornament his urns.

Not all the pieces bearing W. T. B. Gordy's mark were made by him. His shops—the one at Alvaton having three wheels—became a haven for itinerant potters from all over the country. One of these was Ohio-born Charlie Kline, who was based in Atlanta but who first worked at Jugtown when he came to Georgia; evidently accustomed to more sophisticated—possibly jiggering—equipment, Kline was surprised to learn at Jugtown, according to D. X. Gordy, that "all you needed to set up a pottery was a hole in the ground, a wheelbarrow, and a cheesebox lid" (i.e., the headblock of a potter's wheel). The elder Gordy also hired a number of the Browns, Bishops, and Brumbeloes; Jesse Amerson, who earlier was associated with Jasper Bishop; Guy and Larry Dougherty, first cousins from Denton, Texas;[10] Missouri-born Hermann Jegglin, son of a German immigrant potter;[11] Earl Boggs from Alabama (the family still produces garden pottery at Prattville); Arkansas-born Jim Reid, who finally settled at Acworth in Cobb County; and Iowa-born Page Eaton, who had worked in California. These potters were paid by the gallon if they were "in crock or jug work," and by the piece for ornamental work.

W. T. B. Gordy had developed an occupational versatility that permitted him to weather the fluctuating demand for his wares; if the pottery market became glutted he would switch temporarily to carpentry, making or laying bricks, or farming. Rather than abandon pottery-making altogether in the lean times of the Great Depression, when local farming folk were seldom able to

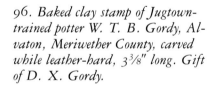

96. Baked clay stamp of Jugtown-trained potter W. T. B. Gordy, Alvaton, Meriwether County, carved while leather-hard, 3⅜" long. Gift of D. X. Gordy.

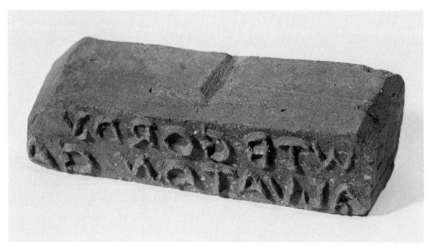

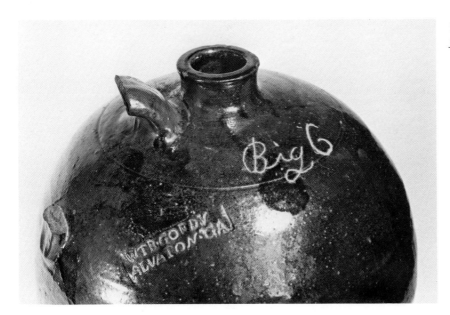

97. Six-gallon, Albany-slip-glazed jug with Gordy mark, ca. 1920s.

purchase his utilitarian products, he decided to shift his emphasis to a more artistic type of ware that would appeal to a wealthier clientele. Alvaton was a bit off the beaten path for this, so in 1935 he made a final short move to Primrose, eight miles north of Greenville on Alternate U.S. Highway 27. This location was frequented by northern tourists traveling to Florida, and was less than twenty miles above Franklin D. Roosevelt's Little White House at Warm Springs, whose gift shop stocked Gordy's work.

Gordy's sons William J. and Dorris Xerxes ("D.X.") had quit school to help in their father's shop and were turning "bigware" such as churns by the age of fourteen. What they may have lost in formal education was at least partly compensated by their exposure to the hired potters with their variety of experience. One of D.X.'s earliest memories is of Charlie Kline setting him on the potter's wheel and declaring, "I'm gonna make a potter out of this boy."

The Gordys pose an intriguing problem of classification to folklorists. The boys experienced their father's transition from traditional forms to tablewares and artistic pottery. They absorbed practical knowledge of folk pottery during the Alvaton period, reinforced by W.T.B.'s stories of Jugtown in the days of the Bishops. But they also recognized the artistic limitations of this functional ware, and shared their father's aspirations to move beyond it. Both were capable of being folk potters, in terms of possessing the inherited tradition (as D.X. later was to demon-

strate at Westville), but instead they chose more individual-istic paths.

As his father had done, Bill Gordy left home once he had married, a self-imposed journeyman or "tramp" potter, as he laughingly speaks of it.[12] This was at the beginning of the depression, and he felt there were better opportunities and broader experience waiting for him elsewhere. He worked first for Jim Reid at Acworth, and then in North Carolina for the Hilton Pottery Company at Hickory, the Kennedy Pottery Company at Wilkesboro, and Herman Cole's shop at Smithfield. While at Wilkesboro, Bill began to correspond with Kentuckian Edsel Rule, a ceramics instructor at New York's Alfred University who was noted for his glaze formulas. Rule was invited to the Kennedy shop to enlarge its glaze repertoire, and it was from him that the young Gordy learned the rudiments of scientific glazing. Now, he could produce the pastel shades that were in vogue for American art pottery, a ceramic branch of the Art Nouveau and Art Deco movements of the late nineteenth and early twentieth centuries.

In 1935 Gordy and his family returned to Georgia, settling just north of Cartersville in the hills of Bartow County, where he established the Georgia Art Pottery. He chose this location for two reasons: it was on a well-traveled artery (U.S. Highway 41) within easy reach of Atlanta, Rome, and Chattanooga, and thus was accessible to the urban market his style of ware would appeal to; and it was near a number of suppliers of glaze chemicals and refined clay (44).

While capable of turning the traditional forms of his father's earlier years, Bill rarely does so, although the clean lines of his vases and tablewares echo something of the older shapes. This work has a slick, machinelike consistency, despite the fact that it is turned by hand on an electric-powered wheel or occasionally on his treadle kick-wheel. The effect is reinforced by his frequent use of metallic-luster glazes. Indeed, much of Bill's energy seems to have been directed toward perfecting his glaze formulas. As a member of the Southern Highland Handicraft Guild, the high points of his year are building up a sales exhibit for the annual Craftsman's Fair at Gatlinburg, Tennessee, and filling Christmas orders. Adjacent to his workshop is a display room where visitors can select and purchase from his stock, a nicety for which the folk potters would have had little use.

D. X. Gordy remained at Primrose, taking over the shop after his father's death in 1955. Like his brother, he had worked out his

own personal approach to the craft, based on artistic forms glazed with natural materials at hand, such as pebbles picked up from a creek-bed and pulverized in a ball mill. The unexpected but often pleasing results reinforce D.X.'s convictions about the values of the natural as opposed to the artificial. A soft-spoken, sensitive man, he mused (in reference to the premature curtailment of his formal schooling), "I had wanted to be more of a sculptor than a potter," and he has, in fact, created a number of finely wrought clay sculptures—mostly religious groups—for his own satisfaction rather than sale. He contrasts his pottery with that of his brother: "My shapes are less traditional than Bill's, but my techniques are more traditional" (43).

In 1969 D.X. was invited to develop the pottery section of Westville, an "open-air" museum representing a Georgia village of the 1850s. Accepting the challenge, he closed the Primrose shop and moved to Lumpkin in Stewart County, where Westville was being constructed. There he demonstrated his many skills by building, virtually single-handed, a replica of a folk-pottery establishment, based on his recollections of his father's early period and his knowledge of the ways of the Jugtown potters.

The shop is an old log double-pen house (donated by a lumber company and moved to the site) similar to that used by his father and E. L. Stork at Shakerag, with the internal partition removed to create a single large, rectangular workroom. D.X. built a small, mule-powered clay mill in front of the shop, and a bigger one in back for mixing brick clay, both having a pyramidal shingled roof affixed to the top of the turning shaft to shield the tub from rain in the manner of the old cotton-baling presses. With the brick-clay mill and wooden molds he fashioned bricks with which he constructed a groundhog kiln like those once employed at Jugtown, set into an earthen bank and roofed over to protect the dirt-covered arch from erosion. He also erected a stone retaining wall along the front of the bank. At the same time, he was filling the shop with equipment made by his own hands: treadle kickwheels complete with ball-opener levers and height gauges, hanging scales for weighing the clay, triangular and oval smoothing chips of oak well-seasoned to prevent warping or splitting from moisture, wooden pot-lifters, and all the other paraphernalia of the Georgia folk potter. As soon as the shop was operable he proceeded to make pottery, reverting, for the sake of authenticity, to the old jug, churn, and pitcher forms and glazing with salt and Albany slip.

Thus, for a time, D. X. Gordy returned to the ceramic tradi-

98. *D. X. Gordy demonstrating at the Second Georgia Folklife Festival in Atlanta's Piedmont Park, 1981.*

tion in which his father had begun, proving himself equally competent as both a folk and studio potter. Although setting up Westville's pottery gave him a sense of accomplishment, he also felt confined by the glazes and forms imposed on him by the historic recreation. After training several young apprentices who could carry on the Westville operation he returned to the Primrose shop, where he has most recently developed a line of wares with delicately painted scenes from the rural past, such as farm buildings, gristmills, spinning wheels, and fauna in their habitats, through which he articulates his respect for the old-fashioned while expressing his individualism and love of nature.

99. *Jugtown-style groundhog kiln at the Westville Pottery, built by D. X. Gordy in 1969.*

The only other Jugtown family to contribute more than one or two potters is the Rogers clan. The previously quoted passage from Nottingham and Hannah's *History of Upson County* stated that Frederick Rogers married Bowling Brown's half-sister "Jennie," and the censuses seem to bear this out. The Virginia shown as William Brown's daughter in 1850 was born the same year as the Virginia listed as "Fedrie" Rogers's wife in the 1880 census for Redbone District of Upson County. Near the couple was Virginia's brother, William S. Brown, in whose shop Rogers's sons, Starling Adolphus and Wiley C., may have learned the craft. Actually, "Wile" is remembered as a shop owner who hired oth-

ers to turn ware, so S. A. Rogers seems to have been the first real potter of the family.

His son, Starling Rufus Rogers (Starling was a local family name), is, to my knowledge, the only Georgia folk potter to leave behind a written record of his work in the form of several ledgers spanning the years 1910–1933. From these books it is clear that the bulk of Rufus Rogers's income was derived from farming, especially the growing of cotton, but that much of the labor was done by hired hands, freeing him to work in the shop alongside an occasional hired potter. Ledger entries from 1912 to 1928 show that he paid the following to "turn jugware": Jefferson F. Key, Javan, Otto, and Bobby Brown, McGruder and Curtis Bishop, and his own son, James Adolphus Rogers. Rufus used mainly Albany slip as his glaze, apparently reserving a special glaze consisting of flint, feldspar, and Spanish whiting for those pieces he decorated with cobalt paint (ordered from the Croxall Chemical Company of New York City). This much can be pieced together from his ledgers.

Rufus Rogers's daughter, Jettie Pearl (Mrs. Leon Gooden), was able to add considerable detail to this rather sketchy picture of his work:

> He was a potter; he dug the clay out of the ground and processed it from then on up to the churns, jugs, pitchers, and flowerpots. He done it from the time he married, or before he married, 'til he got too disabled to work, probably around '45; he died in '54. From the time he give it up, my brother Horace, when he come out the army, took it over 'til he died ten years ago.
>
> Well, to start with, they went down on the Potato swamps next to the creek. They would dig pits; before they got to the clay they had to dig a hole, I reckon it was six foot wide and six foot deep. To give some idea of how deep it was [once the clay was removed], people used to fish in the empty pits. They had to throw all that dirt out and get down in there to the clay; then they had to test it. If it had too much sand in it, then they couldn't use it. They would feel of it with their fingers, and they could tell if there was too much sand in the clay; the clay they used was real slick, you know, almost like glass to rub in your fingers when it was damp. But they would dig that out and haul it up on the truck.

100. S. Rufus Rogers posed with headblock of potter's wheel, ca. 1920s, showing both "arty" and more traditional wares. Courtesy of Mrs. Horace Rogers and the Atlanta Historical Society.

Then we had something sort of like a syrup mill. I mean, it was box thing, like, and it turned like a syrup mill that a mule had to pull. There was a post right in the middle and that post turned. Well, it was levers, like, running out from that post, that had wires fixed on there where they would catch them roots and trash that was in the clay. The tub was about four foot across. We'd keep putting water in there and run them mules all day long, 'round and around, to grind that clay and get all the roots up.

Then they would take it out and make it into blocks about two foot square, and stack it in the shop where he made the pots. He stacked that in the corner and covered it up with croker sacks (that's feed sacks). And we had to keep them feed sacks wet to keep that clay from drying out all the time, until it was used up.

In the shop he had a bench that they had to make up that clay just like they was making up bread, roll it and cut it. They had a wire in the middle that they used to cut the clay and pick out, to be sure they got every little bitty rock or piece of root that didn't catch off out there in the mill. Well, they'd weigh the balls of clay according to what he's gonna make out of it. Like, a pitcher or jug, it would be smaller balls, and then flowerpots and then churns would be bigger. My brother Horace usually made the balls up for Daddy.

And then they had a wheel, had like a driveshaft on a car at the bottom, you know. He pedaled that with his foot and the wheel went around and he'd pull up a piece of clay. But that ball of clay had to be right in the center of that wheel. If it wasn't, he'd have to tear it up and throw it aside; it'd make his pot one-sided. He just had made so many 'til he knew if it wasn't right in the center. To make his churns, he'd turn the top of the churn and get it fixed, and then take a wire and cut it off and lay it over on a shelf. Then he'd turn the bottom, and when he got it as high as he wanted, he'd put that top back on there and seal it around with one hand down in the churn and the other one on the outside [piecing]. He took a wire and went under it and cut it off, and then he had iron clamp things [lifters], had a hinge on it, opened up and clamped around there, had two handles on it. I think they made the clamps themselves; they knew how to make things.

He had planks, I imagine they were about twelve foot long, about eight inches wide, and he filled them full of churns. Before they got dry he'd take a roll of mud and stick it on that churn and pull that down and fix them handles on there. Then he would put one on the other side to handle it with [slab handle]. Then we'd have to tote 'em out in the yard and set them out in the sun. We'd tote them things in and out for several days until they got good and dry. Then he had a glaze from somewhere, I don't

know where he ordered that glaze, but he'd have to mix it with water, and glaze 'em. We had sponges that we dipped in water and then get 'em good and dry and wipe the tops of the churns, so there'd be a rim around the top that ain't glazed.

After that they'd have to put 'em in the kiln. His kiln was arched; you could walk into it but you had to stoop down to get inside the door. Once you were inside you could stand up. It was a shelter kiln, had a tin roof over it to protect it from the rain. The wood box [firebox] was four feet wide and you burned cordwood in it about four

101. Miniature Albany-slip-glazed jug, pitcher, and churn by S. Rufus Rogers, with two cedar stamps. The paddle-shaped stamp has his name carved in relief at the wide end and the gallon number 4 at the handle end, and is 4" long; the oblong stamp is 3" long and contains the numbers 5 and 6.

feet long. You'd close the door up with bricks and red mud, and put the wood in through the window on each side. You had a partition behind the wood box, and they'd stack all the pottery back behind it. Near the chimney they had to put something like little ol' glazed pieces of clay to tell whether they was getting it too hot or too cold. Well, he would start about three o'clock in the evening [i.e., afternoon], using cordwood to cook it with, and keep that fire going all night long. The next morning he would put bricks and rocks in the openings and daub it up with mud and seal that thing up air-tight. And they'd let it stay sealed up for about a week. If you let it cool off too quick the pottery would crack. At the end of the week he'd open it just a brick or two at a time, just gradually let it cool off 'til where they could take it out. And then it was ready for market. When you opened it up, there was a bed of coals that would last for a week later. (42)

When Rufus's son Horace left the service at the close of the Second World War he bought a farm in Meansville, a few miles north of Jugtown, and the Rogers Pottery was moved there, where it still stands. The shop is a two-story rectangular frame building with a door in the front gable end of each story. The upper floor, used for storage, was reached by an outside stairway. The kiln, built by Rufus and Horace together and now in a state of collapse, is above ground level but has earth packed against the sidewalls and a thin layer over the arch.

Horace's wares included churns, pitchers, jugs (both semi-ovoid and the cylindrical "stacker" type), flowerpots, and, in later years, washpot-shaped planters and ornamental vases. He also made some ring jugs "for old times' sake," according to his wife (89), and, for his own amusement, an Albany-slip-glazed, life-sized bust of a man. Some of his clay he obtained from the swamps of Potato Creek, but he found this too gritty to be suitable for much more than flowerpots. For his churns, he hauled a more plastic clay from near Alvaton. At Rufus's Jugtown shop the clay had been mixed in a mule-drawn mill, but an electric mixer did the job at Meansville. Although Horace used mostly Albany slip, he sometimes salt-glazed over it (his wife recalls those wares as having a greenish tint), and spoke of his father having used some ash glaze. Toward the end of his life, much of the pottery he sold was made elsewhere. It was while hauling a load of flowerpots from Bill

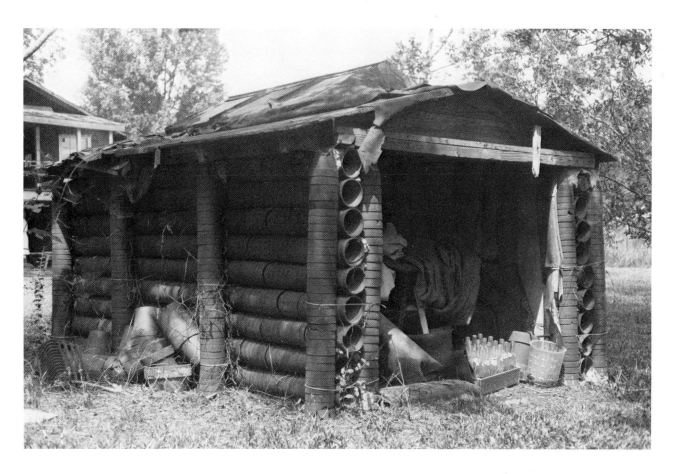

Merritt's Middle Georgia Pottery in Crawford County that his truck was struck from behind and he was killed.

Some years later Horace's widow, Marie Gooden Rogers, began to practice turning ware on his treadle wheel, and by 1974 she had bought a compact electric kiln and was beginning to market her small "Confederate" ring jugs, face jugs, candlesticks, pitchers, and mugs. At first she used Albany slip alone, but on a visit to a ceramics supply shop she was introduced to a chemical called Gerstley borate, which she now mixes with the slip to produce a lighter brown, glassy glaze. Most of her work (the bottoms of which she signs in script or marks with Rufus's wooden stamp) is distributed by the Tullie Smith House sales shop at the Atlanta Historical Society, where she demonstrates pottery-making during the spring Folklife Festival. Not only is Marie Rogers one of the few women folk potters in Georgia's history, she is the last practitioner of the older Jugtown tradition.

102. Storage shed at Horace Rogers Pottery, Meansville, constructed of machine-made flowerpots probably obtained from Bill Merritt's Middle Georgia Pottery in Crawford County. The two-story frame shop is at left rear.

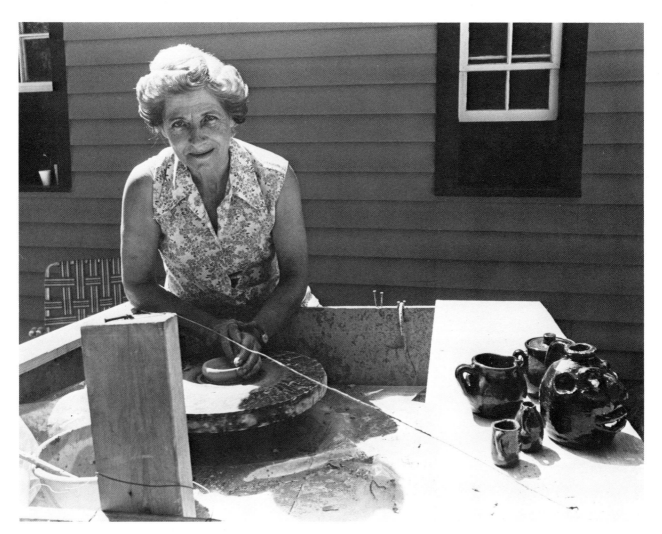

*103. Mrs. Horace (Marie) Rogers
demonstrating on her late husband's
treadle wheel at the Atlanta Histori-
cal Society's Tullie Smith House Res-
toration, 1980. Courtesy of the
Atlanta Historical Society.*

JUGTOWN POTTERS

Amerson, Jesse
Bishop, Andrew J.
Bishop, Curtis G., Sr.
Bishop, Curtis G., Jr.†
Bishop, Fred
Bishop, Henry H.
Bishop, J. D.
Bishop, Jasper A.
Bishop, John†
Bishop, McGruder
Bishop, Thomas*
Bishop, W. Davis
Brown, Bowling
Brown, Bowling P.
Brown, C. Robert
Brown, E. Javan
Brown, James O.
Brown, J. Otto
Brown, John S.
Brown, Taylor*
Brown, Thomas O.*
Brown, U. Adolphus*
Brown, William*
Brown, William S.
Brumbeloe, Camelius
Brumbeloe, Emanuel J.*

Brumbeloe, James A.
Brumbeloe, Newton J.
Brumbeloe, Oscar E.
Brumbeloe, W. Walter D. S.
Brumbeloe, William R.
Childs, James J.
Cofield, Thomas B.
Creamer, John B.
Gordy, William T. B.
Hicks, J. C.
Jackson, W. T.*
Jegglin, Hermann
Key, Jefferson F.
Kline, Charles S.
Long, Frank
Rogers, Frederick*
Rogers, Horace W.
Rogers, James A.
Rogers, Marie (Mrs. Horace)
Rogers, S. Adolphus
Rogers, S. Rufus
Rogers, Wiley C.†
Salter, Benjamin S.
Salter, John W.
Stewart, John H.
Stewart, Tommie W.

* Suspected but not established as a potter, perhaps known as a potter else-
 where.
† Limited involvement in craft as shop-owner or assistant but not turner.

CHAPTER TWELVE

The Atlanta Area
(Fulton County)

Began in 1846, blossomed in 1870s. NUMBER OF POTTERS: *about fifty (thirty at Howell's Mills center).* KEY NAMES: *Brown, Cofield, Kline, Rolader, Smith, and Bird.* GLAZES: *salt (some cobalt-blue decoration and stencil-marking), Albany slip, alkaline, and late Bristol.* MAKER'S MARK: *same as Jugtown.* MAIN FORMS: *whiskey jugs (cylindrical "stacker" and round-shouldered "bonbon" shapes predominating) and food-preserving jars.* SPECIAL-IZED FORMS: *drainpipes, face jugs, grave pots, and ring jugs (mainly Brown family).* HIGHLIGHTS: *Jugtown connections.*

Office buildings, a sprawling shopping center, and a plethora of gasoline stations mark today's congested intersection of West Paces Ferry Road, Northside Parkway, and Howell Mill Road in northwest Atlanta. But at the turn of the century this was the hub of a pottery center on the upper fringe of a farming community known as Howell's Mills, and the scene would have been that of clay being dug from the banks of nearby Nancy Creek, mule-powered clay mills, and kilns belching smoke and flames. The transformation of this area into an Atlanta suburb began in the 1920s as the farms gave way to estates and subdivisions, was accelerated with the building of the Northwest Expressway, and was formalized by incorporation within the city limits in 1952. Continued urbanization has so thoroughly altered the character of the community and obliterated traces of the pottery activity that even Atlanta's foremost historian, Franklin M. Garrett (who once owned property there), was surprised to learn of the extent of the tradition.

The large quantity of Howell's Mills and other locally made wares unearthed in the older part of the city by bottle collectors at early trash dumps and by recent archaeological excavations for the Metropolitan Atlanta Rapid Transit Authority (MARTA) railway is proof that the products of these shops were intended for city dwellers as well as farming folk. Indeed, the potters geared

their output to an urban market by specializing in jugs for local liquor dealers and distillers such as R. M. Rose, who filled and sold them in quantity to the city's numerous taverns before a state prohibition was enacted in 1907. Other urban wares included flowerpots for local florists, sewer and water pipes to run under city streets (a set of hand-thrown, ash-glazed drainpipes was salvaged by archaeologists when Martin Luther King, Jr. Drive, adjacent to Rich's downtown department store, was torn up for MARTA construction), and canning and larger "kraut" jars for preserving the produce of small garden plots and markets.

For at least half a century after Atlanta's founding, stoneware food-storage jars appear to have been no less in demand in the city than in the countryside. Elsewhere I have suggested, by exploring Atlanta's involvement in traditional and early commercial country music, that the city's large working-class population had strong agrarian roots at least into the 1920s.[1] In 1879 a correspondent for *Harper's New Monthly Magazine* described Atlanta in terms not incompatible with the use of folk pottery:

104. Hand-thrown, alkaline-glazed drainpipe cemented to fragment of another pipe, reconstructed from MARTA excavation in downtown Atlanta, 18" long. Courtesy of Linda F. Carnes and Georgia State University Archaeology Laboratory.

> On Mondays you may see tall, straight Negro girls, marching through the streets, carrying enormous bundles of soiled clothes upon their heads; or a man with a great stack of home-made, unpainted split bottomed chairs, out from among the white legs and rungs of which his black visage peers curiously. . . .
> At certain corners stand farmers in scant clothing of homespun, and the most bucolic of manners, waiting for someone to buy, for a dollar, the little load of wood piled up in the center of a home-made wagon. . . .
> You may buy . . . old fruit jars . . . sunbonnets . . . bed clothes made 'befoh de wah,' . . .[2]

The earliest known potters in the area were John and Holland Leopard, brothers who probably were trained in Edgefield District, South Carolina. They appear in the 1830 census for Fayette County, Georgia—from which part of DeKalb, and, in turn, Fulton, County was formed—but there is no evidence that they ran a pottery there, nor did they stay long. By 1840 they had moved on to Randolph County, Alabama, and in 1850 Holland was potting in Winston County, Mississippi, while John had established a shop in Rusk County, Texas.[3]

A more substantial indication of early activity is a passage from an obscure book, *Pioneer Citizens' History of Atlanta, 1833–1902*:

"In 1846 a factory for making earthenware, such as jugs, churns, jars, etc., was operated by Mr. J. R. Craven. It was located on Gilmer Street."[4] Not only is this the first shop documented for the Atlanta area, but it is one of the few actually within the city limits at the time of operation. I have found no other record of a J. R. Craven, but Isaac Newton Craven of the Randolph County, North Carolina, pottery dynasty did migrate from Mossy Creek District in White County to Atlanta, where he appears in the 1850 census. The first city directory (1859) shows him living downtown on the southwest corner of Gilmer and Collins streets (the present location of Georgia State University's Sparks Hall) as pastor of Atlanta's first black church, the African Methodist, nearby.[5]

The majority of folk potters in the Atlanta area, however, worked at the seven shops concentrated at Howell's Mills in the Buckhead (later Collins) District, several miles northwest of the city. "That's where the clay was, and those potters stuck together," explained Javan Brown, who was one of them (18A). Actually, there were two Howell's Mills in the vicinity. The first, situated on the north bank of Peachtree Creek on Howell Mill Road, gave its name to the hamlet the potters identified with and sometimes marked on their wares (plate 42), although it was nearly two miles south of their shops. Clark Howell established a combination grist-saw-planing mill and cotton gin there in 1852, and his residence became a post office in 1876, at which time it was five and a half miles from Atlanta. Called Howell's Mills, the post office was discontinued in 1891.[6] The second Howell's Mill, on Nancy Creek just west of Howell Mill Road and south of West Paces Ferry Road in the immediate vicinity of the potteries, was run in the late nineteenth century by Clark Howell's son Charles (40).

Led by Bowling Brown, a sixty-mile exodus of potters from Jugtown to Howell's Mills seems to have been precipitated by the upheavals of the Civil War. The 1860 population census shows Brown and sons John S. and Bowling P. as potters in Pike County, but included in the 1864 special militia census for District 722 (Buckhead) of Fulton County were B. and John S. Brown, listed as farmers but of the right ages to be Bowling and his son (by 1870 John had moved again and was potting in Titus County, Texas). Bowling must have acquired a substantial farm, for the 1870 census has his real estate valued at $3,000.

Bowling P. Brown's absence from the 1864 militia census suggests that he was then serving in the Confederate Army. By 1870

he was living near his father in the Buckhead District, listed in the census as a day laborer. But the following year he appeared in the city directory as "B. P. Brown, potter," residing on Peters Street near Stephens (now Fair).[7] And from May 9 through August 28, 1871, the following advertisement ran in the *Atlanta Constitution*:

SEWER AND WATER PIPES, Jugs, Jars, etc.

We are now prepared to make contracts to furnish Sewer and Water Pipes to amount of 1,000 feet per day. Our new Press will turn out any size to 18 in hea.
Price—5 to 6½ cents per inch diameter per foot.
We also make

Jugs, Jars, etc.,	B. Brown & Co.,
to order.	Atlanta, Ga.

Factory on Green Ferry Avenue, near United States Barracks

That location, in southwest Atlanta near the present site of Spelman College, was just a few blocks from Brown's residential address, and also close to the Southern Terra Cotta Works on Chapel Street. This apparently rather sophisticated, if short-lived, venture may have been the first Brown pottery in the Atlanta area.

Exactly when the elder Bowling established his shop at Howell's Mills is not known, but the fact that he and others near him were not listed as potters until the 1880 census suggests that it was sometime in the 1870s. Those others were Bowling's grandsons, Ulysses Adolphus and James Osborn (whose father, potter Thomas O. ["Boss"] Brown, had died in the 1870s); his son-in-law, North Carolina–born Thomas B. Cofield (who in 1870 was shown as a carpenter), and Cofield's fourteen-year-old son, Thomas William; and John Daniel, whose sister Sarah had married Boss Brown back in Upson County. While listed as a farmer in 1880, Bowling P. Brown did not lose touch with the craft, for he appears as a potter again in the 1900 census, as do his sons, Edward and Millard. By then, the elder Bowling's brother, William S. Brown, also had migrated up from Jugtown, as had Jasper Bishop's son, John (probably the J. D. Bishop who stamped his ware WOODWARD, GA., a post office from 1888 to 1904 where Howell Mill and Collier roads cross).

This is an appropriate place to reintroduce Charles S. ("Charlie") Kline, who made a brief appearance in the Jugtown chapter as one of those who worked for W. T. B. Gordy. There are two accounts in oral tradition purporting to explain what brought

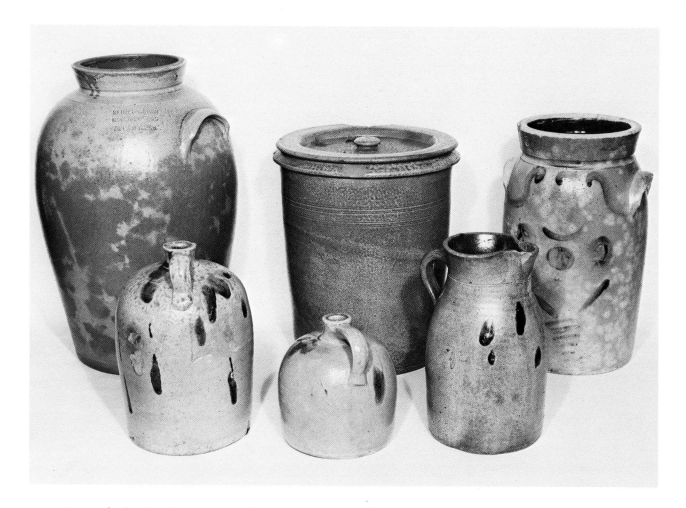

105. Range of salt-glazed wares (with Albany-slip interiors) attributed to Atlanta area, last quarter of the nineteenth century. Left to right, rear: large pickling jar by Charlie Kline and Brown partner (marked), mottled gray coloration due possibly to fluctuating kiln atmosphere, holes in rim to secure lid; kraut jar with lid, salt glaze over slip; churn by Kline (marked), brushed cobalt-blue decoration. Front: bonbon-shaped whiskey jugs and pitcher with typical brick drips, attributed to the Brown family.

Charlie to Georgia from his native Ohio.[8] According to the first, he left home when his potter father refused to raise the wages of a talented European workman who specialized in large vases. In the second, he was employed to oversee a bargeload of ware down the Ohio and Mississippi rivers and sell it at New Orleans, but pocketed the proceeds of the sale and never returned to Ohio. Instead he headed for Jugtown, Georgia, where he is found as a "Jugmaker" in the 1880 census (listing his birthplace as Louisiana). By then he had married Emma Brown, probably the daughter of potter William S. Brown, who had not yet left Jugtown. Another story explains her nickname, "Britches," as deriving from an argument on their wedding night as to "which of them was gonna wear the britches" (43).

By 1883 the Klines had moved up to Howell's Mills, perhaps accompanied by her father.[9] Charlie sometimes decorated his salt-

106. Detail of mark on shoulder of 19" high pickling jar; 4 stamped upside-down to indicate seven gallons.

glazed churns and crocks with cobalt-blue in the northern fashion, and is the only Georgia potter known to have done so. His freehand designs seem to have been limited to two rather basic motifs: a continuously looping line, redoubling upon itself with a calligraphic flourish (color plate 1);[10] and what has been described as a "bowl of fruit," three spheres connected above curved lines in what actually may be a highly stylized floral bouquet. Following his move, Kline did not confine himself to Atlanta, working at Digbey in Spalding County with Henry Bishop, at Jugtown with James Osborn Brown, and at Aberdeen in Fayette County for W. T. B. Gordy. He seems to have spent the remainder of his career in the terra cotta works and semi-industrialized potteries of Atlanta and East Point.

By 1888 Bowling Brown (who was then eighty-two) had moved into the city and was living just west of the Georgia Institute of Technology, which opened that year.[11] His old shop at Howell's Mills, however, continued in operation, mainly under his grandson Ulysses Adolphus ("'Dolphus"), who left for brief periods during the 1920s to work for W. T. B. Gordy at Alvaton and run his own shop at Cleveland in White County. An Albany-slip-glazed face jug with a north Atlanta provenance, a clay lizard crawling on the forehead and inscribed Just Grace / and me / and the baby / Makes III on the throat (undoubtedly derived from George Whiting and Walter Donaldson's hit of 1927, "My Blue Heaven"),

107. Albany-slip-glazed face jug with lizard, 11¼" high, attributed to Brown Pottery, ca. late 1920s; inscription derived from a popular song helps in dating.

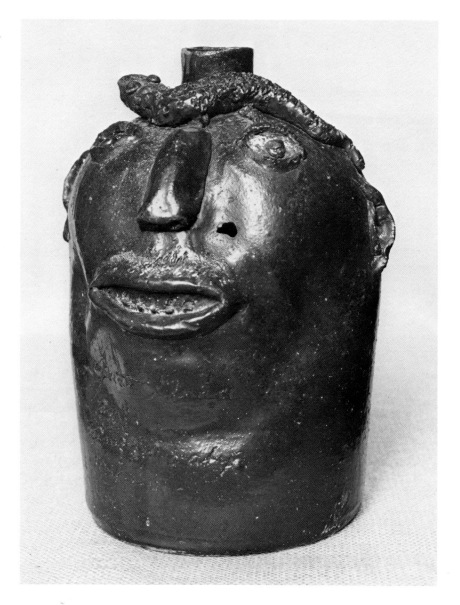

could have been made by him. Barbara Respess of Atlanta fondly recalled visiting the shop in 1931 with her first-grade class of Morningside School: "I remember the woods and all the big violets growing everywhere. The little shop, as I recall was low with lots of windows to let in sufficient light. The floor was dirt and [outside] there was an old blind mule going round and round turning the clay mill. The old man was so nice, he let us each make something on the potter's wheel" (87).

The 1930 city directory shows Adolphus's son, Horace V. Brown, as living and operating a pottery at 1442 Paces Ferry Road, N.W., presumably the same site.[12] The shop must have closed shortly thereafter, for by 1933, following Adolphus's death, Horace had moved to Center Hill on the Bankhead Highway (a west Atlanta community) where he and his son, Horace V. Brown, Jr., are both listed as potters.[13] He moved again in 1934 to the same neighborhood to which Bowling had retired,[14] and the following year he left the state for Louisville, Mississippi, to work at the Stewart Pottery, finally settling at Sulligent in Lamar County, Alabama, where he was known as "Jug" Brown (101).

As for the other Atlanta Browns, their stories are varied. Edward C. Brown, son of Bowling P., was in partnership for a while with Thomas W. Cofield, and also worked with his brother Millard at their own shop on West Paces Ferry Road until 1911, when Ed became a gardener (and later foreman) at Grant Park.[15] We have already accounted for the oldest of Boss Brown's four potter sons, Adolphus. Boss's third son, Charles (who is reputed to have been a good fiddler), left Howell's Mills for Rock Mills in Randolph County, Alabama, a textile as well as pottery center. Boss's youngest son, Rufus Theodore ("Thee"), also seems to have had Alabama connections; according to the 1900 census, both he and his wife were born there. But, except for a stint with the Foreman Pottery at Stockton in south Georgia, where he is found in the 1900 census, he remained mostly in the Atlanta area. By Javan Brown's account, Boss's untimely death necessitated that his second son, James Osborn (Javan's father), learn the craft through formal apprenticeship under Charlie Kline, signing up for five years but staying eight (18B). There may be some truth to this, but in 1880, before Kline had left Jugtown, thirteen-year-old James already was shown as a potter in the census for the Howell's Mills area, living with his widowed mother near her brother, potter John Daniel.

While some of the Browns were relatively more settled than others, the family's high degree of mobility is in sharp contrast to Georgia's other pottery dynasties. Atlanta, for the Browns, was less a home than a base of operations, or staging area from which they periodically sallied forth to do battle with the clays of other districts. And of no other Brown was this more true than James and his six sons. James's travels are explained partly by the fact that "he was always hunting for the best clay," and partly because of his many church connections. While not a full-fledged

farmer, he and his family enjoyed renting a farm when he worked at Jugtown, which he did frequently (81). The 1900 census, however, shows him potting for Milton Puckett at Oakwood in Hall County. In the early 1920s he and his sons also worked in White County for "Daddy Bill" Dorsey and Cheever Meaders, who paid them two cents per gallon for turning ware. Cheever remembered the Browns as "extra good, fast turners; it took a good crew to keep out of their way" (74); his son Lanier adds that they produced heavy pieces requiring a lot of clay.

In order of their births, James's sons were William O. ("Willy"), Charles Robert ("Bobby"), Davis P., Evan Javan ("Jay"), James Otto (called Otto), and Rufus E., who is said to have been the best potter of the bunch but who chose the electrician's trade as his career. They were reared mainly in the Atlanta area, learning the craft at about the age of twelve. The following sketch of their work is not intended to be complete, but is meant to point out some highlights of their lives as potters.

Willy, Bobby, and Javan worked for W. T. B. Gordy at Aberdeen during the First World War, then moved to Manchester in lower Meriwether County to make pottery for a man named Covett, who had discovered clay on his farm. Willy left Manchester for a shop at Raymond in Coweta County, with Javan and Bobby joining him there for a year until the operation folded. Willy returned to work for Gordy—who by then had moved to Alvaton—for another two years, then set up a rival pottery a quarter of a mile from Gordy's shop with the help of Javan and Davis's brother-in-law, a man named Singleton. Gordy was not bothered by this competition, according to his son, D.X. (who supplied much of the information on this generation of Browns in Georgia), for at the time there was enough business for both shops. "Everybody that had a pottery at one time or another had a Brown working in it. They were likable people; some of them liked to make people laugh. Willy and Bobby made up stories, told Uncle Remus stories and jokes. Javan was more serious, but a better turner than the other two" (43).

The Browns' Alvaton shop lasted only six months, after which Willy moved back to Atlanta. Javan worked variously for a Boggs in Alabama, John Henry Stewart and Wiley and Rufus Rogers at Jugtown (the latter in 1920 with Otto), and George Clayton at Inman, South Carolina. Together with Otto and Bobby, he also worked at the Cantrell Pottery in Paulding County; and with Willy and Bobby at the Eason Pottery in Phenix City, Alabama. Bobby more or less settled at Jugtown, operating his own shop

and later, in 1927–28, working for Rufus Rogers; this was followed by a couple of years at Bethlehem in Barrow County, where he and one or two of his brothers made pottery for S. Wesley Bell. Otto moved to Bethune, South Carolina, to work for Rufus Outen (19), and there in 1953 set up the only shop he ever owned, later to be taken over by his son, Otto Brown, Jr. At Bethune, unglazed garden ware—Rebekah pitchers, flowerpots, and urns—was the chief stock in trade, supplemented by the occasional Albany-slip-glazed pet-food dish and souvenir jug.[16]

The final episode of the Brown family saga unfolds at Arden, just below Asheville in the hills of Buncombe County, North Carolina, where Davis Brown discovered clay to his liking in 1923.[17] It was there that he was to sink his roots, for the following year he and Javan established the Brown Pottery, "Home of the Little Brown Jug," in which Davis remained involved for the rest of his life. This location offered the other brothers a change of scenery and dependable employment whenever they wished to travel up from Georgia. But the Great Depression lowered demand for the products of the Arden shop, and Javan decided to return to Georgia and run his own establishment (sometimes with Willy's help) at Forest Park, just southeast of Atlanta in Clayton County. There, from 1928 to 1948, he specialized in what he called "city bottoms," unglazed cylindrical collars that protected the roof of a home from the heat of the chimney flue (18B).

Davis, meanwhile, weathered the depression by traveling the Carolinas in a 1925 International truck and trading his pottery for food and just enough money for gasoline to get to the next town. He also fell back on a related skill, kiln-building, and is said to have constructed a total of fifty-two kilns throughout the East (20). His final response to the hard times was to modernize both his equipment and his product, developing a line of tablewares and French-style cooking ware (Valorware) which he sold to department stores and a New York distributor. This restructuring got the Arden shop back on its feet in a big way, and there was a boom period that lasted until after World War II.[18]

It was at this point that Javan returned to North Carolina, building a shop at Valdese in Burke County, about sixty miles east of Arden. When it closed, he continued working at the shop of his son, Evan Javan Brown, Jr., in Skyland near Arden, until his death in 1980, where he made both nontraditional and traditional wares, including face and ring jugs glazed either with Albany slip or the secret-formula glaze he and Davis had concocted.

On Davis's death in 1967 the Arden shop was taken over by his

108. The late E. Javan Brown, Connellys Springs, North Carolina, 1977.

son Louis, who tried to juggle this new responsibility with his full-time job as a mechanic in a trucking firm. Fortunately Louis's sons, Charles and Robert, were soon old enough to shoulder the lion's share of the work there (occasionally assisted by their cousin, David Wood of Atlanta, another of Davis's grandsons). They continue to produce the line created by Davis, as well as some nicely detailed face jugs.[19] These young men represent at least the eighth generation of one of the South's largest and oldest continuously active pottery families.

Besides the Browns, Cofields, Charlie Kline, and John Daniel, other potters who worked at the Howell's Mills center include William Hamilton Boggs (possibly related to the Boggs potters of North Carolina and Alabama), brothers Julius L. and Walter Smith, James H. Rary, and Lee English. Most had their own shops on or near West Paces Ferry Road. In addition, at Bolton, two and a half miles southwest of there and just below the confluence of the Chattahoochee River and Peachtree Creek, a pottery was operated by Charles H. Bird. The 1900 census indicates that he was born in Pennsylvania and (based on the birthplaces of his children) passed through Minnesota and Illinois before coming to Georgia. Bird himself is listed as a "Potter Jug," his oldest son, Harry, as a laborer in the pottery, and a boarder, Ohio-born Louis Cook, is also shown as a potter. Several of the Browns are said to have worked at Bolton, perhaps in Bird's shop.

On Moores Mill Road between Northside Parkway and Northside Drive, one and a quarter miles east of the intersection where most of the Howell's Mills potters congregated, stood the Rolader Pottery. It was established by William Washington ("Don") Rolader, one of the many children of a German-born Methodist preacher and farmer, William Joseph Rolader (1816–1893). Joseph had left Prussia at the age of twelve with his parents, who died during the Atlantic passage; he was adopted by a couple in Forsyth County, Georgia, but ran away and settled at Howell's Mills (106), becoming a neighbor of Bowling Brown. It is not surprising that his son Don got involved in the craft, especially after marrying potter Thomas B. Cofield's daughter, Arrie.

In the late 1870s Don and his bride moved to the Moores Mill Road location where he built a one-room log cabin that still stands, not overly conspicuous from the outside with its additions and siding, soon followed by a log pottery shop. A younger brother, Low, later joined him for a while in the shop, then set up his own operation where he made flowerpots (18B). There were others who worked for Don; the 1900 census shows Thomas B. Cofield,

his son Thomas W., and Edward C. Brown living adjacent to him, the latter two listed as potters (Rolader himself is shown as a farmer, as he had been in 1880). James Osborn Brown also worked there; it was at that time, in fact, that his son Javan learned to turn ware (18B).

Following World War I one of Don's eight children, Ivon C. Rolader, took over the business, moving into the cabin with his wife Buena, who also had a pottery background. Her father, Thomas Richard Holcombe (unrelated to the Gillsville Holcombs), never owned a shop but had fired the kilns for his father-in-law (Buena's grandfather) William H. Boggs at Howell's Mills and for C. H. Bird at Bolton. There were two potter's wheels in Ivon's shop but he seldom used them, preferring instead to hire his turners—notably Horace and Theodore Brown—while he prepared the clay and marketed the wares. He also farmed, ran a dairy, and later owned a combination gas station and grocery with one of his brothers (90).

109. Residence of potters W. W. and Ivon Rolader on Moores Mill Road, 1975. Original log cabin dating to 1870s is to left of stone chimney under later siding; shop was to right of garage.

As Buena recalled the production process, the clay was dug below a spring in the woods behind the shop (under the present Ivanhoe Drive) and hauled by wagon to the mule-drawn mill in front, leaving pits as deep as the height of a house. After mixing with water, it was forced from a press through a wire screen to remove foreign matter. In cold weather the greenware was dried on shelves over a brick "tunnel" with a wood-burning firebox at one end. Unlike his father, Ivon did not mark his ware. Albany slip was the chief glaze but salt sometimes was used, and in his father's day some alkaline glaze too. A number of alkaline-glazed sherds were excavated from the kiln area, and in the woods near the house an intact ring bottle (possibly made by one of the Browns) was found with a glaze most likely composed of ashes, clay, and pulverized glass.[20]

Flattened or elongated blobs of baked clay and fragments of ring saggers (stacking dishes) found at the site indicate that smaller wares, especially jugs, were stacked in the kiln. In fact, all the whiskey jugs seen with the W W · ROLADER mark are of the later cylindrical type with a stacking ledge around the shoulder. According to Buena the height of the blaze shooting from the chimney was used to gauge the end of the firing, but trial pieces recovered from the site provided a more precise indicator. These are small, rectangular clay chips (some apparently recycled from damaged greenware) with a central hole and neatly beveled edges, that would have been withdrawn periodically with an iron hook through a peephole in the chimney-end of the kiln. Since few showed any glaze deposit and none were intact, they probably were used by breaking and examining the color of the clay in the fracture to determine if the ware was sufficiently burned (plate 60).[21] When the firing was over, the firebox eye was "daubed up" with mud and the chimney-top covered with a sheet of tin to prevent cool-cracking.

Ivon sold much of his ware by wagon through the north Georgia countryside, sometimes traveling as far as Dahlonega in the mountains of Lumpkin County. Toward the end of his career, however, he produced mainly flowerpots, most of which were sold at the shop. These included jardinieres decorated with tooling and fluted rims. Sometime in the 1920s Ivon stopped making pottery altogether, instead selling modeling clay to the Atlanta school system as well as mineral water, whereby he acquired the nickname "Spring-Water" Rolader. Following his death, the kiln and frame shop (which he had built to replace his father's burned log one) were torn down.

East Point, at the southwest end of Atlanta, also harbored a number of potteries. The earliest seems to have been the East Point Jug Factory, incorporated by the State Legislature in 1870 to serve a nearby distillery. The administrative structure of the apparently short-lived enterprise suggests that it was, indeed, a factory rather than the usual small family operation. The *Atlanta Constitution*, which took a generally critical view of the 1870 legislature, reported on November 1: "The East Point Jug Factory has been organized by the election of Thomas G. Simms [former Atlanta postmaster], President; J. D. Lloyd, Secretary; J. T. Lumpkin, Treasurer; J. S. Nall, Inspector; and James D. Robinson, Superintendent. . . . The jugs that were promised to members of the Legislature for voting for the bill incorporating the company, will be ready for delivery by New Year's Day." [22]

The Magnesia Stoneware Company of East Point was recorded just after the turn of the century as making jugs of fire clay and plastic alluvial clay obtained from other parts of the state. [23] This was a two-story building containing eight potter's wheels in which 400 gallon jugs—some glazed with Albany slip, others with Bristol glaze—were produced daily, with James Osborn Brown as foreman upstairs and Charlie Kline supervising downstairs (18B). The state prohibition of 1907 soon put an end to the business.

D. X. Gordy recalled that a small East Point shop, the Rainbow Pottery, was established by a woman in the 1920s and operated for two years by Willy, Bobby, and Javan Brown before it closed, and that Joseph Shannon also ran a shop at East Point (43). In 1900, however, Shannon was working at the Atlanta Terra Cotta Company on North Forsyth Street, and in 1902 he was employed at the Southern Terra Cotta Works near his home on Chapel Street. [24] These firms specialized in architectural clay products such as molded ornamental facing, but in their early years, according to Gordy, also produced some wheel-thrown wares. A shop southwest of East Point but still in Fulton County, between Palmetto and the Chattahoochee River, was operated by an English potter, Jack Turbyfield, and his brother, who later returned to England (43, 105).

There were a number of other shops close enough to Atlanta to be considered in this chapter, but outside Fulton County. For a year or so in the 1930s Claude Bennett, who earlier had worked for the Brumbeloes at Chalker in Washington County, and Larry Dougherty of Denton, Texas, ran an "old-fashioned" shop just west of Jonesboro in Clayton County on U.S. Highway 41 which, despite its brief existence, is said to have been quite productive

(43). And, on the other side of Atlanta, just north of Acworth in Cobb County, Arkansas-born James P. Reid finally settled, taking advantage of the tourist traffic on Route 293, which was then the main road from Chattanooga to Atlanta and, thus, a major link from the North to Florida. Earlier he had worked for James Brewer at Bogart in Oconee County, with Edward L. Stork at Orange in Cherokee County, for W. T. B. Gordy at Alvaton, and for the Cantrells in northern Paulding County ten miles west of Acworth. A dapper little man, he lived with his wife in a log house, producing both "artistic" wares with colored glazes geared to the tourist trade and Albany-slip-glazed utilitarian wares. Toward the end of his life, Bill Gordy (for whose father Reid had worked) came to work with him before journeying on to North Carolina. Nearly seventy and despondent over ill health, Jim Reid put on a new suit of clothes one day in 1930, waited by the railroad tracks near his shop for the noise of a passing train to drown out the gunshot, and committed suicide.

The only Atlanta-area pottery with folk roots still in business is the J. W. Franklin and Sons Pottery of Marietta, also in Cobb County.[25] Located at 899 Franklin Road between highways 41 and 75, the operation was established in 1901 by James Wiley Franklin; originally closer to Marietta, it was soon moved to the present location to be near a good clay supply. The 1900 census, which shows Franklin as a farmer, provides a clue as to how he got involved in the craft: living next to him then was Iowa-born Page S. Eaton, who potted in Texas and California before coming to Georgia, and later worked for W. T. B. Gordy at Alvaton, with L. Q. Meaders in White County, and for the Cantrells in Paulding County.

At first, James Franklin and his sons Bill, Barney, and Floyd produced jugs and churns glazed with Albany slip, salt-glazed fruit jars and sewer pipes, and hand-thrown flowerpots, which were mainly hauled by two-horse wagon to Atlanta. One novel feature of the operation is that goats were used at the clay diggings to keep the grass and weeds down (7). Later, the shop specialized in machine-made flowerpots, which Bill Franklin's son, Lamar Sr., stopped making in 1970. The business now serves as a sales outlet for the products of other plants.

Shortly before the Franklin Pottery ceased production Lamar, who then described himself as a "last-generation potter" because his sons were not interested in continuing the manufacture of flowerpots, discussed the changes that had taken place since his grandfather founded the shop.

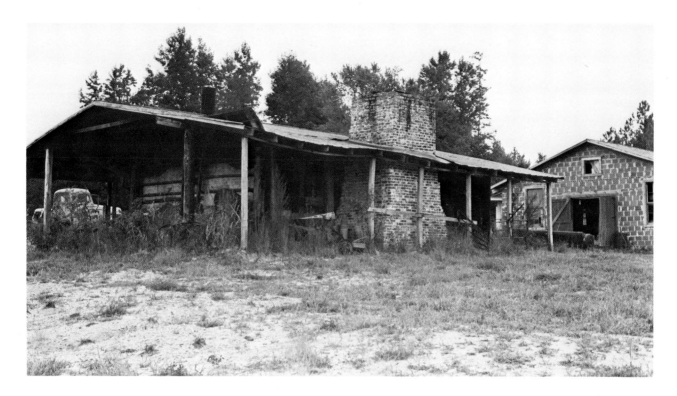

In the beginning the pots were made on a potter's wheel. Had a kick wheel in the beginning, then later on had a power wheel, then after that there was a method called jiggering which used a plaster of Paris mold. Soft clay was put inside and a template pushed the clay against the mold. When the clay dried it shrank away from the mold. Flowerpot presses like we have now, got one machine in 1914, conveyor in 1925. Uses a cast-iron and steel die. We used and still use an alluvial clay we mine down near Rockwood Creek. Used to haul it out by wagon.

In the beginning they made some glazed pottery, jugs, milk bowls and what-not. We've always made flowerpots, but jugs were made for syrup and whiskey. Joke was: T Model Ford came along and it was too rough for jugs so had to go to tin cans. They used a brown glaze called Albany slip, came from up in New York. But made a similar glaze by sifting ashes.

In the beginning most of the pottery was fired by wood. We used coal and wood and, oh, twenty or thirty years ago, we switched over to fuel oil. We have a round downdraft kiln with eight fireboxes around the outside. Most of

110. J. W. Franklin and Sons Pottery, Marietta, 1968.

the small potteries had what they call groundhog kilns. They were built into the ground. Fire was in one end, stack in the other end. My grandfather maybe used that kind of kiln in the beginning.

Most of our business was in the Atlanta area. There used to be a good many florists there. We don't make many pots anymore; we buy most and resell them. Labor got to be a real critical item with us. Also, the clay we've been using is pretty well exhausted now. Of course, we've been squeezed in here by urban growth. Apartment projects on both sides of us. (38)

As a postscript to this discussion of Atlanta-area potters something should be said of Rufus Rose, most prominent of the distillers who helped to keep many of them in business. He established his company in 1867 and began advertising in the city directories in 1870.[26] His retail store was in town, but the distilleries were located at Vinings (on Stillhouse Road in Cobb County, not far from the Howell's Mills pottery center) and Chattanooga, Tennessee. When Atlanta went dry briefly from 1885 to 1887 he moved his offices out of the city, then back again until 1907 (40). That year—the beginning of the state prohibition—the R. M. Rose store at 79 Peachtree Street was taken over by a tailoring firm, and the company transferred its main office to Chattanooga, eventually becoming Four Roses.[27] Among its products, advertised in the Atlanta directories, were Rose's Atlanta Spirit Rye and corn whiskeys produced by "primitive" methods with such names as Rose's Mountain Dew, Blue Ridge, New Sweet Mash, Old Reserve Stock, and Special Old Corn.[28]

Before 1907 many of the jugs used by the company were made on contract by Atlanta-area potters, including James W. Franklin, William H. Boggs, Charles S. Kline, James O. Brown, Andrew J. Bishop, and Charles H. Bird (the latter two using their own stamps on them). The typical Rose jug is a salt-glazed, cylindrical "stacker" jug often with Albany slip on the shoulder and neck for contrast and bearing a cobalt-blue insignia, R.M. ROSE / CO. / DISTILLERS, / ATLANTA, GA. (or something similar) stenciled on the wall.[29] Others are covered entirely with Albany slip or Bristol glaze. These jugs (which, like early Coca-Cola bottles, have become popular local-interest collectibles) embody a little-known facet of Atlanta's history, the rise and fall of a pottery tradition that had become too specialized to survive the onslaught of temperance crusaders.

ATLANTA AREA POTTERS

Bennett, Claude
Bird, Charles H.
Bird, Harry
Bishop, Andrew J.
Bishop, J. D.
Boggs, William H.†
Brown, Bowling
Brown, Bowling P.
Brown, Charles
Brown, C. Robert
Brown, Davis P.
Brown, Edward C.
Brown, E. Javan
Brown, Horace V., Sr.
Brown, Horace V., Jr.
Brown, James Osborn
Brown, J. Otto
*Brown, John S.**
Brown, Millard B.
Brown, Rufus E.
Brown, R. Theodore
Brown, Thomas O.
Brown, U. Adolphus
*Brown, William E.**
Brown, William O.
Brown, William S.
Cofield, Thomas B.
Cofield, Thomas W.
Cook, Louis
Craig, ———

Craven, Isaac N.
Daniel, John
Davidson, Asberry T.
Davidson, William*
Dougherty, Larry
Eaton, Page S.
English, Lee
Franklin, Barney E.
Franklin, J. Floyd, Sr.
Franklin, J. Floyd, Jr.
Franklin, James W.
Franklin, Lamar
Franklin, William J.
Gordy, William T. B.
Holcombe, Thomas R.
Kline, Charles S.
Leopard, Holland*
Leopard, John D.*
Rary, James H.
Reid, James P.
Robertson, Bill
Rolader, Ivon C. (H)
Rolader, Low D. (H)
Rolader, William W. (H)
Shannon, Joseph
Smith, Julius L.
Smith, Walter
Stork, Edward L.
Turbyfield, Jack
Turbyfield, ———

Italic indicates Howell's Mills center potters.
(H) Connected to, but not located at, Howell's Mills center.
* Suspected but not established as a potter, perhaps known as a potter elsewhere.
† Limited involvement in craft as shop-owner or assistant but not turner.

CHAPTER THIRTEEN

Northern Paulding County

Began in late 1860s. NUMBER OF POTTERS: *around twenty.* KEY NAMES: *Shepherd, Brock, and Sligh.* GLAZES: *Albany slip, early ash, and some late Bristol.* MAKER'S MARK: *marked examples rare.* MAIN FORMS: *churns (often with a second loop handle on the lower wall), whiskey and syrup jugs, and some pitchers and deep milk pans.* SPECIALIZED FORMS: *planter-type grave pots.*

On State Highway 61 roughly halfway between Dallas and Cartersville, and about thirty miles northwest of Atlanta, there is a Georgia historical marker commemorating the bivouac of a company in Sherman's Union Army with the heading "Sligh's Mill, Pottery & Tanyard. Noted crossroads settlement of the 1860s."[1] It is at the upper end of Burnt Hickory Ridge, so called, according to one variant of a local legend, because the Yankees, on their march to Atlanta, set fire to a landmark hickory there which continued to burn for six months (103). The sign is the only clue to the casual observer that this was once a small pottery center. In 1909 Otto Veatch briefly described the local ceramic activity: "There are two small potteries located about 10 miles south of Cartersville [which] manufacture common earthenware, as jugs, jars, crocks, flower pots, etc. The work is carried on in a primitive way and the business is purely local. Most of the ware is sold at the kiln and distributed through the surrounding country by peddlers. Most of the clay used by these potteries is obtained from the farm of R. M. Kerens, Paulding county, 6 miles southwest of Allatoona. The clay deposit is located in the valley of Bolong Creek."[2]

The economic hub of this community was the steam-powered sawmill, cotton gin, and gunpowder factory established by the enterprising John N. Sligh. Of Pennsylvania-German stock, Sligh was born in Lexington District, South Carolina, in 1807, and migrated from Columbia to Georgia in the early 1840s. The 1850 census lists him as a carpenter in the Powder Springs area of Cobb County, with real estate valued at $9,100. By 1860 he

had moved to the northern part of adjoining Paulding County, where he was then enumerated as a prosperous farmer owning eight slaves. From 1864 to 1868 he was justice of the county's inferior court, and, having married four times, died at the age of ninety. While Judge Sligh is not known to have been a potter, it appears that his mill attracted members of two pottery families whose skills would provide him with an additional source of income once a shop could be built.

The head of one of these, John L. Brock, was born in North Carolina; the 1830 census shows him with his father, Moses, in the White Creek District of Habersham (now White) County, Georgia, just east of the Mossy Creek pottery center. He moved to Franklin County, then to the Montevideo/Coldwater area of Elbert (now southern Hart) County near the Savannah River, where it is more likely that he became a potter. In the 1850 census he was listed there as a carpenter living just three houses from potter Allen Gunter, who probably was trained in Edgefield District, South Carolina; by 1860 Brock and two sons are shown as potters. Uprooted by the war in which one of those sons lost his life, he and his remaining family traveled westward across the state in a covered wagon to Paulding County, where his older brother, Isaac, had lived in 1840 (17).

The evidence suggests that the Brocks were the first to make pottery at Sligh's Mill. In 1870 John was listed as a farm laborer there and his son Moses L. was working at the sawmill, but two other sons, John Henry and Earvin (or Irwin) Columbus ("Lum"), appear to be listed as "Turners in Factory" (the handwriting on the census sheet is unclear), while his daughter Lucy Ann, who was then seventeen, is shown as "Working in Jug Factory."

North Carolina–born William Shepherd, leader of the other pottery family, stopped in Alabama (where most of his children were born) before coming to Georgia. I have found no indication that he was a potter before settling in Paulding County. In 1870 he was living near John Sligh, when the census shows him and his sons, William F. ("Bud") and John Robert ("Bob"), as laborers in the sawmill. But in the 1880 census all three are listed as potters, clustered with the Brocks around Sligh, who was designated as "Superintendent." The elderly John L. Brock, then shown as a peddler, was probably wagoning the wares; his daughter Lucy Ann had married Bob Shepherd about 1875, a factor which no doubt contributed to the involvement of the latter's family in the craft. The Shepherds eventually established their own shops in the area, with Bob's oldest son, John Franklin, and Bud's son Rowe carrying on the tradition into the 1920s. Their waster dumps

111. Ash-glazed wares from Paulding County. The jug, 10¼" high, was found in woods near Sligh Pottery and may have been made by one of the Brocks, ca. 1870s; jar, 7¼" high, is incised W.F. SH /EPHERD.

and the grave planters associated with the family reveal the use of incised wavy combing as a decorative technique.

Following Judge Sligh's death his widow, Sarah ("Sally") Ann, oversaw the management of the Sligh Pottery until she died in 1901, leaving their sons, Benjamin B. and Jacob Albert Sidney Johnson ("Sid") Sligh, to carry on the operation with the help of the Brocks and James A. Kiser, who had begun working at the shop as a young man. Sid Sligh, who learned to turn ware, was the family member most involved in the business. His son Willy Claude directed me to the pottery site deep in the woods behind his residence, and was able to describe the operation for the first quarter of this century. There were two buildings, the first a

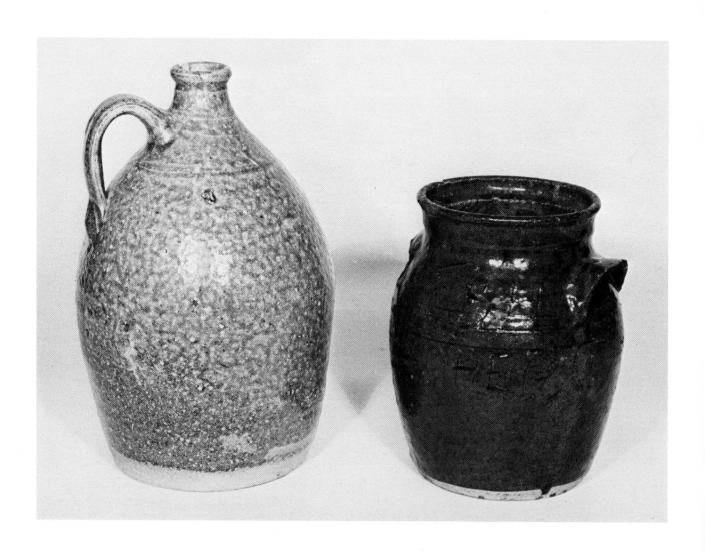

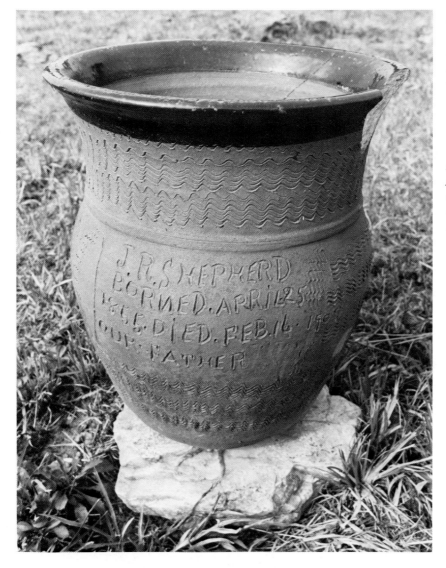

LEFT

112. Inscribed grave planter for potter J. Robert Shepherd, probably made by his son John. Combed decoration, rim dipped in Albany slip.

BELOW

113. Unglazed, two-piece grave planter of red clay with combing and fluted tiers, attributed to the Shepherd family and reconstructed from discarded fragments, 22¾" high total.

frame, dirt-floored turning shop, the other a log drying shed with a trench dug in the earthen floor where a fire could be kindled in the winters to keep the damp greenware from freezing.

The clay mill had, in addition to the usual tub in which clay and water were mixed, a large wooden crushing wheel to pulverize the dry clay. This upright wheel traveled around in a circular track surrounding the tub, rotating around a horizontal axle that extended from the main vertical shaft.[3] Weathered clay lumps first were shoveled into the rut and a mule or steer was led around to pull the wheel-axle, the big wheel crushing the clay into pow-

der. This was passed through a sieve and transferred to the tub at the center where water was added, the revolving blades blending the mixture into a creamy slip. Originally, the clay was not weighed before turning, but Sid Sligh built a set of scales which, according to Willy, permitted the ware to be turned thinner and thus more economically.

Willy entered the business at the age of five, leading the mule or steer around the clay mill. He recalled the speed with which his father and Jim Kiser turned out their ware, especially when it came to forming and attaching the handles: "They'd make them things just as fast as a dog trots" (97). Willy's turning was limited to smaller items, such as gallon jugs and pitchers. He also made sets of hand-rolled, unglazed marbles to give to neighbors.

The first glaze used at the Sligh Pottery was "sand and ash." Albany slip was adopted later, eventually replacing the ash glaze completely. A bulbous half-gallon jug, found in the woods near the site and very likely dating to its early days, is covered with a blotchy green alkaline glaze (plate 111), and a smoother version (possibly substituting glass for sand) was seen on a small percentage of sherds at the waster dump.

The rectangular kiln or "furnace," part of which was still standing when I visited the site in 1972, was large enough to hold about fifteen hundred gallons of ware and tall enough to permit stacking. It was fully arched (no straight sidewalls), with brick keystones along the spine to support the arch and earth packed all around; the chimney was of fieldstone. The burning took from twenty to twenty-four hours, using pine or oak cordwood.

Among the products of the shop were jugs for the "blockaders" who abounded in that area, bigger jugs for sorghum syrup, churns (the larger sizes had a second loop handle near the bottom to facilitate emptying, a trait often associated with Alabama churns), and pitchers. Smoking pipes were made in homemade molds, the cavities of which were packed with clay and then reamed. Willy owned such a mold used by his father, a two-piece lead block in the shape of a parallelogram; the first clay craftsman recorded for Paulding County, in fact, was John Cochran, listed as a "Pipe Maker" in the 1860 census for District 832. Loads of ware were hauled by covered wagon to general stores in the western half of the Georgia mountains—Blue Ridge (Fannin County), Ellijay (Gilmer County), Dalton (Whitfield County), and Walker County—as well as to southwest Georgia (as far as Moultrie in Colquitt County). Sid Sligh retired in 1925, but Willy and Jim Kiser continued the operation for a few more years.

An examination of the waster pile near the kiln suggested that firing problems were encountered in the later days of the shop's history: many of the discarded pieces were squashed and stuck together as if the stacked ware collapsed from overheating. Sand-rolled, flattened clay wads probably used to stabilize stacked ware on the uneven kiln floor and showing curved impressions where the pot-bottoms rested on them were also found (plate 59). One distinctive feature of the Albany-slip-glazed churns seen both there and at one of the Shepherd sites is the use of tooling around the shoulder to indicate gallon capacity: instead of the usual single incised line, as many as six parallel lines appear on the larger churns.

In addition to the Sligh and two Shepherd shops, there were two other potteries in the community. One was established by James A. Little, who evidently had learned the craft at the Sligh Pottery; it was carried on for a short time in the 1920s by his son Luther. The other was run by John Marcus Cantrell (who is said to have learned to turn under Jim Kiser) with help from his brothers, Hoke Strickland and Robert Dennis; there is some indication that their father, Marcus Earl Cantrell, also was a potter.

The Cantrell shop employed a number of local and itinerant potters, including Luther Little, John Henry Dunn (who also had worked for Jim Little, and was John L. Brock's grandson), Bobby, Javan, and Otto Brown (sons of Atlanta-based James Osborn Brown), Arkansas-born James P. Reid (who later established his

115. *Upper sections of two ruined four-gallon, Albany-slip-glazed churns stacked mouth-to-mouth and evidently slagged due to overfiring, from Sligh Pottery waster dump. Note incised lines to indicate gallon capacity.*

own shop at nearby Acworth in Cobb County), and Iowa-born Page Eaton, who died of pneumonia while working there. Ernest Hollingshed, Sr., also was employed for a time as a hired hand; he cut the two and a half cords of wood it took to burn the kiln, and packed wagonloads of the ware in pinestraw to be hauled north to Pine Log (Bartow County), Holly Springs (Cherokee County), and Sonoraville (Gordon County) (60). In addition to Albany slip, the Cantrells later used Bristol glaze, and are among the few Georgia folk potters documented as so doing (18B). This operation was on a relatively large scale, with a gasoline-powered clay mill. After a fire destroyed the shop, a smaller one was built which closed in the early 1930s, the last pottery to operate in northern Paulding County.

PAULDING COUNTY POTTERS

Brock, Earvin Columbus
Brock, J. Henry
Brock, John L.
Brock, Lucy Ann (Mrs.
 J. R. Shepherd)
Brown, C. Robert
Brown, E. Javan
Brown, J. Otto
Cantrell, Hoke S.†
Cantrell, J. Marcus
Cantrell, Marcus E.*
Cantrell, R. Dennis†
Dunn, John Henry
Eaton, Page S.
Kiser, James A.

Little, James A.
Little, Luther
Reid, James P.
Shepherd, George W.†
Shepherd, John F.
Shepherd, J. Robert
Shepherd, Rowe
Shepherd, William
Shepherd, William F.
Sligh, Benjamin B.†
Sligh, J. A. Sidney J.
Sligh, John N.†
Sligh, Sarah (Mrs. John N.)†
Sligh, Willy C.

* Suspected but not established as a potter, perhaps known as a potter else-
where.
† Limited involvement in craft as shop-owner or assistant but not turner.

CHAPTER FOURTEEN

Jug Factory (Barrow County)

Began about 1846. NUMBER OF POTTERS: *around thirty-five.* KEY NAMES: *Ferguson, DeLay, Dial, Robertson, Hewell, and Archer.* GLAZES: *alkaline, and Albany slip later (often under salt).* MAKER'S MARK: *marked examples rare.* MAIN FORMS: *jugs, jars, and slab-handled churns.* SPECIALIZED FORMS: *tableware during Civil War; planter-type grave pots.* HIGHLIGHTS: *Edgefield connections; strong dynastic ties.*

Nowhere in the sparse literature touching Georgia ceramics is there a hint that folk pottery was ever made in Barrow County (created mainly from southern Jackson County in 1914); in 1909 Assistant State Geologist Otto Veatch wrote categorically, "There are no clay industries in [Jackson] county."[1] By that time, to be sure, most traces of pottery production would have vanished. Yet maps of Georgia dating from 1847 through 1889 indicate a site called Jug Factory east of DeLay (a town known as Barber's Creek until 1854 and again after 1872, finally renamed Statham in 1892). This site, in fact, was the hub of a flourishing pottery center from the mid to late nineteenth century, whereupon the activity shifted northward to Gillsville.

The founder of this center, which was in the eastern triangle of present Barrow County near the juncture with Jackson, Clarke, and Oconee counties, appears to have been Charles H. Ferguson. Genealogist Anne Ferguson Royal believes he was born in Warren County, but that Indian troubles there forced his family to remove across the Savannah River to Edgefield District, South Carolina, about 1795 (91). From at least 1818 to 1825 Charles Ferguson lived adjacent to the shop of Abner Landrum,[2] leading figure in the Pottersville stoneware industry, where circumstantial evidence suggests he was employed. In an undated mortgage Ferguson referred to "my good friend Dr. Abner Landrum,"[3] and on other documents his name is associated with potters known to have worked with Landrum.

Map 3. Section of William G. Bonner's 1847 "Map of the State of Georgia" showing location of Jug Factory in what was then southern Jackson County. Courtesy of Georgia Surveyor General Department.

About 1827, the year Landrum sold his "manufactory," Charles Ferguson migrated westward to Walton County, Georgia, where he was recorded as a merchant.[4] By 1846 he had acquired 162 acres in what later would be known as the Santa Fe District of Jackson County, where he settled for the remainder of his life. Evidently he established his pottery soon after this move, for Jug Factory appeared on a map the following year.[5]

Ferguson's tract lay just west of that owned by James DeLay, who had come from Walton County in 1827, when the two may have begun their acquaintance. Said to have measured seven feet tall and weighed four hundred pounds, "Big Jim" DeLay originated in Kershaw County, South Carolina, of Huguenot stock. Once in Jackson County, he ran a blacksmith shop and grocery along with his 700-acre farm (35, 91). A year before his death in 1855, he also became postmaster of the community that was to bear his surname for the next eighteen years. His oldest son, George A. DeLay, succeeded to that position, and in 1860, a

116. John M. DeLay, ca. 1910. Courtesy of his son Wesley M. DeLay.

year after the post office was temporarily discontinued, the census shows him as a potter, the first of the family so designated. That career did not last long, however, for the following year he enlisted in the Confederate Army, later to be killed in the Battle of the Wilderness. Three other brothers—James M., John Milton, and Russell Van—survived the war to carry on an extended involvement in the craft, all three being listed as potters in the 1870 census. Russell Van married a granddaughter of Charles Ferguson following the marriage of one of Charles's sons, potter James S. Ferguson, to a daughter of "Big Jim" DeLay in 1848. As there is no firm evidence that the giant himself was a potter, we must assume that his sons were drawn to Charles Ferguson's shop through these alliances between the two families.[6]

John Milton DeLay's son, Wesley Marvin, worked as a youth in the Statham area and at Gillsville with his father and uncles, mainly preparing clay. When interviewed, he said that his father was in partnership with brother-in-law James S. Ferguson east of Jug Factory in Buncombe District of Clarke County, and also worked west of Jug Factory at Jug Tavern (renamed Winder in 1893 and the present Barrow County seat).[7] Finally, John worked with Eli Hewell at Gillsville before retiring from the pottery business about 1897. His brother Russell Van, however, continued to make pottery at his shop about halfway between Statham and Bogart "as long as he was able to stand up and work" (34). Wesley recalled that, in addition to Albany slip, his father and uncles used a homemade alkaline glaze composed of powdered glass, wood-ashes, and lime, and that they sometimes signed and dated their ware with a pointed stick.

In 1847 a daughter of Charles Ferguson married South Carolina–born Jonathan Dial, whose sister had married Charles's oldest son, John, back in Walton County. The 1860 census lists Dial as a potter, and three years later he was in partnership with one of the Fergusons, most likely his brother-in-law William, also shown as a potter in 1860 and living next to Dial. The following editorial appeared January 28, 1863 in the *Southern Watchman*, published at Athens in Clarke County.

Stone Ware.

See the card of FERGUSON & DIAL in our advertising columns. The establishment is located about 13 miles from this place, and is doing much to supply the people with a substitute for earthenware. We have examined samples of the bowls, pitchers, cups, saucers, mugs, bake-pans &c., which they make. It is true they

are not as smooth and handsome as the articles we have been used to, but are decidedly better than none. This establishment and others of a like character, ought to be, it strikes us, exempt from conscription.

The advertisement itself reads:

POTTERY.

The subscribers are now manufacturing at their establishment in Jackson county, Georgia, all kinds of STONEWARE, which may be had at reasonable prices, either wholesale or retail.

In addition to Jars, Jugs, and such other ware as we have formerly kept, we are now trying to supply the demand for other useful household articles. We are making Bowls and Pitchers, Dinner and Soup Plates, Cups and Saucers, Mugs, Coffee and Tea Pots, Bake Pans, Chambers, and various other needful articles.

FERGUSON & DIAL

Here is proof, then, that some southern folk potters were expanding their repertoire of forms to fill the gap created by the blockade of imported tablewares during the Civil War. Undoubtedly, the products of the Ferguson and Dial shop were alkaline-glazed stoneware which, though rougher than the white-glazed and sometimes fashionably decorated earthenware made in northern and overseas factories, at least would have been more durable. It would seem that, in the case of Jonathan Dial, the editor's plea for exemption of those craftsmen whose work contributed to the Confederate cause was partially heeded, for Dial served in the Home Guard and presumably did not see combat; while the note beside William Ferguson's name in the 1864 militia census reads: "Potter. Exempted justice of peace."

Another potter who worked in the Statham area was Nathaniel Hewell.[8] The censuses of 1850 and 1860 place him in Buncombe District of Clarke County with farming given as his occupation, but by the Civil War he, too, was producing tablewares, according to the widow of his grandson, Mrs. Maryland (Ada) Hewell: "I'd hear my husband talk about his granddaddy being a pottery-maker during the War between the States. 'Mammy' and him was gonna put the table out, you know, and have lunch outside, give 'em a picnic; and one or t'other of the children let the end of the table down, and said off went the dishes and food and all, and they had to make 'em at the pottery then 'fore they could have dishes to eat out of" (56). In 1880 Nathaniel and his son Eli were both listed as potters in Santa Fe District of Jackson

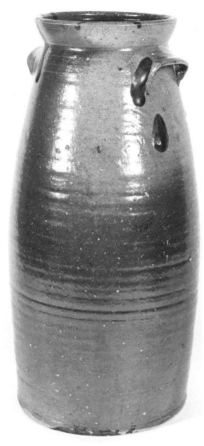

116A. Churn typical of the later Barrow County tradition, ca. 1880, 17¾ tall, salt glaze over Albany slip, with three lines incised around shoulder to indicate gallon capacity.

County, although the father had been unemployed for ten months because of illness. By this time the Hewells had become enmeshed in the dynastic web, for Eli's first wife, Elizabeth, was a daughter of Jonathan and Frances Ferguson Dial, and after Elizabeth's death, Eli married William Ferguson's daughter, Frances; both his wives were thus granddaughters of pioneer potter Charles Ferguson.

Nowhere else in Georgia, it seems, was the pattern of familial ties among potters so well developed as in Barrow County. Of those potters working there who were not blood members of the Ferguson or DeLay clans, virtually all were linked to them by marriage (figure 2). For example, in addition to Charles Ferguson's daughter Frances marrying Jonathan Dial, two other daughters married potters—Nathan Butler (whose sister earlier had married William Ferguson) and James Spence—while a fourth married Benjamin Robertson, whose sons and grandsons became involved in the craft. Of the children of "Big Jim" DeLay, besides the daughter who married James S. Ferguson, two others married potters Collin Steed and James Willard, while, in addition to the son, Russell Van, who married a granddaughter of Charles Ferguson, another son, James M. DeLay, married Margaret Archer, whose brother Robert became a potter in the Statham area.

As has already been suggested, not all the Barrow County potters operated at Jug Factory, although many may have started there. While it is not possible to determine the exact number of shops in the vicinity—some of which were just over the line in neighboring counties—two later operations are still remembered by area residents.

The first was owned by S. Wesley Bell just east of Bethlehem in southern Barrow County; there is some indication that his father, John W. Bell, had run a pottery at Jug Tavern, but neither Bell was a potter. Wesley, according to his son Truman, built the log shop at Bethlehem in 1917 because "he knowed there was some money in it" (12), and hired a succession of potters to work there, beginning with one of the Fergusons (who, by Truman's account, had turned ware for John Bell at Jug Tavern). When he quit about 1920, Robert Archer's son, Marcus, took his place at the wheel. Marcus, who is remembered for his peg leg, had worked previously at a shop in Athens which specialized in whiskey jugs for the Spencer Distillery (56),[9] as well as for Henry Hewell above Winder; in the 1900 census he was living near his father in the Mallorysville District of Wilkes County.[10] In 1922, when he became too infirm to continue working, the Bell Pottery

lapsed into dormancy until C. Robert ("Bobby") Brown and one or two of his brothers could be hired in 1928.

With the onslaught of the Great Depression Wesley Bell found himself trapped in a vicious economic circle, for he had to pay his hired potters five dollars or more a day, while people could not afford to buy the ware at prices that would have permitted him just to break even. As his son put it, "A turner really cost money, an' when ya got to where you couldn't sell it [the pottery], you couldn't keep him. We could swap the stuff to the stores for goods, but you had to have the money to pay the man that done the work" (12). As a result, the shop closed for good in 1930.

Andrew Conner, who grew up on the opposite bank of the Apalachee River from the Bell Pottery, wrote a description of the shop as it operated in the early 1920s.

> Mr. Wesley Bell built a jug shop and kiln; I watched many a time as Mr. Marquis [*sic*] Archer made jugs and other clay products. First, they prepared a grinder for the clay. It consisted of a sort of tub built of upright boards, three feet deep. He put a lever similar to the sort used on an old fashion syrup mill pulled by a horse or mule. There was an upright axle in the middle of the tub with several blades, or paddles, attached to it which cut or ground the mud as it turned. The clay was a special sort, free of sand and pebbles, exceedingly smooth. It was placed in the mill and ground, similar to batter being whipped. I mean by this to get it *velvety* smooth.
>
> Then came the "turning" or shaping, which was done after weighing to govern the size of the object to be turned. This clay was placed on a round turntable that was operated by a foot pedal. The fingers were placed in the middle of this ball of clay with the thumb on the outside, then the operator would start pedaling. As the table turned he shaped the clay into whatever form he wished.
>
> After turning the ware was set outside to dry. Once it was thoroughly dry it was dipped into a *very special* sort of clay made very soupy or thin with water [Albany slip]. This was called glazing. Again it was placed out to dry, after which it was placed in the kiln to burn. (28)

Truman Bell was able to add further details about his father's operation. Wesley originally purchased his clay, which was dug

from a swampy area near a creek on the "old Bradley place" and hauled three miles back to the shop with a "yoke of steers," the same oxen that had brought the bricks from Bethlehem to build the kiln. Ironically, Bell discovered clay on his own property shortly before he had to close the shop.

The clay mill tub, evidently, was set into a hole so that the rim was flush with the ground level:

> When ya got ready to grind it they had a pit dug, a clay pit. It had a three-foot hole in the ground with oak wood all the way around that, and a frame built down in dat hole and ya had knives on it, and wires tied from each one of dem knives to the next one, and that mule went around. It would grind it, would jus' cut it up, and ya pour water in thar, get the roots and stuff out. It'd take half a day to grind a bunch of it 'til it got to where it was like a putty. Take it out an' make it into square blocks.

These were brought into the shop, cut into smaller pieces, wedged,

> and cut with that wire several times to see that there wasn't no mo' roots in it; a little root or somethin' would make a hole when you burned it.

A ball-opener lever was used to gauge the thickness of the bottom of a larger pot on the wheel, and a metal chip was used for smoothing. Churns usually were "pieced" or turned in two sections.

> They'd make a big churn where a man's arm couldn't go to the bottom, and turn the top of that churn an' cut it off with a wire banjo string and set it down on a plank. Then go back and turn the rest of it an' set that top on it, then take your hand and just weld it together. Now, there's some of 'em that brought them up all the way, but a heap of 'em cut 'em off; they said they could make 'em faster that way.

After the piece had been turned,

> they cut it with a piece of wire from the wheel, and then they had lifters that'd open out and catch under, and set 'em on boards. Them lifters was thin curved pieces of iron

with a little hinge in the back, and had handles on 'em.
See, they had different size lifters for every size they made.
In 1917 when my daddy started, there was somebody had
run a shop over there at those woods, I don't remember
who it was; but we went an' got the lifters that he had.
Later we had 'em made at a blacksmith shop in Winder for
some that got lost.

When the pots got partly dry they'd go back and put
the hand-holders on 'em. They just take a ball of mud and
roll it up and shape it out by hand, but if they wanted a
[loop] handle on it they'd take that ball of mud, stick it
up there on top, and work it with their hands and bring it
down, stick it on the bottom.

Pottery-making at the Bell shop was not merely a seasonal oper-
ation:

They made pots year 'round. Now, in real cold weather
they had a big wood heater, build a big fire there, stack
the pots right around close to the heater so the water
would dry out of them so they wouldn't freeze and crack.

Albany slip, and occasionally salt, were the glazes used.

They had a big wooden box and they'd take that glaze—it
was a mud that comes out of a river, I don't remember
where we got it from but they shipped it in a barrel—and
make it real thick, and they'd take that jug or churn and
lay it down in there and turn it over, turn it bottom side
up where all that would drain back out, and there'd be
enough that'd stick to it to glaze it. Sometimes they'd
throw salt in the kiln when it was hot and it'd make
a gray.

The kiln was about sixteen feet long and 'bout five foot
high, and the chimley was about ten feet wide. You fired it
in the front and the smoke went through and out the
chimley. They fired it with cordwood; it got so hot in there
it'd look just like a snow, white heat. When you loaded
that kiln, you set one churn down and turned another one
down on top of it [stacking mouth to mouth]. That's how
you could burn more of them. Now, jugs you'd have to
stick on top of a churn.

They'd take a broken churn, bore a hole in it, put it in

the back [chimney end] of the kiln, had an iron rod with a hook on it and they'd pull that out to test it and see if it was burned. . . . That Mr. Brown, we had him in '29, he burned in only 'bout twelve hours; he was the only man 'at could burn one that quick. Burned his as good as the rest of 'em. When you got it burned you had to cut all the air off, even cover up the smokestack and the firebox door to keep the air from going in, and ya had to cool it 'bout two days before you could take 'em out, otherwise they would bust.

The marketing of the ware was the final step in the process:

The purpose of makin' 'em was to sell 'em. They'd have people come in by the truckload. And sometimes they'd load 'em up an' carry 'em to hardware stores and places like that. Before trucks, we put 'em in box wagons and pack in straw between 'em. (12)

A surface collection from the Bell Pottery waster dump disclosed two stamped marks, W. BELL and BROWN. According to Mr. Conner, one product of the shop was "chicken troughs," jug-shaped poultry fountains with a small hole in the lower wall and an integral drinking trough surrounding the base. Jugs made at the shop were used mainly for water, vinegar, and molasses rather than whiskey, the largest having a six-gallon capacity. Truman Bell added that both his father's and grandfather's shops also produced "small-mouth jars" for preserving fruit.

Around the turn of the century James D. Brewer owned a pottery at Bogart (originally called Osceola) in upper Oconee County, five miles east of Statham.[11] Older Bogart residents recall Brewer's operation, saying that he was not a potter himself but hired others to work in the shop, and described his wares as having a smooth brown glaze (Albany slip). The 1900 census lists him as a farmer living four houses from Arkansas-born James P. Reid, undoubtedly one of Brewer's hired turners and the only one in the community designated as a potter. Nearby, however, were Van Ferguson and Charles Dial, then shown as farmers but known to have been involved in the craft. If, indeed, they worked for Brewer, then both his and Bell's shops were extensions, in respect to some of their hired personnel, of the Jug Factory tradition.

BARROW COUNTY POTTERS

Addington, William R.*
Archer, James A.
Archer, Marcus
Archer, Robert B.
Bell, John W.*†
Bell, S. Wesley†
Brewer, James D.†
Brown, C. Robert
Butler, Nathan D.
Chandler, B. George N.
DeLay, George A.
DeLay, George W.
DeLay, James M.
DeLay, John M.
DeLay, Russell V.
DeLay, Wesley M.†
Dial, Charles C.
Dial, John
Dial, Jonathan
Ferguson, Charles H.

Ferguson, Charles P.
Ferguson, George D.
Ferguson, James S.
Ferguson, John*
Ferguson, Van
Ferguson, William F.
Hewell, Eli D.
Hewell, George†
Hewell, Henry H.
Hewell, Nathaniel H.
Reid, James P.
Robertson, Benjamin E.*
Robertson, J. Marion
Robertson, John B.
Robertson, John W.
Robertson, William C.
Spence, James W.
Steed, Collin*
Thomas, John H.*
Willard, James W.

* Suspected but not established as a potter, perhaps known as a potter elsewhere.
† Limited involvement in craft as shop-owner or assistant but not turner.

Gillsville
(Hall/Banks Counties)

Began in 1850s, blossomed in 1880s. NUMBER OF POTTERS: *about forty.* KEY NAMES: *Hewell, Holcomb, Ferguson, and Addington.* GLAZES: *Albany slip ("black glazin'"), with some ash (later called "glass glaze" with the addition of powdered glass) and salt over Albany slip.* MAKER'S MARK: *uncommon.* MAIN FORMS: *churns, pitchers, and jugs.* SPECIALIZED FORMS: *face jugs (Hewells and Fergusons).* HIGHLIGHTS: *now Georgia's garden pottery center, with three shops making planters.*

Gillsville, a farming village ten miles east of the city of Gainesville, straddles Hall and Banks counties just above their juncture with Jackson County. It also lies roughly midway between the pottery centers of Mossy Creek in White County to the north and Statham in Barrow County to the south, from which it drew its strength as it, too, emerged as a pottery center. The earliest known potter in the vicinity was Clemmonds Chandler of Mossy Creek, who is shown with that occupation in the 1860 census for Hall County. He was buried in the same cemetery as later Gillsville potters, including possibly the most influential, Eli Hewell.

There seems to have been no other ceramic activity until the 1880s, when John Robert Holcomb, another emissary of the Mossy Creek tradition, arrived at Gillsville.[1] In 1856 Holcomb had married Emeline Anderson, apparently the sister of White County potter Frank Anderson, but whether this association launched his career as a potter is not known. His brother, Joseph Cicero Holcomb, also moved to Gillsville from White County, and he, too, may have practiced the craft.[2] J. R. Holcomb is listed as a "jug manufacturer" in *Sholes' Gazetteer* for 1886.[3] About 1895 he left Gillsville for northeastern Alabama, but his second son, William Cicero ("Bunk"), returned to Hall County and, after a stint as a textile millhand in New Holland, reestablished a shop at Gillsville (where the 1900 census shows him as a "Pottery turner"; he

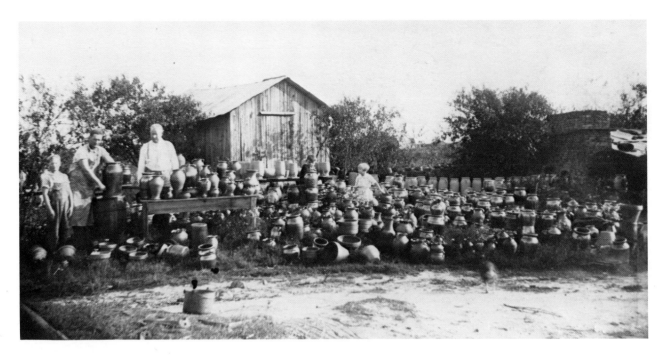

then may have been working for Eli Hewell). Bunk's son, Samuel Rayburn ("Ray") Holcomb, took over the shop in about 1925 and continued to operate it for twenty more years.

A contemporary of J. R. Holcomb was William R. Addington, who also was listed as a jug manufacturer in the 1886 *Sholes' Gazetteer*.[4] Addington lived in Jackson County and used Maysville, the nearest town in that county, as his post office, although he was six miles from it and only two from Gillsville. The pottery site, locally known as "Jug Hill," is now marked by a solitary old oak surrounded by scattered sherds and kiln bricks on the edge of a pasture. His clay was dug from the bottomland of nearby Candler Creek, and his shop is said to have been a cellar-like structure below ground level (56).

Addington appears to have been the first potter to come to Gillsville from Statham. In the 1870 census for the Santa Fe District of Jackson (later Barrow) County he is shown as a young farm laborer living with his brother John, but very near potters Charles H. Ferguson and James M. and Russell Van DeLay. During the 1870s he must have worked in one of their shops, and by 1880 he had moved northward to near Gillsville. A wide range of utilitarian forms, salt-glazed over Albany slip and bearing Addington's stamp or attributable to him, have turned up in a number of surrounding counties. The salt glaze left mustard-tan

117. Holcomb Pottery, ca. 1930. In group at left are William C. ("Bunk") Holcomb, his son S. Rayburn ("Ray"), and twelve-year-old Eugene Dodd (Ray's nephew, who also made pottery). Kiln at right has its loading door in chimney as with some White County kilns. Courtesy of Ray's son, Benjamin Ray Holcomb.

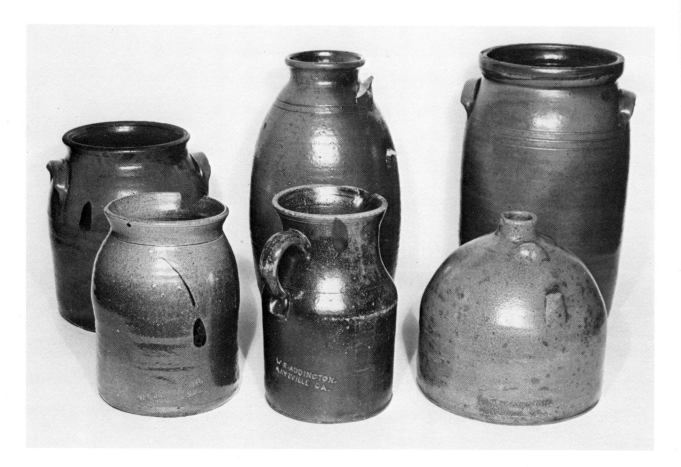

118. Assortment of wares by or attributed to William R. Addington, last quarter of the nineteenth century, salt glaze over Albany slip; those at front are marked.

or green patches where it contacted the brown slip, and the surface of his ware often was further, if unintentionally, highlighted by dark brown brick drippings. Sherds with this same glaze combination were found at the Jug Hill site, along with fragments of clay stacking collars (ring saggers) and separating chucks and a section of an unglazed drainpipe, impressed all around with Addington's stamp.

Near the end of the nineteenth century James Bascomb Henderson, who had no pottery background, bought the farm and shop when Addington moved to Cornelia in Habersham County, where the 1900 census shows him working as a livery stableman. As Henderson's daughter, Mrs. Pearl Ashley, recalled, Charles P. ("Charlie") Ferguson, who had moved to Gillsville from Statham, was hired to run the shop, while a local man named Doc Gailey did the hauling and selling. Some of the sherds collected at Jug Hill are glazed with Albany slip alone and have thinner walls than pieces attributed to Addington; these may date to the time

of Henderson's ownership. According to Mrs. Ashley, her father moved to Atlanta in 1903, at which time the shop was abandoned (2).

It is unlikely that Gillsville would have become much of a pottery center without the Hewell family, nearly twenty members of which have potted there. The first was Eli D. Hewell, son of Statham potter Nathaniel Hewell. Eli migrated up to Gillsville about 1890 following the death of his first wife, Elizabeth—daughter of potter Jonathan Dial—and his subsequent marriage to potter William F. Ferguson's daughter, Frances. He was accompanied or joined later by other Barrow County potters,

119. Face jug by Charles P. Ferguson, Albany slip on hair and eyes, 7¼" high. There once was a canted spout at top rear; base is open, so piece was not intended to function as a container. A similar example, also with mustache, is attributed to his son Pat.

including his brother Henry H., his brother (and son!)-in-law Charlie Ferguson, and his cousin John M. DeLay.

According to Mrs. Maryland Hewell, her father-in-law Eli first worked for W. R. Addington, then established his own shop right in Gillsville, and finally moved a mile south where his second son, John F. Hewell, maintained the shop until his death, when it was taken over for a few more years by John's son, Curtis (56, 52). This operation ceased about 1950, but remnants of the kiln, clay mill, and saddle-notched log shop (approximately twenty-two by twenty-six feet, not including the frame shed attachment at one end) were still standing when I last visited the site.

Eli's oldest son, William J. Hewell, never owned his own shop, but worked for his half-brother Maryland when living at Gillsville. Much of the time, however, he preferred to work at Mossy Creek, twenty miles to the north, for shop-owners "Daddy Bill" and "Little Bill" Dorsey and Loy Skelton. He expressed this pref-

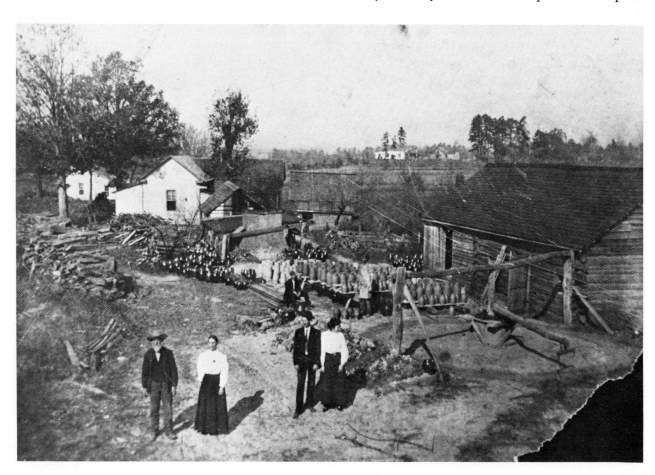

erence as early as 1900, when the census shows him as a laborer in Daddy Bill's pottery along with his uncle Henry, who later ran a shop above Winder. Will Hewell was an important link between the Gillsville and Mossy Creek traditions; it is said that he was at least partly responsible for introducing the concept of the face jug there (74).[5] Guy Dorsey, a White County potter who knew him, was lavish in his praise of Hewell's ability: "He was the best ware-turner ever to hit White County. And I think every turner in the country [area] will admit it. If anything got wrong with their lathe [wheel] and it begin to wobble or give them a little trouble, rather than mess with it themselves they'd just as soon get Will if he was in the country" (36A). What is said to have made his ware so fine was its smoothness; there were no lumps or finger ridges. His sons, William Arlin ("Arlie" or "Caleb"), Markes J. ("Mark"), and Russell L., all worked at Gillsville shops, as well as for Hallie A. Wilson between Lula and Alto in Banks County, a potter who learned the business under Maryland Hewell and Ray Holcomb (57, 107).

Eli's youngest son, Maryland ("Bud"), stayed with his half-brother John for a while, and after working for Jim Brewer at Bogart, Little Bill Dorsey and Cleater Meaders in White County, and the Johnsons at Lanford in Laurens County, South Carolina, set up his own operation just north of Gillsville, which included a log shop about twenty-four feet square. When that building became unserviceable it was torn down in 1936 and replaced by a larger frame shop resembling a dairy barn. In 1965, following Maryland's death, this site was abandoned and the Hewell Pottery was reestablished a mile away at its present location northwest of Gillsville by his sons Carl, Jack, and Harold; a fourth brother, Henry, has returned to work there after a career with the United States Marines.

The changes that have occurred at the Hewell shops tell the story of Gillsville's emergence as Georgia's garden pottery center. At first the potters served the food-oriented needs of their agrarian neighbors by making jugs for whiskey (the nearby settlement of Peckerwood was notorious for its many illicit stills) and "soggum surp," pitchers and churns for dairy products, preserve jars, and large churns for home brew and pickled vegetables (sauerkraut, beans, and corn especially). Sometimes these wares were hauled outside the community, as Harold Hewell recalled: "I remember once my dad and my grandfather went away. And when they slept that night, they lay on the ground and Dad's ear froze to the wagon wheel. It was cold, you know. Elberton [about fifty

FACING PAGE
120. Hewell Pottery, one mile south of Gillsville, ca. 1910. At foreground left are founder Eli Hewell with his second wife, Frances; in background center are two of Eli's potter children, Maryland (seated) and John (standing, with apron). The young couple in foreground center is Eli's daughter Eva and her husband, Lon Hooper, who was a loom-fixer in the local cotton mills. Note log shop with weatherboarded-frame annex and clay mill at right, greenware churns, pitchers, and canning jars drying behind Maryland and John, fired wares (evidently glazed with Albany slip) surrounding kiln beyond, and cordwood fuel. The potter's home was not always so close to the shop as here. Courtesy of Mrs. Maryland Hewell.

121. William J. Hewell, ca. 1930s. Courtesy of his son, W. Arlin Hewell.

122. Face jug attributed to Will Hewell, Albany-slip glaze, 9¼" high, with canted spout and central air-hole. The piece shows affinities with a miniature monkey jug and another face jug probably made by Hewell at "Daddy Bill" Dorsey's shop in White County. Photo courtesy of McKissick Museums, University of South Carolina, Columbia.

miles southeast of Gillsville, where a good deal of Gillsville wares have turned up] was about as far away as they went. Sometimes they would ship a few on the train" (53A).

With the state and national prohibitions the demand for whiskey jugs declined, but the need for other items continued through "Hoover days" (the Great Depression), when folks kept their own cows for milk and butter and "made a lot of surp for sweetening" (50). Eventually, though, most stopped maintaining their own milk cows and became dependent on commercial dairies, so that the demand for churns and milk pitchers dropped. And with the availability of inexpensive sugar in the groceries, sorghum syrup production each fall continued to slacken and with it, the demand for molasses jugs.

For a time the Hewells used ash glaze on some of these wares,

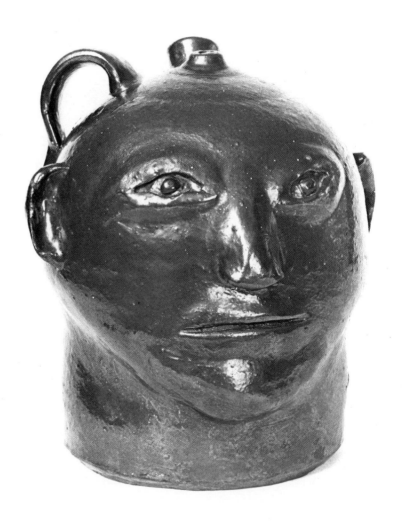

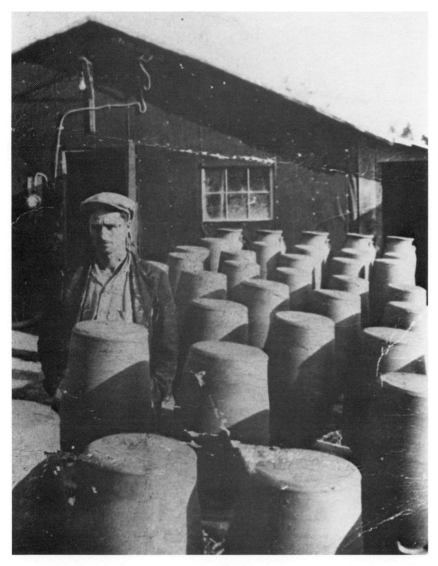

123. W. Arlin Hewell with green-ware churns on drying racks, 1938. He made churns up to fifteen gallons; the larger ones most often were used for salt-curing vegetables or meat, as well as making home brew. Courtesy of W. Arlin Hewell, from a wallet snapshot.

which came to be called "glass glaze" as pulverized glass was substituted for sand. Damaged Nehi soft-drink bottles, purchased from a bottling plant in Gainesville, were crushed in a gasoline-powered pounding machine and mixed with kiln ashes, clay, and water in a hand-turned mill, the runner-stone of which is preserved at the Hewell Pottery. The high proportion of glass produced a smooth, transparent glaze that was either green or light chocolate. A blue band of underglaze cobalt oxide (which tended to bleed when fired) was painted around the shoulder of later glass-glazed churns and pitchers, probably inspired by the

124. Three miniature joined jugs carved from a single lump of leather-hard clay by Maryland Hewell, ca. 1930. Except for an unglazed central band, this whimsical tour de force is glazed with Albany slip.

cobalt highlighting of Bristol-glazed churns then being imported into Georgia. The last glass glaze was used by Maryland Hewell about 1940.

Even before the turn of the century, however, the favorite glaze of Gillsville potters seems to have been Albany slip, which they called "the black glazin'" because it often fired to that color. While easier to prepare than ash glaze, Albany slip had to be used over a better-quality clay with few impurities, for, when melted, it would not flow and fill up cracks and blowout holes to prevent leaks as the older glaze did. According to Curtis Hewell, his father John dug such clay a mile and a half from his shop, transporting it with a wagon pulled by an ox trained to make his own way to and from the clay pit. But this supply of fine clay became exhausted, and for that reason, as well as the decline in demand for the glazed wares, both John and Maryland Hewell, later in their careers, "went to making flowerpots" and other garden pottery such as bird houses and feeders, vented strawberry jars (similar to churns in form but without handles), tall and graceful "Rebekah" pitchers, birdbaths and lawn ornaments cast from molds, and squatty, three-legged planters nostalgically modeled after the old-fashioned iron pots once used for washing and cooking on every farm (52). This transition in repertoire, which occurred mainly in the 1940s, is clearly illustrated by the large waster dumps at the shop sites of John, and especially Maryland, Hewell. The top layers are composed of unglazed garden pottery, which gives way to wares glazed with Albany slip—

mostly churns, with an occasional pitcher, jar, or jug—as one digs deeper.

The technology of the present Hewell Pottery represents considerable change from the earlier methods. The kilns adjoining John and Maryland Hewell's log shops were wood-burning tunnel kilns that the potters had to crawl through to load and unload. "Back in the early days," recalled Harold Hewell, "they used hard forest pine when it was available. Later, when it disappeared, they began to use sorrier woods and then later it went into just a slab which is the waste from sawmills" (53A). Churns were stacked two high, both upright rather than mouth-to-mouth, and to accommodate this the glaze had been wiped from the rim of the bottom churn and the base of the upper churn to prevent adhesion. The kilns were constructed of bricks from a Gainesville brick-manufacturing plant or from old buildings that had been torn down. The "backbone" of the kiln, along the top of the arch, was composed of "wedge-bricks" that acted as keystones to support the arch. The kilns were built on a slight incline so that the upper (chimney) end was a bit higher than the firebox end, providing better heat distribution (52). The present kiln, by contrast, is large enough to walk around in, and holds five thousand gallons of stacked garden wares. Built to burn diesel fuel, it is now fired with natural gas, loads from both ends, and has four corner stacks.

The clay, which is still obtained locally, was originally shoveled up by hand and mixed in a wooden, steer-drawn mill; now it is dug with a backhoe and pugged in a mechanically ingenious belt-driven mill converted from a foundry-made carbon crusher and first installed in 1935. Foot-powered treadle wheels were once used to turn the ware; now there are three electrically driven, hydraulically controlled wheels, which took some getting used to for those caught in the transition. The ball-opener levers were abandoned, but the height gauges are still in use, as are an old homemade wooden clay scale and a graduated set of hand-forged iron lifters carried over from the Maryland Hewell shop. The new shop was designed so that hot air could be piped from a coal-burning furnace into the drying room to keep the greenware from freezing in the winter, but now large fans that blow heat from the adjoining kiln shed do the job more efficiently.

All the wares made at the Hewell Pottery are hand-thrown. The unglazed tub planters come in a wide range of shapes and sizes, sometimes ornamented with fluted rims, incised combing done with a plastic fork, or designs rolled from the plastic wheels

125. Assortment of garden wares at Hewell's Pottery, 1980, including strawberry pots, tub and washpot planters, and ornamental jugs.

of furniture casters into which raised patterns have been burned. There is some seasonal variation in these wares; for example, Harold Hewell's son, Chester, takes credit for dreaming up the pumpkin-shaped jack-o-lanterns that have become big sellers in the fall. In addition, the warehouse/showroom offers a large assortment of imports, including nonceramic novelties. Chester feels the more recent work of his family has not received the recognition it deserves, and offered this rationale for the imported wares: "There's just as much art to making a pot like we make now as there was in making the churns they quit making. Lotta people come here and they just don't realize that when they buy one of our pots, that it's handmade and all that, on accounta we got all this other stuff; but we gotta have this other stuff to help draw the people in to buy what we make" (51).

Harold's wife, Grace, has been actively involved in the business for the past thirty years, beginning "right after the honeymoon" (54). At first she worked at "finishing" the pots turned by

the men, which included "rubbing" (beveling) the bottoms and "handling" and "legging" the washpots. Her husband was too involved with managing the shop to teach her to turn, so she sought help from Russell Hewell, who was then employed there. She learned fast, and is now one of the steadiest producers at the Hewell Pottery (plate 154). The week of September 29, 1980, for example, she made 2,500 smaller pieces, in addition to finishing the strawberry jars (cutting the pockets) and jack-o-lanterns (cutting the face holes) made by the others that week. Chester, who was three weeks old when she began throwing, says admiringly of his mother, "I don't know a man alive who can turn out the volume she does."

Representing the fifth generation of Hewell potters—his young sons, Matthew and Nathaniel, are already turning small pieces, the former for sale—Chester clearly takes pride in his family's craft heritage, but at the same time appreciates the technological improvements that began in his grandfather's day: "To look back from right now to the way it was when we left the old shop, it'd just about scare you to death the way things have changed. Now

126. Face jugs by Chester Hewell, 1975. Knowing of Lanier Meaders's success with such folk-art grotesqueries in White County and aware that an earlier generation of his own family had made them, Chester revived the form and produced a small number for a brief period. Since the Hewell Pottery makes only low-fired garden wares, Chester asked Lanier to glaze and burn them. Example on left, 9″ high, with coggled band below neck and china-fragment teeth, has a modified ash glaze; the other, 8″ tall with extended tongue and quartz teeth, is glazed with "Martin slip," an experimental natural clay glaze similar to Albany slip and obtained by Lanier from property of neighbor Seth Martin.

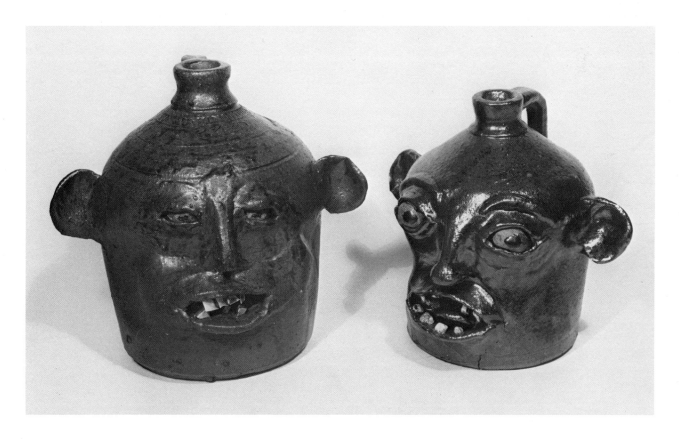

we can produce more—and probably a better product—in a shorter length of time. But maybe, too, all the years of experience our folks have had are behind us, or something" (51).

The success of the Hewell Pottery has prompted healthy competition from a number of neighbors, one of whom was Charles David Perdue, whose father, Robert, married Mary Frances Hewell, a daughter of Eli. Dave Perdue learned the basics of running a pottery shop by working for his uncle Maryland, and then set up his own operation, which was making garden pottery when it closed in the late 1950s (84); his employee, Arlin Hewell, actually produced most of the ware. (Perdue's brother, Rach, was killed as a teenager while employed in Henry H. Hewell's shop, when lightning struck the flue of the stove against which he was napping.)

Another Hewell spinoff is Craven's Pottery, established in 1971 by Billy Joe Craven. Although he descends from the Craven potters of North Carolina and Mossy Creek, several links in the chain of craft transmission had been broken and had to be reforged at the Hewell Pottery. His older cousin, Robert Lee ("Snake Eyes") Craven—whose nonpotter father, Henry Newton, son of White County potter Isaac Henry Craven, moved to Hall County and married another of Eli Hewell's daughters, Mattie—was the first of the family to work there, later running a shop of his own. But Robert's interest in pottery was short-lived, giving way to the cattle and swine business. Billy Joe (who married Karen Brownlow, of another White County pottery family) began working for Maryland Hewell at the age of eleven, and learned to turn ware under Harold. Because of those "skipped" generations, he feels, he has been freer to explore new approaches in his business (30). In some respects it is larger and more modern than the Hewell Pottery, with an enormous import inventory, six electric wheels, and an efficient commercial kiln. Unlike the Hewell plant, Craven's Pottery hires its help from outside the family; Jack Hewell and his nephew Wayne (Carl's son) work there, as do several young men who learned the craft from Billy Joe, one of whom came as a college-trained studio potter. As might be expected, the Craven repertory resembles that of the Hewell Pottery in most respects, with a few notable exceptions. Lacking the long-standing reputation of the older concern, Billy Joe has had to be more aggressive in his marketing, and has come out with a jack-o-lantern packaged in boxes labeled "THE PUNK: made of Georgia red clay" and distinguished from Chester Hewell's creations by naturalistic vertical ribbing. Billy Joe also has built a glaze kiln and is pro-

127. "Old-time" churn made by
Jack Hewell at Craven's Pottery,
1980, glazed with Albany slip and
frit; clay shed is in the background.

ducing a line of "old-time" wares—mainly churns with a nice
early shape—glazed with a mixture of Albany slip and frit (glass)
and made primarily by Jack Hewell.

The third, and most recent, shop currently operating at Gills-
ville has roots as deep as the others. Until 1978 it seemed that the
late William Patrick ("Pat") Ferguson, son of Charlie and Cath-
erine Hewell Ferguson, was the last potter of the Ferguson line;
he had worked with his father for John F. Hewell, and in his own
shop as well as one owned by Barney Colbert. That year Pat's
son, Robert F. ("Bobby") Ferguson, who had been trucking for
the other Gillsville potteries, set up a shop in his backyard, where
he and his son, Joseph Daniel ("Danny"), now make small garden

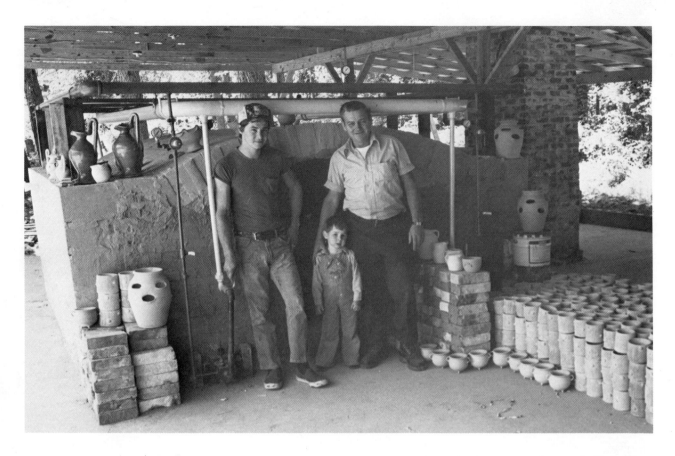

128. *Fifth- and sixth-generation potters Bobby Ferguson and his son Danny in front of their new gas-fired kiln, 1978, surrounded by small tree-stump and washpot planters, strawberry jars, and glazed Rebekah pitchers. Bobby thought his young grandson, Chris, also was showing an inclination toward the craft.*

wares. Danny represents the sixth generation of Ferguson potters.

Although the Hewell, Craven, and Ferguson potteries have kept up with changing times by adopting a later production technology and ware repertory, they have maintained a tradition of strong family involvement in hand-craftsmanship. Nowhere else in Georgia can one get a better understanding of a living pottery community than at Gillsville.

GILLSVILLE POTTERS

Addington, William R.
Brown, J. Otto
Chandler, Clemmonds Q.
Colbert, Barney
Colbert, Charlie R.*
Craven, Billy Joe
Craven, Robert L.
DeLay, John M.
DeLay, Wesley M. †
Dodd, Eugene
Dodd, Zach R.
Ferguson, Catherine Hewell
 (Mrs. Charles P.)
Ferguson, Charles L.
Ferguson, Charles P.
Ferguson, J. Daniel
Ferguson, Robert F.
Ferguson, W. Patrick
Hall, J. T.
Henderson, James B.†
Hewell, Carl W.
Hewell, Charles G. †
Hewell, Chester

Hewell, Curtis
Hewell, Eli D.
Hewell, Grace (Mrs. Harold)
Hewell, Harold
Hewell, Henry
Hewell, Henry H.
Hewell, Jack
Hewell, John F.
Hewell, Markes J.
Hewell, Maryland
Hewell, Matthew
Hewell, Russell L.
Hewell, Wayne
Hewell, W. Arlin
Hewell, William J.
Holcomb, John R.
Holcomb, J. Cicero*
Holcomb, S. Rayburn
Holcomb, William C.
Perdue, C. David†
Perdue, Rach
Wilson, Hallie A.

* Suspected but not established as a potter, perhaps known as a potter elsewhere.
† Limited involvement in craft as shop-owner or assistant but not turner.

CHAPTER SIXTEEN

Mossy Creek
(White County)

Probably began in late 1820s. NUMBER OF POTTERS: *about seventy-five.* KEY NAMES: *Craven, Davidson, Dorsey, Pitchford, Brownlow, and later, Meaders.* GLAZES: *Ash ("Shanghai") and lime, with special subtypes ("iron sand" and "flint"), and Albany slip after 1895; all but "flint" tend to be dark (brown or olive green).* MAKER'S MARK: *Marked examples rare, excepting later Meaders wares.* MAIN FORMS: *churns, elongated syrup jugs, pitchers, whiskey jugs, jars with horizontal slab handles.* SPECIALIZED FORMS: *multi-necked "flower jugs," two-gallon squatty pitcher-type "cream risers," later face jugs by Will Hewell, Brown and Meaders families.* HIGHLIGHTS: *North Carolina connections; Georgia's greatest concentration of potters, including the last active old-time potter, Lanier Meaders.*

As the 1969 Mercury Marquis winds around the roads of Mossy Creek District in southern White County, the driver's voice drawls over the Citizen's Band radio: "Breaker, breaker. This is 'Jughead.'" That is the CB "handle" of Lanier Meaders, the state's most traditional practicing potter, whose face jugs have brought him national recognition. Clearly, fame has not spoiled his sense of humor; it is also clear that, despite his old-fashioned approach to pottery-making, he has one foot firmly planted in the present.

It is not so apparent, riding with Lanier through the gently undulating countryside below Cleveland (the county seat), that this community of no more than five miles in breadth—which includes the crossroads hamlets of Mossy Creek, Leo, and Benefit—was Georgia's most intensive pottery center, harboring over seventy practitioners. His mother, Mrs. Cheever (Arie) Meaders, has counted nineteen shops once active in the area, nine of which were operating simultaneously "within hollering distance" in the early years of this century. The wares of Mossy Creek were sold all over north Georgia and into the Carolina mountains; Guy Dorsey, the last potter of his line, was hardly exaggerating

when he declared, "I can find you a piece of ware, I bet, in fifty counties of north Georgia that was made right here in White County" (36A).

It may seem curious that, of all the potters who have worked at Mossy Creek, only the Meaders name is known to crafts enthusiasts. The justifiable notoriety accorded that family is due, in part, to its continuation of an essentially nineteenth-century ceramic tradition after most American folk potters had either quit or shifted their production to less traditional wares. When first publicized in the 1930s, the Meaders shops represented the quintessential rural-based family handicraft that had once been the norm but by then was on its way to extinction.[1] It is now recognized, however, that the Meaders family's participation in the local pottery tradition came relatively late, at least half a century after the first shops were established.[2]

The Meaderses themselves have certainly been aware of this; shortly before his death in 1967 Cheever dictated to his wife a list of those potters he had known or heard about.

Davey Dorsey a pioneer potter came from South Carolina, operated a shop and kiln of his own on the farm which was a part of the Underwood farm in White County, Cleveland District.

Tarplin Dorsey son of Davey Dorsey owned and operated a shop and kiln of his own until around 1918–21. Was an old man when he died. He operated in White County, Mossy Creek District.

Williams Dorsey, Tarplin's son, worked with his father until his father died, then he operated his father's shop and kiln for several years until his age and health would not permit him to pot any longer.

Jim Dorsey, a brother to Williams Dorsey, both sons of Tarplin Dorsey. Jim never owned a kiln and shop but worked with his brother Williams and father for a few years. He made pottery for others who owned shops and kilns. He made pots until around 1930–35 in White County, Mossy Creek District. Age and health caused him to retire.

Daddy Bill Dorsey owned a kiln and shop in White County in Mossy Creek District, but he wasn't a potter. He hired potters who could pot, namely, Will Hewell; Jim Brown; Willie Brown, Javan Brown, Rufus Brown, all sons of Jim Brown. Also hired Page Eaton a potter, no re-

cord of where Eaton originated. Javan Brown operates at
Arden, N.C. now. Eaton and Browns also made pots for
the Meaders. Daddy Bill ceased operation around 1920–21,
not sure.

Little Bill Dorsey, probably some relation to the other
Dorseys mentioned, operated a kiln and shop of his own.
His brother Bob Dorsey worked with him, he potted also.
They operated in White County, in Mossy Creek District.
The building where Little Bill last operated is still stand-
ing near Mossy Creek Campground on Highway 75.

Billy Pitchford a pioneer potter of White County in
Mossy Creek District, owned a kiln and shop on the farm
joining the Meaders farm around the middle of the 19th
century, no record of how long he operated.

Craven, another pioneer potter, made pottery in White
County in Mossy Creek District. My father purchased the
farm on which he operated. There was evidence of his kiln
there when we moved there on the place in 1912. No record
of how long he operated, but I imagine was around the
middle of the 19th century.

Jerry Brownlow, a pioneer potter also, made pottery
around the middle of the 19th century. His location I be-
lieve was probably in the White Creek District, no record
of how long he made pottery. Don't think any of his off-
spring ever made any and no knowledge of where his kiln
and shop site are.

Warwick, another pioneer potter of White County. No
record of where he operated. His son was at our shop
around five years ago, he was telling us about his father
once making pottery but did not say where his kiln and
shop site was.

Chandler, a pioneer potter. No record of where he oper-
ated, whether he owned a kiln and shop. His great-
granddaughter told me he is buried in Mossy Creek
Church cemetery here in Mossy Creek District, must have
been around the early part of the 19th century.

Dolphus Brown owned and operated a kiln and shop in
White County in Cleveland, Ga. Dolphus is a brother to
Jim Brown mentioned above.

Marion Davidson, a White County potter, lived in
Mossy Creek District, taught the oldest Meaders by Wiley
C. Meaders to make pottery such as churns, jugs, pitchers
and flower pots. I imagine he made pottery around the
middle of the 19th century.

Wiley Meaders, a White County potter, began operating
a pottery shop and kiln around 1895 in the first shop his
father built for him and another one of his brothers.
Marion Davidson, an experienced potter, came and taught
them all he knew about pottery, and of course the younger
ones looked on and learned also. These both married and
went their separate ways and built shops and kilns of
their own.

Casey Meaders, another brother, also made pots at his
father's shop until he married in 1917. He moved and built
a shop and kiln of his own. These all operated in Mossy
Creek District.

L.Q., another Meaders brother but younger, also worked
with his brothers but never owned a kiln or shop.

Cheever, the youngest brother, stayed on at the old
Meaders place and operated the kiln and shop. The first
shop is long gone, another one built and it is gone, the
third one still here.

Lanier Meaders son of Cheever Meaders is operating
there now. Cheever operated at this place since 1920, until
1967 by himself.

While far from complete, this remarkable document shows that
Cheever saw himself and other family members as later links in
a long chain of local pottery activity.

Topographically, White is a transitional county, its upper reaches
dominated by the Blue Ridge, while the area below Cleveland (a
town appropriately heralded by the sign, "Gateway to the Moun-
tains"), including Mossy Creek, belongs to the upper Piedmont.
Fringed by a few foothills, Mossy Creek District nevertheless lies
low enough to have once nourished cotton as a cash crop, some
of it grown by small slaveholders like Lanier's great-grandfather.

The district was in Habersham County until White County
was created from the western part of Habersham in 1857. Sec-
tions of the mother county had begun to see settlement imme-
diately following the Cherokee cessions of 1818–19; by 1820 there
were whites living at Mossy Creek, and among them possibly a
potter or two, although early documentation is scant. In 1849 the
Reverend George White noted that there were four "jug manu-
factories" and eight or nine distilleries in Habersham, adding
that "The females of this county are remarkably skilful in weav-
ing jeans."[3] The names of a few White County potters were pub-
lished in 1879,[4] but it was not until 1909 that the ceramic activity
was described in print:

There are a number of small earthenware potteries located in White county. The clay used is a plastic alluvial clay, which may be found in the valleys of almost any of the streams. No very extensive deposits occur, . . . [but they] are sufficient to meet the needs of the potters.

The potteries are located 15 or 18 miles from the nearest railway; their capacity is small and they are not operated continuously, but only at such times as the owners happen to have leisure from farm or other work, and when there is any special demand for the ware. The ware consists of jugs, jars, churns, and flowerpots; it is not high-grade, being in most cases poorly burned, roughly molded, and carelessly glazed. Albany slip is generally used for glazing, but an artificial glaze is sometimes made by mixing sand, clay and lime in certain proportions and grinding the mixture to a powder between buhr-stones. The clay is pugged in wooden pug mills which are operated by horse-power. The ovens or kilns are low rectangular constructions with arched tops, and are built of stone or brick, and have a capacity of 300 to 500 or 600 gallons. There is very little expense attached to the operation of one of these potteries; fuel, wood, labor and clay are obtained at a very low cost.

The following is a list of the potters: J. M. Meador [sic], 3½ miles south of Cleveland, W. F. Dorsey and Wiley Dorsey, Leo P.O., J. T. Dorsey, Benefit P.O., and Dorsey Bros., Mossy Creek.

A sample of alluvial clay from near Leo, used by the potters, was very plastic . . . and was dark blue in color. This clay is mixed with a yellowish, less plastic and more sandy clay for pottery manufacture.[5]

One of the founders of the Mossy Creek Methodist Church in 1821 was Frederick Davidson, Virginia-born son of a Scots Revolutionary War veteran (94). It is surmised that he first migrated to Buncombe County, North Carolina (which then comprised the entire southwestern finger of the state),[6] then down to Pendleton District, South Carolina (probably via the Saluda Gap drover route), where he is found in the 1800 census, crossing the Tugaloo River into northeast Georgia to end up in Habersham County by 1820. While remembered as a Methodist preacher rather than a potter, the fact that three of his sons—Abram, John, and D. Marion—were potters is highly suggestive.

The Davidsons were among the early "tenters" at Mossy Creek

Campground—established in 1833 and still used in the summers for outdoor revivals—as were other White County pottery families, including the Dorseys, Brownlows, Pitchfords, Holcombs, and Meaderses. The following description of this nondenominational community center offers some insight into the use of both locally made and imported pottery at Mossy Creek:

129. Mossy Creek Campground at revival time, 1975. The open-air tabernacle where services are held is at left, the family "tents" are at center and right.

Campmeeting then was the social event of the year. Many city granddaughters today would prize the beautiful quilts and handwoven coverlets that grandmother used for partitions in the tents. The story is told of a regular tent holder at Mossy Creek whose wife refused to tent one year. When she told him the reason (she was ashamed of her dishes) he went to Augusta—no small trip in that day—

and brought back a barrel of Haviland china. You may be sure that his wife proudly carried a few of these lovely dishes to the campground. . . . All of the tent holders brought their cows tied to the backs of their wagons. Milk was kept in earthenware crocks in the nearby springs.[7]

In addition to Frederick Davidson another likely but undocumented pioneer Mossy Creek potter was Hezekiah Chandler. Born in Virginia about a decade after Davidson, he seems to have traveled a similar route to Georgia, settling in Habersham County by 1820 after stops in Elbert and Franklin counties (4).[8] The Chandlers may have been a family of early Virginia potters, for Thomas M. Chandler (1810 to ca. 1854), a superb potter who worked in Edgefield District, South Carolina, is thought to have been born at Drummondtown (Accomac Court House) on Virginia's Eastern Shore.[9] Further, the family's involvement in the craft could have begun in England; a John Chandler, workman for John Dwight of Fulham near London and then associated with the Elers brothers in Staffordshire during the 1690s, was one of Britain's first stoneware potters.[10]

The earliest dated example of Mossy Creek ware yet discovered, an ash-glazed, bulbous pickle jar inscribed S P d / 1843, is attributed to Hezekiah's son, Clemmonds Quillian Chandler. The initials are said to be those of the potter's brother-in-law, the Reverend Samuel Parks Densmore, for whom the piece was made.[11] By 1850 Clemmonds had moved to mountainous Gilmer County, finally settling near Gillsville in Hall County, where the 1860 census showed him continuing to practice the craft.

A third possibility as one of the original potters of White County is Nathan (or Nathaniel) Pitchford, also born in Virginia.[12] He was recorded as purchasing 250 acres in Mossy Creek District in 1822, at which time he was a resident of Franklin County.[13] Of his eight sons, the only documented potter was William G. Pitchford (whose son, John Henry, practiced the craft as well), but the listing of Georgia-born William (S.?) Pitchford—possibly the son of Nathan's son John B.—as a potter in the 1860 census for Itawamba County, Mississippi, suggests that there was more pottery activity in the family than records would indicate.

Speculation aside, the first known potters in White County were brothers John V. and Isaac N. Craven of Randolph County, North Carolina, the former acquiring land on the northernmost branch of Mossy Creek in 1825.[14] Back in North Carolina the

Cravens were an important pottery dynasty whose patriarch, Peter, is believed to have migrated via Virginia from a New Jersey Quaker settlement in the middle of the eighteenth century (39).[15]

John Craven became a man of means after settling at Mossy Creek, as the 1861 tax digest shows. In addition to the original parcel of land bought in 1825 he had obtained five others (including a house in Cleveland) as well as a slave, the value of this property estimated at $6,154. His possessions, listed in 1877 following his death, suggest that he was also a man of many

130. Ash-glazed pickle jar dated 1843 and attributed to Clemmonds Chandler, 12" high. The initials are said to be those of the potter's brother-in-law, the Reverend Samuel P. Densmore. Note incised wavy line on shoulder within slab handle; rim was repaired by D. X. Gordy.

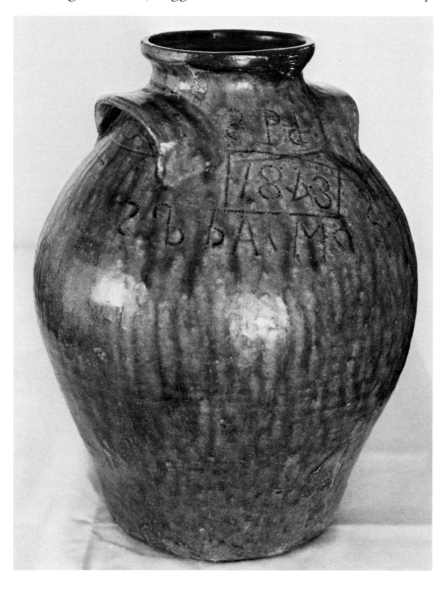

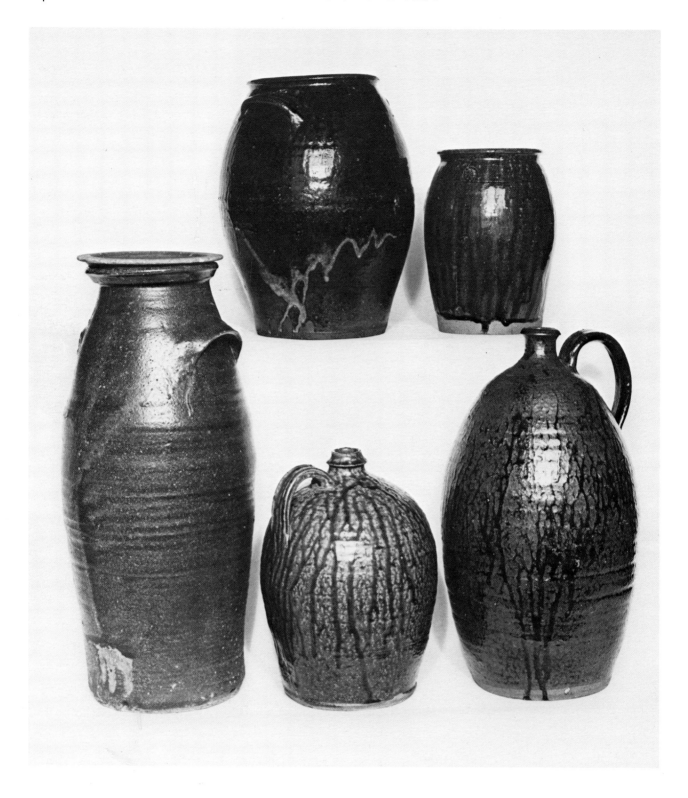

skills: besides "2 Turning Ware Cranks" and a "Turning Lathe" (which, in context, was more likely a potter's wheel than woodworking lathe), he owned a collection of "Carpenters Tools Old," a set of "Blacksmith Tools & Scrap Irons," a "Tanners knife,"[16] and—most interesting—a "Pair Gold scales," a "Table & watch tools," and "3 doz. Watch Cristals," indications that he was a part-time jeweler.[17] A "Lot of Books with the Family Bible" attests to his literacy, and a cotton gin, a pair of steelyards, "5 Pattent Bee Gums (Bees in 3 of them)," and a barrel of syrup point to the usual involvement in agriculture.[18]

While John was listed as a potter in the 1850 census, his son, Isaac Henry Craven, seems to have been the most prolific of the family, operating with the help of his oldest sons into the 1890s. In North Carolina the Cravens used salt to glaze their stoneware,[19] but pieces from Mossy Creek attributed to Isaac Henry are ash-glazed, indicating that the Georgia branch of the family adapted to the dominant local tradition of alkaline glazes. In fact, the Mossy Creek Cravens were noted for a special version of ash glaze sometimes used later by the Meaders family, "iron sand," incorporating an iron-bearing sand—gathered from a particular gully—that colored the glaze a lustrous black or red-brown while contributing silica. The North Carolina background of Isaac Henry Craven's ware was not totally obliterated, however, for the everted and flattened rim characterizing jars from the mother state remained a feature of his; he sometimes took advantage of the rim surface on larger jars to incise the gallon capacity in Roman numerals across its width, a most distinctive marking.

Of the early White County pottery families, the only one that qualifies as a "dynasty" there, in terms of extended involvement in the craft, is the Dorseys. For about a century, fifteen members over four generations were connected with pottery-making at Mossy Creek. The first of these was probably Basil Dorsey, whose father, Basil John, was born in Baltimore County, Maryland, migrated to Lincoln County, North Carolina (where Basil was born), about 1783, and finally settled in Franklin County, Georgia.[20] Following his older brother Andrew, Basil had moved from Franklin to Habersham County by 1828, when he married Nathan Pitchford's daughter, Nancy.[21] While Lincoln and adjoining Catawba County were later to become North Carolina's chief center of alkaline-glazed stoneware,[22] Basil was only a year or so old when taken from there to Georgia, and even if his father had been a potter he died when the boy was four. The likelihood, therefore, is that Basil learned the craft through his association with the

FACING PAGE
131. Group of alkaline-glazed wares believed to have been made at Mossy Creek in the mid nineteenth century. Jars on the top row have a punctated ring mark, as yet unidentified.

BELOW
132. Spittoon attributed to Isaac H. Craven, 3½" high, "iron sand" subtype of ash glaze with metallic sheen.

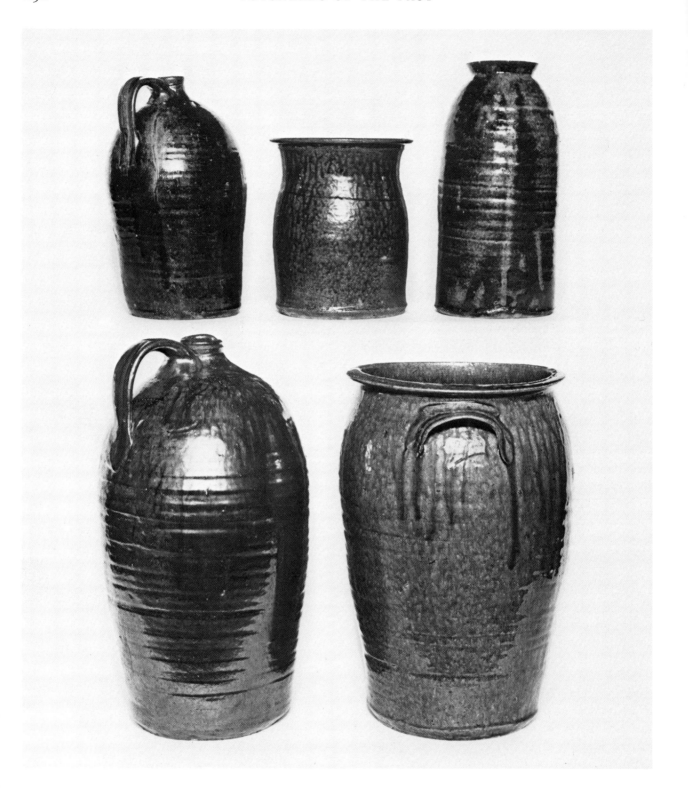

133. Ash-glazed wares attributed to Isaac H. Craven, ca. 1870s. The thin fruit jar and jugs are colored with "iron sand"; the jug necks have an incised collar and are embraced by upper end of handle.

LEFT
134. Closeup of Craven jar, 14⅞" high, showing scoring on flattened rim to indicate gallon capacity (in addition to 4 scratched beneath each slab handle).

Pitchfords, which was further cemented by the marriage of two of Nathan's sons to Andrew Dorsey's daughters.[23] Although there is no evidence that Basil made pottery at Mossy Creek, in 1850 he and his family were living in Marion County, Alabama, where the census identified him as a potter (along with his oldest son, William S., who by 1860 was potting in Itawamba County, Mississippi, with William S. Pitchford).

The pioneer Dorsey potter who made a lasting impression on the Mossy Creek tradition was David L. ("Davey") Dorsey. His relationship to Basil has not been determined, but it is likely they were cousins. Said to have originated in Buncombe County, North Carolina,[24] Davey appears to have migrated to Oconee County in northwestern South Carolina (where his first son, Frederick William Manson Dorsey, remained for a while),[25] then on to Mossy Creek, where he is found in the 1840 census. At his second shop, located closer to good "bottomland" clay (36B), Davey's son Joseph Tarpley ("Tarp") continued to operate, in partnership with Tarp's nephew, Enos.[26] Tarp's sons, Williams and Jim, carried on until about 1930 at a third shop built near the second (which Williams's son Guy ran for a final year or two), while Enos's sons, William Daniel ("Little Bill") and Bob, operated a fourth shop adjacent to the campground. The fifth Dorsey shop was established by William Fowler Dorsey (son of Davey's son Frederick, who had left South Carolina for White County shortly after William was born). "Daddy Bill"—so called to distinguish him from his younger cousin, Little Bill—was primar-

135. The late Guy Dorsey, last potter of his line, atop overgrown waster dump at the site of his father Williams's pottery, 1973.

ily a farmer, hiring others such as William Hewell of Gillsville to work in the pottery alongside his sons Wiley, Herbert, and W. Albert. It was there, also, that Georgia's only known black potter, Bob Cantrell, graduated from assistant to turner.

The glaze used at the last two shops was Albany slip, but the other Dorseys made considerable use of lime glaze. A resident of Cleveland, writing to the editor of the magazine *Antiques* in the early 1930s, described that variety of alkaline glaze: "The glaze is known as Walker glaze, from the fact of its derivation from a deposit of impure lime near Clarkesville, Georgia, known as Walker

136. *Pipe mold of lead and wood thought to originate with the Dorseys, 3⅞″ long; the pipe with cane stem was made from this mold and smoked by Cheever Meaders. In 1968 Guy Dorsey recalled, "I've spent lots of hours—we had two sets of pipe molds, and I'd set there in front of the kiln, chunk {feed} the fire and everything—with a ball of mud, and I'd mold pipes. Then the next time I burnt—you know, you didn't glaze them—you could just fill a flowerpot full of them. Burn a peck of them at a time. Then you get one of these creek-bank canes for a stem; man, there's been many a pound of home-grown tobacco burned in them" (36A).*

lime. This lime mixed with a local pottery clay was ground by hand in a small stone mill and applied to the ware."[27] Further insight into the Dorseys' chief glaze ingredient is provided by the following description of the Walker lime operation near Hollywood in eastern Habersham County, over twenty miles from Mossy Creek:

> The Walker lime kiln was owned by William Lynn Walker. The kilns were built on the side of a mountain with an open mouth to burn the wood. The lime rock was skidded into the kilns by men. I understand the top salary was twenty-five cents a day at that time; my grandfather was one of the laborers. They burned cordwood to heat the rock, and after about eight days the rock began to disintegrate and the lime was separated from the "trash" and made into builder's lime, which was used in a lot of the old courthouses in this section.[28]

Guy Dorsey remembered his father burning the limestone himself in the chimney-end of his pottery kiln, then "slacking" (slaking) it with water in a churn (36A).

The Dorseys were noted for an "extra good" (74) subtype of lime glaze called "flint" or "flint and steel," which contained cal-

137. Jug with light-green "flint" subtype of lime glaze attributed to Davey Dorsey by great-granddaughter who owns it, ca. 1850s, 9¼" high.

cined (burned and pulverized) quartz-bearing rock. When well fired, the flint glaze produced a watery or golden green color over a light clay body, but when underfired it took on a matte ivory or cream color. Tarp Dorsey's flint and regular lime glazes were acknowledged by the Meaderses as the finest glazes in White County; he did, however, also use an ash glaze (75).

The other White County pottery dynasty, of course, is the Meaders family. Its first representative was Christopher Columbus Meaders, who in 1848, at the age of forty, exchanged his property in what is now Banks County for a parcel of land at Mossy

138. "Flower jug" with three bell-shaped necks and "flint" glaze, possibly made by Davey Dorsey in the 1850s.

Creek. There he became a prosperous dry-goods merchant and farmer, and was soon the wealthiest man in the district: in the 1861 tax digest his total property was valued at $14,330, and the slave census of the preceding year shows him owning ten slaves who lived in two slave-houses. His great-grandson, Lanier, "heard my granddaddy [John] talk about the 'darkies,' he called them. They'd have to every night pick the seed out of the cotton 'til they picked a shoeful of cotton seed" (78A). Christopher himself lived with his family in a two-story frame house with a central hallway and chimneys of stone and handmade brick.[29]

The first of the family to become involved in the pottery business was one of Christopher's sons, John Milton Meaders. Never a potter himself, John was a man of other talents—blacksmith, wagon builder, carpenter, and trader—although he was not known for his industriousness, according to his grandson Lanier: "He's said to be one of the strongest men that ever been in this country. Well, he ought to have been; he never hurt hisself! But he was

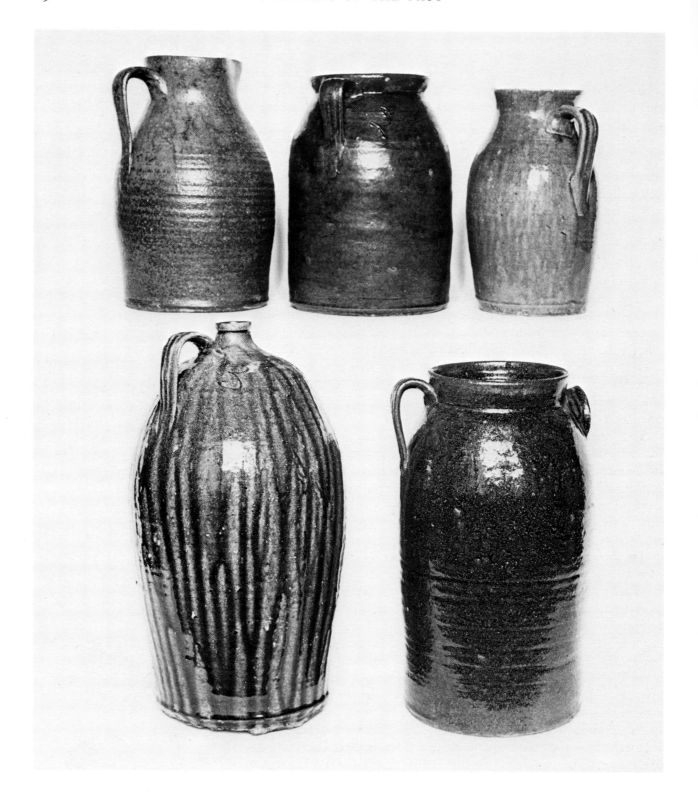

one of the generation that should never have been. He was the 'baby generation' of the Civil War. He was just the baby when slavery ended. He was just completely lost. . . . They say that when John died he wanted them to bury him setting up in his rocker under his favorite shade tree. Well, he liked to set better than any man Dad ever knowed in his life" (78A).

It was as a wagoner that John first saw the economic possibilities of pottery. He used to haul loads of the local ware into the mountains and trade it for chickens, which he'd then sell at market centers like Athens. Seeing the success of the potters around him—his sister Fannie had married Daddy Bill Dorsey and his brother David had wed a Pitchford—he decided to open a shop of his own, hiring potters from other families to work there until his oldest sons could learn from them. One of his younger sons, Lewis Quillian ("L.Q." or simply "Q."), remembered, "very distinctly, about Pa talking with my older brother, said, 'We'll just put us up a ware shop. We'll have something to work at.' And, 'course they were young, chucky boys; that just suited them. They just cut the logs and pulled them right up, . . . built that shop in the winter of '92 and '93. First fellow that ever turned any ware for my father was Williams Dorsey, who was about twenty-five or thirty then. He worked for us a good while off and on" (77A).

The kiln bricks, Lanier recalls hearing, were made on the spot in a fifty-foot-long scove kiln constructed of "soft" (unfired) brick by Daddy Bill Dorsey and his sons. There was a chimney in the center and firebox eyes every ten feet, the structure being honeycombed with narrow draftways for even heating. It took nearly a month and forty cords of wood to burn the square bricks, which, after cooling, were disassembled and used in the pottery kiln.

The Meaders Pottery was launched in the spring of 1893. John Meaders's older boys—Wiley, Caulder, Cleater, and Casey, who were then eighteen, sixteen, thirteen, and twelve, respectively—worked at digging the yellow stoneware clay, cutting wood to fuel the kiln, mixing and "balling" the clay, and generally assisting the hired turners, who were paid on the basis of two cents per gallon. D. Marion Davidson (who by then was in his sixties) as well as Williams Dorsey worked there, and from them the boys learned the fundamentals, passing them on, in turn, to their younger brothers, L.Q. and Cheever.

As the older brothers reached manhood, they made homes for themselves in the community. Wiley, Cleater, and Casey set up their own shops; Caulder, though an excellent turner, became a

FACING PAGE
139. Group of wares attributed to Tarp Dorsey. The syrup jug appears to be ash-glazed, the rest lime-glazed (pitcher at right may exhibit "flint" subtype). Note thin strap handles with vertical finger-ridges and rat-tail terminals; jugs have a rudimentary ring collar at mouth.

140. John M. Meaders, founder of the Meaders Pottery, photographed by his glaze mill in the early 1930s by Doris Ulmann. Courtesy of the Doris Ulmann Foundation and Berea College, Berea, Kentucky.

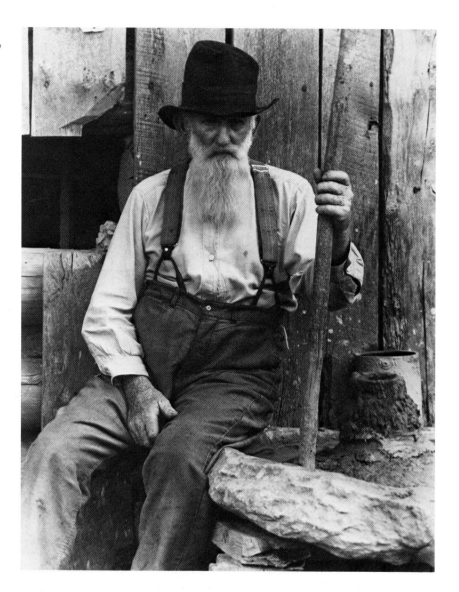

railroad man; L.Q. never built a shop but occasionally worked with the others, mainly as a hauler. Cheever, the youngest, stayed with his father and eventually took over the original operation.

At first Wiley and Cleater worked together across the creek below their father's shop. After Cleater married he continued to produce ware at that site, while Wiley returned to the home shop until he married, at which time he moved due east and established a pottery on Mossy Creek Church Road. As his nephew Lanier recalls him, Wiley was a powerful man—six feet, four inches tall and weighing 230 pounds, with arms nearly four feet

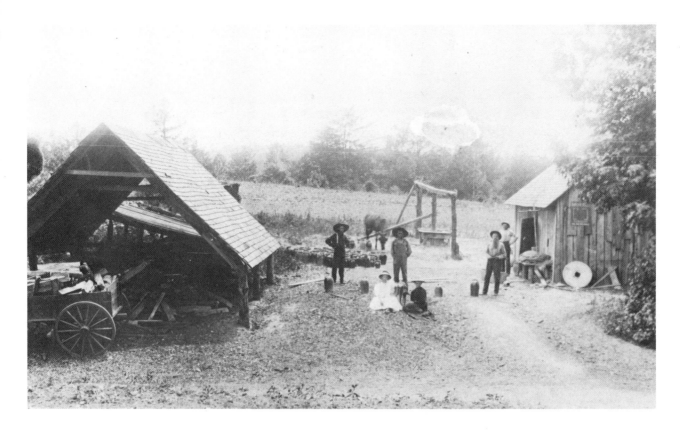

long—whose ware was of uniform thinness from top to bottom.[30]
His only problem, says Lanier, was matching his glazes to his
clay; the "black" creek clay he used tended to "inhale" (absorb)
the glaze.

Cleater temporarily left the craft to become a railroad section
foreman but took it up again during World War I, hiring Gills-
ville potter Maryland Hewell for four years to assist him. In 1921
he bought a farm on the northern edge of Cleveland which in-
cluded a good clay "pond" and set up his second pottery, operat-
ing it with considerable help from his nine children. Although
Cleater had acquired the old Pitchford glazing mill for refining
the alkaline glazes, he found this process too laborious and passed
the mill on to Cheever, adopting the Albany slip which local
potters had begun using about 1895. To this he sometimes added
feldspar, whiting, and flint, all bought in powdered form; the
mixture burned green below two thousand degrees Fahrenheit
and brown above (76).

At Cleveland Cleater continued to make the usual utilitarian
wares, often incising a number of lines around the shoulder to

*141. Meaders Pottery, ca. 1910.
Bearded John Meaders with children
(from left to right) L.Q., Johnnie
May, Cheever, Lizzie, and Casey.
Kiln is behind shelter at left, Lou the
mule is hitched to "mud mill," and
"glazin' rocks" are in front of
weatherboarded-log shop at right; the
field beyond, then planted in cotton,
is now grown up in pines. Courtesy
of Mrs. Cheever Meaders and Lanier
Meaders.*

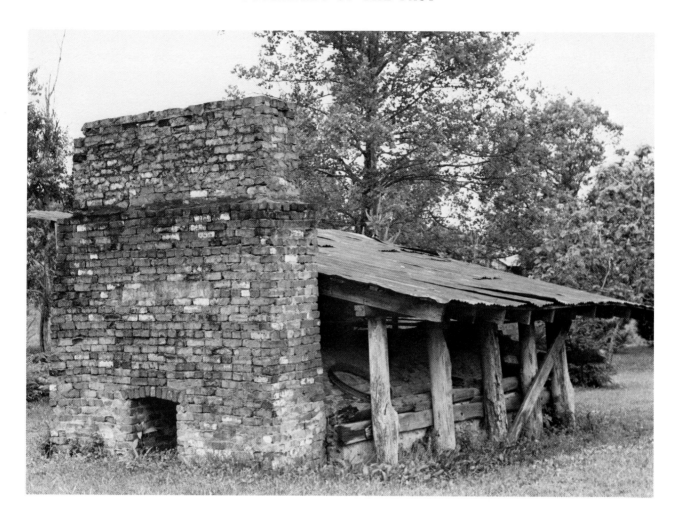

142. "Tunnel" kiln at Cleater Meaders Pottery in Cleveland, dismantled in 1978. CLEVELAND POTTERY / 1928 was inscribed in cement on the chimney. The kiln measured 20' long by 9' 10" wide by 4' high (to top of arch); chimney was 10½' tall. Note that loading door was in chimney end.

indicate gallon capacity,[31] but to appease the tastes of his town customers added vases to his repertoire, sometimes leaving them unglazed on the outside so that they could be painted. He also marked certain pieces with a stamp, which was alien to the Mossy Creek tradition.

In 1928 Cleater's second son, Frank Bell Meaders, built a new kiln to replace the one that had seen seven years of hard use, and this kiln remained as a Cleveland landmark for half a century. But by 1932 Cleater's health would no longer permit him to work, and the operation was carried on for a few more years by Frank and his older brother, Lambert. In 1937 Frank, now married, found he could not make a living at the craft and so moved to Atlanta to work for the Ford Motor Company, leaving Lambert to run the shop. It finally closed the following year when Lambert was

offered a job as a ceramics instructor at Habersham College in Clarkesville (76, 49).

Casey Meaders's shop was located just below his father's by the creek bridge, its remains now overgrown by kudzu. In 1920, after separating from his first wife, he moved to Catawba, North Carolina, where he produced Albany-slip-glazed wares until about 1940; his log shop there was enshrined within a cinderblock shell and still stands (46). L.Q. took over Casey's Mossy Creek shop for a short while, hiring itinerant potter Page Eaton, and eventually became a pottery instructor at Brenau College in Gainesville.

Cheever, meanwhile, took charge of the original Meaders Pottery in 1920. By that time most of the older White County shops had shut down, and in twenty more years his only competition would be Loy Skelton, a livestock farmer who hired Will Hewell after Daddy Bill Dorsey's shop closed. Cheever's determination to continue making pottery carried him through the depression, although he was forced to reduce his prices and output. Lanier recalled that those times were not so hard for them:

> People somehow managed to find a nickel or a dime or a quarter to buy a four or five gallon churn. 'Course he'd take that quarter to the grocery store and buy enough groceries that one person could hardly carry them home. Churns was in more demand then than they've ever been at any time since then. 'Course people used them for processing food. If anybody didn't have a job, you know, they'd have a garden. And if they didn't grow it, they didn't eat. If they didn't preserve it after they growed it, they didn't have it to eat later. And that's the reason, I reckon, it sold so well. And we didn't go hungry, either! (78A)

Although Cheever's "old standby" glaze initially was ash or "Shanghai,"[32] he was acquainted with a variety of others. His lime glaze contained three parts powdered lime, one part stoneware clay, and one part "pretty white sand," mixed with water and run two or three times through the glaze mill (74). Occasionally he also made the "iron sand" and "flint and steel" subtypes. Albany slip, he claimed, was introduced to White County after he and his father returned from a visit to the Hewell Pottery at Gillsville, but by L.Q.'s account William G. Pitchford's son George first saw a newspaper advertisement for the easy-to-prepare "patent" glaze and ordered some from New York, after which it was quickly adopted by Daddy Bill and Little Bill Dorsey (77A).

Cheever Meaders, like Tarp and Williams Dorsey, was less in-
clined to embrace the new glaze and used it sparingly. From the
Browns Cheever learned about Bristol glaze (which his wife later
would use on her decorated wares), and he once tried salt-glazing
over Albany slip. But the glaze he came to use most often was a
modified lime glaze developed by Lanier at the close of the Sec-
ond World War. Possibly inspired by Cleater's mixture, it con-
sisted of Albany slip, stoneware clay, whiting (refined chalk), and
feldspar, and needed no grinding in the mill. Depending on the
firing conditions it would turn either green or brown and, unlike
the drippy-textured ash glaze, tended to melt smoothly. This is
the glaze found on most of Cheever's surviving pieces, a few of
which were actually inscribed MOSSY CREEK GREEN.[33]

It was during the 1930s that the Meaders Pottery was first brought
to the attention of the world beyond north Georgia. The dirt
road that ran by the shop was paved and upgraded to U.S. High-
way 75, and the more curious of those headed south to Florida
began to stop. Then came the publication of Allen Eaton's *Hand-
icrafts of the Southern Highlands* (which included Doris Ulmann's
photograph of Cheever with his sons),[34] and gift shops geared to
the tourist trade began to stock Cheever's wares in addition
to the general and hardware stores. For the most part he resisted
the efforts of outsiders to change his repertoire, for he was hap-
piest when making the familiar churns, jugs, milk pitchers, cream
risers, broad-top pots, and kraut jars. But some of his visitors
became steady customers and friends, and he found it difficult to
refuse their orders for tableware and such. Finally, at the age of
seventy, Cheever decided it was time to retire.

That year, 1957, his wife Arie took advantage of his absence
from the shop to teach herself how to turn. Since their marriage
in 1914 she had been fascinated by the craft, and, after their chil-
dren were grown, would help her husband with some of the more
basic chores, such as "balling" clay. An intelligent and sensitive
woman, she felt the need, at the age of sixty, for a creative outlet
beyond the more conventional domestic ones of gardening and
quilting. As she expressed it, "I just got to wanting to [turn] so
bad I just tried it. I felt like I could. . . . He couldn't make the
things that I could vision in my mind, and I just wanted to do
it myself" (75A). With little technical assistance she learned quickly
on the donated wheel with a plywood headblock set up in the
back room of the shop.

Unfettered by Cheever's conservatism and years of condition-
ing within the local pottery tradition, and encouraged by crafts

enthusiasts such as Atlantan Marianne Kidd, she developed her own forms—vases, platters, sugar bowls and creamers, cookie jars and beanpots—which she decorated with applied or painted grape clusters, dogwood blossoms, morning glories, and even more elaborate designs.[35] Starting with the feldspar and whiting that were key ingredients in both the modified lime and Bristol glazes, she added mail-order metallic oxides to produce a variety of vivid colors, using those materials also for her paints (since the 1930s ceramic supply houses had been sending samples of such chemicals).[36] She would first sketch her designs (sometimes inspired by illustrations from printed sources) on paper, then work out a way to realize them in clay. This was true of her most remarkable creations, a series of strictly ornamental birds—roosters, pheasants, quail, and owls—turned on the wheel in cone-shaped segments (two for the body and one for the base) and handsomely painted. Lanier spoke admiringly of his mother's work: "She does pretty good. 'Course she makes small stuff, mostly up to one-half gallon size. . . . She's a real good painter. She can use a paintbrush good. Or, she can set down with a pencil and draw anything she wants to. . . . She'll keep drawing 'til she finally draws something that suits her, then she goes and makes it. . . . The kind of stuff that she makes isn't made anywhere else in the world" (78A).

Stimulated by the attention his wife was receiving, Cheever returned to the shop and worked with her for a decade until his death, allowing her to decorate some of his churns and being persuaded to make a few of the later forms. Arie stopped making pottery in 1969, but her ideas continued to influence Lanier, who has produced some urns and lidded jars ornamented with grapes and dogwood flowers.

Quillian Lanier (named after his Uncle Q. and Georgia poet Sidney Lanier) and his three brothers all received training in their father's shop, but only he would make the craft his profession, and not until his fiftieth year. At the age of eighteen Lanier joined the U.S. Army, seeing combat as a paratrooper in the European theater of operations in World War II. A succession of jobs in a textile mill, mobile-home plant, paint factory, sheet-metal fabricating shop, and his cousin's chicken farm followed his return. Meanwhile he was living at home and helping his father at the pottery on weekends. His brothers had married and, with families of their own to support, entered "public works," as they call it, John (the eldest) working at a lumberyard, Edwin (the youngest, nicknamed "Nub") at a poultry-processing plant, and Reggie

143. Lanier Meaders, photographed in 1945 at Morrison's Studio, Edinburgh, Scotland. The army introduced him to the world beyond Mossy Creek, and the war provided a source of nightmares that make him feel at times as if he's "coming apart like a joint snake."

144. The late Cheever Meaders with a group of his wares, 1957. All but ash-glazed whiskey jug (top center) exhibit a matte, opaque glaze characteristic of underfiring. Photo by Kenneth Rogers, courtesy of the Atlanta Journal and Constitution Magazine *with thanks to Andrew Sparks.*

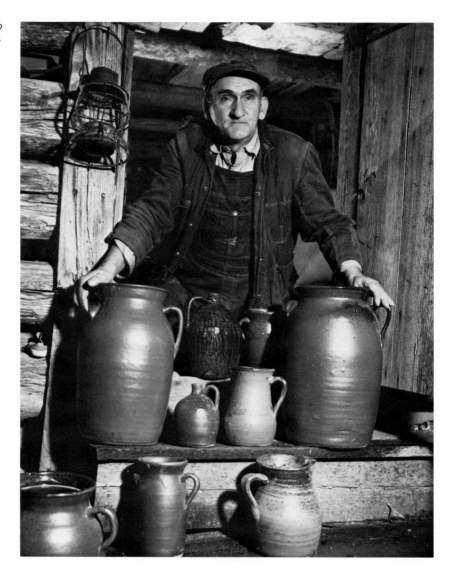

(the third son) becoming an electrician. While remaining in the community, they, unlike Lanier, lost touch with the pottery.

Age and wood-eating insects had taken their toll on the log shop (built to replace the original smaller shop several years after the pottery opened), so in 1952 Lanier constructed a frame building for his father to work in; the last churn made at the old shop was inscribed with the date to commemorate the event.[37] But Lanier's serious involvement in the family business did not begin until the spring of 1967, when a crew from the Smithsonian Institution arrived to make a documentary film.[38] During the film-

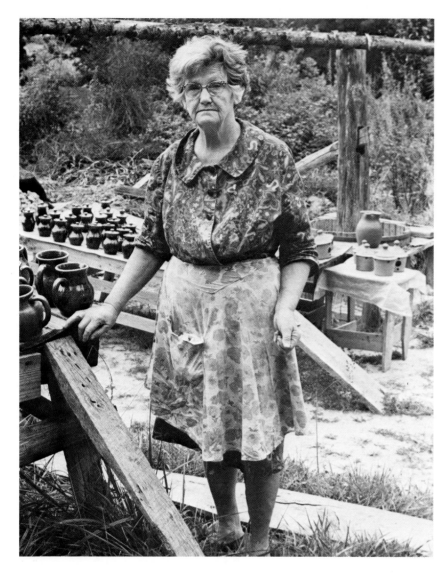

145. Mrs. Cheever (Arie) Meaders, 1968.

ing Cheever became too ill to work, and Lanier stepped in to demonstrate for the cameras. With his father now in declining health, it was he who filled the Smithsonian's order for a large number of face jugs to sell at its first Festival of American Folk-life that summer.[39] And when Cheever died several months later, Lanier made the commitment to becoming a full-time potter. The long hours of his "public" job had worn him down, and the opportunity to be his own boss with flexible working hours promised a definite improvement.

Lanier's first priority was to resolve the problem of Cheever's

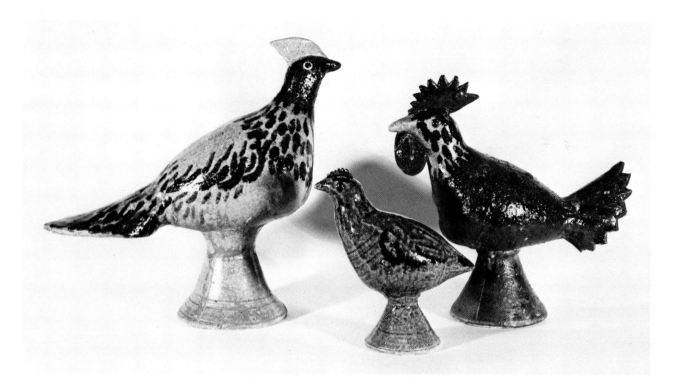

146. Pheasant, quail, and rooster by Arie Meaders, 1968, AM *incised on bases, 12", 7¼", and 10½" high, respectively. Predominant colors are light gray, brown, and dark blue.*

kiln, which was about to collapse. Rather than rebuild it, he decided to construct a new "tunnel" kiln by the side of the shop, recycling many of the usable bricks from the old one. The arched top was formed over a set of five semicircular boards of the type customarily used in building the regional rectangular kilns (similar wooden forms were found in the rafters of Cleater's kiln shelter in Cleveland). Eight feet wide by seventeen feet long including the chimney, it was closely patterned on Cheever's, except that the old kiln's firebox was fed from a semicircular "cathole" in the side so that eight-foot slabs could be inserted, while the firebox eye in Lanier's kiln was in the center of the end wall, necessitating the use of shorter lengths of wood (in a later rebuilding he would adopt his father's side "cathole," and still later abandon it). In the new kiln the doorway for loading and unloading the ware was in the chimney, as it had been in Cleater's and all but the last rebuilding of Cheever's kiln (Lanier has since shifted the loading port back to the firebox end so that he can load in stages, transferring the greenware from the firebox to the floor of the ware chamber, a procedure that would be unnecessary if he had an assistant or two to work "bucket brigade" style).

In respect to form the new kiln was entirely within the Mossy

Creek tradition, but there was one significant departure. Into the two draft-holes in the firebox end, Lanier had inserted electric-powered oil-furnace blowers as an auxiliary fuel source. These oil burners would supplement the one and a half cords of five-foot lengths of pine which he was then sawing himself, cutting down on the intense labor of feeding the firebox in the final hours of "blasting off." In rebuilding the kiln several years later, the rising cost of fuel oil and his dissatisfaction with the results caused him to discard the boosters and revert to pine scraps alone, which he could now obtain free for the hauling at a nearby sawmill.

The few technological changes Lanier has made have allowed him to function more efficiently as a one-man operation; otherwise, he might not have survived for very long (a heart attack in 1970 has necessarily restricted the amount of heavy work he can safely do). In 1960 he had replaced the old wooden "mud mill" outside with an electric-powered one built from scrap metal to ease the task of refining clay for his father and permitting the old mule, Jason, to retire. More recently he constructed a tractor-powered crusher through which the dry clay is fed prior to mixing, pulverizing any pebbles which otherwise would have to be picked out at the wedging board. Yet another of Lanier's labor-saving ideas goes back to the 1940s, his modified lime glaze which, by its use of already processed ingredients, does not require the back-breaking glaze mill. He did not stop using the mill, however, until the hole worn in its base stone grew too large to plug; then, until it ran out, he would mix some ash glaze from a supply he had saved with the modified lime glaze to produce a modified ash glaze. His technique of rolling samples of the thickened glaze into cones, and setting them in clay bases at the chimney end of the kiln to determine more easily when to stop firing, was the brainchild of his mother after she had read about scientific pyrometric cones (plate 60).[40]

In other respects Lanier's manner of working differs little from that of Cheever. He still weighs his clay on the homemade scale with its plowpoint counterweights, and pedals the treadle kick-wheel, complete with height gauge and ball-opener lever. Like his father, he "pieces" his churns by turning them in two separate sections that are then joined, and incises the customary accenting line or two around the shoulder (which his mother used to complain "got in the way" of her applied decoration). And he removes pieces from the wheel with the old hand-forged lifter sets that Cheever had inherited from his uncle, Daddy Bill Dorsey. I once asked Lanier why he didn't adopt an electric wheel like

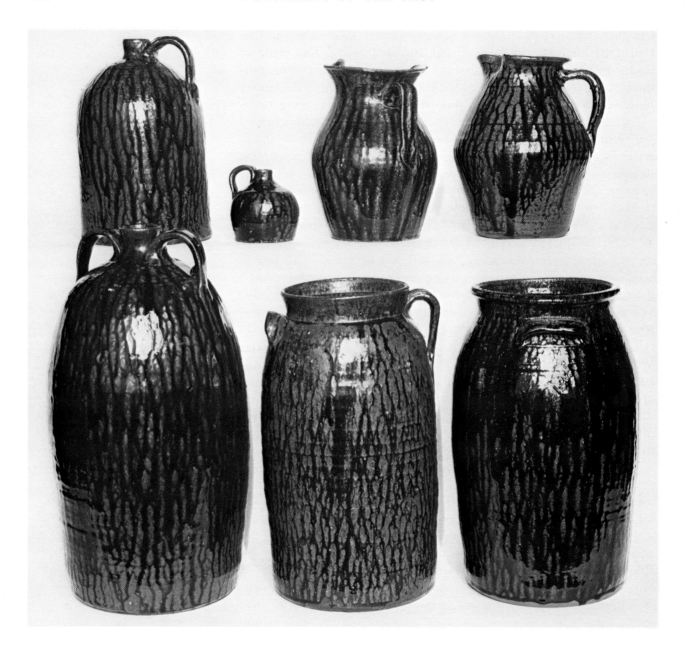

147. *Older and recent Mossy Creek wares showing continuity in the local tradition. All have a dark olive-brown, dendritic ash glaze. Pitcher and churn at far right were made by Lanier in 1975. Other pitcher is attributed to his uncle Casey, while other churn and miniature jug are attributed to his uncle Wiley, all ca. 1915. The syrup jug may also be Wiley's; the maker of the cylindrical gallon jug is unknown.*

current members of other old Georgia pottery families, and he replied, "That would take all the fun out of it." His sense of tradition has kept him from straying very far from the older production methods, and, except for the loss of the runny ash glaze, none of his modifications has noticeably affected his product.

Lanier continues to make the same utilitarian wares as his father, partly in response to community needs (plate 22). Outside interest, however, has prompted a shift in emphasis, and in certain respects his work has shown a progression since he took over the shop. This is especially evident in his face jugs, which he has reserved as a vehicle for innovation. Cheever, who claimed to have first gotten the idea from Daddy Bill Dorsey's hired turner, Will Hewell, produced little more than a dozen of the novelty items in his career, declaring, "People ask for them. But I ain't a-fooling with it much. Don't like to make 'em. Too much work. If I make one, set it off, and time I get it decorated and fixed up, I could turn two or three other pieces of some kind" (74). Lanier, who doesn't much like to make them either, succumbed to outside pressure and financial temptation, and has now produced over six thousand. Newspaper and magazine articles have firmly associated him with this folk-art whimsey, and to appease public demand he burns two or three kilns of face jugs in succession so that he can then relax and concentrate on more functional wares. "Seems like the more useless I make something the more they'll trample each other to get to it," he muses.

His first crude efforts consisted of blobs of clay for the eyes, nose, and mouth so carelessly applied to the jug wall that they tended to crack off when fired; Lanier attributes this problem to his poor state of health at the time. Soon he was taking greater care to integrate the features with the clay of the jug, and by 1968 was beginning to model the damp wall so that it more closely followed the configuration of the human face. One experimental example from that period has an expression suggesting bewilderment. The lips are even and partially open, with no display of teeth; the ears are unobtrusive crescents; the nose is not unnaturally large or ill-shaped; the eyes, widened as if in disbelief, are almond-shaped wads of white clay with blue irises, set into shallow sockets; the eye rims project subtly, with short vertical striations representing eyebrows and lashes; but the feature that most humanizes the face is the hollow cheeks, produced by caving in the wall on either side of the mouth and nose to accentuate the cheekbones and create the effect of gauntness (color plate 11).

In August 1971 Lanier produced a set of four devil's-head jugs.

148. Cheever with unfired face jugs, 1952. Courtesy of Mrs. Cheever Meaders.

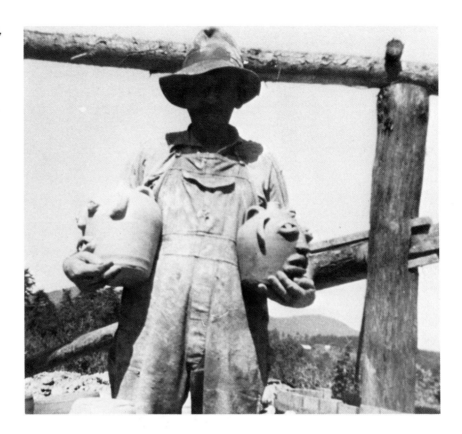

Besides a pair of horns, each had holes cut through the wall at the ears, eyes, and mouth, as well as a large hole in the back through which a candle could be inserted and lit. White ceramic clay, melted down the cheeks from the empty eye sockets, contrasts eerily against the olive-brown ash glaze. When I asked Lanier what inspired these demonic jack-o-lanterns he replied, "That's just the way I was feelin' that day" (i.e., like the devil).

Some alterations in Lanier's repertoire are the result of customer influence, as when a folk-art dealer in Virginia requested some Janus (two-faced) jugs in 1975. Having two handles and a bit larger than his standard model, these became a popular item, but they involved too much work and eventually Lanier resolved to never produce another. At first he liked to think of them as his old army sergeants, who wore a stern face for show but were kind underneath, but with the televised Watergate hearings fresh in his mind he came to refer to them as "politician jugs." In 1978 he did produce a few special two-faced candelabra jugs, each with four hornlike projections terminating in candle sockets—just the thing for a séance or black mass!

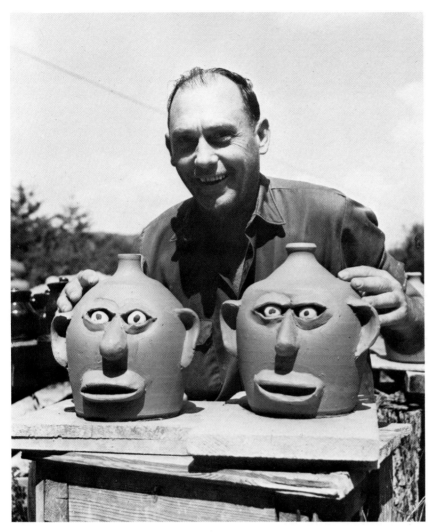

149. Lanier with unfired face jugs made for Smithsonian sales shop, 1968; at this point he was taking greater care to integrate features into jug wall. Photo by Kenneth Rogers, courtesy of the Atlanta Journal and Constitution Magazine.

Meanwhile, even his regular face jugs had come to be more carefully crafted, with details to personalize them such as scars, wrinkled brows, jowls, and pierced earlobes (at least two local teenagers have further customized them by adding wigs, hats, and glasses). Lanier stopped using quartz fragments for the teeth because they had a tendency to crumble, and began to form them from porcelain clay, keeping the glaze off them and the eyes by painting with paraffin melted in an electric frypan. The only face jugs for which he has any affection are those that remind him of people he knows, from local characters to such luminaries as Richard Nixon (that piece reportedly sold for over a thousand dollars up North), Field Marshall Montgomery, Idi Amin, and

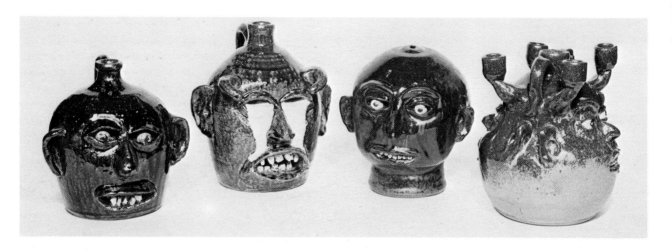

150. Lanier Meaders face jugs showing increasing use of imagination and sculptural approach. Dates, left to right: 1969, 1971, 1974, 1978.

newscaster Roger Mudd! Some of those "dillies," as he calls them, he has displayed at home. The greatest extreme to which Lanier has carried his increasingly sculptural approach is his wig stands, no longer jugs but almost life-sized globular heads turned on the wheel. He has made a small number of these mutations since 1974; one, inscribed on its neck THE DAM BITCH, was his protest against an unnamed woman who kept bothering him, and for a while was placed conspicuously in his living room with a topping of mustard-colored yarn.

Lanier began to sign his work in 1968 as outside attention made him self-conscious about his role as one of America's last folk potters; his mother had established a precedent by initialing much of her work, and occasionally doing the same for the later ware of Cheever, who "couldn't be bothered with such things" himself. This and the evolution of Lanier's face jugs would seem to indicate his emergence as an artist, but he refuses to think of himself that way. His idea of an artist, he told me jokingly in 1977, was a "hippy"; then, in a more serious vein, he said a true artist was mild-mannered and didn't prostitute his God-given talent, in contrast to his self-image as "outspoken and barefaced." Even Lanier's most elaborate creations, a handful of grape vases featuring naturalistically modeled and colored snakes, he does not speak of in aesthetic terms. "When you see me putting snakes on," he told me in 1977, "you know I'm getting tired; it's an excuse for me to slow down and take it easy."

The reader must have surmised by now that Lanier Meaders cannot be considered completely typical of the Mossy Creek potters who preceded him. The outside exposure the shop has seen, beginning in the 1930s and accelerating during Lanier's rela-

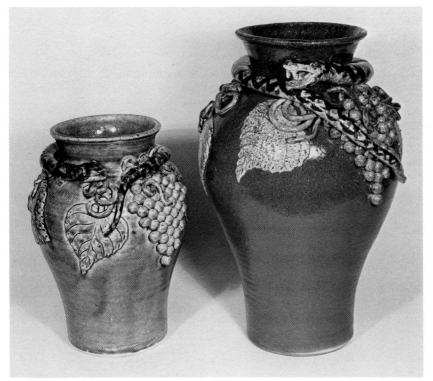

151. *Snake-and-grape vases by Lanier, modified lime glaze. The snakes and grapes are of porcelainous mixture containing kaolin and feldspar, as is body of vase at left, 11" high and made in 1978. On example at right, 15¼" tall and made in 1977, cobalt oxide was worked into grapes as they were rolled to color them light blue, while leaves (pricked to keep them from cracking off) and stems were painted green with copper oxide; the black diamond pattern on the snakes was painted with a mixture of Albany slip and cobalt.*

tively short career, are largely responsible both for his deviations from the norm and, ironically, his survival as a folk potter. Too firmly rooted in the tradition to foresake it, he has struck a balance between the conservative fidelity of his father and the artistic visions of his mother, and the result is a revitalization of the tradition. His ambiguous feelings about his pottery heritage were succinctly stated in 1968: "I could no more stop this than I could fly an airplane. I'm just into it. I'm not going to stop it. Can't stop it. I reckon I'm just supposed to do this. All my movements, all of my work that I've done all my life has led one way or another straight to this shop right here. . . . I'm so deep in it now that I can't get away from it" (78A).

Lacking children who could take up the craft, Lanier knows that he pretty well represents the end of the line for the Mossy Creek tradition. While hardly a sentimental person, there may have been a trace of regret when he reflected on the future of the Meaders Pottery: "This place here will go when I go. This place will go with me 'cause there'll be nobody else to carry it on. And, without it, what they can get here, they can't get anywhere else" (78A).

MOSSY CREEK POTTERS

Anderson, Franklin M.
Austin, Michael*
Brock, John L.*
Brown, E. Javan
Brown, James O.
Brown, Rufus E.
Brown, U. Adolphus
Brown, William O.
Brownlow, Jeremiah S.
Brownlow, John H.
Brownlow, Larkin S.
Cantrell, Robert
Chandler, Clemmonds Q.
Chandler, Hezekiah*
Craven, Isaac H.
Craven, Isaac N.*
Craven, John H.
Craven, John V.
Craven, William T.
Davidson, Abram B.*
Davidson, Asberry T.
Davidson, Asbury Turner
Davidson, D. Marion
Davidson, Frederick*
Davidson, John B.
Davidson, William*
Dorsey, Basil*
Dorsey, David E.†
Dorsey, David L.
Dorsey, Enos C.
Dorsey, F. William M.*
Dorsey, Guy C.
Dorsey, Herbert L.†
Dorsey, James A.
Dorsey, Jefferson
Dorsey, J. Tarpley
Dorsey, Robert L.
Dorsey, Wiley T.†
Dorsey, W. Albert†
Dorsey, William D.†

Dorsey, William F.†
Dorsey, William S.*
Dorsey, Williams H.
Eaton, Page S.
Hall, Joseph B.
Hewell, Henry H.
Hewell, Maryland
Hewell, William J.
Hogan, Riley
Holcomb, John R.*
Holcomb, J. Cicero*
Holcomb, William C.*
Humphries, Louis Shirley
Jarrard, Josiah D.
Jenkins, Bill
Lowry, William J.
Meaders, Alva G.†
Meaders, Arie W.
 (Mrs. Cheever)
Meaders, Casey
Meaders, Caulder
Meaders, Cheever
Meaders, Cleater J., Sr.
Meaders, Cleater J., Jr.
Meaders, Edwin
Meaders, Francis M.†
Meaders, Frank B.
Meaders, John M.†
Meaders, Lambert G.
Meaders, Lewis Q.
Meaders, Q. Lanier
Meaders, R. Moody
Meaders, Wiley C.
Pitchford, Daniel*
Pitchford, George D.*
Pitchford, John B.*
Pitchford, John H.
Pitchford, Lewis*
Pitchford, Nathan*
Pitchford, William G.

Pitchford, William S.*
Sears, Glenn W.*
Sears, Thomas G.

Skelton, Loy A.†
Vestal, Jeremiah*
Warwick, W. Asberry

* Suspected but not established as a potter, perhaps known as a potter else-
where.
† Limited involvement in craft as shop-owner or assistant but not turner.

Epilogue

The time has come to step back from the detailed affairs of individual characters and examine the broader patterns emerging from this narrative. The rising and falling action of its plot is more apparent when the story of Georgia folk pottery is placed within the setting of national, regional, and state history.

Georgia was founded largely as an altruistic experiment, offering the economically oppressed a new beginning. It was in this spirit—as well as to have a product that would help justify the efforts of the English Trustees—that Georgia's first known potter, Andrew Duché, was encouraged to ply his trade in colonial Savannah. But his stay was brief, and there was little other ceramic activity in the state until the 1820s, when a regional stoneware tradition was rapidly spreading westward from the Carolinas. Cyrus Cogburn and Abraham Massey are the earliest documented stoneware potters, and their work in northern Washington County was most likely an extension of the recently developed alkaline-glaze tradition of Edgefield District, South Carolina. By the end of that decade, what would become Georgia's three largest pottery centers were emerging: eastern Crawford County, the Mossy Creek District of southern White County, and Jugtown on the Upson/Pike County line. This was soon followed by the establishment of Jug Factory in Jackson (now Barrow) County. Pioneer potters attracted others into their orbits, and localized traits evolved for each center.

The first historical event of national scope that seems to have had a significant impact on the Georgia pottery tradition is the Civil War. While a substantial number of young potters were lost to the Confederate cause, the blockade of imported goods appears to have stimulated pottery activity at home and encouraged some potters, such as Ferguson and Dial of Jug Factory, to expand their repertoires. The war also evidently dislocated key potters Bowling Brown and John Brock, leading to the formation of new centers at Howell's Mills near Atlanta and in northern Paulding County.

Pottery-making flourished after the war, possibly because the

craft offered rare economic opportunities during the difficult Reconstruction period. It was at this time that Albany slip seems to have begun making inroads, lightening the potter's load but threatening the alkaline glazes that strongly contributed to the ware's regional distinctiveness. Demand for pottery remained high, for while the agricultural system shifted in many sections to tenant farming and sharecropping, the agrarian way of life that supported—and, in turn, was supported by—the use of folk pottery continued; and the glass and metal containers that were flooding the market and providing serious competition to folk pottery up North were still difficult to obtain in much of the South.

The turn of the century marked the climax of folk-pottery activity in Georgia, for the twentieth century was to usher in a series of changes that, cumulatively, would lead to the obsolescence of the craft. The 1907 state prohibition shut down licensed distillers and drastically reduced the call for whiskey jugs, the stock in trade of many potters (especially those of Crawford County and the Atlanta area); and the national Prohibition of 1920 brought a stricter crackdown on illicit distillers. Surviving moonshiners still needed containers for their whiskey, of course, but unbreakable metal cans proved to be a more practical means of transporting the precious liquid down bumpy roads at breakneck speed, while glass Mason jars had become inexpensive enough for point-of-purchase distribution, providing trustworthy uniformity and permitting the customer to see what he was buying.

The same glass jars, with their efficiently sealing lids, were becoming increasingly affordable to the average farm family, reducing demand for stoneware canning jars of the smaller sizes (so-called fruit jars). And other uses were found for metal containers besides hauling "white lightning"; for example, they began to replace jugs for storing molasses (an even more direct cause of the decline of syrup jugs was the drop in molasses production as store-bought sugar became commonplace). The tin lard pail alone has been held responsible for the disappearance of pottery vessels in at least one area of the South.[1]

With the rise of commercial dairies in the 1920s many farmers found it uneconomical to keep their own cows, and so the wares that accompanied home milk processing—milk crocks, "cream risers," churns, and buttermilk pitchers—often were abandoned. At the same time, the substitution of the icebox and, later, the refrigerator for older ways of cooling dairy products (such as the springhouse) made its contribution.

By the First World War, other changes were altering the fabric

of southern life on which the success of folk pottery depended. The industrial jobs in cities and milltowns that were beginning to depopulate the countryside were also offering an attractive economic alternative to young men growing up in rural pottery families, often breaking the chain of craft transmission. And the self-sufficiency that once characterized farm life was giving way to dependence on a cash-based economy and the preponderance of factory-made goods and commercial food products.

For most of the relatively small number of remaining folk potters, the Great Depression was the final blow. Ironically, the potential demand for their products was high, for the hard times forced a partial return to self-sufficiency, with many households reverting to home food-processing. But there was little cash with which to buy the necessary wares. Some potters weathered the storm only by radically altering their products. The Gordys, for example, made the transition to a more artistic ware to attract a wealthier, non-local clientele, while the Merritts and Hewells shifted their production to "dirt cheap" flowerpots and other unglazed garden pottery. It took a rare bird like Cheever Meaders to remain faithful to the tradition, even if it meant bartering his wares or selling them for a nickel a gallon.

When the handicrafts "revival" movement began to gain momentum in the 1930s the Meaders Pottery was anachronistic enough to attract a new market for the old wares, and intensification of this outside interest has supported Lanier Meaders in his role as a folk potter. Recent coverage in the national and regional media, as well as more academic treatment (including the 1976 retrospective exhibit at Georgia State University funded by the Folk Arts Program of the National Endowment for the Arts, the Smithsonian Institution's documentary film, and a special day honoring the Meaders family at the Library of Congress in Washington, D.C.), are indicative of the shop's ongoing reputation.[2]

At the time of this writing, Lanier still burns his kiln on the average of every three weeks (except for the coldest months of winter) and does not want for customers, the steadiest of whom are the Georgia Mountain Arts Cooperative Store at Tallulah Falls and the Tullie Smith House Craft Shop at the Atlanta Historical Society. Now in his mid-sixties, he can look forward to another productive decade if health permits and he follows his father's example, but what is to become of the Meaders Pottery thereafter? I am reminded of my visit to the Wetheriggs Country Pottery in the Lake District of northwestern England where, before retiring in 1973, the elderly folk potter took into intensive ap-

152. *Mrs. Cheever Meaders and Lanier Meaders with the author (center) on Meaders Pottery Day at the Library of Congress, Washington, D.C., March 17, 1978, fielding questions from the audience. Photo by Carl Fleischhauer, courtesy of American Folklife Center, Library of Congress.*

prenticeship a young artist who, with several associates, now produces a fine grade of slip-decorated earthenware using the traditional methods. But Lanier, while admitting that he could use some help with the unskilled heavy work around the shop now that he is feeling his age, says he doesn't have the patience to instruct an apprentice, citing his motto, "He who works alone accomplishes more."

There are two other members of his family who still maintain an involvement in the craft and who conceivably could inherit the Meaders Pottery, but they are not that much younger than Lanier. The first of these is Lanier's cousin and Cleater's fourth son, Cleater J. Meaders, Jr. ("C.J."). Having recently retired, he has more time now to devote to pottery at his home near Warner Robins in middle Georgia, and regularly visits White County, where he is building a summer home. For the Chattahoochee Mountain Fair at Clarkesville in August 1978, he, his brother

Frank, and Lanier demonstrated the Meaders family approach to pottery-making ("My job is to lie to the public," explained Lanier, "while C.J. and Frank Bell do all the work"), and in the fall of 1981 C.J. conducted, with Lanier's participation, a Meaders Pottery Workshop sponsored by the Georgia Council for the Arts.

The other potter of the family is Lanier's youngest brother, Edwin, who, in the winter of 1969–70, set up his own old-fashioned pottery operation behind his home less than half a mile from Lanier's shop. Hoping for the same success as his brother, Edwin became discouraged when the coffeepots, pitchers, and jugs from three firings of his small wood-burning kiln did not sell as easily

154. Mrs. Harold (Grace) Hewell of Gillsville, 1981, supervising her youngest grandson, Nathaniel, named after his great-great-great-grandfather, the first known Hewell potter. Photo by Robert M. Press, Christian Science Monitor.

as expected, and for a time he abandoned the project as a "crazy idea." In the summer of 1981, however, following his retirement, Edwin revived his operation and, with initial guidance from his mother, began to produce a line of roosters, marketed by the Cleveland library in conjunction with a small exhibit of the family's wares.

These recent developments brighten the prospects for the future of the Meaders Pottery, and perhaps some younger family member will become inspired to pick up where Lanier leaves off. It seems to me, however, that the greatest hope for the long-term perpetuation of the ceramic tradition in Georgia is at Gillsville, where young members of three old pottery families—the Hewells, Cravens, and Fergusons—are actively committed to producing the later (but still handmade) garden wares.

If the prognosis for the survival of the state's pottery tradition is not entirely positive, we can at least look forward to increasing recognition of it. A landmark event that has brought this tradition to the attention of the public was the 1976 Georgia Council for the Arts exhibition, "Missing Pieces: Georgia Folk Art 1770–1976." The state's grassroots crafts heritage has begun to provide inspiration for contemporary artists such as Stephen Ferrell of Piedmont, South Carolina, authority on and collector of Edgefield District stoneware and proprietor of the Swamp Fox Pottery, who was impressed by the functional design of Crawford County's flowerpot-shaped pitchers and has been reproducing them since 1977. Currently there is no large collection of Georgia folk pottery on permanent display, but this will be remedied when the Atlanta Historical Society builds its Georgia Folklife Center, planned as a showplace for the collection of traditional crafts that I have been assembling over the past fifteen years. Then, the earthy products of Georgia's brothers in clay will have a new life as objects to be admired and understood.

Notes

NOTES TO THE PROLOGUE

1. (Philadelphia: Henry Altemus Co., 1910), pp. 251–52.

2. The difficulties of researching folk pottery in the South were first discussed in John Ramsay's *American Potters and Pottery* (New York: Tudor Publishing Co., 1947), pp. 81–83.

3. From an interview conducted on September 1, 1971; hereafter, citations for all such quotations will appear not in the notes but as numbers within parentheses following the passages in the text, keyed to an alphabetical list of respondents toward the back of the book. Speaking of the dozen potteries then operating in Crawford County, Otto Veatch, in *Second Report on the Clay Deposits of Georgia*, Geological Survey of Georgia Bulletin no. 18 (Atlanta: State Printer, 1909), p. 220, remarked, "In 1906 . . . their total output was about 160,000 gallons. The figures are only an estimate as the potters keep no records and trust entirely to memory."

4. While the United States population census began in 1790 and has been conducted at each decade thereafter, those for Georgia before 1820 were lost, and most of the 1890 census was destroyed. The censuses of 1850 and later include not just the names of household heads but of their wives and children, as well as each person's age (rather than age bracket), birthplace, and occupation; unfortunately the potters were often enumerated as farmers. The 1900 census (the latest available), in addition, lists the year of birth. For Georgia there are indexes for all but the 1860 and 1870 censuses, although the 1880 Soundex is limited to household heads with offspring ten or under. I worked with microfilm copies of the censuses at the Georgia Department of Archives and History in Atlanta—where there are also copies of many county courthouse records—and the Regional Federal Archives and Records Center at East Point, which has the censuses of every state. To keep the notes from becoming unwieldy, I have not included page references for census and certain other archival data. Where information on marriages is given, the reader can assume that the source is either marriage records from the appropriate county courthouse or the findings of genealogists.

5. A methodology for investigating southern folk pottery was detailed by Charles G. Zug III in "Pursuing Pots: On Writing a History of North Carolina Folk Pottery," *North Carolina Folklore Journal* 27, no. 2 (November 1979): 34–55.

6. Quotations, whether from transcriptions of tape-recorded interviews, field notes, or correspondence, are presented essentially verbatim, having been edited only when necessary to achieve greater clarity and continuity or minimize redundancy.

NOTES TO CHAPTER ONE

1. Harriet Gift Castlen, *That Was a Time* (New York: E. P. Dutton, 1937), pp. 22–23.

2. Floyd C. Watkins and Charles Hubert Watkins, *Yesterday in the Hills* (1963; reprint ed., Athens: University of Georgia Press, 1973), p. 37.

3. J. L. Herring, *Saturday Night Sketches: Stories of Old Wiregrass Georgia* (1918; reprint ed., Tifton, Ga.: Sunny South Press at Georgia Agrirama, 1978), p. 75.

4. Watkins and Watkins, *Yesterday in the Hills*, p. 53.

5. John Foster Stilwell, "Memories of Men and Things of Then and Now" (manuscript, 1911), p. 4. Copy in Georgia Folklore Archives, Atlanta, courtesy of Irene Stilwell Wilcox.

6. Warren E. Roberts, "Folk Crafts," in *Folklore and Folklife: An Introduction*, ed. Richard M. Dorson (Chicago: University of Chicago Press, 1972), p. 240; Peter C. D. Brears, *The English Country Pottery: Its History and Techniques* (Rutland, Vt.: Charles E. Tuttle Co., 1971), p. 57.

7. Tench Coxe, comp., *A Statement of the Arts and Manufactures of the United States of America, for the Year 1810* (Philadelphia: A. Cornman, Jr., 1814), p. 150.

8. Klaus G. Loewald, Beverly Starika, and Paul S. Taylor, trans. and eds., "Johann Martin Bolzius Answers a Questionnaire on Carolina and Georgia," *William and Mary Quarterly*, 3d ser. 15 (1958): 246, and 14 (1957): 242.

9. George M. Foster, "The Sociology of Pottery: Questions and Hypotheses Arising from Contemporary Mexican Work," in *Ceramics and Man*, ed. Frederick R. Matson, Viking Fund Publications in Anthro-

pology, no. 41 (Chicago: Aldine Publishing Co., 1965), p. 47, and Bevis Hillier, *Pottery and Porcelain 1700–1914: England, Europe and North America* (New York: Meredith Press, 1968), chap. 1, ascribe low status to potters of Mexico and Britain, respectively. Arguments for the respectability of potters in the English-speaking world are found in Lorna Weatherill, *The Pottery Trade and North Staffordshire, 1660–1760* (New York: Augustus M. Kelley, 1971), pp. 139–40, Harold F. Guilland, *Early American Folk Pottery* (Philadelphia: Chilton Book Co., 1971), p. 20, Ronald L. Michael and Phil R. Jack, "The Stoneware Potteries of New Geneva and Greensboro, Pennsylvania," *Western Pennsylvania Historical Magazine* 56, no. 4 (1973): 382, and Robert Sayers, "Potters in a Changing South," in *The Not So Solid South: Anthropological Studies in a Regional Subculture*, ed. J. Kenneth Morland, Southern Anthropological Society Proceedings, no. 4 (Athens: University of Georgia Press, 1971), p. 103.

10. Guilland, *Early American Folk Pottery*, p. 68.

11. Stephen T. Ferrell and T. M. Ferrell, *Early Decorated Stoneware of the Edgefield District, South Carolina* (Greenville, S.C.: Greenville County Museum of Art, 1976), [p. 6].

NOTES TO CHAPTER TWO

1. A. H. Rice and John Baer Stoudt, *The Shenandoah Pottery* (Strasburg, Va.: Shenandoah Publishing House, 1929), pp. 271–77.

2. Harden E. Taliaferro [Skitt], *Fisher's River (North Carolina) Scenes and Characters* (1859; reprint ed., New York: Arno Press, 1977), pp. 220–21.

3. Bobby G. Carter, "Folk Methods of Preserving and Processing Food," in *A Collection of Folklore by Undergraduate Students of East Tennessee State University*, eds. Thomas G. Burton and Ambrose N. Manning, Institute of Regional Studies Monograph no. 3 (Johnson City: East Tennessee State University, 1966), p. 27; Floyd C. Watkins and Charles Hubert Watkins, *Yesterday in the Hills* (1963; reprint ed., Athens: University of Georgia Press, 1973), p. 57.

4. Theora Hamblett, "Some Uses of Pottery," *Mississippi Folklore Register* 3, no. 1 (Spring 1969): 5–6.

5. Myrtie Long Candler, "Reminiscences of Life in Georgia during the 1850s and 1860s, Part 2," *Georgia Historical Quarterly* 33 (1949): 118.

6. John A. Burrison, "Alkaline-Glazed Stoneware: A Deep-South Pottery Tradition," *Southern Folklore Quarterly* 39, no. 4 (December 1975): 398–99. For more on Dave see John A. Burrison, "Afro-American Folk Pottery in the South," *Southern Folklore Quarterly* 42 (1978): 178–83, and John Michael Vlach, *The Afro-American Tradition in Decorative Arts* (Cleveland, Ohio: Cleveland Museum of Art, 1978), pp. 77–81.

7. C. Anne Wilson, *Food and Drink in Britain, from the Stone Age to Recent Times* (New York: Barnes and Noble / Harper and Row, 1974), pp. 56, 105.

8. Much has been written about Georgia moonshine (Joseph Earl Dabney, *Mountain Spirits* [New York: Charles Scribner's Sons, 1974]; Eliot Wigginton, ed., *The Foxfire Book* [Garden City, N.Y.: Doubleday and Co., 1972], pp. 301–45; John Gordon, "Slingings and High Shots: Moonshining in the Georgia Mountains," in *The Not So Solid South: Anthropological Studies in a Regional Subculture*, ed. J. Kenneth Morland, Southern Anthropological Society Proceedings, no. 4 [Athens: University of Georgia Press, 1971], pp. 56–65), but, as will be shown in later chapters, folk potters also made jugs for licensed distillers.

9. Gertie Craton Elsberry, "Down through the Years," manuscript ([Dallas, Ga.], n.d., copy in Georgia Folklore Archives, Atlanta), chap. 8, pp. 25–28.

10. Ibid., chap. 9, pp. 10–11, 18, 19. Similar recipes for churning and pickling vegetables in a stoneware churn are found in Wigginton, ed., *The Foxfire Book*, pp. 185–88, 176–77, and *Foxfire* 15, no. 4 (Winter 1981 special issue, titled *Foxfire's Book of Wood Stove Cookery*): 114–17; another good discussion of folk-pottery uses is in Ralph Rinzler and Robert Sayers, *The Meaders Family: North Georgia Potters*, Smithsonian Folklife Studies, no. 1 (Washington, D.C.: Smithsonian Institution Press, 1980), pp. 90–105.

11. Elsberry, "Down through the Years," chap. 7, p. 14, and chap. 8, p. 16.

12. Ibid., chap. 13, p. 36.

13. Ibid., chap. 7, p. 19. Another secondary use of jugs and jars in Georgia and Alabama was as bird houses for purple martins, after a doorway had been knocked through the wall; see Frederic Ramsey, Jr., *Been Here and Gone* (New Brunswick, N.J.: Rutgers University Press, 1960), pp. 20–21.

NOTES TO CHAPTER THREE

1. The large contribution of slave value to the owner's overall wealth is dramatized by contrasting the tax-digest figures of 1854 for Jesse and his father, James; while the son actually owned more land, the total value of his property was less than half that of the father, for James owned ten slaves (Thomas Marshall Green, "Small Slaveholders in Crawford County, Georgia, 1822–1861"

[honors thesis in history, Harvard College, 1978], p. 6).

2. Crawford County Returns vol. C, p. 341; sale held October 23, 1841 and recorded January 26, 1842.

3. Ibid., p. 334; inventory and appraisement certified September 7, 1841.

4. Crawford County Returns vol. F, p. 130; returned by Jesse B. Long, temporary administrator, and entered March 10, 1851.

5. Frank Lawrence Owsley, *Plain Folk of the Old South* (Baton Rouge: Louisiana State University Press, 1949).

6. In the mid 1970s Lanier Meaders was ordering his Albany slip (which he seldom uses alone, but mixes with whiting, feldspar, and regular stoneware clay to produce a modified lime glaze) two 400-pound drums at a time from Hammill and Gillespie of New York City, at $16.00 a barrel in lump form or $25.00 processed, plus $30.00 freight from Pennsylvania.

7. Louis Brown of Arden, North Carolina, remembered his father Davis (brother of Javan and Otto) saying that while at their father's Atlanta home base the boys worked on a quota system with the goal of 100 gallons a day. Every morning the brothers would draw straws to determine which size of churn each would turn, since it was necessary to produce an assortment of sizes; the largest size was preferred, for fewer had to be made to meet the quota (as reported by John Vlach in the summer of 1976 after his visit to the Brown Pottery).

8. An exception is cited in C. B. McCook, *Remembering Lizella* (Lizella, Ga.: privately printed, 1973), p. 141: "Jewel E. Merritt recalls hearing his father tell of 'price wars' they had at times. There were so many jug shops [in Crawford County] that sometimes the market was flooded and in order to get rid of the jugs in Macon, at times they would sell a gallon jug for 5¢."

9. Otto Veatch, *Second Report on the Clay Deposits of Georgia*, Geological Survey of Georgia Bulletin no. 18 (Atlanta: State Printer, 1909), pp. 290, 373.

NOTES TO CHAPTER FOUR

1. Robert Sayers, "Potters in a Changing South," in *The Not So Solid South: Anthropological Studies in a Regional Subculture*, ed. J. Kenneth Morland, Southern Anthropological Society Proceedings, no. 4 (Athens: University of Georgia Press, 1971), p. 104; John A. Burrison, "Clay Clans: Georgia's Pottery Dynasties," *Family Heritage* 2, no. 3 (June 1979): 70–77. The dynastic pattern of craft transmission was hardly unique to Georgia; see, for example, Robert Nicholls, *Ten Generations of a Potting Family* (London: Percy Lund, Humphries and Co., 1931), and Dorothy Cole Auman and Charles G. Zug III, "Nine Generations of Potters: The Cole Family," in *Long Journey Home: Folklife in the South*, ed. Allen Tullos (Chapel Hill, N.C.: Southern Exposure, 1977), pp. 166–74.

2. Sayers, "Potters in a Changing South," p. 102.

3. John Michael Vlach, "Slave Potters," *Ceramics Monthly* 26, no. 7 (September 1978): 66–69; idem, *The Afro-American Tradition in Decorative Arts* (Cleveland, Ohio: Cleveland Museum of Art, 1978), chap. 5; John A. Burrison, "Afro-American Folk Pottery in the South," *Southern Folklore Quarterly* 42, nos. 2 and 3 (1978): 175–99; Georgeanna H. Greer, "The Wilson Potteries," *Ceramics Monthly* 29, no. 6 (Summer 1981): 44–46.

4. Henry Glassie, *Pattern in the Material Folk Culture of the Eastern United States* (Philadelphia: University of Pennsylvania Press, 1968), pp. 4–8, 28–31; idem, "Folk Art," in *Folklore and Folklife: An Introduction*, ed. Richard M. Dorson (Chicago: University of Chicago Press, 1972), pp. 253–80; John Michael Vlach, "Quaker Tradition and the Paintings of Edward Hicks: A Strategy for the Study of Folk Art," *Journal of American Folklore* 94, no. 372 (April–June 1981): 145–65. The problem is that most publications on "folk art" have lumped true folk art together with other kinds of nonacademic art—including idiosyncratic (self-taught) art—and called it all folk art, when what they really mean is art of the common people in a "folksy" style. Recent writers have been more thoughtful in applying the phrase, but semantic confusion remains; see Ian M. G. Quimby and Scott T. Swank, eds., *Perspectives on American Folk Art* (New York: W. W. Norton and Co. for the Henry Francis du Pont Winterthur Museum, 1980).

5. Allen H. Eaton, *Handicrafts of the Southern Highlands* (1937; reprint ed., New York: Dover Publications, 1973), opposite p. 291.

NOTES TO CHAPTER FIVE

1. W. J. Cash, *The Mind of the South* (New York: Alfred A. Knopf, 1941), p. viii; Carl N. Degler, *Place Over Time: The Continuity of Southern Distinctiveness* (Baton Rouge: Louisiana State University Press, 1977).

2. Henry Glassie, *Pattern in the Material Folk Culture of the Eastern United States* (Philadelphia: University of Pennsylvania Press, 1968), pp. 64–124, 234, 236–37; John Burrison, "Folklore of the Regions," *American Folklore Series*, gen. ed. Hennig Cohen, Cassette Curricu-

lum, no. 1609 (Deland, Fla.: Everett/Edwards, 1979).

3. The Yankee equivalent of grits, which sometimes was eaten with milk and/or sugar, inspired Joel Barlow's poem "The Hasty Pudding," published in 1796.

4. Don Yoder, *Pennsylvania Spirituals* (Lancaster: Pennsylvania Folklife Society, 1961); George Pullen Jackson, "Some Factors in the Diffusion of American Religious Folksongs," *Journal of American Folklore* 65 (1952): 367.

5. Wilbur Zelinsky, "The Settlement Patterns of Georgia" (Ph.D. diss., University of California at Berkeley, 1953), p. 430.

6. William C. Ketchum, Jr., *Early Potters and Potteries of New York State* (New York: Funk and Wagnalls, 1970), p. 4.

7. Heinrich Ries, *Clay Deposits and Clay Industry in North Carolina*, North Carolina Geological Survey Bulletin no. 13 (Raleigh: State Printer, 1897), p. 71.

8. John A. Burrison, "The Living Tradition: A Comparison of Three Southern Folk Potters," *Northeast Historical Archaeology* 7–9 (1978–80): 33–38.

9. Charles G. Zug III, *The Traditional Pottery of North Carolina* (Chapel Hill, N.C.: Ackland Art Museum, 1981), pp. 25–31.

10. John A. Burrison, "Alkaline-Glazed Stoneware: A Deep-South Pottery Tradition," *Southern Folklore Quarterly* 39, no. 4 (December 1975): 377–403.

11. At the Jugtown Pottery of Moore County, North Carolina, the term "tobacco spit" was applied to a glaze resembling lead, orange-brown with darker flecks (Jean Crawford, *Jugtown Pottery: History and Design* [Winston-Salem, N.C.: John F. Blair, 1964], p. 81 and plate 4).

12. Nigel Wood, *Oriental Glazes: Their Chemistry, Origins and Recreation* (London and New York: Pitman/

Watson-Guptill, 1978), especially chap. 1.

13. Salt may not have been that expensive, but its availability in the backcountry was limited by trade, whereas the alkaline-glaze ingredients were readily at hand in the potter's environment. It may be significant that Reuben Drake, one of the early potters of Edgefield District, South Carolina—where alkaline glazes are first known to have been used—was also involved in salt production after moving to Louisiana (Ella Lonn, *Salt as a Factor in the Confederacy*, Southern Historical Publications, no. 4 [University, Ala.: University of Alabama Press, 1965], pp. 22–23). As an alternative to the hypothesis of an indirect Oriental connection, Charles G. Zug III has suggested that early potters in the Catawba Valley of North Carolina familiar with German glassmaking techniques may have developed the alkaline glazes, although only the ash type has been documented there ("The Alkaline-Glazed Stoneware of North Carolina," *Northeast Historical Archaeology* 7–9 [1978–80]: 19–20).

14. William Burton, *Porcelain: A Sketch of Its Nature, Art and Manufacture* (London: Cassell and Co., 1906), pp. 88–89, 113–14.

15. Geoffrey Wills, *English Pottery and Porcelain* (Garden City, N.Y.: Doubleday and Co., 1969), pp. 323–30. After discovering china clay in Cornwall, Cookworthy took Richard Champion as a partner and established a porcelain factory at Bristol. In 1784 Champion emigrated to Camden, South Carolina (Kershaw County), to retire on his brother's estate. There is no evidence that he made pottery there—much less any with an alkaline glaze—but he could have brought this glaze to the attention of other potters in the area.

16. Specifically, Abner's uncle,

Reuben Landrum, participated in the Regulator movement of Orange County with Peter Craven, who is believed to be the patriarch of the Craven pottery dynasty in North Carolina, and together they were indicted by the Crown in 1771 (William L. Saunders, ed., *The Colonial Records of North Carolina*, 9 vols. [Raleigh: State Printer, 1886–90], 8: 531–32; Joel P. Shedd, *The Landrum Family of Fayette County, Georgia* [Washington, D.C.: privately printed, 1972], p. 64). Joseph Landrum, another of Abner's uncles, settled in Georgia, but he or his descendants are not known to have made pottery.

17. Thomas G. Smith, "Pottersville Museum—The Result of McClendon Serendipity," *Sandlapper: The Magazine of South Carolina* 3, no. 4 (April 1970): 8–13.

18. (1826; reprint ed., Spartanburg, S.C.: The Reprint Co., 1972), pp. 523–24.

19. Stephen T. Ferrell and T. M. Ferrell, *Early Decorated Stoneware of the Edgefield District, South Carolina* (Greenville, S.C.: Greenville County Museum of Art, 1976), [p. 6]. All three names relate to European decorative ceramics: Josiah Wedgwood, "father" of the eighteenth-century Staffordshire pottery industry, is famed for his cameo jasperware; Bernard Palissy was the sixteenth-century French master of naturalistically colored earthenware reliefs; and Manises is a town in Valencia, Spain, noted for its lustreware.

20. Abraham Massey and Cyrus Cogburn of Washington County, Allen Gunter of Elbert (later Hart) County, Charles H. Ferguson of Jackson (now Barrow) County, Matthew Duncan of Coweta County, and John D. and Holland Leopard of Fayette County are the strongest candidates. See Zug, *Traditional Pottery of North Carolina*, pp. 16–17; Georgeanna H. Greer, "Southern

Alkaline Glazed Stoneware: A Unique American Tradition," in *Potters of the Catawba Valley, North Carolina*, ed. Daisy Wade Bridges, Ceramic Circle of Charlotte Journal of Studies, vol. 4 (Charlotte, N.C.: Mint Museum of History, 1980), p. 9; idem, "The Folk Pottery of Mississippi," in *Made by Hand: Mississippi Folk Art*, ed. Patti Carr Black (Jackson: Mississippi Department of Archives and History, 1980), p. 48; and James M. Malone, Georgeanna H. Greer, and Helen Simons, *Kirbee Kiln: A Mid-Nineteenth-Century Texas Stoneware Pottery*, Office of the State Archeologist Report no. 31 (Austin: Texas Historical Commission, 1979), pp. 8–11.

21. Georgeanna H. Greer and Harding Black, *The Meyer Family: Master Potters of Texas* (San Antonio: Trinity University Press for the San Antonio Museum Association, 1971), pp. 4–6, 33, 37, 69, 71.

22. Zug, *Traditional Pottery of North Carolina*, pp. 38–39, 41; Crawford, *Jugtown Pottery*, p. 82 and plate 9.

23. Arnold R. Mountford, *The Illustrated Guide to Staffordshire Salt-Glazed Stoneware* (New York: Praeger, 1971), chap. 2 and plates 3–18, 244; Pamela J. Wood, *"Made at Nottm": An Introduction to Nottingham Salt-Glazed Stoneware* (Nottingham, England: Nottingham Castle Museum, 1980).

24. For the Germanic cream pot in North Carolina, see John Bivins, Jr., *The Moravian Potters in North Carolina* (Chapel Hill: University of North Carolina Press for Old Salem, Inc., 1972), p. 143 (illustrations 102, 103); for the later stoneware type, see Bridges, ed., *Potters of the Catawba Valley*, pp. 60 (no. 54), 74 (no. 115), 76 (no. 110), Ed Gilreath and Bob Conway, *Traditional Pottery in North Carolina* (Waynesville, N.C.: privately printed, 1974), p. 5, and Stuart C. Schwartz, "Tradi-

tional Pottery Making in the Piedmont," *Tar Heel Junior Historian* 17, no. 2 (Winter 1978), p. 23. The form was known in White County, Georgia, where the ceramic tradition had a strong North Carolina influence; Cheever Meaders called it a "broad-top pot" (Ralph Rinzler and Robert Sayers, *The Meaders Family: North Georgia Potters*, Smithsonian Folklife Studies, no. 1 [Washington, D.C.: Smithsonian Institution Press, 1980], p. 93 [fig. 38]). Common though the Welsh cream pot was (a good example can be seen in the Gallery of Material Culture, Welsh Folk Museum, St. Fagans), I have only found it pictured in publications on Ireland, where it was imported (e.g., E. Estyn Evans, *Irish Folk Ways* [New York: Devin-Adair Co., 1957], plate 1). Potters of Welsh background, like the Owenses, did work in North Carolina.

25. Anna Wadsworth, ed., *Missing Pieces: Georgia Folk Art 1770–1976* (Atlanta: Georgia Council for the Arts and Humanities, 1976), p. 89 (no. 77).

26. John A. Burrison, *The Meaders Family of Mossy Creek: Eighty Years of North Georgia Folk Pottery* (Atlanta: Georgia State University, 1976), p. 22 (no. 23).

27. Peter C. D. Brears's *The English Country Pottery: Its History and Techniques* (Rutland, Vt.: Charles E. Tuttle Co., 1971) is the only full-length treatment of this type of ware; his companion volume, *The Collector's Book of English Country Pottery* (Newton Abbot, England: David and Charles, 1974), features the exceptional decorative tradition.

28. Burrison, "Alkaline-Glazed Stoneware," pp. 396–97. The large, two-handled jug-form is not unknown for the North, where it functioned as a water cooler and cider jug.

29. Burrison, *Meaders Family*, p. 24 (no. 69); Bridges, ed., *Potters of*

the Catawba Valley, p. 64 (no. 72); Betsy Kent, "English Eighteenth-Century Flower Holders," *Antiques* 115, no. 1 (January 1979): 152 (plate 1), 153 (fig. 1).

30. Southern examples are included in Bivins, *The Moravian Potters*, p. 121 (illustrations 50, 51); Zug, *Traditional Pottery of North Carolina*, pp. 51 (no. 27), 55 (no. 74), 64 (no. 213), 66 (no. 238); Beverly S. Burbage, "The Remarkable Pottery of Charles Decker and His Sons," *Tennessee Conservationist* 37, no. 11 (November 1971): 11 (by a potter with a Pennsylvania background); Wadsworth, ed., *Missing Pieces*, pp. 89 (no. 76), 96 (no. 88). According to tradition, ring jugs were carried over the shoulder as a canteen at harvest time, but the hole in some is too small to receive an arm (these would have fit nicely, however, over the hame-knob of a draft animal). The Georgia and North Carolina farmers who bought ring jugs made by the late Davis Brown, according to his son Louis, "whenever they'd be out in the field, [would] hang one of them up on a limb and it'd keep the water cool" (20). Davis's brother Javan sometimes made them with one side unglazed, so that evaporation would help cool the contents. Ring jugs were made as early as the sixteenth century in Italy and England and the seventeenth century in Gemany (George Savage and Harold Newman, *An Illustrated Dictionary of Ceramics* [London: Thames and Hudson, 1974], p. 147; D. J. Freke, "The Excavation of a Sixteenth-Century Pottery Kiln at Lower Parrock, Hartfield, East Sussex, 1977," *Post-Medieval Archaeology* 13 [1979]: 102 [no. 76], 104, and plate 7; Jack Troy, *Salt-Glazed Ceramics* [New York: Watson-Guptill, 1977], p. 67).

31. John A. Burrison, "Afro-American Folk Pottery in the

South," *Southern Folklore Quarterly* 42 (1978): 196 (note 40), 197 (fig. 9); John Michael Vlach, *The Afro-American Tradition in Decorative Arts* (Cleveland: Cleveland Museum of Art, 1978), pp. 86–90. For other southern examples see Bridges, ed., *Potters of the Catawba Valley*, pp. 65 (no. 73), 75 (nos. 75, 125); Zug, *Traditional Pottery of North Carolina*, p. 35 (fig. 23); Burbage, "Remarkable Pottery of Charles Decker," p. 11; Burrison, *Meaders Family*, p. 30 (no. 106); Wadsworth, ed., *Missing Pieces*, pp. 95 (no. 87), 103 (no. 99). The form was not made in England until about 1900, when Doulton of Lambeth reproduced the Salisbury Museum's "Sarum kettle" from South Africa (Desmond Eyles, *Royal Doulton 1815–1965* [London: Hutchinson and Co., 1965], pp. 79–80).

32. Phil Schaltenbrand, "The Stoneware of Greensboro–New Geneva [Pennsylvania]," *Ceramics Monthly* 28, no. 7 (September 1980): 36; Elmer L. Smith, *Pottery: A Utilitarian Folk Craft* (Lebanon, Pa.: Applied Arts, 1972), p. 26 (Virginia); Burbage, "Remarkable Pottery of Charles Decker," pp. 8–9 (Tennessee); idem, "Charles F. Decker's Ceramic Grave Markers," *Studio Potter* 9, no. 2 (June 1981): 55; Samuel D. Smith and Stephen T. Rogers, *A Survey of Historic Pottery Making in Tennessee*, Division of Archaeology Research Series, no. 3 (Nashville: Tennessee Department of Conservation, 1979), pp. 66, 142–43; Zug, *Traditional Pottery of North Carolina*, p. 38 (fig. 27); Gilreath and Conway, *Traditional Pottery in North Carolina*, p. 7; Bennie Lee and Don Lewis, "Graveyard Pots," *Ceramics Monthly* 15 (April 1967): 20–21 (northwestern South Carolina); Wadsworth, ed., *Missing Pieces*, p. 90 (no. 78); Elizabeth P. Newsom, comp., *Washington County Georgia*

Tombstone Inscriptions (Sandersville, Ga.: privately printed, 1967), p. x; Harold F. Guilland, *Early American Folk Pottery* (Philadelphia: Chilton Book Co., 1971), p. 190 (northern Florida); Black, ed., *Made by Hand*, pp. 52, 66 (northeastern Mississippi); Georgeanna H. Greer, *American Stonewares: The Art and Craft of Utilitarian Potters* (Exton, Pa.: Schiffer Publishing, 1981), p. 125 (Texas). Examples—often of "sewertile" stoneware—are also scattered through the Midwest (e.g., Deborah Edwards, "Haydenville [Ohio], A Town of Clay," *Ceramics Monthly* 28, no. 1 [January 1980]: 50; Jack E. Adamson, *Illustrated Handbook of Ohio Sewer Pipe Folk Art* [Barberton, Ohio: privately printed, 1973], [p. 56]; C. Kurt Dewhurst and Marsha MacDowell, *Cast in Clay: The Folk Pottery of Grand Ledge, Michigan*, Publications of the Museum, Folk Culture Series, vol. 1, no. 2 [East Lansing: Michigan State University, 1980], p. 61). The molded slab type of marker is known for Britain: a brown salt-glazed stoneware example dated 1790 from Burslem, Staffordshire, is in the City Museum of Stoke-on-Trent, and there are references to earthenware examples of the seventeenth and eighteenth centuries (Savage and Newman, *Illustrated Dictionary*, p. 140; John Hodgkin and Edith Hodgkin, *Early English Pottery: Named, Dated, and Inscribed* [1891; reprint ed., Wakefield, England: EP Publishers, 1973], p. 143); an African tradition of cylindrical, wheel-thrown grave markers is documented in Robert Farris Thompson and Joseph Cornet, *The Four Moments of the Sun: Kongo Art in Two Worlds* (Washington, D.C.: National Gallery of Art, 1981), pp. 76–94.

33. Smith, *Pottery: A Utilitarian Folk Craft*, p. 26; Black, ed., *Made by Hand*, p. 66.

34. Burrison, "The Living Tradition," p. 37.

35. Guilland, *Early American Folk Pottery*, pp. 83–84; Bridges, ed., *Potters of the Catawba Valley*, p. 8 (fig. 2).

36. Cornelius Osgood, *The Jug and Related Stoneware of Bennington* (Rutland, Vt.: Charles E. Tuttle Co., 1971), p. 116.

37. Georgeanna H. Greer, "Preliminary Information on the Use of the Alkaline Glaze for Stoneware in the South, 1800–1970," in *The Conference on Historic Site Archaeology Papers 1970*, vol. 5, ed. Stanley South (Columbia: Institute of Archeology and Anthropology, University of South Carolina, 1971), p. 161.

38. Cylindrical butter-pots made in Georgia may have their origin in England, where the form was known as early as the seventeenth century (Lorna Weatherill, *The Pottery Trade and North Staffordshire, 1660–1760* [New York: Augustus M. Kelley, 1971], plate 1A); straight-sided pottery churns date to the early nineteenth century in America (Donald Blake Webster, *Decorated Stoneware Pottery of North America* [Rutland, Vt.: Charles E. Tuttle Co., 1971], pp. 133, 164 [no. 212]; Bivins, *Moravian Potters in North Carolina*, p. 163 [no. 138]).

39. Brears, *The English Country Pottery*, p. 72.

40. Ferrell and Ferrell, *Early Decorated Stoneware of the Edgefield District*, [p. 10].

41. Zug, *Traditional Pottery of North Carolina*, pp. 34 (fig. 22), 35 (fig. 23); Bridges, ed., *Potters of the Catawba Valley*, front cover, pp. 52 (no. 23), 61 (no. 91), 69 (nos. 92, 89), 70 (no. 93), 84 (no. 111); Burrison, "Alkaline-Glazed Stoneware," p. 402. Contemporary Catawba Valley folk potter Burlon B. Craig has revived the melted-glass decoration. There is also reason to believe that at

least one north Georgia potter of North Carolina background used the technique (Peggy A. Loar, *Indiana Stoneware* [Indianapolis: Indianapolis Museum of Art, 1974], p. 34 [no. 54, an alkaline-glazed syrup jug mistaken as of Indiana origin but which I attribute to the Dorsey family, Mossy Creek, White County]).

42. Brears, *The English Country Pottery*, pp. 37, 129.

43. Burrison, "Afro-American Folk Pottery," pp. 183–98; Vlach, *The Afro-American Tradition*, pp. 81–94; Bridges, ed., *Potters of the Catawba Valley*, pp. 35 (fig. 27), 36 (fig. 28), 46 (figs. 46, 47), 74 (no. 122), 80 (no. 144), 86 (figs. 95, 96), 88 (fig. 98); Wadsworth, ed., *Missing Pieces*, pp. 95, 98 (no. 91), 99 (no. 93), 101; Black, ed., *Made by Hand*, p. 83 (no. 20).

NOTES TO CHAPTER SIX

1. John H. Goff, "Thomas Griffiths' 'A Journal of the Voyage to South Carolina in 1767' to Obtain Cherokee Clay for Josiah Wedgwood, with Annotations," *Georgia Mineral Newsletter* 12, no. 3 (Winter 1959): 113–22.

2. In England and New England the horse-powered tub-and-blade pug mill, sometimes called a "flying Dutchman," was in use by the early nineteenth century (Peter C. D. Brears, *The English Country Pottery: Its History and Techniques* [Rutland, Vt.: Charles E. Tuttle Co., 1971], pp. 92–93; Lura Woodside Watkins, *Early New England Potters and Their Wares* [Cambridge, Mass.: Harvard University Press, 1950], p. 5 and plate 2), and may have derived from an English flint-grinding mill patented in 1732 for use in the pottery industry (G. Bernard Hughes, *English and Scottish Earthenware, 1660–1860* [London: Abbey Fine Arts, n.d.], p. 48).

3. As opposed to the Continental

"kick and paw" wheel, where the seated potter's foot directly engages the flywheel, the treadle wheel evidently is of English origin (Brears, *The English Country Pottery*, p. 97; Harold F. Guilland, *Early American Folk Pottery* [Philadelphia: Chilton Book Co., 1971], p. 34).

4. Jeannette Lasansky, *Made of Mud: Stoneware Potteries in Central Pennsylvania, 1834–1929* (University Park: Pennsylvania State University Press / Keystone Books, 1977), p. 35; Georgeanna H. Greer, *American Stonewares: The Art and Craft of Utilitarian Potters* (Exton, Pa.: Schiffer Publishing, 1981), pp. 49, 51.

5. Brears, *The English Country Pottery*, pp. 100, 102; Geoffrey Wills, *English Pottery and Porcelain* (Garden City, N.Y.: Doubleday and Co., 1969), p. 52 (a French illustration of the early 1700s); Helmut Müller, "Das Töpferhandwerk in Schermbeck und Altschermbeck," in *Töpferei in Nordwestdeutschland*, ed. Wingolf Lehnemann (Münster: Volkskundliche Kommission für Westfalen, 1975), p. 222 (Germany).

6. Probably an adaptation of the ancient hand-turned gristmill surviving in less developed areas of the world into the twentieth century, the potter's quern was used as far east as Iran (Hans E. Wulff, *The Traditional Crafts of Persia: Their Development, Technology, and Influence on Eastern and Western Civilizations* [Cambridge, Mass.: M.I.T. Press, 1966], pp. 151–52), and is well documented in the United States for the production of lead glazes; for southern examples see John Bivins, Jr., *The Moravian Potters in North Carolina* (Chapel Hill: University of North Carolina Press for Old Salem, Inc., 1972), pp. 81 (illustration 17), 85, and Samuel D. Smith and Stephen T. Rogers, *A Survey of His-*

toric Pottery Making in Tennessee, Division of Archaeology Research Series, no. 3 (Nashville: Tennessee Department of Conservation, 1979), pp. 146–47. For detailed illustrations of the Meaders glaze mill see Ralph Rinzler and Robert Sayers, *The Meaders Family: North Georgia Potters*, Smithsonian Folklife Studies, no. 1 (Washington, D.C.: Smithsonian Institution Press, 1980), pp. 71–75.

7. Georgeanna H. Greer, "Groundhog Kilns—Rectangular American Kilns of the Nineteenth and Early Twentieth Centuries," *Northeast Historical Archaeology* 6, nos. 1–2 (Spring 1977): 42–54; idem, "Basic Forms of Historic Pottery Kilns Which May Be Encountered in the United States," in *The Conference on Historic Site Archaeology Papers 1978*, vol. 13, ed. Stanley South (Columbia, S.C.: Institute of Archeology and Anthropology, University of South Carolina, 1979), pp. 133–47. The origin of the southern rectangular kilns remains something of a mystery; according to Dr. Greer (correspondence of October 24, 1979) rectangular downdraft kilns similar to those excavated at an early eighteenth-century pottery site in Yorktown, Virginia (Norman F. Barka, "The Kiln and Ceramics of the 'Poor Potter' of Yorktown: A Preliminary Report," in *Ceramics in America*, ed. Ian M. G. Quimby, Winterthur Conference Report 1972 [Charlottesville: University Press of Virginia for Henry Francis du Pont Winterthur Museum, 1973], pp. 294–301) were recently found by the London Archeological Group at the late-seventeenth-century site of John Dwight's Fulham pottery, but are the only known British examples used for stoneware, while rectangular stoneware kilns are more numerous for Germany and France.

8. Cf. Brears, *The English Country Pottery*, pp. 130–32; D. B. Webster, *The Brantford Pottery, 1847–1907*, Art and Archaeology Occasional Paper no. 13 (Toronto: University of Toronto Press for Royal Ontario Museum, 1968), pp. 34–35; Carmen A. Guappone, *United States Utilitarian Folk Pottery* (McClellandtown, Pa.: Guappone Publishers, 1977), pp. 8–11; Smith and Rogers, *A Survey of Historic Pottery Making in Tennessee*, pp. 144–45.

9. Emmie Carnes Bankston, *History of Roberta and Crawford County, Georgia* (Macon: privately printed, 1976), p. 252, apparently based on information supplied by Mrs. John W. (Annie) Long, Sr., daughter of potter Seaborn Becham.

NOTES TO CHAPTER SEVEN

1. James B. Stoltman, "New Radiocarbon Dates for Southeastern Fiber-Tempered Pottery," *American Antiquity* 31 (1966): 872–74.

2. In my doctoral dissertation, "Georgia Jug Makers: A History of Southern Folk Pottery" (University of Pennsylvania, 1973), pp. 115–16 (notes 2 and 5), I provided a partial bibliography of southeastern Indian pottery relating to Georgia.

3. Quoted in Robert L. Giannini III, "Anthony Duché, Sr., Potter and Merchant of Philadelphia," *Antiques* 119, no. 1 (January 1981): 201.

4. Ibid., pp. 198–203. See also Susan H. Myers, "A Survey of Traditional Pottery Manufacture in the Mid-Atlantic and Northeastern United States," *Northeast Historical Archaeology* 6, nos. 1–2 (Spring 1977): 3 (fig. 4); Donald Blake Webster, *Decorated Stoneware Pottery of North America* (Rutland, Vt.: Charles E. Tuttle Co., 1971), p. 31 (fig. 5).

5. Lura Woodside Watkins, *Early New England Potters and Their Wares* (Cambridge, Mass.: Harvard University Press, 1950), chap. 6.

6. Courtesy of the Museum of Early Southern Decorative Arts, Winston-Salem, North Carolina, with thanks to Bradford L. Rauschenberg.

7. Graham Hood, "The Career of Andrew Duché," *Art Quarterly* 31, no. 2 (1968): 182 (note 10); E. D. Wells, "Duché the Potter," *Georgia Historical Quarterly* 41 (December 1957): 384; Gregor Norman-Wilcox, "Pottery and Porcelain, Part One: The Wares Made in America," in *The Concise Encyclopedia of American Antiques*, ed. Helen Comstock (New York: Hawthorn Books, 1965), p. 216.

8. Allen D. Candler, comp., *The Colonial Records of the State of Georgia*, 26 vols. (Atlanta: State Printer, 1904–16), vol. 22, pt. 1, pp. 168–69 (hereafter cited as *CRG*).

9. *CRG*, 5: 142, from a journal entry of the Earl of Egmont dated March 16, 1739.

10. Ibid.

11. *CRG*, 30: 145–46 (unpublished typescript in Georgia Department of Archives and History).

12. Wells, "Duché the Potter," p. 383; Norman-Wilcox, "The Wares Made in America," p. 216. In a letter to the Trustees dated December 29, 1739, General Oglethorpe wrote: "Andrew Duche is the Potter at Savannah who goes on very well there, is one of the most industrious in the Town, & has made Several Experiments, which seem to look like the making of China, he had two Servants whom he breeds to the Potter's Trade" (*CRG*, 22, pt. 2: 291).

13. Ruth Monroe Gilmer of Louisa, Virginia, found, in 1946, a lead-glazed earthenware milk pan

and a blue-decorated porcelain bowl she attributed to Andrew Duché, for which see Norman-Wilcox, "The Wares Made in America," pp. 249 (plate 93-A), 253 (plate 97).

14. *CRG*, 4 (supplement): 169, dated June 17, 1741.

15. Ibid., pp. 220–21, dated August 17, 1741.

16. Documentation said to be in the papers of the late E. D. Wells of Savannah, as reported by James A. Williams of Savannah in a conversation of February 23, 1980.

17. Norman-Wilcox, "The Wares Made in America," p. 216.

18. *CRG*, 5: 140, from a journal entry of the Earl of Egmont dated March 16, 1739.

19. *CRG*, 4 (supplement): 25, journal entry of November 10, 1740.

20. While no marked examples have as yet been found, earthenware was listed in an inventory of Anthony Duché's shop (Giannini, "Anthony Duché, Sr.," p. 203 [n. 15]).

21. *CRG*, 4:253, from a journal entry dated December 29, 1738.

22. *CRG*, 4 (supplement): 25, journal entry of November 10, 1740.

23. Ibid.

24. Ibid., 23: 80–81, letter dated July 30, 1741.

25. Hood, "The Career of Andrew Duché," pp. 173–81.

26. Ibid., p. 183 (n. 37).

27. *CRG*, 7: 142. In 1751 Johann Martin Bolzius, pastor of the Salzburgers at Ebenezer, noted the presence of a potter in Savannah, presumably William Ewen (Klaus G. Loewald, Beverly Starika, and Paul S. Taylor, trans. and eds., "Johann Martin Bolzius Answers a Questionnaire on Carolina and Georgia, Part 2," *William and Mary Quarterly*, 3rd ser. 15 [1958]: 246); the other possibility is Samuel

Bowen, who is said to have made porcelain through the 1760s, with the help of apprentice Henry Gossman, in the potworks vacated by Duché (Norman-Wilcox, "The Wares Made in America," p. 217).

28. Harold E. Davis, *The Fledgling Province: Social and Cultural Life in Colonial Georgia, 1733–76* (Chapel Hill: University of North Carolina Press, 1976), pp. 65, 170; E. Merton Coulter, ed., *The Journal of William Stephens, 1743–1745* (Athens: University of Georgia Press, 1959), p. 269.

29. *Columbian Museum and Savannah Advertiser*, April 25, 1797, p. 2, courtesy of the Museum of Early Southern Decorative Arts, Winston-Salem, N.C. A Charles Radiques, recorded in the 1790 tax digest for Chatham County, may have been the same man (*Substitutes for Georgia's Lost 1790 Census* [Albany, Ga.: Delwyn Associates, 1975], p. 51).

30. Adelaide L. Fries, *The Moravians in Georgia, 1735–1740* (Raleigh, N.C.: privately printed, 1905), p. 131.

31. Joseph Caldwell, Catherine McCann, and Frederick Hulse, *Irene Mound Site: Chatham County, Georgia* (Athens: University of Georgia Press, 1941), p. 77.

32. Fries, *The Moravians in Georgia*, p. 155.

33. John Bivins, Jr., *The Moravian Potters in North Carolina* (Chapel Hill: University of North Carolina Press for Old Salem, 1972), pp. 17, 49.

34. From an 1807 letter by Hawkins to a Moravian missionary director, quoted in Carl Mauelshagen and Gerald H. Davis, trans. and eds., *Partners in the Lord's Work: The Diary of Two Moravian Missionaries in the Creek Indian Country, 1807–1813*, School of Arts and Sciences Research Paper no. 21 (Atlanta: Georgia State University, 1969), p. 7.

35. Burckhard and Petersen specialized in the making of spinning wheels (both the flax and cotton varieties), which they sold chiefly to Indians while at the Creek Agency. Hawkins, in his attempt to encourage the Indians in the arts of spinning and weaving, ordered a large lathe from Philadelphia so that the Brothers could produce flax wheels. They also made looms, barrels, and tinware, and built stone chimneys at the agency. Their frustrated missionary zeal was expressed in a letter of March 12, 1809 to Christian Benzien, one of the missionary directors at Salem: "We are so well known for our tin ware, that persons from all parts of the country search us out to purchase our wares. Would to God they were as anxious for the Word of God as they are for things temporal." (All letters quoted were translated by Dr. Carl Mauelshagen and are used with the permission of the Moravian Archives at Winston-Salem, N.C.)

36. From a letter of September 1803 by a Brother Steiner to the authorities at Salem, telling of his visit with Hawkins.

37. Biographical information supplied by Mary Creech, archivist of the Moravian Archives, in a letter to the author dated July 9, 1971. See also Bivins, *The Moravian Potters*, pp. 38–42.

38. Letter to Brother Benzien dated January 19, 1810. The "machine" undoubtedly was a simple version of the pipe presses described and illustrated in Bivins, *The Moravian Potters*, pp. 96–98, 175 (illustration 155).

39. From separate letters by Burckhard and Petersen to Brothers Reichel and Benzien at Salem, both dated June 24, 1810.

40. According to a letter by Benjamin Hawkins to Brother Benzien at Salem dated November 7, 1810.

41. Bivins, *The Moravian Potters*, pp. 40–42.

42. Ibid., pp. 258–59.

NOTES TO CHAPTER EIGHT

1. Kenneth Coleman, *Georgia History in Outline* (Athens: University of Georgia Press, 1960), p. viii; Wilbur Zelinsky, "An Isochronic Map of Georgia Settlement, 1750–1850," *Georgia Historical Quarterly* 35 (1951): 191–95; James Etheridge Callaway, *The Early Settlement of Georgia* (Athens: University of Georgia Press, 1948), chaps. 6–10; Henry D. Green, *Furniture of the Georgia Piedmont before 1830* (Atlanta: High Museum of Art, 1976), pp. 11–13.

2. (n.p., n.d. [Augusta, ca. 1900?]), pp. 3–4.

3. Gerald L. Holder, "The Fall Zone Towns of Georgia: An Historical Geography" (Ph.D. diss., University of Georgia, 1973).

4. George E. Ladd, *A Preliminary Report on a Part of the Clays of Georgia*, Geological Survey of Georgia Bulletin no. 6A (Atlanta: State Printer, 1898), pp. 80–91; Otto Veatch, *Second Report on the Clay Deposits of Georgia*, Geological Survey of Georgia Bulletin no. 18 (Atlanta: State Printer, 1909), chaps. 4–6, 8, 10.

5. Peter C. D. Brears, *The English Country Pottery: Its History and Techniques* (Rutland, Vt.: Charles E. Tuttle Co., 1971), p. 83. In Britain, however, potters were also careful to locate near measures of coal, their major fuel (p. 58), whereas this was not a determinant in the well-forested South.

6. Stephen T. Ferrell and T. M. Ferrell, *Early Decorated Stoneware of*

the *Edgefield District, South Carolina* (Greenville, S.C.: Greenville County Museum of Art, 1976); John Michael Vlach, *The Afro-American Tradition in Decorative Arts* (Cleveland, Ohio: Cleveland Museum of Art, 1978), pp. 76–91.

7. Charles G. Zug III, *The Traditional Pottery of North Carolina* (Chapel Hill, N.C.: Ackland Art Museum, 1981), pp. 15–18.

8. *Sholes' Georgia State Gazetteer, Business and Planters' Directory 1881–82* (Augusta: Sholes and Co., 1881), p. 560.

9. According to Floyd Allen, a second shop was operated at Stockton by Floyd Fender. Other south Georgia potters include those of eighteenth-century Savannah (discussed in Chapter 7), Lawrence Lovett of Albany, and a New England potter named Parsons who made earthenware on Wassaw Island in the early twentieth century (29).

10. Daisy Wade Bridges, ed., *Potters of the Catawba Valley, North Carolina*, Ceramic Circle of Charlotte Journal of Studies, vol. 4 (Charlotte, N.C.: Mint Museum of History, 1980), p. 64 (no. 72).

11. C. W. Norwood, comp., *Sholes' Georgia State Gazetteer and Business Directory for 1879 and 1880* (Atlanta: A. E. Sholes and Co., 1879), p. 771.

12. Other Georgia mountain potters were Abram B. Davidson, J. C. and James F. Hill, D. Robinson, and Spencer M. Warthen, all of Walker County, Peter Howard and Sanford Tilman of Lumpkin County, John P. Smith of Murray County, Clemmonds Q. Chandler of Gilmer County, and George W. Dillard of Rabun County. The earliest record of pottery activity in Georgia's highlands is the 1840 manufacturing census, which lists two shops in Chattooga County each employing three people, but no names are given.

13. The Gunter Pottery is mentioned in John William Baker's *History of Hart County* (n.p., 1933), pp. 274–75. In the 1820 census for Edgefield County, South Carolina, Allen Gunter is shown six houses from potter John Landrum.

14. Potter James Kirbee and his sons had moved to Elbert County from Edgefield District by 1830, but continued on to Montgomery County, Texas (James M. Malone, Georgeanna H. Greer, and Helen Simons, *Kirbee Kiln: A Mid-Nineteenth-Century Texas Stoneware Pottery*, Office of the State Archeologist Report no. 31 [Austin: Texas Historical Commission, 1979], pp. 8–9). Much later, Bailey George Nolan Chandler, a potter trained in Jackson (now Barrow) County, worked in Elbert County (John A. Burrison, "George Chandler, Elbert County Potter," in *Historical Investigations of the Richard B. Russell Multiple Resource Area*, ed. The History Group, Inc. [Atlanta and Washington, D.C.: Interagency Archeological Services, U.S. Department of the Interior, 1981], pp. 203–10).

15. Augusta was the terminus of the southern branch of the Great Philadelphia Wagon Road, which channeled pioneers from the Middle Atlantic States into the interior of the South (Green, *Furniture of the Georgia Piedmont*, p. 11).

16. The first appeared in the issue of August 5 (p. 1) and ran through August 26; the second appeared in the issue of September 16 (p. 3) and ran through October 14.

17. Augusta's brick industry is discussed in Ladd, *Preliminary Report*, pp. 152–54. On p. 155 Ladd mentions a pottery at Grovetown in Columbia County, about fifteen miles west of Augusta. The stamp

HAHN POTTERY WKS. / AUGUSTA, GA. appears on Albany-slip-glazed fruit jars dating to about the turn of the century; the Hahn family is known to have made pottery at Trenton and North Augusta, South Carolina.

18. Franklin Fenenga and Emelyn Armstrong Fenenga, "Pots, Pans and Placenames: A Potter's Gazetteer of the American South," *Pottery Collectors Newsletter* 1, no. 5 (February 1972): 60.

19. Charles G. Zug III, "Jugtown Reborn: The North Carolina Folk Potter in Transition," *Pioneer America Society Transactions* 3 (1980): 2–4.

20. Samuel D. Smith and Stephen T. Rogers, *A Survey of Historic Pottery Making in Tennessee*, Division of Archaeology Research Series, no. 3 (Nashville: Tennessee Department of Conservation, 1979), p. 94.

21. Margaret W. Morley, *The Carolina Mountains* (Boston and New York: Houghton Mifflin, 1913), pp. 187–89.

22. John Ramsay, *American Potters and Pottery* (New York: Tudor Publishing Co., 1947), p. 238.

NOTES TO CHAPTER NINE

1. George E. Ladd, *A Preliminary Report on a Part of the Clays of Georgia*, Geological Survey of Georgia Bulletin no. 6A (Atlanta: State Printer, 1898), pp. 150–51.

2. *Records of the 1820 Census of Manufacturers Schedules for North Carolina, South Carolina, and Georgia*, microcopy no. 279, roll 19 (Washington, D.C.: National Archives Microfilm Publications, 1965), p. 523.

3. Ibid., p. 527.

4. Edgefield Deed Book 32, p. 441 (in Edgefield County Courthouse, Edgefield, South Carolina).

5. Collection of Stephen T. Fer-

rell, Piedmont, South Carolina, from Phoenix Factory site, at which Abner Landrum's brother, Amos, worked.

6. Elizabeth P. Newsom, ed., *Washington County Georgia 1825 Tax Digest* (Sandersville, Ga.: privately printed, 1968), p. 13.

7. Georgeanna H. Greer, "Southern Alkaline Glazed Stoneware: A Unique American Tradition," in *Potters of the Catawba Valley, North Carolina*, ed. Daisy Wade Bridges, Ceramic Circle of Charlotte Journal of Studies, vol. 4 (Charlotte, N.C.: Mint Museum of History, 1980), p. 9; Jewell Cogburn Raisty, "The Family of John Cogburn (ca. 1745–1810) of Edgefield District, South Carolina," mimeographed (n.p., 1965, copy in Georgia Department of Archives and History). John Cogburn, who originated in Isle of Wight County, Virginia, was in North Carolina (probably Martin County) when in 1772 he received a grant for land in what later became Edgefield District; after settling in South Carolina, he was associated with Abner Landrum's other potter brother, the Reverend John Landrum (Raisty, p. 3). Cyrus may have been an unrecorded son or nephew of John Cogburn.

8. Newsom, *Washington County 1825 Tax Digest*, pp. 128, 13; Cogburn is included in the defaulters list, owing two dollars in taxes.

9. Theo S. Daniel III, "A History of the Henderson County, Texas, Pottery Industry," typescript (Athens, Tex., for the Henderson County Historical Survey Commission, 1972, copy courtesy of Georgeanna H. Greer), p. 3.

10. As reported by Georgeanna H. Greer, San Antonio, Texas, in correspondence of December 30, 1977.

11. Daniel Huntley Redfearn,

History of the Redfearn Family (Miami, Fla.: privately printed, 1954), chap. 10. Branson may have been the grandson of Isaac Redfearn, who had settled in the pottery center of Randolph County, North Carolina (chap. 9).

12. Elizabeth P. Newsom, comp., *Washington County Georgia Tombstone Inscriptions* (Sandersville, Ga.: privately printed, 1967), pp. x, 132.

NOTES TO CHAPTER TEN

1. In 1825, four years after the Creek Indians ceded the land that became Crawford County, the Marquis de Lafayette passed through on his way westward from Macon. His secretary, surprised to find the area so undeveloped, wrote, "Within a league of [Macon], we are again in the bosom of virgin forests." (A. Levasseur, *Lafayette in America in 1824 and 1825*, trans. J. D. Godman, 2 vols. [1829; reprint ed., New York: Research Reprints, 1970], 2:70).

2. Thomas Marshall Green, "Small Slaveholders in Crawford County, Georgia, 1822–1861" (honors thesis in history, Harvard College, 1978), p. 34.

3. C. B. McCook, *Remembering Lizella* (Lizella, Ga.: privately printed, 1973), p. 141, as reported by Jewel Merritt.

4. George E. Ladd, *A Preliminary Report on a Part of the Clays of Georgia*, Geological Survey of Georgia Bulletin no. 6A (Atlanta: State Printer, 1898), pp. 99–100.

5. Otto Veatch, *Second Report on the Clay Deposits of Georgia*, Geological Survey of Georgia Bulletin no. 18 (Atlanta: State Printer, 1909), pp. 219–20.

6. Richard W. Smith, *Sedimentary Kaolins of the Coastal Plain of Georgia*,

Geological Survey of Georgia Bulletin no. 44 (Atlanta: State Printer, 1929), p. 90.

7. Lot 123, District 3, deeded January 19, 1826, and recorded June 12, 1832, Crawford County Deed Book A, p. 271.

8. Adiel Sherwood, *A Gazetteer of the State of Georgia*, 2d ed. (Philadelphia: Martin and Boden, 1829), p. 99.

9. Locating James Long's family in South Carolina is complicated by the existence there of another Long family, of Swiss descent; see Eytive Long Evans, *A Documented History of the Long Family, Switzerland to South Carolina, 1578–1956* (Atlanta: privately printed, 1956). Some genealogist descendants of Crawford County's pioneer potter believe him to have been the son of a James Long listed as one of twelve children in the 1775 will of Matthew Long of Ninety Six District, Granville (probably present-day Anderson) County (ibid., p. 281; Caroline T. Moore, ed., *Abstract of Wills of the State of South Carolina*, 4 vols. [Columbia, S.C.: R. L. Bryan Co., 1969], 3:288), but this has yet to be proven.

10. R. C. Bell and M. A. V. Gill, *The Potteries of Tyneside* (Newcastle-upon-Tyne, England: Frank Graham and Laing Art Gallery and Museum, 1973), which shows a W. Laing owning a pottery on Lime Street about 1877 (p. 38). It is possible, however, that in oral transmission this city became confused with the town of Newcastle-under-Lyme, home of some Staffordshire potters (Peter C. D. Brears, *The English Country Pottery: Its History and Techniques* [Rutland, Vt.: Charles E. Tuttle Co., 1971], pp. 208–9).

11. Other members of the family may have gone to Pennsylvania; Abraham and Samuel Long were

making earthenware in York County in 1799 (Jeannette Lasansky, *Central Pennsylvania Redware Pottery 1780–1904* [University Park: Pennsylvania State University Press / Keystone Books, 1979], p. 19).

12. A William Long, age forty, is shown as a potter in the 1860 census for Chatham County, North Carolina, where some of the family may have remained.

13. Virginia S. Wood and Ralph V. Wood, eds., *1805 Georgia Land Lottery* (Cambridge, Mass.: Greenwood Press, 1964), p. 210; Silas E. Lucas, Jr., comp., *The Second or 1807 Land Lottery of Georgia* (Vidalia, Ga.: Georgia Genealogical Reprints, 1968), p. 119; idem, *The Third and Fourth or 1820 and 1821 Land Lotteries of Georgia* (Easley, S.C.: Georgia Genealogical Reprints and Southern Historical Press, 1973), p. 215.

14. Ruth Blair, ed., *Some Early Tax Digests of Georgia* (Atlanta: Georgia Department of Archives and History, 1926), p. 166. James Long would have been too young to have owned land at that time, so this may have been his father.

15. Elizabeth P. Newsom, ed., *Washington County Georgia 1825 Tax Digest* (Sandersville, Ga.: privately printed, 1968), p. 128.

16. The same mark appears on two other pieces found in Georgia. One is a moderately ovoid crock of about two gallons capacity (although stamped 3) with a rather high, flaring neck, an irregular brown glaze resembling ash glaze, incised wavy combing around the shoulder, and two horizontal slab handles cut from a wheel-turned ring (color plate 1). The other is a ring bottle covered in a thin, light green (evidently lime) glaze; the mark is impressed on the base inside the hollow foot (plate 36).

17. Sprigging was employed by John Dwight of Fulham and his successors from the late seventeenth through the early nineteenth century; see Geoffrey A. Godden, *British Pottery: An Illustrated Guide* (New York: Clarkson N. Potter, 1975), pp. 56–57, 62–63. For use of the technique in America see Donald Blake Webster, *Decorated Stoneware Pottery of North America* (Rutland, Vt.: Charles E. Tuttle Co., 1971), chap. 10.

18. Green, "Small Slaveholders," pp. 55, 60, 62.

19. Crawford County Returns, vol. F: inventory, March 10, 1851, p. 131; appraisement, March 27, p. 140.

20. Ibid., sale bill, April 26, 1851, entered May 9, p. 138.

21. Charles G. Zug III, authority on North Carolina folk pottery, reports that the stoneware potters of Buncombe County, North Carolina, sometimes used the same material to color their ash glaze (conversation of February 22, 1981).

22. N. O. Thomas, Jr., *The Beckham Family* (Shreveport, La.: privately printed, 1969), pp. 3–5.

23. Frances Wynd, *Washington County Georgia Records* (Albany, Ga.: privately printed, n.d.), pp. 6, 28–29.

24. Ibid., p. 28.

25. Smith, *Sedimentary Kaolins*, pp. 90–91.

26. Stephen T. Ferrell and T. M. Ferrell, *Early Decorated Stoneware of the Edgefield District, South Carolina* (Greenville, S.C.: Greenville County Museum of Art, 1976), [p. 7]. Edward L. Stork, who settled at Orange in Cherokee County, Georgia, but who was linked to the Edgefield tradition, made such bowls; see Anna Wadsworth, ed., *Missing Pieces: Georgia Folk Art 1770–1976* (Atlanta: Georgia Council for the

Arts and Humanities, 1976), p. 96 (no. 89).

27. Smith, *Sedimentary Kaolins*, p. 91.

NOTES TO CHAPTER ELEVEN

1. In his *American Potters and Pottery* (New York: Tudor Publishing Co., 1947), p. 238, John Ramsay listed the Rogers Pottery but created a double error by locating Jugtown at Thomasville in Hall County (Thomasville is in Thomas County). Otto Veatch, in his *Second Report on the Clay Deposits of Georgia*, Geological Survey of Georgia Bulletin no. 18 (Atlanta: State Printer, 1909), p. 373, made reference to three "jug potteries" in northern Upson County but did not use the name Jugtown, while Richard W. Smith, in "A Visit to Jugtown," *Forestry-Geological Review* 4 (March 1934): 7, used the word generically for all Georgia's pottery communities. Jugtown is also mentioned in Lizzie R. Mitchell, *History of Pike County Georgia, 1822–1932* (n.p., [1932]), pp. 122–23.

2. Carolyn W. Nottingham and Evelyn Hannah, *History of Upson County, Georgia* (n.p., 1930), p. 754.

3. Pike County Will Book C, p. 72, item 5: "That if my son Bowling Brown shall take up or cause to be taken up the note given by me for the hundred acres of land whichon he lives [or lived] then he is to have the title made according to his discretion."

4. Pike County Court of Ordinary, Inventories and Appraisements vol. H, p. 59, recorded September 16, 1851.

5. Upson County Deed Book A, pp. 188–89; Pike County Deed Book C, p. 132, February 3, 202½

acres in District 9, lot 233; all other lands deeded to William Brown between 1834 and 1849, with one exception, were in Districts 8 and 9.

6. Ruth Blair, *Some Early Tax Digests of Georgia* (Atlanta: Georgia Department of Archives and History, 1926), pp. 35, 63.

7. Information on the Storks was pieced together from the 1850–80 censuses of Richland County, South Carolina. It appears that there was intermarriage between the Stork and Landrum families.

8. In Carolyn C. Cary, ed., *The History of Fayette County 1821–1971* (Fayetteville, Ga.: Fayette County Historical Society, 1977), pp. 500–501, there is a slightly varying account of Gordy's Fayette County years.

9. Further discussion of Stork's work can be found in John A. Burrison, "Georgia Jug Makers: A History of Southern Folk Pottery" (Ph.D. diss., University of Pennsylvania, 1973), pp. 394–99, and Anna Wadsworth, ed., *Missing Pieces: Georgia Folk Art 1770–1976* (Atlanta: Georgia Council for the Arts and Humanities, 1976), pp. 94 (no. 86), 96 (nos. 88–89).

10. According to George R. Hamell, authority on New York State ceramics, Guy Dougherty later worked for approximately twenty years with Roadside Craftsmen at East Bloomfield, New York (correspondence of September 6, 1978). See his "Earthenwares and Salt-glazed Stonewares of the Rochester-Genessee-Valley Region: An Overview," *Northeast Historical Archaeology* 7–9 (1978–80): 11.

11. Charles van Ravenswaay, *The Arts and Architecture of German Settlements in Missouri* (Columbia: University of Missouri Press, 1977), p. 470.

12. Charles Counts and Bill Haddox, *Common Clay* (Atlanta: Droke House / Hallux, 1971), p. 44.

NOTES TO CHAPTER TWELVE

1. John A. Burrison, "Fiddlers in the Alley: Atlanta as an Early Country Music Center," *Atlanta Historical Bulletin* 21, no. 2 (Summer 1977): 59–87.

2. Quoted in Franklin Garrett, *Atlanta and Environs*, 3 vols. (New York: Lewis Historical Publishing Co., 1954), 1: 962–63.

3. Georgeanna H. Greer, "The Folk Pottery of Mississippi," in *Made by Hand: Mississippi Folk Art*, ed. Patti Carr Black (Jackson: Mississippi Department of Archives and History, 1980), p. 48.

4. (Atlanta: The Pioneer Citizens' Society of Atlanta, 1902), p. 116, possibly gleaned from an 1846 newspaper advertisement.

5. *Williams' Atlanta Directory, City Guide, and Business Mirror* (Atlanta: M. Lynch, 1859), pp. 69, 23. A ten-gallon jug and two poultry fountains made by "N. J." Craven were exhibited at the Southern Central Agricultural Society fair in Macon in 1851 (David W. Lewis, *Transactions of the Southern Central Agricultural Society, from Its Organization in 1846 to 1851* [Macon: Benjamin F. Griffin, 1852], p. 61). Sometime later another Mossy Creek potter, Asberry T. Davidson (son of John B.), came to Atlanta; the 1880 census shows him as a potter living at 74 Walker Street near the Southern Terra Cotta Works (Pellegrini and Castleberry), and the state business gazetteers of 1881 to 1888 list as potters "A. T. Davidson and Brother"—probably William, who was driving a street-car in Atlanta in 1880—at Cross Keys (present-day Chamblee), just northeast of Atlanta in DeKalb County.

6. Garrett, *Atlanta and Environs*, 1: 343–44.

7. *Hanleiter's Atlanta City Directory for 1871* (Atlanta: William R. Hanleiter, 1871), p. 91.

8. There is a concentration of Klines in the 1860 census for the Cincinnati area, where cobalt-decorated stoneware of the sort Charles later made in Georgia was produced, according to Gary and Diana Stradling of New York, authorities on Ohio pottery (conversation of December 27, 1980). A Philip Kline made redware in Pennsylvania during the early nineteenth century (John Ramsay, *American Potters and Pottery* [New York: Tudor Publishing Co., 1947], p. 165; Jeannette Lasansky, *Central Pennsylvania Redware Pottery 1780–1904* [University Park: Pennsylvania State University Press / Keystone Books, 1979], p. 20).

9. *Georgia State Gazetteer, Business and Planters' Directory, 1883–84* (Savannah: J. H. Estill and C. F. Weatherbe, 1883), p. 471.

10. Anna Wadsworth, ed., *Missing Pieces: Georgia Folk Art 1770–1976* (Atlanta: Georgia Council for the Arts and Humanities, 1976), p. 88 (no. 75).

11. *Street Directory of Atlanta* (Atlanta: R. L. Polk and Co., 1888), p. 391.

12. *Atlanta City Directory 1930* (Atlanta: Atlanta City Directory Co., 1930), p. 280.

13. *Atlanta City Directory 1933* (Atlanta: Atlanta City Directory Co., 1933), p. 217.

14. *Atlanta City Directory 1934* (Atlanta: Atlanta City Directory Co., 1934), p. 222.

15. *Atlanta City Directory 1911* (Atlanta: Atlanta City Directory Co., 1911), p. 532.

16. Courtenay Carson, "Seven Generations of Pottery Makers,"

Sandlapper: The Magazine of South Carolina 1, no. 8 (August 1968): 18–20; Stanley South, "A Comment on Alkaline Glazed Stoneware," in *The Conference on Historic Site Archaeology Papers 1970*, vol. 5, ed. Stanley South (Columbia: Institute of Archeology and Anthropology, University of South Carolina, 1971), pp. 181–83.

17. Edward L. DuPuy and Emma Weaver, *Artisans of the Appalachians* (Asheville, N.C.: Miller Printing Co., 1967), p. 48.

18. Robert Sayers, "Potters in a Changing South," in *The Not So Solid South: Anthropological Studies in a Regional Subculture*, ed. J. Kenneth Morland, Southern Anthropological Society Proceedings, no. 4 (Athens: University of Georgia Press, 1971), pp. 97–100.

19. Elinor Lander Horwitz, *Mountain People, Mountain Crafts* (Philadelphia and New York: J. B. Lippincott Co., 1974), p. 111.

20. Wadsworth, ed., *Missing Pieces*, p. 89 (no. 76).

21. Such a use of "testers" or "toten pieces" is described in Samuel D. Smith and Stephen T. Rogers, *A Survey of Historic Pottery Making in Tennessee*, Division of Archaeology Research Series, no. 3 (Nashville: Tennessee Department of Conservation, 1979), p. 23.

22. Quoted in Garrett, *Atlanta and Environs*, 1: 850. See also *Acts and Resolutions of the General Assembly of the State of Georgia . . . Session of 1870* (Atlanta: State Printer, 1870), p. 241 (item no. 162); Rebecca Foltz Dodd, "East Point, Georgia: A History, 1821–1930" (M.A. thesis, Georgia State University, 1971), p. 13.

23. Otto Veatch, *Second Report on the Clay Deposits of Georgia*, Geological Survey of Georgia Bulletin no. 18 (Atlanta: State Printer, 1909), pp. 329, 428.

24. *Atlanta City Directory 1900* (Atlanta: Foote and Davies Co. and Joseph W. Hill, 1900), p. 1487.

25. Another Marietta-area potter was Bill Robertson (apparently not the William C. Robertson who worked at Statham in Jackson—later Barrow—County), who is said to have been an old man in 1905, when he was making flowerpots and Albany-slip-glazed churns (99).

26. *Hanleiter's Atlanta City Directory for 1870* (Atlanta: William R. Hanleiter, 1870), p. 198.

27. Garrett, *Atlanta and Environs*, 2: 517.

28. *Atlanta City Directory 1905* (Atlanta: Foote and Davies Co. and Joseph W. Hill, 1905), opposite p. 785; *Byrd's New Directory of Atlanta 1909* (Atlanta: Byrd Printing Co., 1909), opposite pp. 1636–37.

29. Wadsworth, ed., *Missing Pieces*, p. 94 (no. 85).

NOTES TO CHAPTER THIRTEEN

1. *Georgia Historical Markers* (Valdosta, Ga.: Bay Tree Grove Publishers, 1973), p. 387.

2. Otto Veatch, *Second Report on the Clay Deposits of Georgia*, Geological Survey of Georgia Bulletin no. 18 (Atlanta: State Printer, 1909), pp. 290–91.

3. A similar apparatus is shown in Samuel D. Smith and Stephen T. Rogers, *A Survey of Historic Pottery Making in Tennessee*, Division of Archaeology Research Series, no. 3 (Nashville: Tennessee Department of Conservation, 1979), p. 79.

NOTES TO CHAPTER FOURTEEN

1. Otto Veatch, *Second Report on the Clay Deposits of Georgia*, Geological Survey of Georgia Bulletin no. 18 (Atlanta: State Printer, 1909), p. 336. A recent—and otherwise comprehensive—county history compiled by C. Fred Ingram, *Beadland to Barrow* (Atlanta: Cherokee Publishing Co., 1978), makes no mention of a local pottery tradition.

2. Edgefield Deed Book 42, p. 119.

3. Ibid., p. 327, recorded February 7, 1827.

4. Anita B. Sams, *Wayfarers in Walton: A History of Walton County, Georgia, 1818–1967* (Monroe, Ga.: General Charitable Foundation, 1967), p. 62.

5. "Map of the State of Georgia" (Milledgeville, Ga.: William G. Bonner, 1847). It and the other maps alluded to are in the Office of the Surveyor General, Georgia Department of Archives and History, Atlanta.

6. Family genealogist Zell DeLay, however, believes the DeLays may have been involved in the potter's craft before their association with the Fergusons, citing the facts that in 1850 Jonathan Patton, stepson of "Big Jim's" brother Jesse (who is not known to have been in Jackson County), was listed as a "Jugwright" next to Jesse near Woodstock in Cherokee County, and that "Big Jim's" half-brother Jason's middle name was Minton (Thomas Minton was a noted pottery manufacturer in Staffordshire in the late eighteenth and early nineteenth century); their father, Seth DeLay, is thought to have emigrated from England (35).

7. For various explanations of the origin of the name Jug Tavern, see Ingram, *Beadland to Barrow*, pp. 34–36, and Sams, *Wayfarers in Walton*, p. 321.

8. Nathaniel seems to have escaped the 1870 census. Family tradition hints that he was not the first Hewell potter. According to the 1880 census he was born in Georgia, his father (Wyatt?) in Ireland—possibly, like the DeLays, of Hu-

guenot stock—and his mother in Virginia.

9. This may have been the Athens Manufacturing Company, which advertised that it produced pottery as well as textiles (*Georgia State Gazetteer, Business and Planters' Directory, 1888–89* [Atlanta: A. E. Sholes, 1888], p. 265).

10. The Archers may have been involved with the potters who inscribed an Albany-slip-glazed pitcher, Mrs. Thomas Newsom Pitcher Manufactured by Wright, & Hintin & Wright / Mallorysville, Wilkes Co. Ga. January 1886.

11. It is claimed in John Ramsay's *American Potters and Pottery* (New York: Tudor Publishing Co., 1947), p. 236, that Brewer began his operation about 1870, but in light of his 1862 birth the earliest he could have opened his shop would have been the 1880s. Veatch, *Second Report on the Clay Deposits of Georgia*, p. 350, listed him in 1909.

NOTES TO CHAPTER FIFTEEN

1. Mrs. Lewin D. McPherson, *The Holcombes: Nation Builders* (Washington, D.C.: privately printed, 1947), pp. 655–57. John Ramsay's *American Potters and Pottery* (New York: Tudor Publishing Co., 1947), pp. 87, 238, and William C. Ketchum, Jr.'s *The Pottery and Porcelain Collector's Handbook* (New York: Funk and Wagnalls, 1971), pp. 73, 163, both mistakenly assert that the Holcombs and Hewells were operating at Gillsville as early as the 1830s.

2. J. C. Holcomb is listed as a Gillsville potter in the *Georgia State Gazetteer, Business and Planters' Directory 1883–84* (Savannah: J. H. Estill and Ch. F. Weatherbe, 1883), p. 407, but it is possible that the middle initial is a typographical error.

3. (Title page missing from copy in University of Georgia Library), p. 496.

4. Ibid.

5. Anna Wadsworth, ed., *Missing Pieces: Georgia Folk Art 1770–1976* (Atlanta: Georgia Council for the Arts and Humanities, 1976), p. 95.

NOTES TO CHAPTER SIXTEEN

1. Allen H. Eaton, *Handicrafts of the Southern Highlands* (1937; reprint ed., New York: Dover Publications, 1973), pp. 212–14. The Doris Ulmann photographs opposite pp. 139, 142, and 291 were taken at the Cleater Meaders Pottery in Cleveland; the one opposite p. 143 shows Cheever with his children, including Lanier.

2. This point must be made, for it is erroneously claimed that the Meaderses were potting in White County as early as 1830 by John Ramsay in *American Potters and Pottery* (New York: Tudor Publishing Co., 1947), pp. 87, 237, and William C. Ketchum, Jr., in *The Pottery and Porcelain Collector's Handbook* (New York: Funk and Wagnalls, 1971), pp. 73, 163.

3. George White, *Statistics of the State of Georgia* (Savannah: W. Thorne Williams, 1849), p. 300.

4. C. W. Norwood, comp., *Sholes' Georgia State Gazetteer and Business Directory for 1879 and 1880* (Atlanta: A. E. Sholes and Co., 1879), p. 563.

5. Otto Veatch, *Second Report on the Clay Deposits of Georgia*, Geological Survey of Georgia Bulletin no. 18 (Atlanta: State Printer, 1909), pp. 381–82.

6. Richard E. Lonsdale, *Atlas of North Carolina* (Chapel Hill: University of North Carolina Press, 1967), p. 44. Frederick Davidson's tombstone—one of the earliest dated examples in the Mossy Creek

Methodist Church cemetery—states that he came from "Bunkum" County. In 1794 a "Georg Davidson" of Iredell County took Cornelius Craise as an "apprentice to the potter's trade" (James H. Craig, *The Arts and Crafts in North Carolina 1699–1840* [Winston-Salem, N.C.: Museum of Early Southern Decorative Arts, 1965], p. 89).

7. Historical Facts Committee, *Historical Facts and Legends {of} White County, 1857–1957* (Cleveland, Ga.: White County Chamber of Commerce, 1957), {p. 10}.

8. Hezekiah Chandler was in Elbert County in 1795, when he voted for delegates to the Constitutional Convention (*Substitutes for Georgia's Lost 1790 Census* [Albany, Ga.: Delwyn Associates, 1975], p. 85), and was in Franklin County as early as 1803 (Martha W. Acker, comp., *Deeds of Franklin County, Georgia 1784–1826* [Easley, S.C.: Southern Historical Press, 1976], p. 159). On March 20, 1821 he bought 250 acres on Mossy Creek (Lot 54, District 2), as recorded April 2 in Habersham County Deed Book A, p. 51. This land was seized by the sheriff in 1842, possibly at the time of Chandler's death.

9. Stephen T. Ferrell and T. M. Ferrell, *Early Decorated Stoneware of the Edgefield District, South Carolina* (Greenville, S.C.: Greenville County Museum of Art, 1976), {p. 10}.

10. In 1693 John Dwight brought suit against potters he believed were infringing upon his patents of 1671 and 1684. A document relating to the case states that Dwight had "formerly hired one John Chandler of Fulham and employed him in the making {of stoneware} . . . thereupon John Elers and David Elers (who are foreigners and by trade silversmiths) together with James Morley of Nottingham and also Aaron Wedgwood, Thomas

Wedgwood and Richard Wedgwood of Berslem in the County of Stafford . . . did insinuate themselves into the acquaintance of the said John Chandler and enticed him to instruct them and to desert the complainant's service to enter into partnership together with them to make and sell the said wares, but far inferior to them" (G. Bernard Hughes, *English and Scottish Earthenware, 1660–1860* [London: Abbey Fine Arts, n.d.], p. 33).

11. John A. Burrison, "Alkaline-Glazed Stoneware: A Deep-South Pottery Tradition," *Southern Folklore Quarterly* 39, no. 4 (December 1975): 392; idem, *The Meaders Family of Mossy Creek: Eighty Years of North Georgia Folk Pottery* (Atlanta: Georgia State University, 1976), pp. 2, 17 (no. 1).

12. A William Pitchford, possibly Nathan's father, was in Wilkes (later Elbert) County, Georgia in 1785, having migrated from Mecklenburg County, Virginia (3).

13. Lot 103, District 2, purchased December 23, 1822, and recorded April 5, 1823, in Habersham County Deed Book B, p. 37. Nathan was in Franklin County as early as 1803 (Acker, comp., *Deeds of Franklin County*, pp. 227, 380, 423).

14. Lot 104, District 2, purchased November 10 and recorded November 30, 1825, in Habersham County Deed Book D, p. 81, as witnessed by Clemond Quillian, the man after whom the potter Chandler evidently was named (possibly his mother's brother, as she was a Quillian). John Craven was married in Randolph County, North Carolina, in 1825 (39), so he wasted little time in getting to Mossy Creek. A third (non-potter) brother, the Reverend Thomas W. Craven, who joined John and Isaac N. at Mossy Creek, was in Spartanburg County, South Carolina, in 1820, suggesting their route to northeast Georgia. The 1830 census shows their uncle, Thomas Craven, Jr., in Clarke County, Georgia, before he and his sons established a shop in Henderson County, Tennessee (Samuel D. Smith and Stephen T. Rogers, *A Survey of Historic Pottery Making in Tennessee*, Division of Archaeology Research Series, no. 3 [Nashville: Tennessee Department of Conservation, 1979], pp. 110–13).

15. Charles G. Zug III, *The Traditional Pottery of North Carolina* (Chapel Hill, N.C.: Ackland Art Museum, 1981), p. 30.

16. Charles A. Craven of Birmingham, Alabama, grandson of John Craven's brother Thomas W., wrote to Mrs. Frances Craven Burke of Kansas City, Missouri, on February 4, 1926, "I do not know where in England my people originated; some of them were potters and followed it after coming to this country. They were also familiar with the tanner's trade, and manufactured leather." Courtesy of Mrs. Mildred Craven Galloway of Arlington, Virginia.

17. The 1880 census for Mossy Creek lists his son Bascomb, age nineteen, as a jeweler.

18. Inventories and Appraisements for White County Book A, p. 68.

19. Zug, *The Traditional Pottery of North Carolina*, pp. 27, 31 (fig. 19), 39 (fig. 29), and cat. nos. 59–72.

20. John Tucker Dorsey, *The Dorsey Family: Descendants of Edward Darcy/Dorsey of Virginia and Maryland* (Marietta, Ga.: privately printed, 1957), pp. 57–58.

21. Ibid., p. 163.

22. Daisy Wade Bridges, ed., *Potters of the Catawba Valley, North Carolina*, Ceramic Circle of Charlotte Journal of Studies, vol. 4 (Charlotte, N.C.: Mint Museum of History, 1980).

23. Dorsey, *The Dorsey Family*, p. 59.

24. Ibid., p. 144. The 1830 census shows a David Dorsey in Macon County, North Carolina (which would have been part of Buncombe at the time of his birth), in the right age bracket for our potter. The 1850, 1860, and 1870 censuses for Habersham/White County show his birthplace as Georgia, South Carolina, and North Carolina respectively, but the latter recurs in the 1880 census.

25. Ibid., pp. 146–47.

26. There is some question as to the year of birth for Enos (also found as "Enoch"), but it appears that he was just a few months younger than his uncle Tarp, his mother (Davey's daughter Emmaline, nicknamed "Little Mammy") having married quite young a member of Basil's branch of the family.

27. From a letter by W. E. Wylam of Cleveland, quoted in Homer Eaton Keyes, "Perplexities in Pottery," *Antiques* 23 (February 1933): 54–55, the article which first brought southern alkaline glazes to the public's attention. A misreading of Wylam's letter led Ramsay in *American Potters and Pottery*, pp. 87, 237, to the conclusion that Walkerville was another name for Cleveland; actually, Cleveland was originally called Mount Yonah.

28. From an interview with Mike Farrman of Clarkesville, conducted in November 1967 by Phyllis Bestwick and Rheba Jones, Georgia Folklore Archives D-28.

29. When the old house was destroyed two doors from the back wall were saved and used in building the 1919 cottage presently occupied by Lanier and his mother.

30. Burrison, *Meaders Family*, p. 32 (nos. 110–11).

31. Ibid., p. 19 (nos. 26–28).

32. This term first appears in Eaton, *Handicrafts*, p. 213, from a conversation with L. Q. Meaders.

33. Burrison, *Meaders Family*, p. 21 (no. 36); Anna Wadsworth, ed., *Missing Pieces: Georgia Folk Art 1770–1976* (Atlanta: Georgia Council for the Arts and Humanities, 1976), p. 99 (no. 94).

34. Eaton, *Handicrafts*, opposite p. 143; Lanier is at the far right, seated. Perhaps more important for informing the general public of the Meaders Pottery is its inclusion on the American Automobile Association Tour Map of the United States, and Andrew Sparks's "They Create Beauty from Mud, Rags and Oak Splits," *Atlanta Journal and Constitution Magazine*, March 3, 1957, pp. 12–13, 32–33, which featured Cheever on the cover.

35. Marianne Kidd, "Handicrafters at Work in North Georgia," *Georgia Magazine* 2, no. 1 (June–July 1958): 10–11; Joan Falconer Byrd, "Meaders Pottery—White County, Georgia," *Pottery Collectors Newsletter* 3, no. 6 (March 1974): 77; Charles Counts and Bill Haddox, *Common Clay* (Atlanta: Droke House/Hallux, 1971), [p. 1 of portfolio]; Burrison, *Meaders Family*, pp. 26–29; John Coyne, "The Meaderses of Mossy Creek: A Dynasty of Folk Potters," *Americana* 8, no. 1 (March–April 1980): 44.

36. Edward L. DuPuy and Emma Weaver, *Artisans of the Appalachians* (Asheville, N.C.: Miller Printing Co., 1967), p. 60.

37. Burrison, *Meaders Family*, pp. 20–21 (no. 34); Wadsworth, ed., *Missing Pieces*, p. 100 (no. 95).

38. "The Meaders Family: North Georgia Potters," released in 1980 and available through Audio Visual Services, Pennsylvania State University, University Park, Pa. 16802.

39. Sarah Booth Conroy, "Face Jugs in Smithsonian," *Atlanta Journal and Constitution Magazine*, September 15, 1968, pp. 34–36; "The Meaders Pottery Today: Still Going Strong," *Foxfire* 2, nos. 3 and 4 (Fall–Winter 1968): 7–9, 134–35.

40. Burrison, *Meaders Family*, p. 31 (no. 109).

NOTES TO THE EPILOGUE

1. Margaret W. Morley, *The Carolina Mountains* (Boston and New York: Houghton Mifflin, 1913), p. 189.

2. Besides the film produced by the Smithsonian's Office of Folklife Programs, Lanier Meaders appears in two others: "Echoes from the Hills" (1970, for WQXI Television, Atlanta, available from the Cotton States Insurance Companies in Atlanta) and "Missing Pieces: Georgia Folk Art" (1976, available from the Georgia Council for the Arts, Atlanta). The "Meaders Pottery Day" at the Library of Congress was March 17, 1978.

Respondents

Those who were primary sources for much of the information in this book, with their locations and dates of interviews or correspondence (the latter so indicated). Numbers within parentheses which follow quotations or citations in the text refer to the numbers of the alphabetical list below.

1. Allen, Floyd. Stockton. May 24 and November 8, 1980.
2. Ashley, Mrs. Pearl Henderson. Maysville. June 30, 1973.
3. Atkinson, Harry W. Flowery Branch. Correspondence of September 26, 1981.
4. Atkinson, Mrs. Harry W. (Mamie Gettys). Flowery Branch. 1975.
5. Attaway, Mrs. Boyce (Evelyn Chandler). Ninety Six, S.C. June 13 and 14, 1980.
6. Ball, Mrs. John W., Jr. (Fannie May Meaders). Atlanta. July 9, 1978.
7. Barfield, Manche. Atlanta. July 20, 1972.
8. Baynham, Mark, Jr. ("Buddy"). North Augusta, S.C. September 1, 1971.
9. Becham, Frank J. Roberta. December 31, 1980.
10. Becham, Henry L. Roberta. October 9, 1971; December 31, 1980.
11. Becham, William A. Lizella. Correspondence of July 8, 1978.
12. Bell, Truman W. Bethlehem. November 12, 1972.
13. Bishop, Fred. Jugtown. July 20, 1971; July 15, 1978.
14. Blackwell, Mrs. Elberta Stork. Orange. May 1972.
15. Bohannon, Butch. Mitchell. May 31, 1981.
16. Boozer, Mrs. Annie. Acworth. February 23, 1976.

17. Brock, Mrs. Harold E. (Jean). Marietta. September 25 and October 12, 1975; October 27, 1980.
18. Brown, E. Javan. Connellys Springs, N.C.
 A. December 19, 1972.
 B. July 1, 1977.
19. Brown, Mrs. J. Otto (Emmaus Averett). Bethune, S.C. November 6, 1980.
20. Brown, Louis. Arden, N.C. Summer 1968 by Robert Sayers, courtesy of interviewer and Office of Folklife Programs, Smithsonian Institution.
21. Brumbeloe, Howell. Augusta. August 5, 1981.
22. Brumbeloe, Joel H. Conyers. August 6, 1981.
23. Burns, Mrs. Cicero S., Sr. (Annie). Barnesville, correspondence of August 4, 1972; Ailey, February 13, 1982.
24. Burns, Morris. Orange. May 1972.
25. Burton, Castalow. Mount Airy. July 14, 1977.
26. Cantrell, W. Charles. Dallas. February 18, 1979.
27. Chandler, Raymond, Jr. Elberton. April 13 and June 13, 1980.
28. Conner, Andrew H. Winder. Correspondence of July 19 and 25, 1972.
29. Coolidge, Herman W. Savannah. Correspondence of July 31, 1978 to Thomas F. Collum of Atlanta, courtesy of Mr. Collum.
30. Craven, Billy Joe. Gillsville. October 4, 1980.
31. Craven, Mrs. Billy Joe (Karen Brownlow). Gillsville. June 30, 1973; correspondence of February 6, 1979.
32. Culpepper, Mrs. Louise. Milledgeville. Correspondence of July 21 and 25, 1972.
33. Cummings, W. Oscar. Warthen. November 7, 1975.
34. DeLay, Wesley M., Sr. Lithia Springs, May 15, 1973; Douglasville, April 14, 1979.
35. DeLay, Zell. Knoxville, Tenn. December 29, 1973; March 6, 1974; July 7, 1978; June 6, 1981; December 19, 1981.
36. Dorsey, Guy. Mossy Creek.
 A. July 29 and August 2, 1968, by Robert Sayers, courtesy of interviewer and Office of Folklife Programs, Smithsonian Institution.
 B. February 6, 1971.
37. Franklin, Barney H. Marietta. December 17, 1972; August 7, 1980; January 6, 1982.
38. Franklin, Lamar. Marietta. November 1970.
39. Galloway, Mrs. Mildred Craven. Arlington, Va. Correspondence of June 14 and 22, 1979; correspondence of January 8, 1979 to Mrs. Billy Joe Craven of Gillsville.

40. Garrett, Franklin M. Atlanta. 1972 to present; correspondence of July 8 and 29, 1980.
41. Gibson, Mrs. Martha Cummings. Agricola. December 3, 1978.
42. Gooden, Mrs. Leon (Jettie Pearl Rogers). Meansville. August 1972.
43. Gordy, D. X. Westville and Primrose. July 16, 1970; April 27, 1975; December 29, 1978.
44. Gordy, William J. Cartersville. June 10, 1977; September 20, 1980.
45. Green, Thomas M. Culloden. Correspondence of June 28, 1979.
46. Griggs, Mrs. Martha Meaders. Claremont, N.C. July 2, 1977.
47. Hampton, Mrs. Martha Jane. Macon. Correspondence of May 11, 1979.
48. Harvey, Mrs. Pauline Brumbeloe. Atlanta. August 6, 1981.
49. Haynes, Mrs. Hazel Meaders. Clermont.
 A. Correspondence of July 30, 1972.
 B. Correspondence of June 1975.
50. Hewell, Carl W. Gillsville. August 8, 1973.
51. Hewell, Chester. Gillsville. November 12, 1977.
52. Hewell, Curtis. Gillsville. August 12, 1970.
53. Hewell, Harold. Gillsville.
 A. August 1, 1968 by Robert Sayers, courtesy of interviewer and Office of Folklife Programs, Smithsonian Institution.
 B. August 8, 1973.
54. Hewell, Mrs. Harold (Grace). Gillsville. October 4, 1980.
55. Hewell, Mrs. John F. (Ida). Gillsville. August 12, 1970.

56. Hewell, Mrs. Maryland (Ada). Gillsville. August 8, 1973; November 12, 1977; October 4, 1980.
57. Hewell, W. Arlin. Gainesville. March 24, 1979.
58. Hightower, Mrs. Mattie E. Fairmount. Spring 1980.
59. Holcomb, Benjamin Ray. Lula. December 14, 1977; December 20, 1978.
60. Hollingshed, Ernest T., Sr. Dallas. February 18, 1979.
61. Hudgins, Mrs. Grover. Tucker. December 15, 1978.
62. Ivey, Mrs. R. W. Milledgeville. Correspondence of August 23, 1973.
63. Jones, Mrs. Dock (Maude MacDougal). Blairsville. October 31, 1971.
64. Jones, J. W., and Mrs. Lizella. February and March 24, 1973.
65. Lewis, Betty Jean. Mossy Creek. Correspondence of November 29, 1978.
66. Lewis, Steve. Mossy Creek. February 16, 1975.
67. Lewis, Mrs. Steve. Mossy Creek. February 16, 1975; November 25, 1978.
68. Long, Bennett A. Macon. February 1973.
69. Long, Jasper N. ("Jack"). Columbia, S.C. Correspondence of November 30, 1964, February 25, 1965, and March 12, 1965 to Mrs. Marie Kirksey Darron of San Diego, Calif., copies courtesy of Mrs. Darron.
70. Long, Mrs. John W., Sr. (Annie Becham). Lizella. July 15, 1978.
71. Maddox, Mrs. June Bishop. Molena. June 22 and July 14, 1981.
72. McMillan, Kenneth G. Milledgeville. Correspondence of August 17, 1972.

73. McWhorter, Mrs. Jean Gray. Unadilla. Correspondence of January 29, 1975; March 18, 1975.
74. Meaders, Cheever. Mossy Creek. February 13 and May 2–7, 1967 by Ralph Rinzler, courtesy of interviewer and Office of Folklife Programs, Smithsonian Institution.
75. Meaders, Mrs. Cheever (Arie Waldrop). Mossy Creek.
 A. May 6 and November 16, 1967 by Robert Glatzer and Ralph Rinzler, courtesy of Mr. Rinzler and Office of Folklife Programs, Smithsonian Institution.
 B. 1968 to the present.
76. Meaders, Frank Bell. Lilburn. December 17, 1972; February 19, 1982.
77. Meaders, Lewis Q. Mossy Creek.
 A. May 7, 1967 by Ralph Rinzler, courtesy of interviewer and Office of Folklife Programs, Smithsonian Institution.
 B. February 16, 1975.
78. Meaders, Q. Lanier. Mossy Creek.
 A. July 29–August 2, 1968 by Robert Sayers, courtesy of interviewer and Office of Folklife Programs, Smithsonian Institution.
 B. March 1968 to the present.
79. Merritt, Jewel E. Lizella. Spring 1970; February 1973.
80. Merritt, William E. Lizella. Spring 1970.
81. Milhoan, Mrs. Loudella Brown. East Point. July 9, 1973.
82. Moore, Mrs. Fred. Mossy Creek. February 16, 1975.
83. Newberry, Mrs. Charles (Eudora Merritt). Macon. July 28, 1980.
84. Perdue, Mrs. C. David (Cal-

lie). Gillsville. June 30, 1973.

85. Philbrick, Mary H. Greenville, S.C. Correspondence of October 21, 1968.

86. Pitchford, B. W. Baton Rouge, La. Correspondence of October 3, 1981.

87. Respess, Mrs. Barbara. Atlanta. Correspondence of May 21, 1971.

88. Richbourg, Cohen. Warthen. July 14, 1973.

89. Rogers, Mrs. Horace (Marie Gooden). Meansville. January 8, 1972; August 5, 1978; September 16, 1980.

90. Rolader, Mrs. Ivon (Buena Holcombe). Atlanta. December 13 and 26, 1972; June 18 and September 7, 1977; June 9, 1982.

91. Royal, Mrs. V. A. (Anne Ferguson). Birmingham, Ala. Correspondence of August 4, 1977.

92. Ruff, Mrs. James (Edith Cantrell). Cartersville. February 18, 1979.

93. Sears, Rodan. Cleveland. January 1, 1978.

94. Sizemore, Mrs. Margaret Davidson. Birmingham, Ala. Correspondence of April 28 and July 21, 1978.

95. Sligh, Clarence. Cartersville. February 18, 1979.

96. Sligh, John A. Atlanta. October 25, 1980.

97. Sligh, Willy C. Dallas. March 23, 1972; October 11, 1975.

98. Smith, Mrs. Francis C. Atlanta. Correspondence of November 15, 1972.

99. Smith, Mrs. J. Furlow. Atlanta. June 28, 1973.

100. Snyder, Mrs. Herman. Warthen. July 14, 1973.

101. Stewart, Gerald M. Louisville, Miss. November 1973.

102. Stokes, Bobby F. Lizella.
 A. July 1 and 15, 1978.
 B. Correspondence of July 9 and October 19 and 25, 1978.

103. Thomason, Bevie H. Dallas. February 18, 1979; October 24, 1980.

104. Traylor, William L. Jugtown. November 1970.

105. Turbyfield, J. Brewster. Palmetto. September 30, 1978.

106. Walker, Gregory. Tucker. June 29, 1976.

107. Wilson, Hallie A. Lula. December 14, 1977.

108. Wood, Mrs. Dorothy Brown. Atlanta. 1972.

Selected Bibliography

Includes all known works on Georgia folk pottery and other publications in which southern folk pottery is substantially represented.

Auman, Dorothy Cole, and Charles G. Zug III. "Nine Generations of [North Carolina] Potters: The Cole Family." In *Long Journey Home: Folklife in the South*, edited by Allen Tullos, pp. 166–74. Chapel Hill, N.C.: Southern Exposure, 1977.

Barka, Norman F. "The Kiln and Ceramics of the 'Poor Potter' of Yorktown: A Preliminary Report." In *Ceramics in America*, edited by Ian M. G. Quimby. Winterthur Conference Report, 1972, pp. 291–318. Charlottesville: University Press of Virginia for Winterthur Museum, 1973.

——, and Chris Sheridan. "The Yorktown Pottery Industry, Yorktown, Virginia." *Northeast Historical Archaeology* 6 (1977): 21–32.

Bivins, John, Jr. *The Moravian Potters in North Carolina*. Chapel Hill: University of North Carolina Press for Old Salem, Inc., 1972.

Bowden, Elizabeth. "The Hewells' Pottery Is a Tradition." *Gainesville (Ga.) Times*, November 23, 1979, pp. 1, 3–5 leisure section.

Bridges, Daisy Wade, ed. *Potters of the Catawba Valley, North Carolina* [exhibit catalog]. Ceramic Circle of Charlotte Journal of Studies, vol. 4. Charlotte, N.C.: Mint Museum of History, 1980.

Burbage, Beverly S. "The Remarkable Pottery of Charles Decker and His Sons." *Tennessee Conservationist* 37, no. 11 (1971): 6–11. Reprinted in *Pottery Collectors Newsletter* 1 (1972): 93–96.

"Burlon Craig: [North Carolina] Folk Potter." *Foxfire* 15 (1981): 200–225.

Burrison, John A. "Afro-American Folk Pottery in the South." *Southern Folklore Quarterly* 42 (1978): 175–99.

——. "Alkaline-Glazed Stoneware: A Deep-South Pottery Tradition." *Southern Folklore Quarterly* 39 (1975): 377–403. Reprinted in *Antique Monthly* 11, no. 10 (1978): 16B, 18–19B; *Pottery Collectors Newsletter* 7 (1978): 65–72.

——. "Clay Clans: Georgia's Pottery Dynasties." *Family Heritage* 2 (1979): 70–77.

——. "Folk Pottery of Georgia." In *Missing Pieces: Georgia Folk Art 1770–1976* [exhibit catalog], edited by Anna Wadsworth, pp. 24–29, 86–103. Atlanta: Georgia Council for the Arts and Humanities, 1976.

——. "George Chandler: Elbert County Potter." In *Historical Investigations of the Richard B. Russell Multiple Resource Area*, by The History Group, Inc., pp. 203–10. Atlanta and Washington, D.C.: Interagency Archeological Services, U.S. Department of the Interior, 1981.

——. "Georgia Jug Makers: A History of Southern Folk Pottery." Ph.D. dissertation, University of Pennsylvania, 1973.

——. "The Living Tradition: A Comparison of Three Southern Folk Potters." *Northeast Historical Archaeology* 7–9 (1978–80): 33–38.

——. *The Meaders Family of Mossy Creek: Eighty Years of North Georgia Folk Pottery* [exhibit catalog]. Atlanta: Georgia State University, 1976.

——. "Traditional Stoneware of the Deep South." *American Ceramic Circle Bulletin* 3 (1982): 119–32.

Byrd, Joan Falconer. *A Conversation with Lanier Meaders* [booklet accompanying exhibit]. Cullowhee, N.C.: Chelsea Gallery, Western Carolina University, 1980.

——. "Lanier Meaders—Georgia Folk Potter." *Ceramics Monthly* 24, no. 8 (1976): 24–29.

——. "Meaders Pottery—White County, Georgia." *Pottery Collectors Newsletter* 3 (1974): cover, 73–77.

Carson, Courtenay. "Seven Generations of Pottery Makers [Brown family]." *Sandlapper: The Magazine of South Carolina* 1, no. 8 (1968): 18–20.

Chappell, Edward A. "Morgan Jones and Dennis White: Country Potters in Seventeenth-Century Virginia." *Virginia Cavalcade* 24 (1975): 148–55.

Conroy, Sarah Booth. "[Meaders] Face Jugs in Smithsonian." *Atlanta Journal and Constitution Magazine*, September 15, 1968, pp. 34–36.

Cordell, Actor. "The Last of the Mossy Creek Potters." *Atlanta*

Journal and Constitution Magazine, February 1, 1976, pp. 16–18, 26.

Counts, Charles. "Searching for the Folk Pottery of Georgia." *Brown's Guide to Georgia* 4, no. 4 (1973): 21–25.

————, and Bill Haddox. *Common Clay.* Atlanta: Droke House/Hallux, 1971.

Coyne, John. "The Meaderses of Mossy Creek: A Dynasty of Folk Potters." *Americana* 8, no. 1 (1980): 40–45.

Crawford, Jean. *Jugtown Pottery [North Carolina]: History and Design.* Winston-Salem, N.C.: John F. Blair, 1964.

Dean, Nicholas. "Sixteen North Georgia Potters." *Studio Potter* 5, no. 2 (1976–77): 29–45 (Chester Hewell featured on pp. 38–39).

DuPuy, Edward L., and Emma Weaver. *Artisans of the Appalachians: A Folio of Southern Mountain Craftsmen.* Asheville, N.C.: Miller Printing Co., 1967.

Eaton, Allen H. *Handicrafts of the Southern Highlands.* 1937. Reprint. New York: Dover Publications, 1973.

Faulkner, Charles H., ed. *The Weaver Pottery Site: Industrial Archaeology in Knoxville, Tennessee.* Knoxville: Department of Anthropology, University of Tennessee, 1981.

Fenenga, Franklin, and Emelyn Armstrong Fenenga. "Pots, Pans and Placenames: A Potter's Gazetteer of the American South." *Pottery Collectors Newsletter* 1 (1972): 60.

Ferrell, Stephen T., and T. M. Ferrell. *Early Decorated Stoneware of the Edgefield District, South Carolina* [exhibit catalog]. Greenville, S.C.: Greenville County Museum of Art, 1976.

Fredgant, Don. "T. B. Odom and

J. W. Kohler: Two Nineteenth Century West Florida Potters." *Antiques Journal* 36, no. 6 (1981): 26–29, 46–47.

Gilmer, Ruth Monroe. "Andrew Duché and His China, 1738–1743." *Apollo* 45 (1947): 128–30.

Gilreath, Ed, and Bob Conway. *Traditional Pottery in North Carolina.* Waynesville, N.C.: The Mountaineer, 1974.

Greer, Georgeanna H. "Alkaline Glazes and Groundhog Kilns: Southern Pottery Traditions." *Antiques* 111 (1977): 768–73.

————. *American Stonewares: The Art and Craft of Utilitarian Potters.* Exton, Pa.: Schiffer Publishing, 1981.

————. "The Folk Pottery of Mississippi." In *Made by Hand: Mississippi Folk Art* [exhibit catalog], edited by Patti Carr Black, pp. 45–54, 66, 83–85. Jackson: Mississippi Department of Archives and History, 1980.

————. "Groundhog Kilns—Rectangular American Kilns of the Nineteenth and Early Twentieth Centuries." *Northeast Historical Archaeology* 6 (1977): 42–54.

————. "Preliminary Information on the Use of the Alkaline Glaze for Stoneware in the South, 1800–1970." In *The Conference on Historic Site Archaeology Papers 1970,* vol. 5, edited by Stanley South, pp. 155–70. Columbia: Institute of Archeology and Anthropology, University of South Carolina, 1971.

————. "The Wilson Potteries [Texas]." *Ceramics Monthly* 29, no. 6 (1981): 44–46.

————, and Harding Black. *The Meyer Family: Master Potters of Texas* [exhibit catalog]. San Antonio: Trinity University Press for San Antonio Museum Association, 1971.

Hamblett, Theora. "Some Uses of Pottery." *Mississippi Folklore Register* 3 (1969): 5–6.

Harrell, Bob. "Fourth Generation Potter [D. X. Gordy] Keeps Up Tradition." *Pottery Collectors Newsletter* 4 (1975): 131, reprinted from *Atlanta Constitution.*

————. "Stevens Pottery." *Atlanta Constitution,* February 2, 1971, p. 11A.

Hood, Graham. "The Career of Andrew Duché." *Art Quarterly* 31 (1968): 168–84.

Humphreys, Sherry B., and Johnell L. Schmidt. *Texas Pottery: Caddo Indian to Contemporary* [exhibit catalog]. Washington, Tex.: Star of the Republic Museum, 1976.

Keyes, Homer Eaton. "Perplexities in Pottery." *Antiques* 23 (1933): 54–55.

Kidd, Marianne. "Handicrafters at Work in North Georgia." *Georgia Magazine* 2, no. 1 (1958): 10–11.

Kirkpatrick, W. S. "Things of Beauty from Georgia Clay [D. X. Gordy]." *Atlanta Journal and Constitution Magazine,* November 12, 1961, pp. 18, 20, 23.

Ladd, George E. *A Preliminary Report on a Part of the Clays of Georgia.* Geological Survey of Georgia Bulletin no. 6A. Atlanta: State Printer, 1898.

"Lanier Meaders: Folk Potter." *Foxfire* 16 (1982): 3–16.

Lee, Bennie, and Don Lewis. "[South Carolina] Graveyard Pots." *Ceramics Monthly* 15 (1967): 20–21.

Malone, James M.; Georgeanna H. Greer; and Helen Simons. *Kirbee Kiln: A Mid-Nineteenth-Century Texas Stoneware Pottery.* Office of the State Archeologist Report no. 31. Austin: Texas Historical Commission, 1979.

"The Meaders Pottery Today: Still Going Strong." *Foxfire* 2, nos. 3–4

(1968): 7–9, 134–35.

"Norman Smith: [Alabama] Folk Potter." *Foxfire* 15 (1981): 183–99.

Press, Robert M. "Southern Family [the Hewells] Shapes Its History at Potter's Wheel." *Christian Science Monitor*, October 27, 1981, p. 6.

Price, David. "Lanier Meaders—Occupation: Potter." *Soquee Journal* 1, no. 6 (1975): 4–5.

Rauschenberg, Bradford L. "'B. DuVal & Co / Richmond': A Newly Discovered Pottery." *Journal of Early Southern Decorative Arts* 4, no. 1 (1978): 45–75. Reprinted in *Pottery Collectors Newsletter* 8 (1979): 25–36.

Rice, A. H., and John Baer Stoudt. *The Shenandoah Pottery.* 1929. Reprint. Berryville, Va.: Virginia Book Co., 1974.

Rinzler, Ralph, and Robert Sayers. *The Meaders Family: North Georgia Potters.* Smithsonian Folklife Studies, no. 1. Washington, D.C.: Smithsonian Institution Press, 1980.

Salter, Charles. "Jugtown: No Jugs, Many Memories." *Atlanta Journal*, November 25, 1977, p. 2C.

Sayers, Robert. "Potters in a Changing South." In *The Not So Solid South: Anthropological Studies in a Regional Subculture*, edited by J. Kenneth Morland. Southern Anthropological Society Proceedings, no. 4, pp. 93–107. Athens: University of Georgia Press, 1971.

Schwartz, Stuart C., comp. *North Carolina Pottery: A Bibliography.* Charlotte, N.C.: Mint Museum of History, 1978.

———. "Traditional Pottery Making in the [North Carolina] Piedmont." *Tar Heel Junior Historian* 17, no. 2 (1978): 22–29.

Smith, Richard W. "A Visit to Jugtown [Georgia]." *Forestry-Geological Review* 4 (1934): 7.

Smith, Samuel D., and Stephen T. Rogers. *A Survey of Historic Pottery Making in Tennessee.* Division of Archaeology Research Series, no. 3. Nashville: Tennessee Department of Conservation, 1979.

Smith, Thomas G. "Pottersville Museum—The Result of McClendon Serendipity." *Sandlapper: The Magazine of South Carolina* 3, no. 4 (1970): 8–13.

South, Stanley. "A Comment on Alkaline Glazed Stoneware." In *The Conference on Historic Site Archaeology Papers 1970*, vol. 5, edited by Stanley South, pp. 171–85. Columbia: Institute of Archeology and Anthropology, University of South Carolina, 1971.

"South Carolina Pottery." *Pottery Collectors Newsletter* 3, no. 8 (1974).

Sparks, Andrew. "They Create Beauty from Mud, Rags and Oak Splits." *Atlanta Journal and Constitution Magazine*, March 3, 1957, cover, pp. 12–13, 32–33.

Terry, George D., and Lynn Robertson Myers. *Southern Make: The Southern Folk Heritage* [exhibit catalog]. Columbia: McKissick Museums, University of South Carolina, 1981.

Veatch, Otto. *Second Report on the Clay Deposits of Georgia.* Geological Survey of Georgia Bulletin no. 18. Atlanta: State Printer, 1909.

Vlach, John Michael. *The Afro-American Tradition in Decorative Arts* [exhibit catalog]. Cleveland, Ohio: Cleveland Museum of Art, 1978.

———. "Slave Potters." *Ceramics Monthly* 26, no. 7 (1978): 66–69.

Wells, E. D. "Duché the Potter." *Georgia Historical Quarterly* 41 (1957): 383–90.

Whatley, L. McKay. "The Mount Shepherd Pottery [North Carolina]: Correlating Archaeology and History." *Journal of Early Southern Decorative Arts* 6, no. 1 (1980): 21–57.

Wigginton, Eliot, ed. *Foxfire 8.* Garden City, N.Y.: Doubleday/Anchor Press, 1984 [includes feature on active southern folk potters].

Wiltshire, William E., III. *Folk Pottery of the Shenandoah Valley.* New York: E. P. Dutton, 1975.

Wood, Marie Stevens Walker. "One Hundred One Years in Ceramics: Stevens-Bone Family. . . ." *Georgia Magazine* 3, no. 2 (1959): 16–22.

Zug, Charles G., III. "The Alkaline-Glazed Stoneware of North Carolina." *Northeast Historical Archaeology* 7–9 (1978–80): 15–20.

———. "Jugtown Reborn: The North Carolina Folk Potter in Transition." *Pioneer America Society Transactions* 3 (1980): 1–24.

———. "Pursuing Pots: On Writing a History of North Carolina Folk Pottery." *North Carolina Folklore Journal* 27 (1979): 34–55.

———. *The Traditional Pottery of North Carolina* [exhibit catalog]. Chapel Hill: Ackland Art Museum, University of North Carolina, 1981.

Checklist and Index
of Georgia Folk Potters

Information on known folk potters who have worked in Georgia is presented in the following order: potter's name (if followed by the symbol *, suspected but not established as a potter, perhaps known as a potter elsewhere; if followed by the symbol †, limited involvement in craft as shop-owner or assistant but not turner; italics indicate given name or part thereof by which he was commonly known; nickname in quotation marks); years of birth and death (sources include censuses [which are not always consistent from decade to decade], tombstone inscriptions, and findings of genealogists, with slash indicating range of years when sources differ; state of birth or death other than Georgia given in parentheses following the year, if known); base(s) of operation as a potter (where county name has changed, latest one given); year(s) documented in written records as potter, and specific occupational designation (sources include censuses, state gazetteers, the 1898 Jackson County voting list, clay bulletins of Geological Survey of Georgia, and signed and dated ware); father's name if known or suspected as a potter, to place in genealogical framework; wife's name if known to be from pottery family, to show pattern of intermarriage; maker's mark; page(s) in text mentioning potter (numbers in italics indicate illustrations on pages where potters are not also mentioned in the text). Abbreviations: a. = after; b. = before; C. = century; ca. = circa; Md. = married (number in parentheses indicates which of several marriages); [r] = letter it follows in mark is backwards; Trans. = transitional (made or representing significant shift from folk to non-folk or later wares such as machine-made flowerpots, handmade garden or artistic pottery); *var.* = variant spelling.

Adair, Ezekiel W. 1830–? Near Buford, Gwinnett Co. 1860: potting business.

Addington, William R. 1849–a. 1900. Barrow Co. 1870; near Gillsville, Jackson Co. 1880; 1886, 1888: jug mfgr. W R. ADDINGTON · / MAYS[r]VILLE GA. See pp. 63, 225–26, 228.

Allen, Dewy. 1849–? Stockton, Lanier Co. 1880: works at jug factory. See p. 115.

Amerson, Jesse. 1875–? Jugtown 1900: potter; later for W. T. B. Gordy. See p. 174.

Anderson, *Frank*lin M. 1830–a. 1900. White Co. 1880: potter. See p. 224.

Archer, James A. 1868–a. 1900. Barrow Co. Son of Robert.

Archer, Marcus A. (*or* J. E.). 1866–a. 1922. Barrow Co. Son of Robert. See pp. 218–19.

Archer, Robert B. 1837–a. 1900. Barrow Co. 1870, 1881: potter. See p. 218.

Austin, Michael.* 1822–? White Co. 1850; Cherokee Co., N.C. 1860: potter.

Avera, Jerome. 1855–? Crawford Co. 1880: works in jug factory. Son of John. See pp. 30, 141, 160.

Avera, John C. 1832/34–a. 1900. Crawford Co. 1870: jug turner; 1871: Marshall foxhunt jug. Md. Mary Ann Elizabeth Long. See pp. 30, 158–61, color plate 5.

Averett (*var.* Everett), Andrew.* 1857–a. 1900. Crawford Co. See p. 147.

Averett, Eddie C. 1876/77–1928. Crawford Co. 1927: potter. Son of Andrew. ECA See pp. 147–50, 154.

Averett, Henry. 1807/17–187?
Crawford Co. 1850, 1860: jug
maker. Md. Catherine Merritt.
HA See pp. 146–47, 150.
Averett, John B. 1840/44–? Crawford Co. 1860: jug maker; 1880:
works in jug factory. Son of
Henry. Md. Sarah Merritt. See
pp. 141, 147, 150.
Averett, Thomas J. 1875–? Crawford Co. 1900: laborer pottery.
Son of William. TJA See p. 147.
Averett, William. 1838–a. 1911.
Crawford Co. 1870: jug manufacturer; 1880: works in jug factory.
Son of Henry. See p. 147.
Avery, Charles. 1875–? Crawford
Co. 1906: potter. CJA [?]

Becham (var. Beckham, Beckom),
Allen [R.?]. 1832/33–ca. 1864.
Crawford Co. 1850, 1860: jug
maker. Son of John, Sr. See pp.
144–45.
Becham, Benjamin J[ackson?].
1837–ca. 1915. Crawford Co.
Son of John, Sr. BB See pp. 64,
70, 144–46, 151.
Becham, Franklin Lafayette ("Fate").
1871–1958. Crawford Co. Son of
Washington. FLB and FB See
pp. 146–47.
Becham, Glover. 1888–? Stockton,
Lanier Co. 1900: labor pottery.
Son of John. See p. 115.
Becham, Jackson Columbus. 1862–
1928. Crawford Co. 1906: potter.
Son of Washington. CJB See pp.
145–46.
Becham, John, Sr.* Ca. 1795
(S.C.?)–184? Washington Co.;
Crawford Co. 1830. See pp. 126,
144–45.
Becham, John, Jr. 1830–1886.
Crawford Co. 1850: jug maker.
See pp. 144–45.
Becham, John III [or W.?]. 1857–?
Crawford Co. 1900: laborer pottery; 1906: potter. JWB [?] See
pp. 132, 146.
Becham, John. 1860–ca. 1917.

Crawford Co.; Stockton, Lanier
Co. 1900: turner pottery wks.
Son of William [W.?]. See p.
115.
Becham, Seaborn. 1853–ca. 1913.
Crawford Co. 1898: potter. Son of
John, Jr. See pp. 132, 146, 290
(n. 9, col. 1).
Becham, Washington. 1835–1918.
Crawford Co. 1898: potter. Son of
John, Sr. WB See pp. 95, 132,
144–46.
Becham, William. 1879–? Stockton,
Lanier Co. Son of John. See p.
115.
Becham, William [W.?]. 1824–
b. 1880? Crawford Co. 1850,
1860: jug maker; 1870: jug mfgr.
Son of John, Sr. See pp. 144–45,
148.
Bell, John Wesley.*† 1849–1934.
Winder, Barrow Co. Owner? J.W.
BELL / JUG TAVERN [reported] See
p. 218.
Bell, Sanford Wesley.† 1888–1963.
Bethlehem, Barrow Co. Owner
1917–22, 1928–30. Son of John.
S.W. BELL See pp. 12, 52, 197,
218–22.
Bennett, Claude. Washington Co.
1920s; Jonesboro, Clayton Co.
1930s. Son of George. See pp.
128, 201.
Bennett, George.† Washington Co.
1920s. Md. (1) Roxy Brumbeloe.
See p. 128.
Bennett, John.† Washington Co.
1920s. Twin brother of George.
See p. 128.
Berry, George O. 1848 (Ala.)–? Columbus, Muscogee Co. 1898:
potter and brick maker; 1900:
brick maker; later ran shop in
Russell Co., Ala.
Bird, Charles H. 1850 (Pa.)–1913.
Atlanta area 1900: potter
jug. C.H. BIRD: / BOLTON[r].
GA See pp. 198–99, 204.
Bird, Harry. 1880 (Minn.)–? Atlanta area 1900: laborer in pottery. Son of Charles. See p. 198.

Bishop, Andrew J. 1868–ca. 1925.
Jugtown; Atlanta area. Son of Jasper. A.J. BISHOP See pp. 170,
204.
Bishop, Curtis Grover, Sr. 1891/92–
1961. Jugtown 1927–28
for S. Rufus Rogers. Son of
W. Davis. C.G. BISHOP AND SON /
DELRAY, GA. See pp. 35, 170–
71, 180.
Bishop, Curtis G., Jr. ("Junior").†
1922–1975. Jugtown.
Bishop, Fred. 1918– Jugtown
1930s. Son of Curtis, Sr. See pp.
170–71.
Bishop, Henry H. 1840–? Jugtown;
Digbey, Spalding Co. Son of
Thomas. BISHOP AND KEY See
pp. 168–69, 172, 193.
Bishop, Jasper A[ndrew?] ("Dite").
1836–1923. Jugtown. Son of
Thomas. Md. Emily Salter. JA
BISHOP / DELRAY, GA. and JA
BISHOP / KENZIE, GA. See pp. 94,
165, 168–72, 174.
Bishop, John O. [or D., A.]. 1864–
1935. Jugtown; Atlanta area
1900. Son of Jasper. JD BISHOP
and J.D. BISHOP / WOODWARD,
GA. See pp. 170, 191.
Bishop, McGruder ("Mac").
?–ca. 1970 (N.C.). Jugtown
1925 for S. Rufus Rogers; moved
to N.C. Son of Andrew. McG.
BISHOP / RoN[r]DA / N[r]. C. See
pp. 35, 180.
Bishop, Thomas B. (or D.)* 1800
(S.C.)–185? Jugtown by 1840.
Son of James? See pp. 168, 172.
Bishop, William Davis. 1861/62–
1943. Jugtown. Son of Jasper. WD
BISHOP / MEANSVILLE / GA. See
pp. 170–71.
Boggs, Bonner. ?–1976. Long Cane,
Troup Co.
Boggs, W. Earl. Based at Rock
Mills, Randolph Co., Ala.;
worked for W. T. B. Gordy at Alvaton, Meriwether Co. See p.
174.
Boggs, William Hamilton.† 1842–

1911. Atlanta area. Owner. See pp. 198–99, 204.

Brewer, James D.† 1862–? Bogart, Oconee Co. Owner until at least 1906. JD BREWER See pp. 202, 222, 229.

Bridges, William E. 1830–? Washington Co. 1860: jug maker.

Brock, Charles J. M. 1839–1863. Montevideo/Coldwater, Hart Co. 1860: potter. Son of John L.

Brock, Earvin (or Irwin) Columbus ("Lum"). 1851/53–1904. Paulding Co. 1870: turner in factory; 1880: potter. Son of John L. See p. 207.

Brock, John Henry. 1832/41– a. 1907. Montevideo/Coldwater, Hart Co. 1860: potter; Paulding Co. 1870: turner in factory; 1900: pottery work. Son of John L. See p. 207.

Brock, John L. 1805 (N.C.)–1896. Montevideo/Coldwater, Hart Co. 1860: potter; Paulding Co. 1870. See pp. 119, 207, 211, 276.

Brock, Lucy Ann (Mrs. J. R. Shepherd). 1853–1920. Paulding Co. 1870: working in jug factory. Daughter of John L. See p. 207.

Brown, Bowling (or Bolling, Bowlin, Bolden). 1806–1892. Jugtown 1860: jug mfgr.; Atlanta area 1864; 1880: potter. Son of William. See pp. 121, 163–64, 166–68, 190–91, 193, 198, 276.

Brown, Bowling P. 1842–? Jugtown 1860: jug maker; Atlanta area 1871, 1900: potter. Son of Bowling. B.P. BROWN / ATLANTA, GA. See pp. 168, 190–91.

Brown, Charles. 1869–? Atlanta area; moved to Rock Mills, Randolph Co., Ala. Son of Thomas. See p. 195.

Brown, Charles Robert ("Bobby"). 1889–ca. 1959. Based in Atlanta area. Son of James Osborn. See pp. 180, 196–97, 201, 211, 218–19, 222.

Brown, Davis Pennington. 1895–1967 (N.C.). Atlanta area; moved to Arden, Buncombe Co., N.C. 1924. Son of James Osborn. Trans. See pp. 10, 52, 76, 196–97, 285 (n. 7), 287 (n. 30).

Brown, Edward C. 1870/73–1944. Atlanta area 1900: potter. Son of Bowling P. E.C. BROWN[r] and T.W. COFIELD / E.C. BROWN[r] See pp. 59, 191, 195, 199.

Brown, Evan Javan ("Jay"). 1897–1980 (N.C.). Based in Atlanta area; moved to Valdese/Connellys Springs, Burke Co., N.C. 1948. Son of James Osborn. Trans. See pp. 9, 35, 51–52, 58, 78, 86, 168, 180, 190, 195–97, 199, 201, 211, 241–42, 287 (n. 30).

Brown, Horace V., Sr. ("Jug"). 1889–195? (Ala.). Atlanta area until 1935; Louisville, Winston Co., Miss.; settled at Sulligent, Lamar Co., Ala. Son of U. Adolphus. Md. (2) Hattie Mae Stewart. See pp. 195, 199.

Brown, Horace V., Jr. Atlanta area 1933: potter. See p. 195.

Brown, James Osborn. 1866–1929. Atlanta area 1880: potter; Oakwood, Hall Co. 1900: potter; Jugtown. Son of Thomas. J.O. BROWN[r] See pp. 51, 70, 76, 86, 164, 168, 191, 193, 195–96, 199, 201, 204, 241.

Brown, James Otto. 1899–1980 (S.C.). Based in Atlanta area and Jugtown; settled in Bethune, Kershaw Co., S.C. Son of James Osborn. Md. Emmaus Averett. Trans. See pp. 35, 148, 154, 180, 196–97, 211.

Brown, John S. 1838–? Jugtown 1860: jug maker; Atlanta area 1864; Titus Co., Tex. 1870: potter. Son of Bowling. See pp. 168, 190.

Brown, Millard B. 1877–1953. Atlanta area 1900: potter. Son of Bowling P. See pp. 191, 195.

Brown, Rufus Edwin. 1901–? Atlanta area. Son of James Osborn. See pp. 196, 241.

Brown, Rufus Theodore ("Thee"). 1872 (Ala.)–? Atlanta area; Stockton, Lanier Co. 1900: turner pottery wks. Son of Thomas. See pp. 115, 195, 199.

Brown, Taylor, Sr.* 1807–a. 1880 (Tex.). Born in Ga.; Rusk Co., Tex. by 1843, where he owned a pottery.

Brown, Thomas O. ("Boss"). 1833–ca. 1875. Jugtown; Atlanta area. Son of Bowling. Md. Sarah Daniel. See pp. 115, 191, 195.

Brown, Ulysses Adolphus (" 'Dolphus," "Dop"). 1858–ca. 1933. Atlanta area 1880, 1900: potter; White Co. early 1920s. Son of Thomas. U.A. BROWN[r] See pp. 191, 193–95, 242.

Brown, William.* 1784 (Va.)–1851. Jugtown by 1830. See pp. 167–68, 179.

Brown, William E.* 1855–? Atlanta area. Son of William S.? V.E. BROWN

Brown, William Osborn ("Willy"). 1887–ca. 1966. Based in Atlanta area. Son of James Osborn. See pp. 86, 196, 201, 241.

Brown, William S. 1832/33– a. 1900. Jugtown 1860: jug maker; 1880: potter; Atlanta area by 1900. Son of William. Md. Nancy C. Bishop. W.S. BROWN[r] / HOWLSMILLES GA. See pp. 168, 179, 191–92.

Brownlow, Jeremiah Sanford ("Jerry"). 1852/53–a. 1900. White Co. 1880, 1883–88: potter. Son of Larkin. See p. 242.

Brownlow, John Henry. 1850– a. 1900. White Co. 1883, 1886, 1888: potter. Son of Larkin.

Brownlow, Larkin S. 1831–189? Forsyth Co. 1850; White Co. 1860; 1881, 1883–88: potter.

Brumbeloe, Camelius [C.?]. 1836–? Jugtown; Stockton, Lanier Co.

1880; Jugtown 1906: potter. Son of Emanuel. See pp. 115, 172.

Brumbeloe, Emanuel J.* 1808 (N.C.?)–ca. 1859. Jugtown. See p. 172.

Brumbeloe, James Andrew ("Jimmy"). 1877–? Jugtown. Son of William R. J.A. BRUMBELOE See p. 172.

Brumbeloe, *Newt*on Jasper. 1879–ca. 1930. Jugtown 1900: potter; moved to Washington Co. ca. 1910. Son of Camelius. See pp. 22–23, 127–29, 164–65, 172.

Brumbeloe, Oscar Early. 1871–1944. Jugtown 1900: potter; moved to Washington Co. ca. 1910. Son of Camelius. Md. Ella Hahn. See pp. 22–23, 127–29, 172.

Brumbeloe, William R. ("Billy"). 1844/45–b. 1911. Jugtown 1880: jugmaker; 1906: potter. Son of Emanuel. Md. Martha Salter. WRB See pp. 170–72.

Brumbeloe, William *Walter* Davis Scattergood. 1864–1916. Jugtown 1900: potter; moved to Washington Co. ca. 1910. Son of Camelius. See pp. 22–23, 115, 127–29, 172.

Bryant, James E., Sr.* 1856/59–a. 1900. Crawford Co. Son of Laban.

Bryant, James E., Jr. 1872–1936. Crawford Co. 1906: potter.

Bryant, John Lafayette ("Fate").* 1847–1930. Crawford Co.

Bryant, Laban L. ("Labe"). 1832 (S.C.)–1904. Crawford Co. 1870: jug mfgr. Son of Robert?

Burns, Cicero Solomon. 1900–1964. Barnesville, Lamar Co. late 1950s (hobbyist helped by S. Rufus and Horace Rogers). Trans.

Bussell (*var.* Bussle), James M. 1844–a. 1900. Crawford Co. 1870; Washington Co. 1880; 1898: potter. Son of James Bustle? See pp. 122, 126.

Bustle, James. 1804/5–? Washington Co. 1837?; Crawford Co. 1850; 1860: jug maker. See pp. 62, 126–28.

Butler, Nathan D. 1834–1862. Barrow Co. 1860: potter. Md. Sara Elizabeth Ferguson. See pp. 44–45, 218.

Cade, ———.* Petersburg, Elbert Co. 19th C. CADE [reported].

Cantrell, Frank (?) *Robert.* 1887?–ca. 1958. White Co. for William F. Dorsey. Afro-American. See pp. 49–50, 252.

Cantrell, Hoke Strickland.† 1881–1930. Paulding Co. Son of Marcus E. See p. 211.

Cantrell, John Marcus ("Mark"). 1889–1943. Paulding Co. Son of Marcus E. See p. 211.

Cantrell, Marcus Earl.* 1844–1924. Paulding Co. See p. 211.

Cantrell, Robert *Dennis.*† 1884–1952. Paulding Co. Son of Marcus E. See p. 211.

Capels, Charles. 1835/39 (England)–? Stevens Pottery, Baldwin Co. 1870: potter; 1880: working in pottery.

Chandler, Bailey *George* Nolan. 1853–1934. Barrow Co.; east of Elberton, Elbert Co. See pp. 37–38, 292 (n. 14).

Chandler, Clemmonds (*or* Clemons) Quillian. 1820–1893. White Co. 1843: Densmore pickle jar; Gilmer Co. 1850: potter; near Gillsville, Hall Co. 1860: potter. Son of Hezekiah. See pp. 224, 242, 246–47, 292 (n. 12).

Chandler, Hezekiah.* Ca. 1775 (Va.)–184? White Co. by 1820. See p. 246.

Childs, James J. 1860–1927. Jugtown. J.J. CHILDS See pp. 10, 164.

Cofield, Thomas B. 1832 (N.C.)–

a. 1900. Jugtown 1860: jug mfgr.; Atlanta area 1870; 1880–81: potter. Md. Mary Jane Brown. See pp. 168, 191, 198.

Cofield, Thomas William. 1865–? Atlanta area 1880: works in pottery; 1900: potter. Son of Thomas B. T.W. COFIELD / HOWEL. MILL / GA and T.W. COFIELD / E.C. BROWN[r] See pp. 71, 191, 195, 199.

Cogburn, Cyrus. 1782 (N.C.)–ca. 1855 (Tex.). Washington Co. by 1818 from Edgefield Dist., S.C.; 1820: stone ware mfgr.; Talbot Co. 1830; Macon Co., Ala. 1840; Rusk Co., Tex. 1850. See pp. 123–24, 134, 168, 276, 286 (n. 20).

Cogburn, Jackson.* 1817–1900 (Tex.). Rusk Co., Tex. 1850: potter. Son of Cyrus.

Cogburn, Levi S.* 1812–1866 (Tex.). Washington Co.; Athens, Henderson Co., Tex. 1857: potter. Son of Cyrus.

Cogburn, Tomlinson F.* 1818–? Rusk Co., Tex. 1850: potter. Son of Cyrus.

Colbert, Barney. 1910– Gillsville ca. 1935–40. Son of Charlie. See p. 237.

Colbert, Charlie Reece ("Bud").* 1871–1950. Gillsville.

Cook, Louis. 1856 (Ohio)–? Atlanta area 1900: potter; Cook Pottery reported for Geneva, Talbot Co. See p. 198.

Covett, ———.† Manchester, Meriwether Co. ca. 1918. Owner. See p. 196.

Craig, ———. Atlanta area 1880s: "expert potter from Scotland."

Craven, Balaam Fesmire.* 1806 (N.C.)–? (Tenn.). Clarke Co. 1830 from Chatham Co., N.C.; moved to Henderson Co., Tenn. Son of Thomas, Jr.

Craven, Billy Joe. 1947– Gillsville: opened garden pottery shop

1971. Great-great-grandson of Isaac H. Md. Karen Brownlow. Trans. See pp. 236–37.

Craven, Isaac Henry. 1839–a. 1900. White Co. 1880–81, 1883, 1886–88: potter. Son of John V. See pp. 66, 236, 242, 249–51, color plate 1.

Craven, Isaac Newton. 1806 (N.C.)–ca. 1869. White Co. 1826 from Randolph Co., N.C.; Atlanta 1846: potter? Son of John. See pp. 10, 190, 246.

Craven, John Hicks. 1860–? White Co. 1880s. Son of Isaac H. JHC [incised]

Craven, John V[andevere?]. 1798 (N.C.)–ca. 1877. White Co. 1825 from Randolph Co., N.C.; 1850: potter. Son of John. See pp. 246–47, 249.

Craven, Robert Lee ("Snake Eyes"). 1904–1971. Gillsville 1930s. Grandson of Isaac H. See p. 236.

Craven, Thomas, Jr.* 1765 (N.C.)–1857 (Tenn.). Clarke Co. 1830 from Chatham Co., N.C.; moved to Henderson Co., Tenn., by 1840. See p. 298 (n. 14).

Craven, William Thomas ("Billy"). 1863–? White Co. before moving west. Son of Isaac H.

Creamer, John. 1850–ca. 1898? Jugtown. See pp. 164–65, 170.

Croom, Giles W. 1832 (N.C.)–? Crawford Co. 1860: jug maker.

Crowell, Churchwell A. 1830/31 (N.C.?)–? Snapping Shoals / Rocky Plains, Newton Co. 1860: potter.

Daniel, John. 1852–? Atlanta area 1880: potter. See pp. 191, 195.

Davidson, Abram (or Abraham) Burdyne. 1813 (S.C.)–1885 (Ala.). White Co.; Walker Co. 1850: potter; Blount Co., Ala. Son of Frederick. See pp. 10, 244, 292 (n. 12).

Davidson, Asberry T. 1851–

a. 1900. White Co.; Atlanta 1880: potter; Cross Keys, DeKalb Co. 1881–88: potter, mnfr. crockery. Son of John B. See p. 295 (n. 5).

Davidson, Asbury Turner. 1856–a. 1900. White Co. 1879–81: potter. Son of D. Marion.

Davidson, Demetrius Marion. 1831–ca. 1918. White Co. 1879–81: potter. Son of Frederick. See pp. 242–44, 257.

Davidson, Frederick.* Ca. 1764 (Va.)–1832. White Co. 1820 from Pendleton Dist., S.C. Son of John. See p. 244.

Davidson, John B. 1819 (S.C.)–? White Co. 1860: potter. Son of Frederick. See p. 244.

Davidson, William.* 1856/57–? White Co.; Atlanta 1880; worked with brother Asberry at Cross Keys? Son of John B. See p. 295 (n. 5).

Davis, Hightower.* Indian Spring(s) Pottery near Augusta, Richmond Co. 1814: manager. See p. 119.

DeLay, George A. 1829–1864. Barrow Co. 1860: potter. Son of James. Md. Sarah Archer? See pp. 44–46, 215–16.

DeLay, George W. 1864–? Barrow Co. 1898: potter. Son of George A.

DeLay, James M. 1836–1902. Barrow Co. 1870, 1880: potter. Son of James. Md. (2) Margaret Archer. See pp. 216, 218, 225.

DeLay, Jesse W[ilson?].* 1801 (S.C.)–ca. 1901. Near Woodstock, Cherokee Co. by 1846. Son of Seth, brother of James. See p. 296 (n. 6).

DeLay, John Milton. 1838–1932. Barrow Co.; Clarke Co. (near Barrow Co. pottery center) 1870: potter; Gillsville 1890s. Son of James. See pp. 216, 228.

DeLay, Russell Van. 1840–1917/19. Barrow Co. 1870, 1879–81,

1898: potter. Son of James. Md. Martha Ann Ferguson. See pp. 216, 225.

DeLay, Wesley Marvin.† 1886–1979. Gillsville ca. 1900. Son of John. See p. 216.

Dial, Charles C. 1857/60–? Barrow Co. 1880: works in jug factory; Bogart, Oconee Co. 1900. Son of Jonathan. See p. 222.

Dial, John. 1848–1910. Barrow Co. 1880: works in jug factory. Son of Jonathan. JOHN DIAL / BOGART, GA. [reported]

Dial, Jonathan. 1822 (S.C.)–1897. Barrow Co. 1860, 1863, 1870: potter. Md. Frances Ferguson. See pp. 44–45, 48, 216–18, 227, 276.

Dickson, Leonidas Scott. 1867–1938. Crawford Co. 1900: bought Thomas Dickson's jug wheel. Son of Thomas.

Dickson, Thomas ("Cross-Eyed Tom"). 1826–1900. Crawford Co. 1898: potter. D [?] See pp. 31, 132.

Dillard, George W. 1852–b. 1900? Rabun Gap, Rabun Co. 1880, 1883: potter. See p. 292 (n. 12).

Dober, John Andrew.* Savannah, Chatham Co. 1737; Moravian potter from Germany. See p. 108.

Dodd, Eugene. 1918– Gillsville 1930s at Holcomb Pottery. Grandson of William C. Holcomb. See p. 225.

Dodd, Zach R. 1876–ca. 1927. Gillsville. Z[r]. R. DODD

Dorsey, Basil.* 1803 (N.C.)–? White Co. by 1828; Marion Co., Ala., 1850: potter. Son of Basil John. Md. Nancy Pitchford. See pp. 249, 251.

Dorsey, David Edward.† 1869–? White Co. Son of J. Tarpley.

Dorsey, David L. ("Davey"). 1799 (N.C.)–a. 1880. White Co. by 1840; 1860: potter. See pp. 241, 251, 254–55.

Dorsey, Enos (*or* Enoch; "Een")
Chandler. Ca. 1847–1925. White
Co. 1879–82, 1886, 1888,
1900: potter. Son of David L.'s
daughter Emmeline. See p. 251.
Dorsey, Frederick *William* Manson.*
1827 (N.C.)–1862. White Co.
ca. 1855 from Westminster, Oco-
nee Co., S.C. Son of David L. See
p. 251.
Dorsey, Guy Cloapton. 1897–1975.
White Co. until ca. 1938. Son of
Williams. See pp. 18–19, 50–
51, 62–63, 95, 229, 240–41,
251–53.
Dorsey, Herbert Louis. 1880–?
White Co. 1920s. Son of Wil-
liam F. Md. Kate M. Davidson.
See p. 252.
Dorsey, James Andrew. 1875–?
White Co. until early 1930s. Son
of J. Tarpley. Md. Carrie B.
Davidson. See pp. 241, 251.
Dorsey, Jefferson. 1838 (N.C.)–
ca. 1863? White Co. 1860: pot-
ter. Son of David L.
Dorsey, Joseph *Tarp*ley (*or* Tarplin).
1847–1925. White Co. 1879–
81, 1886, 1888, 1906: potter.
Son of David L. See pp. 241,
244, 251, 254, 256, 262.
Dorsey, Robert Lee. 1875–1954.
White Co. Son of Enos. See pp.
242, 244, 251.
Dorsey, Wiley Thomas. 1876/77–
1927. White Co. 1906: potter.
Son of William F. See pp. 244,
252.
Dorsey, William *Albert*.† 1886/87–
1953. White Co. until ca. 1926.
Son of William F. See p. 252.
Dorsey, William Daniel ("Little
Bill").† 1877/78–1921. White
Co. Owner. Son of Enos. See pp.
8, 14, 228–29, 242, 244, 251,
261.
Dorsey, William Fowler ("Daddy
Bill").† 1852/53 (S.C.)–1936.
White Co. Owner. Son of F. Wil-
liam. Md. Frances L. Meaders.

See pp. 8–9, 50, 196, 228–29,
241–42, 244, 251–52, 257, 261,
267, 269.
Dorsey, William S.* 1830–? White
Co.; Marion Co., Ala., 1850:
potter; Itawamba Co., Miss.,
1860: potter. Son of Basil. See p.
251.
Dorsey, Williams Horatio. 1868–
1954. White Co. until ca. 1928.
Son of J. Tarpley. See pp. 18–19,
241, 251, 257, 262.
Dougherty, Guy. From Denton,
Tex.; worked for W. T. B. Gordy
1915–16, 1928, 1930; N.C.;
East Bloomfield, N.Y. See p.
174.
Dougherty, Larry ("Lon"). From
Denton, Tex.; worked for
W. T. B. Gordy 1920s; Jones-
boro, Clayton Co. 1930s. First
cousin of Guy. See pp. 174, 201.
Duché, Andrew. 1710 (Pa.)–1778
(Pa.). Charleston, S.C., from
Philadelphia by 1735: potter;
New Windsor, S.C.; Savannah,
Chatham Co. 1738–43: potter.
Son of Anthony. See pp. 79, 101–
7, 276.
Duncan, Matthew.* Ca. 1796
(S.C.)–ca. 1881 (Tex.). Coweta
Co. 1828–3? from Edgefield
Dist., S.C.?; Randolph Co., Ala.,
1840; Bastrop Co., Tex., 1856–
80: potter. See p. 286 (n. 20).
Dunn, John Henry. 1862–1928.
Paulding Co. ca. 1910. Grandson
of John L. Brock. See p. 211.

Eaton, Page S. 1851 (Iowa)–193?
Texarkana, Bowie Co., Tex.
1880, 1882: potter; Marietta,
Cobb Co. 1900: potter; for
W. T. B. Gordy; White Co. for
L. Q. Meaders 1921; Paulding
Co. for Cantrells. See pp. 174,
202, 212, 241–42, 261.
English, Lee[roy?]. 1871?–? Atlanta
area ca. 1900. See p. 198.
Ewen, William. Ca. 1720 (En-

gland)–a. 1776. Savannah,
Chatham Co. 1749–55: potter.
See pp. 10, 107.

Fender, Floyd. 1859–ca. 1920.
Stockton, Lanier Co. until ca.
1909. Owner? See p. 292 (n. 9).
Ferguson, Catherine L. Hewell.
1881/82–1944. Gillsville ca.
1900. Daughter of Eli Hewell.
Md. Charles P. Ferguson. See pp.
45–46, 48, 237.
Ferguson, Charles H. 1793–1878/
79. Apparently trained Edgefield
Dist., S.C., early 1820s; Barrow
Co. 1846; 1870: potter. See pp.
44–45, 48, 214–16, 218, 225,
286 (n. 20).
Ferguson, Charles L. 1884–? Jack-
son Co. (near Gillsville) 1900:
potter. Son of Charles P.
Ferguson, Charles Patrick ("Char-
lie"). 1850–1917. Barrow Co.
until ca. 1890; Jackson Co. (near
Gillsville) 1898: pot man; 1900:
potter. Son of William F. Md.
(1) Adeline U. Thomas; (2) Cath-
erine L. Hewell. See pp. 45–48,
117, 226–28, 237.
Ferguson, George D. 1850–
ca. 1927. Barrow Co. 1869:
signed and dated jug reported.
Son of James.
Ferguson, James S. 1829–1864.
Clarke Co. (near Barrow Co. pot-
tery center) 1860: potter. Son of
Charles H. Md. Mary Temperance
DeLay. See pp. 44–46, 216.
Ferguson, John [F.?].* 1820
(S.C.)–187? Barrow Co. Son of
Charles H. Md. (2) Christia Dial.
See p. 216.
Ferguson, Joseph Daniel ("Danny").
1958– Gillsville since 1978.
Son of Robert. Trans. See pp.
237–38.
Ferguson, Robert Franklin
("Bobby"). 1933– Gillsville
since 1978. Son of W. Patrick.
Trans. See pp. 237–38.

Ferguson, Van S. (*or* G.). 1864–
1922. Barrow Co.; Bogart, Oco-
nee Co. 1900. Son of James. See
p. 222.

Ferguson, William F. 1821 (S.C.)–
1888. Barrow Co. 1860, 1864:
potter. Son of Charles H. Md.
Martha Butler. See pp. 44–45,
117, 216–18, 227, 276.

Ferguson, William *Pat*rick. 1908–
1968. Gillsville 1920s–30s. Son
of Charles P. and Catherine. See
pp. 227, 237.

Foreman, Glover G. 1835 (S.C.)–
b. 1900. Stockton, Lanier Co.
1881, 1883: potter. See p. 115.

Foreman, Joe S. 1872–? Stockton,
Lanier Co. until 1912/20. Son of
Glover. Md. Mellie Fender. See
pp. 115–16.

Foreman (*orig.* Lunday), McLin J.
1863–? Stockton, Lanier Co.
1900: supt. pottery wks. Adopted
son of Glover? See p. 115.

Franklin, Barney E. 1887–1950.
Marietta, Cobb Co. Son of
James W. Trans. See p. 202.

Franklin, James *Floyd*, Sr. 1889–
1962. Marietta, Cobb Co. Son of
James W. Trans. See p. 202.

Franklin, James *Floyd*, Jr. 1914–
1981. Marietta, Cobb Co. Trans.

Franklin, James Wiley. 1856–1930.
Marietta, Cobb Co. after 1901.
Trans. J.W. FRANKLIN / MARI-
ETTA. GA See pp. 140, 202–4.

Franklin, Lamar, 1914– Marietta,
Cobb Co. Son of William. Trans.
See pp. 202–4.

Franklin, William J. 1884–1940.
Marietta, Cobb Co. Son of
James W. Trans. See p. 202.

Gibson, Frank. Alvaton, Meri-
wether Co.; left for N.C. 1907.
See p. 172.

Giles, ———.* Washington Co.
19th C.

Gordy, Dorris Xerxes. 1913–

Primrose (near Greenville), Meri-
wether Co.; established Westville
Pottery, Stewart Co. 1969. Son of
William T. B. Trans. See pp. ix,
xviii, 9, 43, 79, 163, 172–79,
196, 201.

Gordy, William Joseph. 1910–
Alvaton, Meriwether Co.; for
James Reid, Acworth, Cobb Co.;
N.C.; Cartersville, Bartow Co.
since 1935. Son of William T. B.
Trans. GA. ART POTTERY
and HAND MADE / BY / W.J.
GORDY See pp. 9, 175–76,
202.

Gordy, William Thomas Belah.
1877–1955. Jugtown; Alvaton,
Meriwether Co. 1907; Shakerag
and Aberdeen, Fayette Co. 1908–
18; Alvaton 1918–35; Primrose
(near Greenville), Meriwether Co.
after 1935. Nephew of Jasper and
Henry Bishop. Trans. WTB ·
GORDY / ALVATON · GA and
GORDY'S POTTERY / GREENVILLE,
GA. See pp. 9, 71, 121, 170,
172–76, 191, 193, 196, 202,
color plate 1.

Griffin, Henry.* 1826–? Washing-
ton Co.: signature on antebellum
jar.

Gunter, Allen. 1801 (S.C.)–
b. 1860? Montevideo/Coldwater,
Hart Co. 1830 from Edgefield
Dist., S.C.; 1850: jars & jugs.
Son of James? See pp. 119, 207,
286 (n. 20).

Gunter, Allen J. 1838/40–a. 1900.
Montevideo/Coldwater, Hart Co.
1860: potter. Son of Allen.

Gunter, Elijah B. 1822–? Monte-
video/Coldwater, Hart Co. 1860:
potter. Son of Allen.

Hahn, ———. Augusta, Richmond
Co. ca. 1900 (may actually have
worked at North Augusta, Aiken
Co., S.C.) HAHN POTTERY WKS. /
AUGUSTA, GA. See p. 292 (n. 17).

Hall, J. T. Barrow Co.?; Gillsville
early 20th C. for Maryland Hew-
ell.

Hall, Joseph (B.?). 1835/36–
a. 1900. White Co. 1880: potter.

Harper, Jesse. 1843/53–? Crawford
Co. 1880: works in jug factory.
Md. Lucinda A. Long. JH See
pp. 30–31.

Harper, Sylvester. 1867–? Crawford
Co. 1880: works in jug factory.
Stepson of Jesse. See p. 31.

Hart, ———.* Crawford Co. ca.
1900. Afro-American.

Hartley, J. Monroe. 1872–1941.
Crawford Co. 1906: potter. Md.
Tiny Becham.

Henderson, James Bascomb.† 1853/
54–1911. Jackson Co. (near
Gillsville). Owner of Addington
shop 1890s–1903. See pp. 226–
27.

Hewell, Carl William. 1913–
Gillsville. Son of Maryland.
Trans. See pp. 49, 229.

Hewell, Charles G.† 1883/86–
1932/38. Gillsville 1900: pottery
laborer. Son of Eli.

Hewell, Chester. 1950– Gills-
ville. Son of Harold. Trans. See
pp. 48–49, 234–36.

Hewell, Curtis. 1914–1980. Gills-
ville until ca. 1950. Son of John.
Trans. See pp. 76, 228, 232.

Hewell, Eli D. 1854–1920. Barrow
Co. 1880: potter; Gillsville ca.
1890; 1900: turner pottery. Son
of Nathaniel. Md. (1) Elizabeth
Dial; (2) Frances Ferguson
Thomas. See pp. 45–48, 216–
18, 224–25, 227–28, 236.

Hewell, George.† 1867–? Barrow
Co. 1880: works in pot shop. Son
of Nathaniel. See p. 47.

Hewell, Grace Nell Wilson. 1933–
Gillsville after 1950. Md. Harold
Hewell. Trans. See pp. 48, 234–
35, 281.

Hewell, Harold. 1926 (S.C.)–
Gillsville. Son of Maryland.

Trans. See pp. 12–13, 44–45, 48–49, 229–30, 233, 236.

Hewell, Henry. 1924– Gillsville. Son of Maryland. Trans. See p. 229.

Hewell, Henry H. 1869/70– ca. 1937. Barrow Co. 1880: works in pot shop; Gillsville; White Co. 1900 for William F. Dorsey; between Winder and Gillsville, Barrow Co. Son of Nathaniel. H·H· HEWELL / WINDER GA / RFD 20 See pp. 47, 218, 228–29, 236.

Hewell, Jack. 1914– Gillsville. Son of Maryland. Trans. See pp. 49, 229, 236–37.

Hewell, John F. 1882–1947. Gillsville. Son of Eli. Trans. JF HEWELL See pp. 71, 228–29, 232–33, 237.

Hewell, *Mark*es John. 1909–1975. Gillsville; Lula, Banks Co. for H. A. Wilson. Son of William J. Trans. See p. 229.

Hewell, Maryland ("Bud"). 1891–1964. Gillsville; also Athens, Clarke Co.; Bogart, Oconee Co. for James Brewer; White Co. for Cleater Meaders. Son of Eli. Trans. See pp. 37, 48–49, 80, 228–29, 232–33, 236, 259.

Hewell, Matthew. 1972– Gillsville. Son of Chester. Trans. See pp. 49, 235.

Hewell, Nathaniel H. 1832– ca. 1887. Barrow Co. 1880: potter. Son of Wyatt? Md. (2) Sarah J. Thomas. See p. 217.

Hewell, Russell L. 1912– Gillsville; Lula, Banks Co. for H. A. Wilson. Son of William J. Trans. See pp. 229, 235.

Hewell, Wayne. 1955– Gillsville. Son of Carl. Trans. See pp. 49, 236.

Hewell, William *Arlin* ("Arlie," "Caleb"). 1907– Gillsville; Lula, Banks Co. for H. A. Wilson. Son of William J. Trans. See pp. 229, *231*, 236.

Hewell, William Jefferson. 1876/80–1943. Gillsville; White Co. 1900 for William F. Dorsey: laborer in pottery; later for Loy Skelton. Son of Eli. See pp. 228–30, 241, 252, 261, 269.

Hicks, Elijah H.* 1812–? Crawford Co. 1851: bought Joseph Long's raw jugware.

Hicks, J. C. Jugtown ca. 1900. J.C. HICKS (a John C. Hicks [1850–95], possibly son of Elijah, lived in Crawford Co.).

Hill, J. C. 1815 (N.C.)–b. 1870? In Ga. by 1844 from S.C.; Duck Creek, Walker Co. 1860: potter. See p. 292 (n. 12).

Hill, James F. 1841/42 (S.C.)–? Duck Creek, Walker Co. 1870, 1880: potter; 1883, 1886: jug mfgr. Son of J. C. See p. 292 (n. 12).

Hinton, ———. Mallorysville, Wilkes Co. 1886: signed and dated pitcher (possibly William C. [born 1851] or Noah H. [born 1843]). See p. 297 (n. 10, col. 1).

Hogan, Riley. White Co. ca. 1900.

Holcomb, John Robert. 1837–1925 (Miss.). White Co.; Gillsville 1886, 1888: jug mfgr.; Pisgah, DeKalb Co., Ala., ca. 1895; Carriere, Pearl River Co., Miss., 1920. Son of Robert. Md. Emeline Anderson. See p. 224.

Holcomb, Joseph *Cicero*.* 1831–1909. White Co.; Gillsville 1883: jug mfgr. Son of Robert. See p. 224.

Holcomb, Samuel *Ray*burn. 1892/93–1951. Gillsville ca. 1925–45. Son of William. SRH [reported] See pp. 97, 225, 229.

Holcomb, William Cicero ("Bunk"). 1862–1932/33. Gillsville until ca. 1925; 1900: pottery turner. Son of John. Md. Sarah S. Colbert. See pp. 224–25.

Holcombe, Thomas Richard. 1872/75–ca. 1947. Atlanta area ca.

1900. Md. Nancy Boggs. See p. 199.

Holland, John Frederick. 1781 (N.C.)–1843 (N.C.). Creek Agency, western Crawford Co. 1810 from Salem, N.C. See pp. 108–10.

Holloman, Daniel. 1807–? Warren Co. (near Washington Co. pottery center) 1850: potter.

Hornsby, C. C. Bowenville, Carroll Co. 1879, 1881: potter.

Hornsby, S. A. Bowenville, Carroll Co. 1881, 1883, 1886: potter.

Howard, P[eter?]. 1812 (S.C.)–? Amicalola Dist., Lumpkin Co. 1850: potter. See p. 292 (n. 12).

Humphries, Louis Shirley. 1851/56 (N.C.)–a. 1900. White Co. 1880, 1883, 1886, 1888: potter.

Jackson, W. T. Jugtown late 19th C.? W. T. JACKSON

Jarrard, Josiah D. 1830–1901. White Co. 1883, 1886, 1888: physician and pottery. Md. Mary S. Dorsey. See p. 10.

Jay, Thomas. 1825–? Forsyth Co. 1850: potter.

Jegglin, Hermann. Ca. 1860 (Mo.)–? Jugtown ca. 1905–10 for Wiley Rogers; Alvaton, Meriwether Co. for W. T. B. Gordy. Son of John, a German potter who settled at Boonville, Mo. See p. 174.

Jenkins, Bill. White Co. late 19th C. for the Pitchfords.

Jones, Dock R. 1891–1961. Young Cane, Union Co. 1903–ca. 1915. Son of J. Wesley. See p. 118.

Jones, Henry. 1880–? Young Cane, Union Co. 1900: turner (jugs & jars). Son of J. Wesley. See p. 118.

Jones, James A. 1842–? Young Cane, Union Co. 1879, 1886, 1888: jug mnfr. Son of Wilson. See pp. 116–17, color plate 6.

Jones, John *Wesley*. 1845–ca. 1905. Young Cane, Union Co. until

Sears, Thomas G. 1825–b. 1880?
White Co. 1850, 1860: potter.

Shannon, William *Joseph*. 1838/39–
1919. Atlanta area 1900, 1902:
terra cotta works. See p. 201.

Shantz, Christopher. 1718 (Ger-
many)–? Savannah, Chatham Co.
1739 as apprentice to Andrew
Duché. See p. 104.

Shantz, William. 1721 (Ger-
many)–? Savannah, Chatham Co.
1739 as apprentice to Andrew
Duché. Brother of Christopher.
See p. 104.

Shepherd, George Washington.†
1881/83–1973. Paulding Co. Son
of J. Robert.

Shepherd, John Franklin. 1877/78–
1950. Paulding Co. 1900: potter
trade. Son of J. Robert. See pp.
207, 209.

Shepherd, John Robert ("Bob").
1855 (Ala.)–1907. Paulding Co.
1880, 1900: potter. Son of Wil-
liam. Md. Lucy A. Brock. See
pp. 207–9.

Shepherd, Rowe [James Monroe?].
1892?–ca. 1925. Paulding Co.
Son of William F. Md. ———
Kiser. See p. 207.

Shepherd, William. 1822 (N.C.)–
1905. Paulding Co. 1880: potter.
See p. 207.

Shepherd, William F. ("Bud").
1851/52 (Ala.)–a. 1911. Pauld-
ing Co. 1880, 1906, 1911: pot-
ter. Son of William. Md. Harriet
Brock. W.F. SHEPHERD [in-
cised] See pp. 207–8.

Skelton, Loy A.† 1894–1974.
White Co. ca. 1919–45. Owner.
See pp. 8, 228, 261.

Sligh, Benjamin B.† 1877–1944.
Paulding Co. until ca. 1905. Son
of John. See p. 208.

Sligh, Jacob Albert *Sid*ney Johnson.
1879–1960. Paulding Co. ca.
1895–1927. Son of John. See pp.
208–12.

Sligh, John Nicholas.† 1807
(S.C.)–1897. Paulding Co. by

1860; established Sligh Pottery b.
1870. Owner. See pp. 206–8.

Sligh, Sarah ("Sally") Ann Terry.†
1857–1901. Paulding Co. Man-
aged Sligh Pottery 1897–1901.
Fourth wife of John. See p. 208.

Sligh, Willy Claude.† 1902–1978.
Paulding Co. 1920s. Son of Sid.
See pp. 208–11.

Smith, John P. 1812 (Tenn.)–?
Murray Co. 1850: potter. See p.
292 (n. 12).

Smith, Julius L. 1872 (S.C.)–? At-
lanta area 1900: potter. J.L.
SMITH CO. / ATLANTA, GA. and
ATLANTA, Ga. / J.L. SMITH See
p. 198.

Smith, Walter. 1888–? Atlanta area.
Brother of Julius. See p. 198.

Spence, James W. 1828–1884/
1900. Barrow Co. 1880: jug
maker. Md. Mary S. Ferguson.
See p. 218.

Steed, Collin.* 1812–? Barrow Co.
Md. Frances DeLay. See p. 218.

Stevens, Henry.† 1813 (England)–
1883. Stevens Pottery, Baldwin
Co. after 1861. Owner.

Stewart, John Henry. 1878–1953.
Jugtown until 193? JH
S[r]TEWART / MEAN[r]S[r]VILLE
and J.H. S[r]TEWART / JO
BROWN[r] See pp. 35, 164–65,
196.

Stewart, Tommie W. 1905–1961.
Jugtown. Son of John.

Stork, Edward Leslie. 1868/69
(S.C.)–1925. Columbia, Richland
Co., S.C. 1880s; Ala.; Miss.; El-
bert Co.; Orange, Cherokee Co.;
Senoia, Coweta Co.; Washington
Co.; Crawford Co.; Alvaton,
Meriwether Co. 1907; Fayette
Co. 1908; Orange 1909–25. Son
of John. E.L. STORK / ORANGE,
GA. and EL STORK / ABERDEEN /
GA See pp, 70–71, 128, 172–
73, 202, 294 (n. 26).

Stork, Earl. ?–1968. Orange, Cher-
okee Co. 1926–27. Son of Ed-
ward.

Thomas, John H. 1842–b. 1888?
Barrow Co. until ca. 1878; Young
Cane, Union Co. 1879: jug
mnfr.; 1880: potter. Md. (2)
Frances Ferguson. See pp. 116–
17.

Tilman, Sanford. 1829 (S.C.)–? Yel-
low Creek Dist., Lumpkin Co.
1850: potter. See p. 292 (n. 12).

Turbyfield, Jack. ?(England)–ca.
1900. Palmetto, Fulton Co. late
19th C. with brother, who re-
turned to England. See p. 201.

Tyler, John. 1827/28–? Snapping
Shoals/Rocky Plains, Newton Co.
1860: jug maker.

Ussery, Benjamin F.* 1826/28
(N.C.)–a. 1880 (Miss.). Union
Co., N.C.; Randolph Co., Ala.
ca. 1848–55; Ga. ca. 1856–58;
Hardeman Co., Tenn. 1860: pot-
ter; Yalobusha/Calhoun Co., Miss.
after ca. 1875. B.F. USSERY /
WATER VALLEY, MISS.

Vestal, Jeremiah.* 1785 (N.C.)–?
White Co. 1830; Blount Co.,
Ala. 1850; 1860: potter.

Warthen, Spencer Marsh. 1866–?
LaFayette, Walker Co. 1906: pot-
ter or owner. See p. 292 (n. 12).

Warwick, Wiley *Asberry*. 1819
(S.C.)–1901. White Co. Md.
Mary Ann Pitchford. See p. 242.

Whittington, Jasper Newton.* ?–b.
1850. Crawford Co. Md. Eliza-
beth Long.

Willard, James. 1841 (S.C.)–? Bar-
row Co. 1880: potter. Md. Sara J.
DeLay. See p. 218.

Wilson, Hallie A. 1911– Gills-
ville; Flowery Branch, Hall Co.
1949–51; Lula/Alto, Banks Co.
Md. Monteen Skelton. Trans.
H.A. WILSON / POTTERY CO / GILLS-
VILLE GA See p. 229.

Wilson, Jimmy Ray. 1945– Lula/
Alto, Banks Co. Son of Hallie.
Trans.

Wilson, Wayne. 1940– Lula/ Alto, Banks Co. Son of Hallie. Trans.

Wright, [Thomas P.?]. 1848?–? Mallorysville, Wilkes Co. 1886: signed and dated pitcher. See p. 297 (n. 10, col. 1).

Wright, [William L.?]. 1852?–? Mallorysville, Wilkes Co. 1886: signed and dated pitcher. See p. 297 (n. 10, col. 1).

Yaughn, Coot. 1868–? Crawford Co. 1900: bought Thomas Dickson's jug wheel. Son of James.

Yaughn, James. 1846/49–1925. Crawford Co. 1906: potter. JY

Yaughn, Rodolphus ("Doll"). 1885/86–1921. Crawford Co. Son of James. See p. 144.

General Index

Excludes Georgia folk potters, who are indexed separately in the preceding Checklist; numbers in italic indicate illustrations on pages where the subject is not also mentioned in the text.